Art in Society

Art in Society

Studies in style, culture and aesthetics

edited by
MICHAEL GREENHALGH
and
VINCENT MEGAW

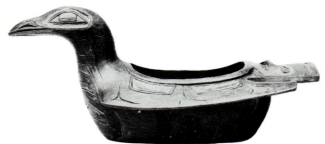

St. Martin's Press
New York

© by Gerald Duckworth & Co. Ltd. 1978

All rights reserved. For information, write:
St. Martin's Press, Inc., 175 Fifth Avenue, New York, N.Y. 10010
Printed in Great Britain
Library of Congress Catalog Card Number 78-69954
ISBN 0–312–05267–7
First published in the United States of America in 1978

Designed by Derek Doyle

Title page illustration: Carved and painted wooden bowl in the form of a duck, from the North-West coast of America, first half of the nineteenth century
(British Museum [Museum of Mankind]; photo: Michael Greenhalgh)

To the artists without whom
there would be nothing to study

CONTENTS

Section Three
SOME ETHNOGRAPHIC EXAMPLES

CONTRIBUTORS

Michael Cardew, Wenford Bridge Pottery, St Breward, Cornwall

P.J.C. Dark, Department of Anthropology, Southern Illinois University, Carbondale

J.B. Donne, 55 Ledbury Road, London W 11

James C. Faris, Department of Anthropology, University of Connecticut

David Frankel, Department of Western Asiatic Antiquities, British Museum, London

Peter Gathercole, University Museum of Archaeology and Ethnography, Cambridge

Adrian A. Gerbrands, Instituut voor Culturele Antropologie en Sociologie der niet-Westerse Volken, Rijksuniversiteit, Leiden

Nelson H.H. Graburn, Department of Anthropology, University of California, Berkeley

Michael Greenhalgh, Department of the History of Art, University of Leicester

Josef Herman, 120 Edith Road, London W14

Adrienne L. Kaeppler, Bernice P. Bishop Museum, Honolulu

Sheila M. Korn, Department of Anthropology, London School of Economics and Political Science

Robert Layton, Australian Institute of Aboriginal Studies, Canberra

Malcolm D. McLeod, Museum of Mankind, British Museum, London

Vincent Megaw, Department of Archaeology, University of Leicester

Martin A. Nettleship, 30 Joneswood Drive, Athens, Ohio 47501

G. Reichel-Dolmatoff, Instituto Colombiano de Antropología, Universidad de los Andes, Bogotà

Michael D. Roaf, Wolfson College, Oxford

Thurstan Shaw, 37 Hawthorne Road, Stapleford, Cambridge

George Swinton, Department of Art History, Carleton University, Ottawa

Joan M. Vastokas, Department of Anthropology, Trent University, Peterborough, Ontario

G.N. Wilkinson, Department of English, University of Nigeria, Nsukka

Richard Wollheim, Department of Philosophy, University College London

PREFACE

This volume has its origins in a symposium arranged by the present editors under the auspices of the Research Seminar in Archaeology and Related Subjects and held at Leicester University in January 1975. The object of the organisers – an archaeologist and an art historian each with a complementary interest in the other's discipline – was to offer a forum for those who study art and those who produce it. The experiment was to see if it was possible to achieve what one participant described as her life's ambition – a happy interdisciplinary marriage between art and anthropology.

Although this volume is not intended to be a formal record of proceedings at the Leicester Symposium, it would be improper if a number of formal acknowledgments were not made. The practical arrangements for the Seminar were the joint responsibility of the Departments of Adult Education and Archaeology at the University of Leicester. Both Brian Threlfall, Assistant to the Director, Department of Adult Education, and ourselves wish to thank first and foremost our secretaries at the time, Dorothy Walker and Laurel Kirkby, for a seemingly unending supply of energy, abridged typescripts, accommodation bookings, reminder letters, good nature and unflappability. Warwick Bray, Don Brothwell, Peter Gathercole, Stuart Piggott, Michael Rowlands and William Watson, who acted as chairmen for various sessions at the seminar, deserve our gratitude, since the discussions they so skilfully orchestrated provided the themes which have formed the basis of this book. The late Terence Powell closed the Symposium with a demonstration of Celtic erudition and wit admirably suited to the many-faced nature of our deliberations.

Individual publication credits are indicated as appropriate. Maureen Raine transformed some almost medieval palimpsests into legible typescripts, while the index for this book, as in previous volumes associated with the Research Seminar, has been prepared with her customary skill by Susan Johnson.

It should be noted that in many cases the texts as published here are, with minor revisions, abbreviated versions of manuscripts first submitted in November 1974. Some papers were not originally given at the seminar, but were commissioned afterwards; we are indebted to Richard Wollheim, John Donne and Thurstan Shaw for so positively responding to our invitations.

C.M.B.G.
J.V.S.M.

Michael Greenhalgh and Vincent Megaw

Introduction: the study of art in society

> Our father Adam sat under the Tree and scratched
> with a stick in the mould;
> And the first rude sketch that the world had seen
> was joy to his mighty heart,
> Till the devil whispered behind the leaves,
> 'It's pretty. But is it art?'
>
> (Rudyard Kipling, *The Conundrum of the Workshop*)

There have been several attempts at a cross-cultural approach to art but, as Raymond Firth has noted,

> Dialogue between artists and anthropologists (has) been rare ... the interest of artists and art critics in primitive art ... may have encouraged the anthropologists in their belief in the seriousness of the study, but it may even have held back systematic enquiry into the internal significance of the material – that is, in terms of the values of the people who produced it (Firth, 1973).

One related problem is indeed the definition of the 'artist' himself. The dedication of this book may in fact seem more than a little ethnocentric since, as several papers which follow will demonstrate, 'artists' as a definable and recognisable class simply do not exist in many ethnographic contexts. The 'artist' as the creative perceptor or interpreter of social situations is very much a historically determined figure in European society and is very difficult – and probably impossible – to define or find cross-culturally.

Art historians and anthropologists must examine their motives for interest in societies radically different from their own if they wish their conclusions to be accepted as valid. Is the modern study of societies in which artists still have a useful place, regulated by tradition and perhaps sanctified by religion, any more than a modern Romanticism? Can we really capture art – 'by which' as with religion, as Clive Bell remarked, 'men escape from circumstance to ecstasy' (Bell, 1914, 92) – on the tape-recorder and the cine-camera of

the modern field-worker or on the computer of the up-to-date archaeologist, helped by elegant model-building borrowed from the philosopher and social scientist? Or is the gap between the 'fine' art of the European tradition and the art of non-Western societies too great to be bridged even by the most committed field-worker? Indeed, as one writer notes in the present volume, maybe the very word 'art' should be avoided in order to try and 'remove a few of the multitude of problems created by labelling as "art" what we do not understand' (McLeod).

Clearly, that gap exists and it will not go unnoticed that there are no contributions in the present volume from indigenous artists. The following pages do, however, offer a variety of approaches to the study of the artist within society. Three contributors (Dark, Layton and Wollheim) face the difficulties of arriving at a definition of art or style as opposed to examining the role of the artist within his own society. Three more (Donne, Graburn and Greenhalgh) deal with the related problem of assessing the impact of art on a different cultural environment. Such studies underline the difficulties inherent in any investigation which attempts to correlate artistic productivity with any single aspect or, indeed, group of aspects within a society (cf. McGhee, 1976; Wolfe, 1969). Many of the essays, however, leave on one side arguments within their own discipline or between disciplines, and concentrate either on demonstrating the ways in which their subject may be approached, or on reporting the results of field work. Section Two, *Methods of study and style analysis*, ranges from an examination of style *via* mathematics (Roaf) or *via* formal analysis using a computer (Korn) to the attempts of Frankel and Nettleship to pin down the relationship between art and social structure. Section Three, *Some ethnographic examples*, includes speculation about the meaning of Asante images (McLeod), a close study of the artist-apprentice relationship in Western New Britain (Gerbrands), and an attempt to explore the relationship between music and visual art in Tonga (Kaeppler). One theme which runs through all the papers which form this third section is that of ethnographic art as a non-verbal system of communication, a system of conveying information either within its own social context or linked to other systems of expression such as dance or music, or through European means of perception.

Elsewhere, scholarly interest in the role of the artist within society has led to a plea for the development of a sociology of art. We are told, in a recent book on modern Western art (Hess 1975), that ' ... the work of the artists can only be understood by following or repeating the creation of their imagination which, like ours, is rooted in social life'. A cross- or trans-cultural approach to artistic and aesthetic values – Maquet's (1971) 'aesthetic anthropology' – must surely be our ultimate aim as indeed Wollheim suggests.

Such ideals are, however, vitiated rather than enriched by the

diverging interests of the scholars concerned, and by the frequently mutual disdain between artists and scholars. The views of artists or craftsmen writing about art (such as the essays published here by Cardew and Herman), particularly those views expressed by Western artists on non-Western art, have often met with derision from anthropologists. There are, of course, anthropologists or those working in anthropology who themselves are artists or craftsmen (Swinton, Nettleship and Wilkinson in the present volume) but three contributors to informal discussions during the Leicester Symposium, respectively an anthropologist, a prehistorian and an art historian, showed how distant is that dream of aesthetic anthropology. Compare the following statements:

> Anthropology has evolved in the direction of evaluating things only in terms of the general system of culture in which they are found and within their own patterns of belief. This is entirely the wrong trend for anthropology to take if it is interested in art, because the only real way to appreciate art is to know in advance the particular system within which art objects themselves are centred. As yet, anthropologists have neither the sense nor apparently the skill to study art in this way; art historians and artists may show us the way …

> Superficially the values of the past may look like one's own but, the more they appear so, the more likely one is to be wrong – and more wrong than the anthropologist dealing with the present. Recognising that there is no valid division in so-called 'alien' societies between craft-objects and works of art, our task as archaeologists must still be to define, as far as we can, the terms in which they were valued both by individuals and by social groups in the society on which one is trying to work …

> Anthropologists have to deal within the confines of social science, and art is not – yet – so easy to categorise however hard we may try. Nevertheless, through art we may gain insight into a culture. We therefore need a more relaxed approach in which theoretical model-building may have no place …

The pious hope of the first speaker, the anthropologist, will, at least in Britain, fall on deaf ears. Here, the accent in the universities is wholly on 'fine' art. In contrast to America or Australasia, there are, as far as we are aware, no courses offered in British universities which apply art historical disciplines to ethnographic material within the context of conventional art history courses. An inbred mistrust of the social sciences likewise tends to have been adopted in an attempt to keep the art historian 'pure', and ensure that he exercises temperance in the interpretation of his material. A comparison between art history

WHEN I ARRIVED I FELT SHY

THERE WERE LOTS OF PEOPLE
ALL AROUND, AND I
DIDN'T KNOW ANY OF THEM

THEY WERE ALL VERY LEARNED
AND I FELT
EXPOSED

BUT I SOON FOUND
THAT THEY
WERE FRIENDLY

AND EVEN LISTENED
TO THE THINGS
I SAID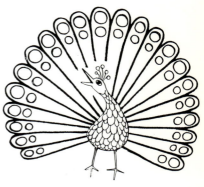

AND FINALLY
ASKED WHAT I HAD
TO GIVE

Michael Gill

periodicals from, say, the 1920s and the 1970s would reveal few differences of approach. That the same could not be said of archaeology or, for that matter, history reveals a disturbing insularity in the art historian.

Yet a strictly anthropological approach to alien art can, perhaps, tell us little more about that art (as opposed to our Western reactions to it) than the less 'scholarly' reactions of Western artists. Is it not in reaction to these seemingly inevitable limitations of approach that interest has recently grown in the 'biosocial bases of art' (cf. Brothwell, 1976)? A book mainly concerned with the visual arts must surely include a visual statement from an artist. At the end of the Leicester Symposium we invited Michael Gill, potter and painter, for his views on the proceedings. Since Gill maintained that as an artist he was a maker of images he gave a pictorial answer (opposite).

We cannot expect the present collection of essays to explain all art to all men. Until some future prehistorian of art uncovers Adam's very first drawing, Kipling's conundrum must remain unsolved. It is simply in the desire that everyone interested in art will take notice of techniques and ideas from different disciplines (even at the risk of following the fads of fashion) that we offer this volume.

REFERENCES

Bell, Clive (1914), *Art*, London.
Brothwell, Don R. (ed.) (1976), *Beyond Aesthetics: Investigations into the Nature of Visual Art*, London.
Firth, Raymond (1973), 'Preface', in Anthony Forge (ed.), *Primitive Art and Society*, London, v-vii.
Hess, Hans (1973), *Pictures as Arguments*, London.
McGhee, Robert (1976), 'Artistic productivity in Eskimo culture', *Current Anthropology*, 17, 203-20.
Maquet, J. (1971), *Introduction to Aesthetic Anthropology*, Addison-Wesley Module in Anthropology, Reading, Mass.
Wolfe, Alvin W. (1969) 'Social structural bases of art', *Current Anthopology*, 10, 3-44.

I

APPRECIATION AND AESTHETICS

Richard Wollheim

Aesthetics, anthropology and style: some programmatic remarks

1. Aesthetics has much to learn from anthropology, and anthropology has much to learn from aesthetics. In this paper I cannot hope to do more than say something fairly general about these two processes and their interrelations, and then to illustrate what I have said by reference to a problem that is necessarily of great interest both to the philosophy and to the anthropology of art. The problem is that of style. In talking of art and of style I shall have particularly in mind pictorial art and pictorial style.

2. Certain concepts – and these I shall call from now onwards, without prejudice, 'aesthetic concepts' – find a significant employment in connection with art. This employment may be in the production, or in the perception, or in the assessment, of works of art. Of these concepts some may be employed only in connection with one of these activities, but there seems good general reason to believe that those concepts which can lay claim to centrality in our understanding of art will occur in all three contexts.

Of course, this belief needs to be carefully interpreted, and it is plausible only on the assumption that a given concept can be employed in a given context without there being given verbal expression. But this seems on independent grounds realistic. It seems realistic, for instance, to assume that a concept should be employed in the production of art, that it should occur there regulatively, and that this should not be linguistically manifest.

The relevance of this to the present topic is that the concept of style is a very strong candidate for being one of those central to our understanding of art.

3. Aesthetics may be said to begin when an aesthetic concept is subjected to analysis. To subject a concept to analysis is to set out its conditions of application. Ideally analysis would take the form of laying down the truth-conditions for all those assertions, or all those

types of assertion, in which the concept characteristically is used. In practice analysis falls short of this ideal, but its success will be measured in terms of the understanding it offers us of the concept under analysis.

Very roughly, it may be said that a concept will be subjected to analysis in one or other of two very different circumstances. On the one hand, the application of the concept may be problematic: that is to say, there will be a considerable degree of uncertainty whether something does or does not fall under the concept, and in consequence the motivation for analysing the concept will be to resolve this uncertainty. The uncertainty, it will be felt, can be resolved by, but only by, making the conditions of application as explicit as philosophical ingenuity permits. On the other hand, the application of the concept may be quite unproblematic. There will be no more than a marginal degree of uncertainty whether things do or do not fall under the concept, and over at least the central range of cases all is clear. Nevertheless the analysis is motivated, for what lies behind it is the desire to have a better grasp of the concept and, more specifically, to grasp how it stands to related concepts. In such cases we know when to say that something falls under the concept, but we do not know, or we do not fully know, what we are saying when we say this: whereas in the other cases, though we don't know when to say that something falls under the concept, we probably have fuller knowledge of what we would be saying when we did say this though such knowledge is thus far merely implicit.

4. This distinction between the two very different circumstances in which an aesthetic concept may be subjected to analysis suggests an amplification of my opening remark. For it suggests one way in which it might be determined whether aesthetics has something to learn from anthropology, or whether anthropology has something to learn from aesthetics. And the suggestion would be that when the application of the relevant concept is unproblematic, then aesthetics will learn from anthropology, but when the application is problematic, then the lesson will go in the reverse direction.

The rationale to this way of effecting the division would go thus: It is to aesthetics, not to anthropology, that, naturally enough, the task of producing the analysis falls. However, there are situations in which aesthetics might look to anthropology for evidence on which to base its analysis. Now, when the application of the concept is unproblematic, then anthropology might be expected to supply aesthetics with many many clear instances where the concept applies and many many clear instances where the concept does not apply, and a consideration of these cases and of what also holds true of them is precisely what should aid aesthetics in making explicit the conditions of application for the concept. By contrast, when the application of the concept is problematic, then anthropology will have nothing to offer aesthetics in

the way of clear instances of the concept's applying or not applying, and so aesthetics in formulating the conditions of application of the concept will have to rely on its own resources: it will have, that is, to rely on linguistic intuitions and on comparative material – where comparative material would be material drawn from other and well-confirmed conceptual analyses. It is, however, a correlate of this that, when the application of the concept is unproblematic, anthropology has no identifiable advantages to look forward to from the making explicit of its conditions of application: but that there are clear advantages for anthropology to anticipate – in the way, that is, of determining in many cases whether the concept does or does not apply – when its application has been hitherto problematic.

Such, I have said, is one natural way of thinking that it is determined whether anthropology has something to learn from aesthetics or whether aesthetics has something to learn from anthropology. Reflection, however, might further suggest that, convincing though it is as far as it goes, it is also superficial. There are two complications that it overlooks.

The first complication is this: that whenever anthropology has something to learn from aesthetics, or whenever aesthetics has something to learn from anthropology, the chances are that there is also a lesson to be learnt the other way round. The point is, once considered, reasonably obvious, and perhaps the only implication that needs to be emphasised here is that the question that we should pose is when it is that anthropology has *more* to learn from aesthetics, or when it is that aesthetics has *more* to learn from anthropology.

The second complication, however, is more significant and makes itself felt at just this point. For so far I have talked as though, when an aesthetic concept comes up for analysis, there are two and just two possibilities. Either the application of the concept is unproblematic or the application of the concept is problematic: and in the first case anthropology will be able to provide aesthetics with clear instances of its use, and in the second case aesthetics will not have clear instances of its use to go on. But not merely does this not exhaust the possibilities that theoretically are open, but it does not touch upon one possibility that, in the nature of the subject-matter, is highly likely to obtain when it is an aesthetic concept whose analysis is at issue.

This possibility, stated at its most abstract, is that the application of the concept will be unproblematic over one domain but problematic over another. And what it is in the nature of the subject-matter that makes this a likelihood is that art – the topic of aesthetics – is an essentially historical phenomenon (cf. Wollheim, 1970). Essentially art changes, and these essential changes find expression in, amongst other localities, the conceptual structure that surrounds art. So, to spell out the possibility, the application of a certain aesthetic concept may be unproblematic in connection with one historic manifestation of art and problematic in connection with another. And, given the way

in which, understandably, aesthetics has developed, it is only a short step from this to think that a situation highly likely to arise is one where aesthetics will have to provide an analysis of a concept whose application is unproblematic over the art of 'our' culture and problematic over the art of an anthropological culture.

5. But, it might be argued, what does this situation do to alter, as opposed to refine, the original suggestion about when it is that aesthetics has more to learn from anthropology and when the converse holds? For the situation is, surely, just one where anthropology has more to learn from aesthetics and for the reason that the original suggestion canvasses: that is, that prior to the analysis anthropology has little, or no, evidence to offer aesthetics, and yet, once the analysis has been produced, anthropology can make good use of it.

But to argue thus is – or so one might put it – to find the notion of the application of a concept being problematic itself insufficiently problematic. It is to assume that, when the application of a concept is problematic, there is either simple ignorance what the conditions of application are or simple ignorance whether these have been satisfied. But ignorance on both these scores can be complex, and the significance of the new situation under review is that it brings out the degree to which this complexity can go.

6. An aesthetic concept, let us suppose, is unproblematic over 'our' society but problematic over an anthropological society.

The first reason why the concept may be problematic over the anthropological society is that we do not know how to pick out for this society conditions that are equivalent to the conditions that determine its application in our society. The answer may ultimately be that there are no such conditions, and that the concept is therefore limited in its transcultural application. If, however, the concept is not limited in this way – and my own feeling would be that we do right to assume that an aesthetic concept is culturally universal until we have reason to think that it isn't – and we nevertheless have difficulty in extending the class of its conditions of application, the reason may well be that we are looking for the equivalence on too unabstract a level. Or – to put the matter the other way round – it may be that, when we initially identified the conditions of application for the concept in our society, we included too much of the concrete setting that is peculiar to that society, and it is this that proves recalcitrant to generalisation.

But there is another factor, again in the nature of the subject-matter, that may further add to the difficulties of determining the conditions of application for an aesthetic concept transculturally. For if it is true, as I claimed earlier on – though I produced no arguments in support of this claim – that, for at least the central aesthetic concepts, if they are to be used in the perception or assessment of works of art, then they must have been used in the production of those

works, the implications for the present problem are serious. It follows that in picking out the conditions that would justify us in applying a given concept to the art of some anthropological society, we must satisfy ourselves that these conditions are also evidence for our thinking that that concept was employed in the production of that art. In using it of a society we need assurance that it was used in the society.

Now this factor clearly complicates the problem of determining transculturally the conditions of application for an aesthetic concept. But this does not exhaust its consequences.

For the second reason why an aesthetic concept may be problematic over an anthropological society is that, even when we have picked out its conditions of application, we may be systematically uncertain whether these are satisfied. And the more complex these conditions, the more likely this is to be the case. And this is where the factor that I have just been considering is likely to make itself felt again. For, if amongst the conditions of application for an aesthetic concept over an anthropological society are evidence of the use of that concept in that society, the problem when the concept does and when it does not apply is bound to increase in difficulty. Both the logic and the epistemology of aesthetic concepts in their transcultural use exhibit a fairly radical complexity.

7. This incursion into just how it is that the application of an aesthetic concept over an anthropological society is problematic was undertaken with a purpose. It was undertaken in order to dispute the suggestion that, when this is so, aesthetics has nothing, or nothing sizeable, to learn from anthropology. For this would be so, I claimed, only if the ignorance that prevents anthropology from applying it unproblematically – whether this was ignorance of its conditions of application or ignorance whether these conditions were satisfied – was simple. I have tried to show that it is more likely to be complex. And in this state of complex ignorance anthropology can already have found out or worked out material of inestimable use to aesthetics when it comes to provide an analysis of the concept. To give two examples that come straight out of what I have been saying: Given a particular concept, any indication of what would be the suitable level of abstraction on which we should look for the conditions of its application transculturally, or, again, any suggestion of what we should take as adequate evidence (linguistic or non-linguistic, it will be remembered) for the regulative employment of that concept in this or that culture – these are just the things that would be of inestimable value for aesthetics and also likely to derive from anthropology. If so far anthropology has not taught aesthetics a great deal along these lines, this may be only because aesthetics has been slow to indicate to anthropology what it is that it needs to learn.

8. So much for methodology.

I now wish to turn to the substantive problem of style, where by 'style' I mean individual style, not general style. And the significance of this problem in the present context is twofold.

In the first place, it is widely conceded that the application of the concept of (individual) style to a work of art of 'our' culture is a precondition of its aesthetic interest (Wollheim, 1974). (Related to this fact, it would seem, is another, almost as widely conceded: namely, that – again, within 'our' culture – the satisfaction of the concept of style is a precondition of a work of art's expressiveness (Gombrich, 1963; 1968).) Now if this is so, it must be a matter of serious moment whether this concept can be applied transculturally. For if it cannot, then either works of art produced outside our culture lack aesthetic interest or aesthetic interest adheres to them along a different route. Many philosophers and anthropologists of art who accept the premiss of this argument would appear to deny the conclusion quite light-heartedly and without explanation.

Second, if the concept of style can be applied transculturally, the methodology of its application is an interesting variant of that which I have just sketched. However, to appreciate this second point, as well as to be in a good position to try to adjudicate upon the first, it is necessary to settle one issue which is often left unsatisfactorily vague: and that is whether, in talking or thinking of (individual) style, we are talking and thinking of something that is, or of something that is not, endowed with psychological reality. Or – to put it another way – whether we are taking what may be distinguished – following the practice of linguistic theory (Chomsky, 1965) – as a taxonomic, alternatively a generative, view of style.

9. To explain this last point let us start a few moves back.

A historian of art considers the work of an artist who is generally agreed to have had and used a formed style. The historian formulates a characterisation of this style, which I shall call a style-description. (We might conveniently contrast a style-description, which characterises the style of the artist, with stylistic descriptions which characterise the artist's individual works but from the point of view of their style, and are therefore dominated by some style-description.) However, when he has produced his style-description, it would be natural for him to ask of it, Is it adequate? But if he is to answer this question, he must have – either explicitly or implicitly – a criterion of adequacy for style-descriptions. Now the distinction I have in mind between the two views of style might be conveniently brought out by considering two possible criteria of adequacy, both of which enjoy some measure of support and which can be paired off with these two different views.

The first criterion of adequacy would be this: A style description is adequate if and only if

1. it picks out all the interesting, significant, distinctive, features of
 the artist's work; and
2. it groups them conveniently;

where the key words, 'interesting', 'significant', 'distinctive', 'convenient', are all undisguisedly intended to make reference to a point of view from which the features show up as interesting, significant, distinctive, and their grouping is found convenient. That point of view is the historian's.

The second criterion of adequacy would be this: A style-description is adequate if and only if

1. it picks out those elements of the artist's work which are dependent upon certain processes or operations characteristic of the artist's activity; and
2. it groups these elements into stylistic features accordingly, i.e. according to the processes on which they are dependent.

To invoke the first criterion of adequacy is to take a taxonomic view of style, and to invoke the second criterion of adequacy is to take a generative view of style. And to take a generative view of style is to imply that style has psychological reality.

10. There are, I think, powerful reasons for taking a generative view of style (Wollheim, 1974; Hellman, unpublished); though it is worth recording that the consensus of orthodox art-historical opinion seems still committed to the taxonomic view (Ackerman, 1963) in which they are reinforced by anti-theoretically minded philosophers of art (e.g. Weitz, 1970). Here I shall cite only one reason, and that is not so much a reason for the generative view of style as (more modestly) a reason against the taxonomic view of style. It is that, if we take the taxonomic view of style, we are totally unable to account for the fact about style that I claimed was widely conceded: namely, that style is a precondition of aesthetic interest. Indeed, if we take the taxonomic view, we cannot appeal to style – that is, to the artist's possession of an individual style – as a precondition of anything. For on this view, just as it is not a fact about the artist that he has the style that the style-description assigns to him, so it cannot be a fact about him that he has a style. For from a different point of view, he might have a different style assigned to him, ·or no style at all. Indeed, relativised in this way neither the style that an artist has nor his having a style can any longer be said to be 'facts' in any straightforward way, and therefore are unsuitable to be introduced in order to explain further aspects of the artist and his work (cf. Fodor, 1968).

11. However, someone convinced in general of the correctness of a generative view of style might very plausibly find difficulty in

understanding how to interpret this view. A central problem (and one that, as we shall see in a minute, links up with the problem of applying the concept of style trans-culturally) is what is meant here by a process and how processes are to be individuated – for they must be individuated, if pictorial elements are to be grouped into stylistic features by reference to them.

On the relevant notion of a process I shall say this: that a stylistic process involves as a minimum a conceptualisation or schematisation of the pictorial elements, and then the application of these schemata or concepts to the pictorial area. Examples may bring out what I intend, and I offer two drawn from the classical art of modern Europe. We might think that we have different stylistic processes when we observe that one artist, for example Raphael, conceptualises contour and shading together, under a single schema, so that they make an undifferentiated contribution to his work, whereas another, Leonardo, conceptualises them separately, under different schemata, so that each makes its own contribution to his work. It is to be noted that the schemata and concepts that in this way are regulative of stylistic processes could be much more abstract than this. They could determine just very general invariances.

It follows from this that any adequate style-description must reflect or pick up on the conceptual equipment of the artist. If it fails to do this, then, on the generative view of style, it misrepresents his style.

12. It is now time for us to look at what I have called the methodological variant that appears in the application, transculturally, of the concept of style. For the concept of style shares with other aesthetic concepts the requirement that the conditions for its application to other cultures include something of the conceptual habits of those cultures. But with the normal run of aesthetic concepts, the relevant condition is that the concept itself should have been employed in the production of that to which it is applied. But with the concept of style the condition is less direct. It is that some concept, or set of concepts, capable of regulating a stylistic process should have been employed in the production of that to which the concept of style is applied. The transcultural application of the concept of style requires the previous regulative employment not of that very concept but of a concept dominated by it.

This is the variant.

But, of course, before we can comply with it we need to know in some general kind of way how to identify at least approximately the concepts that are dominated by the concept of style or that could regulate stylistic processes. What, we might ask, borrowing a term from literary analysis, are the primes of style?

Now, in asking this question, we might be tempted to think that we cannot begin applying the concept of style transculturally until we have answered it. But would not this precisely be an example of the

simple-minded way of finding the application of an aesthetic concept to another culture problematic? It would be tantamount to saying that, since the application of the concept to an anthropological society is problematic, anthropology must wait on aesthetics and meanwhile aesthetics has nothing to learn from anthropology. And that we have seen is error.

I shall conclude by saying that I am fairly confident that it is worth redefining this error in the context of the concept of style. For insight into the primes of style, and how they can be transculturally re-identified, is precisely the kind of thing that philosophers of art should clamour for from anthropologists of art.

Postscript

All the time that I was writing this essay it struck me that the points that I was trying to make would be immeasurably clearer and more vivid if I could find a way of illustrating them visually. However, whenever I came close to looking for suitable material, an objection restrained me. For surely if my points were sound, did it not follow that there was no way of illustrating them – at any rate, of illustrating them out of anthropological material?

Take, for instance, the notion of 'stylistic feature', about which the reader might well feel some uncertainty. But suppose what I say about it in this essay is true, then two conditions would have to be satisfied before any piece of anthropological material could be regarded as an adequate illustration of it. The first is this: that it would have to be the case that the material illustrated was indeed the outcome of a formed style, and to be certain of this one would have to be assured that the relevant concept i.e. individual style, did apply over anthropological art. The second condition is this: that for the material to illustrate a stylistic feature one would have to be able to isolate that feature from the rest of the material, and to be able to do this one would need to know on what level of abstraction to look for the feature. But in my essay I argue that whether the concept of individual style can be applied beyond our culture and how levels of abstraction for stylistic features are to be identified are two questions on which it is hard to make much progress before anthropological material has been carefully gathered, sifted, and analysed. So, in trying to illustrate the notion of stylistic feature I would simply jump over what I have been arguing for in the text.

However, it has since occurred to me that by relaxing somewhat the requirements, it might yet be possible to use visual material to make my points. So: We might relax the requirement that it is an actual stylistic feature, as opposed to something that could be a stylistic feature, that is illustrated. We might relax the requirement that the illustration isolates the feature and only insist that it somehow

contains it. And we might abandon the requirement that the material illustrated is anthropological: it could be the more familiar material processed by art-historians.

Consider the schedules employed by Giovanni Morelli, the founder of scientific connoisseurship,[1] to establish not (as it turns out) individual style but something related though weaker, what might be called 'fingerprint' (Fig. 1).

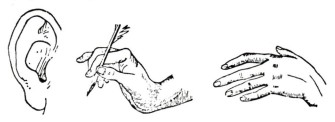

Figure 1. Ears and hands of Botticelli, according to Morelli.

Let us assume that this schedule represents not only the fingerprint but also the style of the relevant artist i.e. Botticelli. Then the question would be legitimately raised, how many stylistic features are illustrated here? There would of course be only one correct answer to this question, depending on the correct style-description for Botticelli. In ignorance of the correct answer, we might imagine the answer to be one, two, three, four ... With each thought experiment we would imagine the schedules to contain – though, of course, never to isolate – stylistic features differently individuated. And with each different individuation of stylistic feature, we could associate the notion of a different level of abstraction. If we imagine the answer to be one, it follows that that feature exists on the highest level of abstraction.

Or consider the following quiz taken from a book on graphology (Singer, 1969):

Each of the four rectangles has been drawn by one of each of the four writers of the word 'money'. The task is to pair off writer and rectangle.

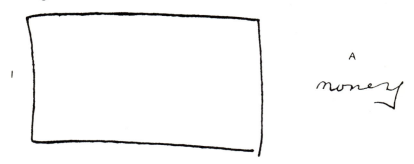

1 I have dealt with this at greater length elsewhere (Wollheim, 1973)

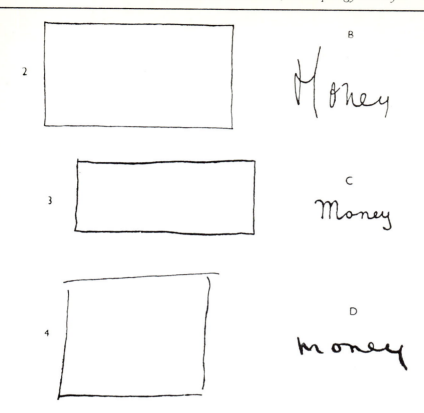

Suppose we tried to solve this quiz by stylistic analysis. We should be justified .in doing this only if we thought that drawing rectangles/writing the word 'money' is an activity controlled in the appropriate way by stylistic process. Nothing in the material before us can settle this for us, but if the activity is stylistic, then we have before us material illustrative of four styles. Suppose that we start on the handwriting. Then we have two questions that cannot be answered independently. On what level of abstraction should we, for each style, look for its stylistic features? What are the stylistic features constitutive of the different styles? (Theoretically it might be possible to specify levels of abstraction without giving examples of features that exist on them, but I don't see how.) Then, if we had answers to these questions, we could then turn to the rectangles and try to see where these stylistic features recur. But of course rectangles and pieces of handwriting might be in the same style and not share stylistic features – they might come out of different parts of the style. Or, when we turned to the rectangles we might see that we had given faulty style descriptions i.e. we had identified the stylistic features inappropriately.

The official answer to the quiz is this:

No. 1 has been drawn by writer D, easily recognisable by the strong pressure of the stroke and the slight slant to the left of the vertical stroke.

No. 2 has been drawn by writer C. Both are very regular and completely upright.

No. 3 has been drawn by writer B. Both are upright. In both the stroke is extended at the top.

No. 4 is drawn by writer A. Both are done a bit haphazardly. Both are slightly inclined to the right.

Has the official answer been arrived at by 'stylistic analysis'?

REFERENCES

Ackerman, James S. (1963), 'Western Art History', in James S. Ackerman and Rhys Carpenter (eds.), *Art and Archaeology*, Englewood Cliffs, N.J., 123-231.

Chomsky, Noam, (1965), *Aspects of the Theory of Syntax*, Cambridge, Mass.

Fodor, Jerry A. (1968), *Psychological Explanation*, New York.

Gombrich, E.H. (1963), *Meditations on a Hobby-Horse*, London.

Gombrich, E.H. (1968), 'Style' in David L. Sills (ed.), *International Encyclopaedia of the Social Sciences*, New York, 352-61.

Hellman, Geoffrey (unpublished) 'Symbol Systems and Artistic Styles'.

Singer, E. (1969), *A Manual of Graphology*, London.

Weitz, Morris (1970), 'Genre and Style' in Howard E. Kiefer and Milton K. Munitz (eds.), *Contemporary Philosophical Thought: The International Philosophy Year Conference at Brockport*, Vol. iii, *Perspectives in Education, Religion and the Arts*, New York, 183-218.

Wollheim, Richard (1970), *Art and its Objects*, Harmondsworth.

Wollheim, Richard (1973), *On Art and the Mind*, London.

Wollheim, Richard (1974), 'Style Now', in Bernard Smith (ed.), *Concerning Contemporary Art*, Oxford, 133-53.

Michael Cardew

Design and meaning in preliterate art

I would like to suggest that art, as distinct from verbal discourse, is essentially a preliterate form of expression and belongs to 'the ages before logic'. Art begins by being subjective, but technique, without which no art can exist, rescues it from subjectivity and makes it a vehicle of universal communication. The communication is less exact than that of logic and mathematics, but it reaches places where logic does not reach. A message does not have to be clear-cut and exact to be both communicable and acceptable. 'There are propositions which are self-evident though they cannot be formulated in words' (St Exupéry, 1950).

Preliterate art – tribal art, 'primitive' art – is comparable to the art of children; and children's art is certainly significant of something; but *of what* exactly, is hard to say because of its subjective character. When children start going to school, most of them lose their gift for preliterate art because the education they are receiving is meant to be training them to take part in a civilisation which is based on intellectual abstraction. They are taught new mental skills and they – or most of them – find these skills so fascinating and so useful for understanding and manipulating the external world, that they willingly discard and forget their early art-faculty.

A few of them however do not feel completely satisfied by the new skills they have been taught. They cannot forget that there was a significance in their earlier mode of expression which is missing from these new abstractions and manipulations they have been taught, and they decide that they will not allow their preliterate art-faculty to wither away. They refuse to give up their primitive nature and obstinately insist on continuing to cultivate those channels of expression which the educational curricula tended to crowd out. These are the ones who in their adult life become artists. In this view all adult art is a continuation of preliterate modes of communication.

The rest of us, the majority, also had that genius for art in early childhood, but we consent to forget it and allow it to atrophy, so that

it never grows beyond the embryonic stage. 'Art' is then consciously or unconsciously dismissed as childish, and most modern adults are trained, or train themselves, to consider it a luxury or a frill. So in the civilisation created by Western man, most artists feel more or less alienated from the main stream of their society.

But when a literate, scientifically trained person finds himself dealing with preliterate or 'primitive' peoples, he is surprised to find that in these societies, artists are the main stream itself. They are all artists of some sort, though naturally some are more talented and more professional than others. He is not only surprised by this discovery – he usually finds it emotionally moving as well. This susceptibility on his part is not weakness or nostalgia; it is the recognition that once – in the Golden Age, or Before the Fall (that is, when we were very young) – we all had that 'poiëtic' power.

Some civilisations did not surrender the concrete for the abstract quite so totally as we did in the West. The Chinese did not abandon the pictographic-ideographic script; written communication was not reduced, as it is with us, to manipulating alphabetic letters which individually mean nothing until they have been put together into the combinations called words and sentences. In Chinese the writing itself – the shape, the drawing – expresses the thing – in a sense *is* the thing – in a way which is quite beyond the range of our abstract spellings. Even where the pictograms or ideograms have to be combined in a semi-phonetic system, the shapes still have a much bigger part in conveying the meaning than is the case with European scripts (Karlgren, 1962). Consider for example the following characters:

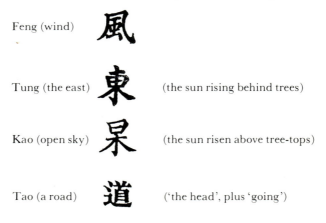

Feng (wind) 風

Tung (the east) 東 (the sun rising behind trees)

Kao (open sky) 杲 (the sun risen above tree-tops)

Tao (a road) 道 ('the head', plus 'going')

Perhaps it was the lack of this element in our script which made William Blake adopt his typographical eccentricities – his curious punctuation and his lavish use of capital letters; because he was straining to inject a direct visual expressiveness into his words. In Chinese, the script itself helps to bridge the gap between writing and

drawing, to the great gain of Chinese culture not only in the past but probably also in the future.

The mental apparatus of educated Western people is based on abstraction; and so our first instinct on meeting with the designs used by tribal artists is to assume that this language is a code to be cracked so as to make it intelligible; that what you need is a key to be provided by a reliable native interpreter, and that with this key you will be able

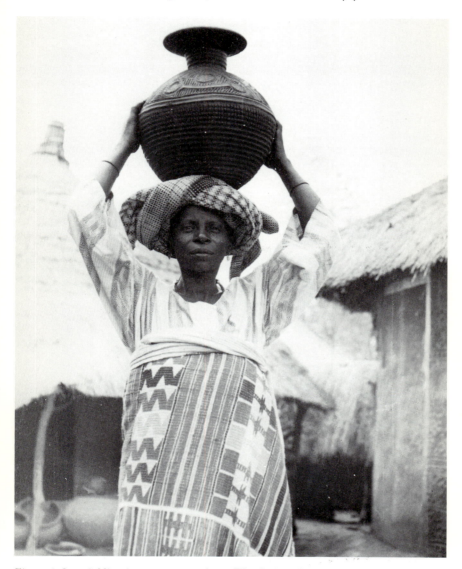

Figure 1. Lapai, Nigeria: – woman and pot. The designs, both on the pot and the dress, are certainly significant, but the meanings cannot be satisfactorily translated into the medium of words. (*Photo. Donald MacRow, Nigeria Magazine*)

to read the designs 'like a book'. I do not doubt that the designs on Hopi Indian pots or Navajo textiles (Waters, 1969), or those used in Ashanti weaving and on their printed *adinkra* cloth (Rattray, 1927), or in the Australian Aborigines' body or sand paintings (Munn, 1973), are representations of mythology or of philosophical or cosmological ideas, or are symbols for rain, thunderclouds, rivers, the starry sky and so on. But we should be cautious how we accept these explanations. There are also cases where you will get the reply 'No, I don't know of any special meaning in those creatures' – as when in Nigeria I used to ask Ladi Kwali about the scorpions, chameleons, fishes and birds on her pots made in the Gwarin Yamma tradition. Is this a case where the interpretation did exist originally but is now forgotten, the design being repeated simply because it is traditional? Or perhaps the person you question is just plain inarticulate? But this is certainly not the case with Ladi Kwali herself (Figs. 1-2).

I think the negative reply is just as likely to be a case of an honest inability, or even an unconscious unwillingness, to explain the meaning. If it could be labelled neatly like that, it would lose some of its magic. It takes the form of a design precisely because it cannot be *explained away*. In requiring an explanation you are trying to desecrate a mystery – it was made that way *because* the meaning is (contrary to our conceptual way of thinking) not amenable to articulation in

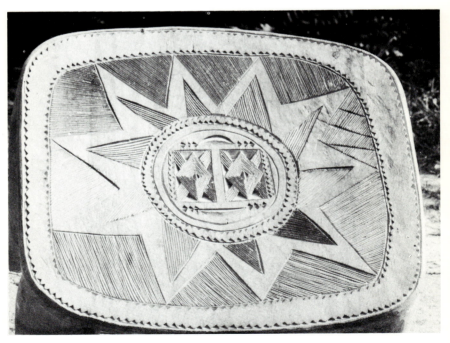

Figure 2. Paiko, Nigeria: – Nupe carved table top. 'What does it mean?' is not really a fair question. (*Photo. D. Simmonds*)

words. 'If that's all it means, why do it at all?' is the artist's feeling. Picasso did not write 'explanations' of what the bull's face on his pottery dish 'means'. He made it so that it would *do something* to you, not in order to instruct your intellect and its apparatus of conceptual analysis.

Often the mere presence of a scientific questioner falsifies the investigation. There is no way out of that difficulty, but it emphasises again the need for caution. Most field anthropologists can probably tell stories – sometimes at their own expense – of the investigator who in encouraging this kind of explanation, unconsciously suggests the answers he expects. In one version of the story the interpreter, an educated man, replies that he will have to consult the village elders; then disappears and returns later with the required answer. What he has been doing meanwhile is, not consulting the elders but looking the matter up in a book written by the investigator himself – an extreme case of 'giving the white man the answers he likes to hear'.

We are like those literary critics who can never read a novel except as a *roman à clef*. Our habits of conceptual thinking have become so much a part of us that they are second nature, and we forget that it is not so with the others.

In 1945 I was trying to teach elementary ceramic theory to a group of Ghanaians. I told them that pure kaolin consists, approximately, of Alumina 39.5 per cent, Silica 46.5 per cent, Water 14 per cent. Of course that is a very misleading way of expressing it, but it is what in those days we used to be taught, and teach. Then I said that if you fire the kaolin to about 1,000°C it will now be Alumina 46 per cent, Silica 54 per cent. The best-educated member of the class immediately asked 'Where then does it get the additional alumina and silica?'; and I, being only an amateur teacher, could not convince him that it was merely the same kaolin, minus the hydroxyls. I had been so long accustomed to thinking about potters' materials in this artificial way that I failed to appreciate how confusing my presentation was to someone whose mind was still healthily concerned with concrete things and was not preconditioned to the use of abstraction.

Our desire to have scientific interpretations of pre-logical mind-processes is itself an unscientific prejudice. We are by habit as blind to the world of preliterate semantics as the preliterate is blind to the abstractions used in all our thinking processes. For instance, – to cite a well-known example – we say 'six plus three equals nine' and it seems quite simple. But only to us, who have been to school. For us each term in the proposition $6 + 3 = 9$ is a symbol, or shorthand, for the process by which we manipulate abstractions for a practical purpose. But to someone who has never been to school or been taught to appreciate the usefulness of this kind of abstract statement, the proposition $6 + 3 = 9$ is a problem about *shapes*. If you tell him that + means 'join to', and = means 'the same as' or 'turns into', he will probably conclude 'Right! Here is this design, this *picture*, 6; join to it

the mystical squiggle 3 and the symbol which means 'turns into', then the meaning of that curious squiggle 3 must surely be 'turn upside down'. The message is quite clear: Turn 6 upside down, it becomes 9 ...

REFERENCES

Karlgren, B. (1962), *Sound and Symbol in Chinese*, Hong Kong.
Munn, Nancy D. (1973), *Walbiri Iconography: Graphic Representation and Cultural Symbolism in a Central Australian Society*, Ithaca and London.
Rattray, R. (1927), *Religion and Art in Ashanti*, Oxford.
St Exupéry, A. de (1950), *Pilote de Guerre*, Paris.
Waters, F. (1969), *The Book of the Hopi*, New York.

Robert Layton

Art and visual communication

The analysis of culture as a system of meanings is not a new approach.
'Without symbols', Durkheim once wrote (1915, 231), 'social
sentiments could have only a precarious existence ... social life, in all
its aspects and at every period of its history, is made possible only by a
vast symbolism.'

To substantiate this claim Durkheim presented his classic analysis
of Aboriginal religion, arguing that the totemic method of classifying
natural phenomena characteristic of Aboriginal culture proceeded by
comparing and contrasting certain tangible properties possessed by
the totemic species and then positing that where a culture possessed
such a structured classificatory scheme its members were provided
with a set of entities that functioned as 'symbols' of a less readily
perceived phenomenon: the unity and distinctiveness of the social
groups with which these totems were identified. Celebration of its
totem thus became a reaffirmation of the group's identity as a unit
within a wider whole. This identity, in Durkheim's view, was given
visible expression in the pictorial representation of the totemic species
on sacred objects which the group possessed (Durkheim, 1915, 155-6,
206).

Following the terms of the linguistic theory formulated by Saussure
shortly after Durkheim had carried out his study of religion, the
paintings and carvings representing the totem were *signifiers*, for which
the sense of the social collectivity was the real *signified*. The totemic
species which is in a strict sense what the design signifies, is merely an
intermediate step to the design's real significance. According to
Barthes (1967, 23), Saussure had actually been influenced by
Durkheim's work and in certain key respects Saussure's structural
theory of linguistics parallels Durkheim's interpretation of the art and
ritual of totemism.

But Saussure's analysis went beyond this (and the analogy with
Durkheim's work is not stated in his *Course in General Linguistics*). In
contrast to the representational nature of much art, the sounds of
spoken language were shown by Saussure to have no intrinsic

connection with the ideas for which they stood. In one way the connection between sound and idea can be said to be arbitrary. It is, however, extremely interesting to find that Durkheim was also led, by the highly geometric nature of designs on Central Australian sacred objects, to believe they were arbitrarily chosen (cf. Durkheim, 1915, 127). He added a footnote saying: 'It cannot be doubted that these designs and paintings also have an aesthetic character; here is the first form of art. Since they are also, and even above all, a written language, it follows that the origins of design and those of writing are one: it even becomes clear that man commenced designing, not so much to fix upon wood or stone beautiful forms which charm the senses, as to translate his thought into matter.'

Durkheim and Saussure would probably have agreed that the structure of a spoken language is considerably richer than the totemic systems envisaged by Durkheim. And, perhaps even more importantly, the individuals who share a common language use it, according to rules of syntax, to create an enormous variety of individual statements whose meaning depends on the choice of words and their combination in particular sequences. The only kind of 'statement' possible in Durkheim's totemic system would be that in which each clan celebrates its personal totemic affiliation – and it is doubtful whether that deserves to be considered 'speech' in Saussure's terms.

The rigour of Saussure's analysis and the tremendous success of its application in the study of language has resulted in a reversal of the earlier situation, in the sense that anthropologists now look to linguists for a model according to which they can analyse non-verbal modes of communication. Lévi-Strauss, who is very largely responsible for showing how revealing analyses of culture based on linguistic methods can be, has discussed how art can be understood as a system of signs, like language in some respects but not in others. 'In the arts which we call primitive,' he writes (rather contentiously), 'there is always a disparity between the technical means at the artist's disposal and the resistance of the materials he fashions, which prevents him from making the work of art a simple facsimile. He is thus constrained to *signify* the object he portrays' (Lévi-Strauss, 1960, 65-6). On the other hand, he emphasises, most representational art objects, unlike linguistic signifiers, *do* resemble what they portray (i.e. signify), even if they do not exactly reproduce them. At times, however, Lévi-Strauss seems to revert to an entirely Durkheimian viewpoint. Language, as he points out, 'is a collective phenomenon; it is a characteristic of the collectivity and exists only by virtue of the collectivity'; but he deduces from that, that 'as much as an element of individualisation intrudes into artistic production so, necessarily and automatically, the semantic function of the work tends to disappear' (Lévi-Strauss, 1960, 66). If we suppose that art traditions lie somewhere between Durkheim's simplified account of totemism and

the real complexity of language itself, then we ought to ask if any possibilities exist for meaningful, but individual statements by those who create works of art within those traditions.

Visual communication in ethnographic art

Perhaps the best-studied ethnographic instance of visual communication is one from Highland New Guinea which relies heavily on non-pictorial elements of colour and design, but whose meaning has still in part to be understood in the light of local cultural associations. This is the Stratherns' work on body-decoration in Mount Hagen (Strathern, A. and M., 1972).

Hagen society is a competitive one: the small descent groups led by Big Men are constantly competing for temporary advantages over one another. The principle field for this competition is in a competitive ceremonial exchange system called the *moka*. In the past, warfare provided a crucial complementary activity to ceremonial exchange: raids and revenge killings forming the mechanism by which groups who did not exchange related to one another. Each ceremonial exchange has elements of rivalry, expressed in speeches, the size of presentations and the form of decorations worn. It is within this context of constantly changing inter-group relationships that Hagen self-decoration operates and it operates partly to give tangible expression to the particular form of current relationships between groups. Despite its greater complexity this is not a system completely unrelated to Durkheim's simple model of totemic ritual.

The total matrix of social situations to which decoration relates includes funerals, warfare, daily productive activities, trading visits, courting parties and ceremonial exchanges. To demonstrate that there is a discrete system of visual communication in self-decoration it must be shown that there are a sufficient number of signifying units for each position in this total pattern to be associated either with one or an assemblage of distinct signifiers.

One axis of Mount Hagen signification is colour, principally the colours red, white and black. It is clear, however, that three colours alone are not enough for one colour to stand only for a single situation out of the list given above: the same colour is going to have to reappear in several contexts. The Hageners sometimes appear for this reason to adopt 'ambiguous' attitudes towards the meaning of colours and this raises the question as to whether colours are functioning in a fashion parallel to the morphemes (units of meaning) or the phonemes (elements of sound) of language. In certain contexts for instance, Hagen men wear clay to signify health and attractiveness. They do this at exchange festivals and here the clay represents shining pig fat, pigs being the major item of value and exchange at such festivals. Hageners also wear clay at funerals, where they combine it with

ashes. Now the clay signifies ill-health; a poor skin condition. The clay, like the ashes, is viewed as a dull substance. In both cases texture is as significant as colour. It is on the basis of the dullness of decorations that warfare is classed with funerals and differentiated from minor ceremonies of a positive kind.

In addition to colour and texture there is a third set of signifying units, on an axis running from careless to careful design. At one pole lies the form of body covering used in funerals. Mourners tear off their wigs, pull out their hair and smear their bodies with mud, clay and ashes. The neutral position on this scale (that of minimal decoration) corresponds to garden and household work. From this point, we pass to the category labelled 'second-best decorations', a degree of elaboration appropriate to two rather different contexts: warfare and minor ceremonies (it is, as has been mentioned, the texture of ornaments which distinguishes between these). Few or no decorations are worn in minor skirmishes, but in major warfare participants wear red plumes of an inferior brownish shade and other feathers which might be worn when peacefully visiting other groups. The whole body is charcoaled. A similar *degree* of decoration is appropriate to those who travel on trading expeditions, but here objects worn are glossy rather than dull. The most complex decorations accompany major exchanges. The greater the differentiation in the composition of decorations between donors, recipients and helpers (allied clans or sub-clans), the greater the implied political distance separating these groups (Strathern, A. and M., 1972, 66-68, 82). On this axis of progressive elaboration one thus finds several discrete elements of signification: the negative one of funerals, the neutral one of everyday work, then 'second-best' and 'best' designs.

The total system assembled in this way allows the signification of quite a large number of particular social positions. Each of these signified statuses is denoted by an assemblage which combines one element from each of the three axes. To illustrate the total number of positions that might be denoted in this way one would have to construct a three-dimensional grid: the three colours constituting one dimension, the two textures another and the four degrees of elaboration the third. The number of social positions that could possibly be represented thus appears to be $4 \times 3 \times 2 = 24$: more, apparently, than the actual number – but some combinations may involve an internal contradiction. The Hageners recognise rules for the combination of elements of decoration so as to form a set appropriate to the context signified: 'People ... refer to ... the overall appearance of a dancer, and the way the different items of his attire *fit together* and *suit the occasion*' (Strathern, A. and M., 1972, 11: my emphasis; see also p. 126) (Fig. 1).

Saussure used the term 'speech' for the selection of signs from out of the total system of the lexicon and their stringing together to form messages. Speech, he argued, was as individual as language

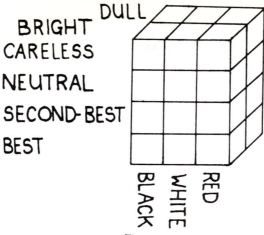

Figure 1.

(vocabulary and grammar) was collective. Not withstanding Lévi-Strauss' comments and the fact that it is sub-groups, not individuals, who are here constructing messages, these messages still function to convey a significant amount of *information*; that is, those who observe a set of people wearing a particular form of self-decoration can learn from it status positions and intentions of which they might have been unaware before, or the designs can at least reinforce and concretise what was suspected.

But is it art?

There is no more reason to assume that all forms of visual communication are necessarily art than there is to suppose that all which is written or spoken is poetry. I don't, for instance, see any reason for considering cartography an art form; it does demand a skill in visual expression, and that means the choice of an appropriate style and the matching of visual signifiers to ideas; but a comparable skill is demanded in any form of effective verbal communication. And there are many forms of visual expression in the cultures of Africa, Aboriginal Australia, etc., which I do not think need be considered as objects produced as art: fetishes, some initiation figures and so forth (see Cory, 1956). On the other hand, concepts comparable to our notions of 'what is art' sometimes appear in other cultures and where they do they affect the organisation and form that visual communication takes.

It is possible to take two elements which have repeatedly been treated as diagnostic traits of art in our own culture and show that they occur in many traditions of visual representation in other cultures. These are on the one hand rhythm, balance and harmony,

and on the other symbolism – the convention that the entities represented in the work of art themselves represent other, perhaps less readily apprehended constructs. It may be that since both have so frequently been thought of as crucial elements in art – be it poetry, drama, sculpture or painting – they constitute alternative realisations of a more general goal: clues that allow one to suggest what may be the distinguishing features of communication in art. It is not always easy to discover the implicit criteria by which the objects we would like to think *art* in other cultures have been constructed. Members of other cultures may value rhythm, harmony and balance in their paintings or sculptures, but how are we to be sure of that fact?

Some peoples have words in their own languages which express aesthetic sentiments; Willett (1971) has compiled a number of instances from Africa. But where such words are lacking or remain undiscovered, aesthetic and other values may be confused. One solution is to ask a people to rank indigenously-produced art works in order of merit and see whether one's own judgment agrees with theirs. When Forge did this among the Abelam of New Guinea he reached the conclusion that Abelam artists had the same notions as himself as to what constituted the 'best' paintings, but he also found that to the Abelam public 'best' meant 'most effective in ritual', effectiveness being measured by the quality of the yams the village subsequently grew (Forge, 1967, 82-3).

Franz Boas (1927) escaped this dilemma by not seeking people's own statements about formal qualities in their art, concentrating instead on an abstract study of compositions, showing how the use of colour and motifs created rhythmic or symmetrical designs, comparing the work of North American and Latin American cultures. He discussed in detail the art of the north-west coast Indians, famous for its split representation, showing how this style contributed, among other things, to balanced and harmonious compositions. The

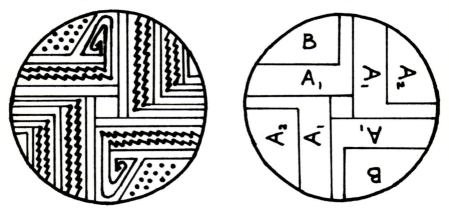

Figure 2. Radial and bilateral symmetry: South-western Pueblo pottery, after Boas, with analysis of motifs added.

production of complex balanced compositions may even, he wrote, result in the iconography of the motifs becoming submerged beneath purely decorative patterns (Fig. 2).

Some cultures, however, may explicitly deny aesthetic regard for what we, as outsiders, have labelled their 'art'. 'I was unable to find any carved headpiece intended to convey beauty', Horton writes of Kalabari sculpture. '... The situation is much like that of handwriting in modern Western culture. So long as the minimum test of legibility is passed, one piece of handwriting is as good as another' (Horton, 1965, 14, 23). The Kalabari conform neatly to Durkheim's inference that it is 'the translation of thought into matter' that is paramount.

The greatest problem with using aesthetics as a criterion for identifying art works is that, while it deals well with purely decorative work, it ignores the whole question of imagery. Perhaps the most dramatic use of visual metaphors in the recent art of the West is in the work of Magritte, or some of Max Ernst's surrealism. Among non-literate cultures the visual expression of the imagery of myth is common. An excellent example is provided by the art of the Asmat of New Guinea. The Asmat were traditionally head-hunters and much of their imagery is concerned with headhunting. They conceive of man being created by an ancestral hero who carved a ceremonial houseful of wooden figures and brought them to life: for them man and tree are in important ways equivalent concepts. So, too, are the concepts man and praying mantis. This identification, according to Gerbrands (1967), is based partly on the human, even headhunter-like behaviour of the mantis: the way it moves its limbs, the fact that the female bites off the head of the male after mating. But the mantis also resembles a piece of wood. When it moves it is like a cluster of twigs come to life; and so the mantis epitomises the man-tree analogy, having elements of both. Not surprisingly, the mantis figures prominently in Asmat sculpture. Sometimes it is carved with specifically insect qualities, sometimes the figure is deliberately schematised in such a way that it suggests equally man and mantis: a visual expression of their symbolic identity.

Both aesthetic and cognitive definitions of art imply that art works possess specific attributes over and above those necessary to achieve visual communication. The problems these attributes pose for analysis can be considered under two headings: *symbolism* and *redundancy*, the first relating to the mechanisms by which imagery is expressed, the second to the expression of aesthetic qualities.

Symbolism

Innumerable works have been written on this subject and the term 'sign' and 'symbol' defined in every conceivable way. I would suggest there are two important aspects of communication in art to bear in mind.

1. There is a very real difference between the conventional signifying units of language and pictorial representation in art. We can often (although by no means always) identify what is portrayed in the art of cultures whose language we cannot speak because while the sounds have no necessary connection with their meaning, pictures do resemble what they portray.

2. The objects portrayed pictorially in art are often themselves, by virtue of cultural experience, associated with more general and less readily apprehended phenomena. That is, the ideas signified by visual motifs themselves signify other ideas.

One might thus distinguish (1) unmotivated signs in language (secular or poetic) from motivated, iconic signs in visual representation. Here art shares the same attributes as the graphic designs of trade marks, road signs etc. One can also distinguish (2) single meaning levels in prosaic speech or non-artistic modes of visual communication from multi-level (symbolic?) meanings in art. In this specific respect we can group poetry with painting and other art forms. It must however be insisted that cultural convention plays a great part in determining both these qualities of artistic communication. Any attempt to define an art style universally recognised as naturalistic is likely to run into trouble because different cultures have different ways of representing things: the resemblance between the object and the visual motif portraying it is never more than partial.[1]

The fact that the imagery of art and ritual is not the outcome of the arbitrary association of ideas has likewise sometimes led people to postulate that at least certain symbols are universal. Turner's discussion of colour symbolism among the Ndembu provides a good instance (Turner, 1966, 58-9). The Stratherns, writing with explicit reference to Turner's work, take the more satisfactory view that Hagen colour symbolism is determined by associations characteristic of usages and experiences in that culture, that context can modify meaning and that in certain cases (particularly with respect to the colour white) certain of the ideas symbolised in different contexts may be unconnected. It is in the essence of cultures to construct patterns of meaning and social relevance out of the diverse phenomena of experience, and the variety of the patterns so constructed shows how creative a process this is. 'The very type of phenomenon with which the anthropologist concerns himself, that is, the relation between nature and culture and the transition from one to the other, finds a privileged manifestation in art' (Lévi-Strauss, 1960, 131).

1 For a criticism of one such an attempt, see Layton, in press.

Redundancy

Redundancy has long been a key concept in communication theory. It bears upon communication in art with respect to the aesthetic elements of rhythm and harmony. In prosaic, functional communication redundancy figures as an unfortunate quality rendered necessary only by the inefficiency of the medium through which communication is conducted. Yet repetition, elaboration and variation of themes and passages appears integral to many art media, musical, poetic as well as visual forms. Does this mean that art forms are particularly inefficient media, demanding an especially high degree of redundancy? I think this view would be false. An anonymous humorist compiled a *Report by a Work Study Engineer after a Visit to a Symphony Concert*, suggesting, among other points, that:

> There seems to be too much repetition of some musical passages, e.g. no useful purpose is served by repeating on the horns a passage which has already been handled by the strings. It is estimated that if all the redundant passages were eliminated, the whole concert time of two hours could be reduced to twenty minutes and there would be no need to waste time on an intermission.

As Wollheim has written: 'the conditions in which a work of art gains in unity are the same as those in which redundancy is increased: for our awareness of a pattern is coincident with a large number of our expectations being realised' (Wollheim, 1970, 150).

Conclusion

Both criteria, the symbolic and the aesthetic, characterise art traditions in various parts of the world, giving particular qualities to the form that visual communication then takes; but neither is universal, nor do they always occur in conjunction. Decorative and abstract art seem devoid of symbolism; the art of visual metaphor sometimes seems to pay little attention to rhythm and harmony. And yet, if each has been taken as a sufficient trait to indicate the presence of art, both must make manifest art's aim.

 Art is perhaps concerned with ordering experience and expressing that order not in general statements but in a most succint and concrete way that nevertheless is capable of being referred to the many diverse orders of experience that man encounters: the natural, the animal, the social, the physiological; and this may be done representationally, through symbolism, or it may be done abstractly, through the portrayal of order in balanced or rhythmically repeated forms.

Acknowledgments

The first draft of this paper was based on lecture notes compiled while teaching a course on 'the Anthropology of Art' at University College, London between 1971 and 1974. I inherited the course and its bibliography from Peter Morton-Williams and Peter Ucko and was greatly influenced by them in the way the course was taught. I am also very grateful to Peter Ucko, Peter Sutton and Athol Chase for their comments on the draft prepared for the Leicester symposium, not to mention the many comments I had from students while teaching the course.

REFERENCES

Barthes, R. (1967), *Elements of Semiology*, London.
Boas, F. (1927), *Primitive Art*, New York (re-issued 1952).
Cory, H. (1956), *African figurines: their ceremonial use in Tanganyika*, London.
Durkheim, E. (1915), *The Elementary Forms of the Religious Life*, London.
Forge, A. (1967), 'The Abelam artist', in M. Freedman (ed.), *Social Organisation: Essays Presented to Raymond Firth*, London, 65-84.
Gerbrands, A.A. (1967), *Wow-Ipits: eight Asmat carvers of New Guinea*, The Hague and Paris.
Horton, R. (1965), *Kalabari Sculpture*, Lagos.
Layton, R. (in press), 'Naturalism and cultural relativity in art', in P.J. Ucko (ed.), *Form in Indigenous Art: Proceedings of 1974 Biennial Conference, Australian Institute of Aboriginal Studies, Canberra*.
Lévi-Strauss, C. (1960), *Entretiens avec Claude Lévi-Strauss*, Paris (French text by Georges Charbonnier, quotations cited here translated by the author).
Saussure, F. de (1960), *A Course in General Linguistics*, London.
Strathern, A. and M. (1972), *Self-Decoration in Mount Hagen*, London.
Turner, V.W. (1966), 'Colour classification in Ndembu ritual', in M. Banton (ed.), *Anthropological Approaches to the Study of Religions*, Association of Social Anthropologists, Monograph 3, London.
Willett, F. (1971), *African Art*, London.
Wollheim, R. (1970), *Art and its Objects*, Harmondsworth.

P.J.C. Dark

What is art for anthropologists?[1]

The discipline of anthropology has existed for about a hundred years. Has it reached a stage where it may cease as such? Is it giving birth to new disciplines or just to new subjects which will remain attached to the parent by theoretical umbilici though nourished by attention to new phenomena? The offspring are numerous and many are grown up, facing the world with their own social organisation and membership: the Society for Medical Anthropology, the Society for the Anthropology of Visual Communication, Council on Anthropology and Education, Maritime Anthropology and many others, even anthropologists interested in 'Sports Anthropology' (A.A.A., 1974, 12).

The pursuit of the study of art by anthropologists, while not perhaps the most recent of their interests, is relatively recent in the amount of attention they have given it. Indeed, why has its study been so perfunctory? The exotic arts have been left for the Western artist to draw inspiration from and for one or two anthropologists and art historians to perceive their origins as lying somewhere on a scale of evolutionary progress from primitive to civilised depending on their locus in the world. Were they left rather on one side because of frustration at trying to make sense out of decorations that were formally describable but intelligibly indecipherable? It was probably sufficient to establish formal order, for the affairs of the world were well regulated and all men men of good sense; these were qualities inherited from the last century which gave meaning to those who sought understanding. More recently we have begun to question our own context as we see our established institutions crumble and seek new forms of convictions that will give us back order and meaning, or point us in their direction.

It is perhaps opportune to take a quick look at what art has meant for anthropologists and then consider the problems of discerning art as a phenomenon of culture, and its context. In this latter respect,

1 The material presented in this article derives from a much larger enquiry into the conditions for art which I am conducting (P.J.C. D.).

perhaps my paper should be more properly entitled: 'What is the study of art for anthropologists?'

The problem of understanding the aesthetic canons of other cultures has been enhanced by long conditioning to confusing terms, particularly to the term 'primitive', which has been thoroughly wedded to the word 'art'. Happily it has largely slipped out of the ordinary vocabulary of most anthropologists, less so from that of the art historian, but is still widely used by non-professional people who are interested in the world's art forms.

Attempts to come to grips with the term go back quite a way. The title of Sir Hercules Read's 1918 presidential address to the Royal Anthropological Institute was 'Primitive art and its modern developments'. In it he was concerned 'to get at a real meaning of the term primitive'. He complained of the loose use of the word and the confusion caused thereby, but restricted his discourse to a consideration of cave art. It should be recalled that the term 'primitive' was used to designate certain types of societies, but what really were the characteristics of primitive society was not clear or precise. More than forty-five years after Read's expressed concern, the subject was still a worry, as evidenced by Francis Hsu's (1965) article entitled 'Rethinking the concept of "Primitive"'.

The term warrants further consideration, if only for the purpose of clarifying that the phenomenon of art is present in all cultures, in one form or another. It is that different peoples express themselves differently, not that the phenomenon each interprets is qualitatively different, as is unhappily implied by such a term as 'primitive art'.

If one turns to the *Concise Oxford Dictionary* (Fowler and Fowler, 1964), the reasons for people's connotations of 'primitive art' become apparent. 'Primitive', on the one hand, refers to early and ancient and, on the other, to simple or even rude. It has the meaning of primary in the context of human development, thus implying the earliest stage of human culture. Generally, people think of the Palaeolithic period as representative of such a stage and consider the cave art of the Upper Palaeolithic as primitive, which is nonsense, for the Franco-Cantrabrian art of the Magdelenians is not representative of the earliest stage of the Palaeolithic; rather, it comes towards its close. Read (1918), made the point by asking his audience to make up their own minds as to whether the Magdelenian paintings he showed them on slides were not, in all probability, ' ... the outcome of a previous stage of artistic infancy'. Similarly, one can hardly consider the art of the people living today in Africa or New Guinea as representative of an early stage of their cultures for they are our contemporaries and their ancestors have been in their countries longer than most of ours have been in Western Europe or America.

But people used to divide the world into peoples who were civilised and those who were savages. It was the art of the savages which was primitive. Read (1918), while noting that it was important to refer to

the cultural stage a people had attained, tended to agree that 'the art products of the Australian native or those of the Veddahs' were primitive but stressed that 'it would be wrong to use the same word to describe the elaborate ornamental motives of the Maori or the involved, and at times strictly artistic, sculptures of the African negro'.

That the art of peoples of the world can be called primitive, in the sense of being rough and ready, or crude, belies the skill of those who make art. Few can match the perfection of the finish of an adze from the Harvey Islands, the surface treatment given to an object by a Kwakiutl carver, or the technical control of the Benin bronze caster. The point is that most Westerners have sought art in other parts of the world in terms of the kinds of its manifestations found in their own culture. Skill can be evident in one particular aspect of art that a people have chosen to stress or elaborate while not bothering to give attention to others. Some pursuits and manufactures may be done in a rough and ready way but there will always be others which are of particular concern and attention. Much of our own production is coarse and slapdash and, in fact, deliberately designed to deteriorate and fall apart within a given period: that is indeed rude work *par excellence*.

Linton (1941), in a well-known article on primitive art, was also concerned as to what we meant by the term. He referred to its use to indicate the early stages in development of a particular art, such as the Italian primitives. Read (1918) made this point much earlier. A second use, Linton pointed out, was in reference to our own primitives, or people who had had no formal training in our own techniques and tastes, such as Grandma Moses. Finally, he avoided settling the issue by saying that the term 'is used to refer to the works of art of all but a small group of societies which we have chosen to call civilised'. What Linton meant by the term 'civilised' he indicated later in his book *The Tree of Culture*. There he distinguished civilisation from peasant communities but ceded that it was difficult to draw any hard and fast lines. 'Perhaps the best criterion for differentiation is the presence or absence of cities.' By city he meant 'a community which subsists by the exchange of manufactured products and services for food and raw materials. Its very existence depends upon this exchange', whereas that of the village does not (Linton, 1955, 118).

In 1965, the opinions of a number of authorities were given in reply to Claerhout who brought up for discussion the problem of applying the concept of primitive to art.[2] But it would seem that the point in time has now been reached at which the term 'primitive art' need no longer be confusing or misused. It would seem, too, to have largely

2 See Claerhout (1965), where the opinions of several authorities were expressed. Enquiries into the meaning of the term, what it encompasses, alternatives, and what Gerbrands (1957, 11) expressed in the title of his first chapter, 'The problem of the name', are to be found in Gerbrands (1957), Hasselberger (1961), Taylor (1959), Collingwood (1938), to name a few.

established for itself a historical context. Perhaps it slips out sometimes but at least not to be misunderstood. However, concepts are like clothes, to be used when in fashion, and then discarded. In the sixties, terms like, 'exotic art' and 'ethnological art' (Hasselberger, 1961) came and went. The former gets used somewhat whereas the latter was never accepted. Recent interests of anthropologists in art since the second world war (Dark, 1967; 132-3) have led to quite a lot of casting around for appropriate fences to put round the phenomena concerned. In consequence, there has been considerable reluctance to lose sight of the old term: Fraser (1966) used the title *The Many Faces of Primitive Art* for his book published eight years ago; Jopling's (1971) anthology is called *Art and Aesthetics in Primitive Societies*; but with her reader, Otten (1971) finally shakes free, calling it *Anthropology and Art* and subtitling it *Readings in Cross-cultural Aesthetics*; the title of the present volume side-steps the issue in an acceptable manner.

Current searching perhaps manifests the present state of the subject. Terms like 'anthropological art' and 'aesthetic anthropology', though not sitting well with most people, do reflect a concern by anthropologists to place the subject fairly and squarely in anthropology. In some ways this is an admission that it never really was there in the first place, perhaps because so many people of different backgrounds were interested in it; not only the anthropologist, but for instance, the art historian, the curio collector, the dealer, the connoisseur and the museum curator. That the subject should now be taken into the anthropological fold is due to the work of a few anthropologists who have studied the art of other cultures in the context of those cultures (see Dark, 1967, 133) and brought to people's attention the fact that art is very much a part of culture, quite as much as such customary fields of study as kinship and marriage, economic and religious institutions and oecological relationships.

If the term 'primitive' can be considered at this point to have been put well enough aside, it behooves one to try to delimit what is the nature of the phenomenon art so that it is clear what the anthropologist is concerned with when he seeks to comprehend it in the context of other cultures.

There are to be found in Webster's Dictionary (Gove, 1961) a series of numbered entries for each of the terms 'art', 'craft' and 'beauty'. Abstracting from some of these, one can establish that art is 'skill in performance, acquired by experience, study, or observation', 'human contrivance or ingenuity, as in adapting natural things to man's use', and the 'systematic application of knowledge or skill in effecting a desired result'. But craft is 'art or skill' or 'a manual art'. This virtual interchangeability of art and craft stems from the origins of the term art, if one considers its etymology, for *ars* in Latin meant craft and a practitioner of art was someone who was engaged in an occupation requiring skill or craft. A craftsman was someone with a knack, or aptitude for his trade, and an acknowledged skill at it. When what he

produced was something of taste and manifested his skill then it was art; art is the 'application of skill and taste to production according to aesthetic principles'. The use of the modifier 'aesthetic principles' leads to the notion of beauty in art and its expression. Webster puts it simply: 'such application of skill and taste to the production of beauty by imitation or design, as in painting and sculpture'. But what is beauty? The term often seems to lead to confusion, probably because of the rather mundane application we usually make of it. Beauty is 'that quality or combination of qualities which gratifies the eye or ear, or which delights the intellect or moral sense by its grace or fitness to the end in view'. Fitness is the key word here. The sense of fitness varies from culture to culture and depends on the ends viewed as acceptable to a particular culture. Beauty or its equivalent must thus be used for the qualities which are acknowledged as a society's canon of aesthetics.

Art, then, is produced by applying aesthetic principles to a medium with skill and taste. Skill is modified by culture and taste determined by it. They are acquired by the individual and applied by him to make something be it object or poem, dance or song. If beauty is produced how is it recognised? Beauty must manifest qualities which gratify the senses and satisfy the intellectual canons of the observer by its sense of appropriateness or aptness. Collingwood (1938) wrote that what we call art derives from our imagination: 'By creating for ourselves an imaginary experience or activity we express our emotions and this is what we call art'. But the degree to which we express our emotions, as the result of imaginary experience, would seem to be a measure of our aesthetic response and of the success of the artist's production in evoking such a response. The problem is not only to determine the form of the emotions which lead to aesthetic responses in any one culture, but the nature of those responses and in what areas of culture they are manifest. A corpus of aesthetic values are to be sought in a people's canons of artistic taste.

The study of art cross-culturally has been referred to as the study of ethno-aesthetics, a term of relatively widespread usage currently. Gerbrands (1967, 7) records that the term was first suggested to him by Herskovits in 1959, which was a time at which a number of anthropologists were becoming increasingly concerned with the undertaking of studies in ethnoscience. Terms like ethno-aesthetics had for a long time been used by anthropologists who had always felt the need to discover the ideas, the popular notions, the concepts and the theories held by people in different cultures about nature and man. How does man in culture A classify phenomena as opposed to man in culture B? The *Cross-Cultural Survey* at Yale University in the thirties took into account the need to consider this area of ethnoscience and, in its subsequent form of the *Human Relations Area Files*, delegated one of its seventy-eight major categories to subjects such as ethnophysics, ethnobotany and ethnozoology (see Murdock, *et*

al., 1950). In an article on ethnoscience published in 1964, Sturtevant surveyed what he referred to as 'a new approach in ethnography'. The prefix ethno 'refers to the system of knowledge and cognition typical of a given culture ... If a folk classification is ever to be fully understood, an ethnoscientific analysis must ultimately reduce to a description in terms approximating culture-free characteristics' (Sturtevant, 1964, 99-101). The term 'culture-free' is confusing, but the aim of the ethnographer is to find out how a particular people classify phenomena in their own terms and describe how they do it. The ethnographer's aim here is considered to be 'emic', which is contrasted with the term 'etic' where he describes, for comparative purposes, the particular manner of structuring ideas about phenomena that he had discovered in a particular people (see further Sturtevant, 1964; Pelto, 1970, ch. 4).

The terms 'emic' and 'etic' have become fashionable and are perhaps used rather more loosely than Pike (1954), who devised them, intended. The terms tend to polarise two major concerns of the anthropologist which are difficult to reconcile in practice: the perception of phenomena by people and its classification by the scientist. While the biological principles of sensation and perception will gradually become established, their function through the individual's behaviour will always be subject to the special cultural twist of that individual's particular culture. In focussing attention on art, the anthropologist seeks to learn what art means to a particular group of people. What for them are the phenomena they classify as art and how do they group such phenomena? What are the principles underlying the groupings they make? Turning to another culture, it must be asked again: what do its people make of their art? What, then, is there comparable between the two? Continuing, one is led to ask: what is it in art that is universal? If art results from the application of knowledge and skill to a particular medium delimited by the canons of taste held as artistic in a culture, one is left to discover by what criteria a people select what they do for expression and why it results in art. Unfortunately, most people do not have the elaborate terminology of the Western art historians, such as rhythm, symmetry, vitality and sensibility, which are specially devised to establish criteria.

Most peoples view a product, a man-made thing, from the position as to whether it is technically well executed. Is it a competent piece of work within the demands which the culture sets on productions? But there's the rub, for standards of technological execution vary from culture to culture. Reynolds (1968) held a very poor view of the artistic productions of the Tonga, and, except for pots, their craft work manifested little skill. The Australian Aborigines used to use any suitable tool that came to hand, such as a stone flake, modifying it only to the point where it was usable. In this case technical skill was applied to form in direct relationship to the function of the object in

the culture, in its cultural context. At one extreme, then, the impress of man's hand may be minimal: he may just knock off one or two flakes from a stone core so that the object meets its functional requirements, which are to cut something. Or, at the other extreme, he may work at the form till it is embellished with highly decorative qualities. What those qualities are and how they are manifest are determined by the canons of taste held as aesthetic in his culture. To establish what those canons are requires studying art in the context of that culture. The powerful expression of all that is best in English art in the genius of Coventry Cathedral can be compared with the majestic form of a men's house created by the Abelam architect (Fig. 1) which can be seen on a distant ridge, rising sixty feet or more as it juts out of the forest. Both function to focus a culture's values and

Figure 1. Front of Abelam *tamberan* house (1964).

beliefs in such a way that they are reinforced and continue. But the meaning of the forms, of the symbolism and the role that art plays in the lives of the people, is particular to each and only to be understood in the context of the culture of each.

Understanding of context requires familiarity. We have little difficulty in apprehending the wall painting which we give a right of its own to exist as a work of art. Exotic art forms we can deal with best when we fit them into our own context just as we do the art we have produced. Unfamiliar forms and contexts require making up some kinds of association in order to make them familiar but this leads us into all sorts of complexities some of which involve us in misconceptions. The context of a Tahitian dancing we can handle fairly easily, if we start with Gauguin, or with romantic notions about Pacific peoples,[3] but the Oba of Benin seen in full ceremonial costume of coral beads, with ivories, supported by attendants, floors us (Davidson, 1966, 191). We are so used to stopping time and freezing action in a picture, particularly today in the form of a photograph, that the sense of continuity in context tends to escape us (Spiers, 1971, 56-68).

Our tendency to isolate phenomena may lead us to impose a separateness on things, giving them a meaning which they are not intended to have. For West Africa we have learned that the aesthetics of some people are extremely elaborate but that their concept of art is not necessarily ours. On the other hand, the conditions for art may mean the subservience of the individual artist to the strength of the requirements or canons of taste permissable for expression: conventions may dominate virtuosity. The conditions may be that art is a temporary vehicle for aesthetic expression and one which is conjured up as occasion demands. It is an interest focus for a brief period. Its iconography, its symbolism, is but to be seen in the light of the meaning it has or contributes when activated as art, rather than something which is always there as art. In a particular context it functions as art. At other times the forms and materials of art take on other kinds of functions – religious, economic – or remain passive.

I am tempted to suggest, as far as art is concerned, that we are 'splitters', makers of images, as opposed to 'lumpers', the users of images, though the complexity of our Western culture is probably better characterised as tensed between isolation and collectivism. Art, for Western culture, tends to seek art for itself; many peoples seek art for a purpose.

The operational problem for the anthropologist to solve is the complexity of context. A brief consideration of a festival called *agosang* by the Kilenge of West New Britain may help isolate certain factors which help delimit the problem. Figures 2-11 provide some idea of the

3 For instance James Spiers' (1971) photographs. In one (p. 108) he has deliberately posed two girls in the position of Gauguin's two models in his painting *The girls with red flowers*.

Figure 2. Agosang festival, Kilenge (1967). A male performer, with spear and shield, dances out from a semicircle of men towards lines of women advancing on the men and retreating.

Figure 3. Part of the male chorus in full song; they are decorated with leaves, some of which are sweet smelling.

Figure 4. Male dancers advance and retreat at intervals from the semicircle of which they are a part together with a chorus of men with drums.

Figure 5. Lines of women, wearing large 'bustle' skirts and various plant leaves as additional decoration, their hair cut and dyed, dance toward the male chorus.

Figure 6. A male dancer returns to the male chorus while another ventures forth.

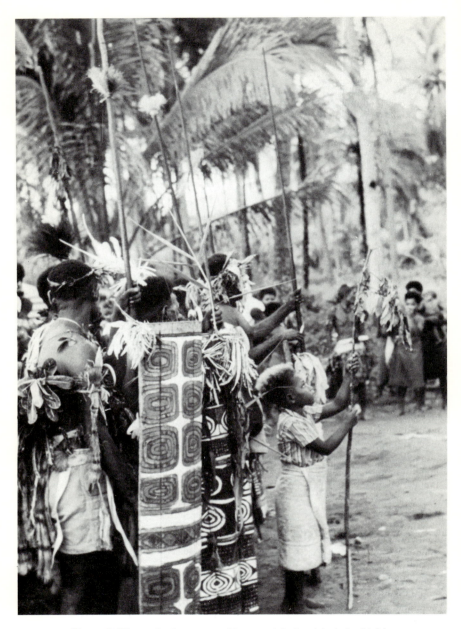

Figure 7. The male chorus stand in a semicircle with their shields.

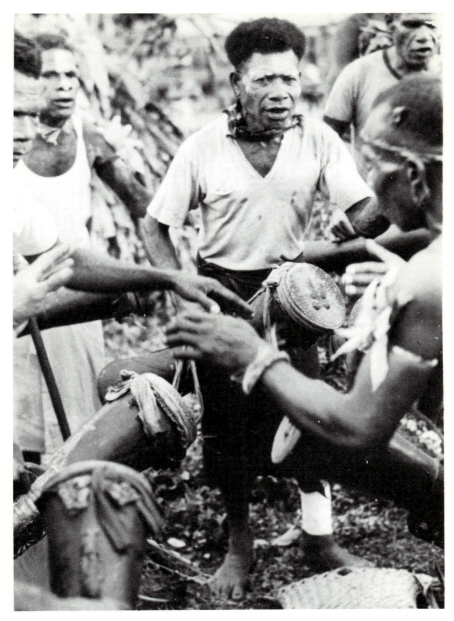

Figure 8. At the centre of the chorus are the drummers, also singing. The whole dance is regulated by their playing.

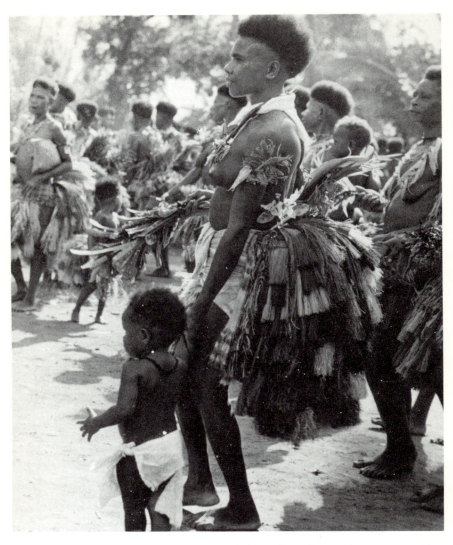

Figure 9. Children learn by accompanying their mothers. Some, who are too small to walk, are carried on their mother's hips, e.g. second from the right.

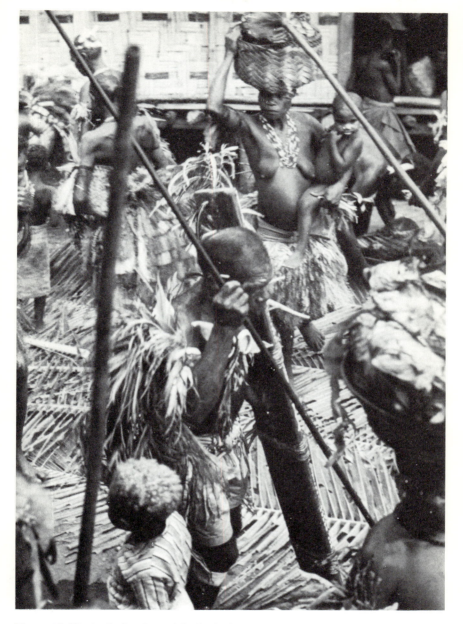

Figure 10. Towards the close of the festival, women pick up the food produced by the sponsor as they set out for home.

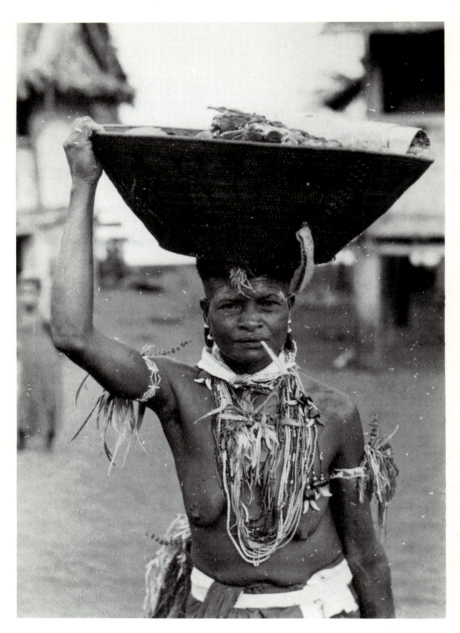

Figure 11. Logom of Korvok, smoking trade tobacco rolled in newspaper, also provided by the sponsor of the festival, returns home with her basket of food and gifts of newspaper. (*Photos 1-11: P.J.C. Dark*)

different performers involved, the complexity of the costume, decoration and accoutrements of the dancers, how the dances are learned, and the results of the activity or festival. The whole takes place in front of an audience which is only partially visible (Fig. 4). The performers are both male and female. Some of the men drum and sing; some only sing but others dance with shield and spear. All female performers dance. The costume, accoutrements and decoration of all performers represent an elaborate use of materials from the environment and their processing, in some instances requiring the employment of specialists; all performers are involved in some stages of decoration and costuming and hence the aesthetic process. The action is regulated by the choruses based on drum music. The duration of the total activity is arbitrary: all night or part of an afternoon. The sponsor, the Big Man, has complex arrangements to make before the festival can take place and which are necessary to its proper conclusion: essential is the provision of adequate supplies of food for the participants to take home at the end. The results of the festival are also complex: aesthetic pleasure in performance or as audience, release of interpersonal tensions under conditions of social control, and enhancement of the prestige of the sponsor, the Big Man.

The context of the activity sketched above can be summarised in diagrammatic form in the following manner:

In considering what the relationship is between context and aesthetic experience in an artistic activity, the factors to be noted are first, the position, or positions occupied by the personnel of the activity, i.e. by the persons in context, and how they are related in it; and, second, the conditions of the context.

The position, or contextual position, occupied by a person depends on whether he or she is a member of the audience, or of the performers, whether the maker of a mask, or of a costume, the leader of the activity or its sponsor. The visitor to a gallery could be considered a member of an audience as much as a theatre-goer watching a ballet. Each person occupies a position in an artistic situation or activity, and that position determines, or sets limits, to the kind of aesthetic experience possible. Similarly, a limiting factor is the conditions of the situation or activity, its context of occurrence. This might be a museum, cluttered in the manner of our Victorian forbears or full of open spaces dotted with little pedestals surmounted by invisible objects. It might be a park with sculptures hiding around

corners of bushes or only to be reached at the end of long paths. It
might be a nightclub floor, a funeral, a service in Chartres Cathedral
or an initiation ceremony at the *tamberan* house of an Abelam village.
It might be the tattooing of a Maori chief outside his house or the
occasion of the appearance of masked dancers of the Poro Society. But
the conditions described are all examples in which man is tied
terrestrially. What of the conditions set by our modern world in which
it is so easy to see things from the air? Does this condition make any
difference? Not really, except that it virtually eliminates direct
participation in a context and makes observation and connoisseurship
somewhat remote. Seeing the temple of Angkor Wat from the air is
rather different from seeing it as the Khmer did when they had
completed it in the twelfth century, but we accept an aerial view of it
as an illustration of a work of art in a book as quite comparable with a
photograph of a Greek statue isolated on a pedestal or a museum
showcase full of Etruscan gold ornaments. We have had no difficulty
in absorbing into our aesthetic system the new dimension thrust upon
us by the invention of the aeroplane (cf. Malraux, 1967, 75ff.: *Eds*.).

What then is art in culture, that which anthropologists study?
What is it in terms that will delimit its domain and allow one to see
the part that it plays in men's lives? I think one can begin to delimit
the answer to this question by considering the relationship between
four factors in an activity: the personnel of the activity – the people
involved in it, the system of reference – the standards to which the
personnel refer, the experience of the activity – the socio-psychological
states experienced, and the social institution of which the activity is a
part – the cultural domain in which action takes place. Where art is
that institution the relationship can be expressed visually as follows:

In the performance of their roles in an artistic activity, the
personnel – the artists, the actors, the audience – make reference to
their cultural system of standards or canons of taste. These are
dependent on a number of interacting conditions, which are complex
in the way they are integrated in the individual and cause him to
behave as he does. At one level they can be thought of in terms of
oecological and physical qualities interacting with the individual. The
physical environment contributes a particular setting for the occasion

as well as the material needs of the activity, the masks, the costumes, the musical instruments, the mud for a shrine and the ivory for a carved tusk, and so on; and in it also may lie the inspiration for a design, the reason for a pattern, the motivation even of the activity. But what is selected will depend on what is permissible, what is appropriate: the room for manoeuvre and innovation is often finely balanced between inspiration and tradition. At another level, the particular emotional responses of a participant will derive from a complicated set of interactions of his physical and culturally conditioned self. His behaviour will depend on the way the perceptual apparatus of his body has been conditioned to respond and participate in formulating his actions.

The elements of the conditions for behaviour can be thought of as integrated into a system of reference: what can be done and not done, what is permissible and not permissible, what attainable and not when the canons of taste are applied to an artistic situation and implemented by the personnel. It is the activation of the system of reference by the personnel, performing their roles, which produces art. The interaction of the personnel with art results in aesthetic experience. Art expresses the canons of taste of a society when the individual interacts with the system of reference for artistic action and attains an aesthetic experience. It follows that the preferences which a people have, and the choices which they make, operate within and are circumscribed by the system of taste, of appropriateness, of aptness, to which the society subscribes. The production of art involves action on or in an appropriate medium as limited by the predilections and alternatives offered by the system or canons of taste and leads to what we in Western culture call aesthetic experience. But what that is for a particular people is the anthropologist's business to discover. It seems unlikely that for many people art 'gives off the immediate electric tingle of an artistic experience' (Gosling, 1974).

REFERENCES

A.A.A. (1974), *Preliminary Program, 73rd Annual Meeting, American Anthropological Association.*

Claerhout, G.H. (1965), 'The concept of primitive applied to art', *Current Anthropology,* 6, 432-8.

Collingwood, R.G. (1938), *The Principles of Art,* Oxford.

Dark, P.J.C. (1967), 'The study of ethno-aesthetics: the visual arts', in June Helm (ed.), *Essays on the Verbal and Visual Arts, Proceedings of the 1966 Annual Spring Meeting of the American Ethnological Society,* Seattle and London, pp. 131-48.

Davidson, B. (1966), *Africa, History of a Continent,* London.

Fowler, H.W. and F.G. Fowler, (eds.) (1964), *The Concise Oxford Directionary of Current English,* Oxford.

Fraser, D. (ed.) (1966), *The Many Faces of Primitive Art: A Critical Anthology,* Englewood Cliffs, New Jersey.

Gerbrands, A.A. (1957), 'Art as an element of culture, especially in Negro Africa', *Mededelingen van het Rijksmuseum voor Volkenkunde, Leiden,* 12.

Gerbrands, A.A. (1967), *Wow-ipits: Eight Asmat Woodcarvers of New Guinea*, The Hague and Paris.

Gosling, N. (1974), 'Belated tribute', *The Observer Review*, 4 Aug., p. 26.

Gove, P.B. (ed.) (1961), *Webster's Third New International Dictionary*, Springfield, Mass.

Hasselberger, H. (1961), 'Method of studying ethnological art', *Current Anthropology* 24, 341-84.

Hsu, F. (1965), 'Rethinking the concept of "primitive" ', *Current Anthropology*, 5, 3, 169-78.

Jopling, C.F. (ed.) (1971), *Art and Aesthetics in Primitive Societies: A Critical Anthology*, New York.

Linton, R. (1941), 'Primitive art', *Kenyon Review*, iii, 34-51.

Linton, R. (1955), *The Tree of Culture*, New York.

Malraux, A. (1967), *Museum without Walls*, London (trans. S. Gilbert and F. Price).

Murdock, P., *et al.* (1950), *Outline of Cultural Materials*, New Haven, Conn.

Otten, C.M. (1971), *Anthropology and Art: Readings in Cross-Culture Aesthetics*, New York.

Pelto, P.J. (1970), *Anthropological Research: The Structure of Enquiry*, New York.

Pike, K. (1954), *Language in Relation to a Unified Theory of the Structure of Human Behaviour*, i; Glendale, California, Summer Institute of Linguistics.

Read, Sir C.H. (1918), 'Primitive art and its modern development: Presidential address', *Journal of the Royal Anthropological Institute*, xlviii, 11-21.

Reynolds, B. (1968), *The Material Culture of the Peoples of the Gwembe Valley*, Manchester.

Spiers, J. (1971), *Tahiti in Colour*, Rutland, Vermont and Tokyo.

Sturtevant, W.C. (1964), 'Studies in ethnoscience' in A.K. Romney and R.G. d'Andrade (eds.), *Transcultural Studies in Cognition*, American Anthropologist, 66, 3, Pt. 2, 99-131.

Taylor, D. (1959), 'Anthropologists on art', in Morton H. Fried (ed.), *Readings in Anthropology*, ii, New York, 478-90.

Nelson H.H. Graburn

'I like things to look more different than that stuff did': an experiment in cross-cultural art appreciation

Introduction[1]

The arts and crafts of non-Western peoples have become increasingly subject to the impact of industrialised societies. Some traditions have disappeared or been modified out of all recognition, while others have been kept going by commercial demands. Still other genres have been modelled after previous traditions or reinvented for the world market (Graburn, 1969). While there has been considerable anthropological study of the traditional 'primitive arts' very little research has been done on commercial art forms until recently (Graburn, 1976), and even less has investigation been directed towards the nature and functions of the art collecting society itself. This paper examines the responses of North American audiences to two commercial forms of 'primitive' art/crafts: the wooden Cree Craft of the Naskapi-Cree Indians of the Canadian Sub-Arctic and the soapstone carvings of the

1 The field researches upon which the knowledge of the Eskimo and Indian cultures are based were carried out in the Eastern Canadian Arctic in 1959, 1960, 1953-64, 1967-68 and 1971, the latter three embracing communities in the Canadian Sub-Arctic. Further fieldwork among the Naskapi-Cree was carried out by Lucy Turner of the University of California, Berkeley, in 1970-71 and 1974. The research in Berkeley has been aided by funds from the Committee on Research, the Institute of International Studies and the National Institute of Mental Health. The interviewing was carried out by Steve Alterman for the Cree Craft and Mark Curchack for the Eskimo exhibit: both were anthropology students at Berkeley. The subsequent analysis of the responses was aided by discussions with Judy Kleinberg, Lucy Turner, Terry Paris and Lynda Draper. Gratitude is also extended to staff and members of the various producers' cooperatives in the Eastern Canadian Arctic and Sub-Arctic and especially to La Fédération des Coopératives du Nouveau-Québèc, Levis and Montreal, P.Q.

Eskimos of the Canadian Arctic.[2] In that the investigator knows the cultures of both the creators and the consumers, the experiment is a sort of multiple cultural projective test, reflecting not only the contextually qualified aesthetic values of the consumer groups, but also the success of the creator groups in adapting their arts to these tastes.

The main contention of this paper is that there is no simple way of making or measuring cross-cultural aesthetic judgments and that these judgments, and the consequent feedback from the market to the producer peoples, is complicated by the level of reaction and the mode of presentation. In spite of such initial attempts to elucidate cross-cultural aesthetic agreements and disagreements, such as those of Child and Siroto (1965) or Wolfe (1969, 4-7), it should not be surprising that the aesthetic judgments are possibly as much determined by the context as by the forms themselves. Here we attempts to show that *context* may contain three separable but inter-related facets:

1. The location and setting of the objects displayed, such as in a museum, in display cases, in use as masks or ritual paraphernalia, or even in films or as illustrations in books.
2. The wider context includes the audience's knowledge and biases about the creator peoples or even about the artists themselves, leading to expectations and judgments about what criteria are fulfilled and what are not (as opposed to some aesthetic absolutes).
3. Most important perhaps is the cultural context of the viewers themselves in providing the background against which these other judgments are being made; this would include such culture-bound notions as the nature of arts and crafts themselves, and about the relations between materials and art genres within the traditions of the viewers' culture.

The experiment

The Cree Craft was on display on the Berkeley campus of the University of California for three months in the spring quarter of 1971, and the Eskimo exhibit was in the same case during the autumn. The

2 For the purpose of this paper I have decided to use the common appellations Eskimo and Cree for the makers of the handicrafts involved, though there has been a trend in the literature, including some of my own papers, to use the ethnically more correct self-designation *inuit* for Canadian Eskimo. However, this is widespread only in Canada and would require the most unusual use of the term *iijuuts* for these Indians as a parallel; furthermore the productions themselves, which are the subject matter of this paper, are known over most of the world as Eskimo sculpture and Cree Craft.

Figure 1. Exhibit of Eskimo materials. (*University of California, Berkeley*).

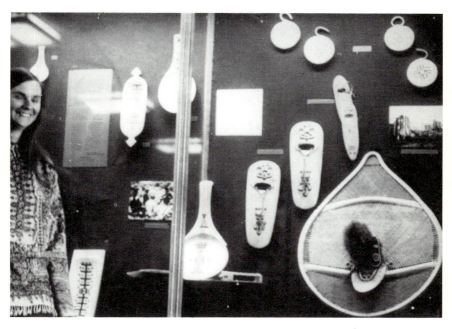

Figure 2. Exhibit of Cree materials, and (left) the anthropologist, Lucy W. Turner. (*University of California, Berkeley*).

Eskimo sculpture and artifacts (Fig. 1) were chosen to illustrate a number of contrasts within contemporary Eskimo style productions: size, colour of stone, rough versus fine finish, intricate and complex forms versus simple and smooth, realistic versus abstract, human versus animal and other content, two versus three dimensional representations, soapstone versus ivory and skin/wood model.

The Cree Craft display (Fig. 2) exhibited a relatively narrow range of form and content. These crafts produced for commercial markets since 1969 are almost entirely wood, and are mostly fullsize copies of traditional implements[3] (Rogers, 1967): ladles, snow shovels, dishes, rattles — and, for contrast, a full-size beavertail snowshoe and moccasin (made by Shefferville Naskapi). The Cree Craft were made by a large number of men in Great Whale River and Wemindji (Paint Hills), but the designs are painted on them in bright acrylics by two to three men in the local co-operative. The technique of painting the designs is new, but the designs are supposed to be traditional, at least in elements and colour, though they were formerly found on other cultural items. Both displays were accompanied by a map showing what areas they came from, a short text giving the recent history of each people and their crafts, and in the case of the Cree Craft, two photographs showing the Indians in semi-traditional settings.

For the Cree Craft twenty-seven people were interviewed of whom at least fifteen appeared to be non-students; in addition about one hundred students from a class I was teaching also gave responses. For the Eskimo exhibit forty-five people were interviewed, of whom ten identified themselves as non-students. Each person was interviewed separately, some with a tape recorder, and the responses were completely transcribed for analysis. The viewers were asked the following questions, in this order:

1. What do you think of this …? (Answer) Well, what particular feature or pieces are you reacting to in making these judgments?
2. What pieces do you like best and/or worst, and why?
3. In these pieces what do you think the creators were trying to get over, or at least what do you get out of them?
4. What other kinds of arts and crafts do you like or know or have at home/experience? (Generally probed to get their experiences of tastes and styles.)

3 Cree Craft was promoted by the Fédération des Coopératives du Nouveau-Québèc in the late 1960s, after these same Indians had unsuccessfully tried several commercial arts and crafts forms; first, copying Eskimo soapstone carving (which the Government stopped), then making soft stone 'dolomite' animals and figurines, then wooden figurines, and, lastly, wooden replicas of their traditional implements. According to the Fédération, their employee Andrée Roegier worked with the Cree of Great Whale River in developing the Cree Craft, ensuring that the forms, colours and motifs were authenticated by the traditional elders. Since the time of the experiment described herein, Cree Craft has also become a commercial failure, undoubtably for the reasons which this paper analyses.

Other questions were asked where appropriate to follow up interesting responses.

Responses to the Cree Craft exhibit

The Cree Craft exhibit drew mixed reactions from the various viewers. Although the audience was able to specify which pieces they liked most twice as often as they could designate the ones they liked least, the total number of negative comments outnumbered the positive 287 to 184. Despite areas of considerable agreement, students and younger people were more negative in their judgments than older people, a fact which was not the case with the Eskimo exhibit. An examination of the comments reveals that there are two separate kinds of motivations for the responses, accounting partly for the age differential. These aspects may be called the aesthetic and the political, as suggested by one of the project interviewers, Steve Alterman (1971).

Among all the objects displayed the large snowshoe and its attached moccasin (Figs. 2-3) received by far the most positive comments, followed by the four skin-covered ceremonial rattles (Fig. 3, left) and the grease ladles (Fig. 4, left). However, the snowshoe and the moccasin also generated the most negative responses, followed by the wooden snow-goggles and the rattles. Aesthetic judgments of the form of the objects were generally positive. Respondents pointed out the qualities of simplicity, balance, symmetry, good shapes and colours and overall design, in that order. There were also negative comments about the plainness, over-simplicity and poor choice of

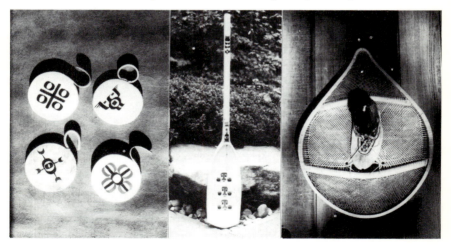

Figure 3. (a) Cree Craft: four rattles with caribou skin faces; (b) wooden snow shovel; (c) Snowshoe and moccasin, made by Sammy and Minna Paschene of Schefferville, P.Q. (1964).

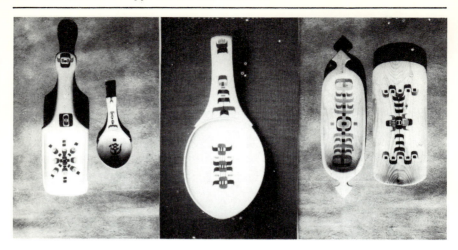

Figure 4. (a) Cree Craft: ladle and spoon; (b) sacred grease ladle; (c) wooden dishes.

colour. A frequent comment was that the painted designs and their central placement worked against the basic wooden forms.

The majority of the audience, especially the older members, admired the workmanship of these hand-made utensils, commenting on the smoothness and the obvious familiarity the Indians had with their medium. Unfortunately the Indians' expertise also worked against them, for in their efforts at standardisation and perfection, they generated an overwhelmingly negative series of responses, comments that the pieces looked almost mass-produced, too well-finished, too new, too clean, cheap and plastic! A few informants admitted that somehow they expected Indian things to be 'primitive', rough, with a subdued quality, or at least unique and old looking. Others said that their negative reactions stemmed from the lack of masks, figurines or functionally worked objects: from most of these people the snowshoe and mocassin elicited admiration. Examples of comments: 'What I expected were more items with worn, weather-beaten, people-used characteristics' (young woman). 'It would be in the Naskapi's interest to dirty them up a bit before exhibiting them' (young man). Few informants liked the wood as much as the other materials such as skin and fur. They specifically did not like the light-coloured bare wood even if they admired the workmanship itself: they preferred darker wood or wood with more grain or less finish. Question 4 brought a common sequence of reactions articulated by many of the younger people; at first glance, they liked the forms and the wood – they were reminded of the good taste exemplified by Scandinavian furniture and European utensils in their own backgrounds and homes. Then they quickly realised that these were Indian implements and that their own initial value judgments were middle-class and American. Finally they responded that there was

something wrong with Cree Craft because it should be more exotic or un-middle-class!

The contextual and functional aspects of Cree Craft provided stimulation for as many comments as the formal aesthetic, and many of these were negative. People were concerned about 'authenticity' and troubled by the decorative functions of these utilitarian objects. Some thought that most, especially the snowshoe, looked authentic. The majority thought they did *not* mainly because the Cree Craft did not fit their preconceptions of what 'Indian' things should be like. In addition to not appearing 'Indian' enough, the objects appeared too commercial or too 'Western' by their finish and lack of variety. As one young man said 'I like things to look more different than that stuff did'. The painted symbols on the utensils detracted from their utilitarian authenticity and according to some informants, so did the floral pattern beadwork on the moccasins (which, though possibly European in origin, has been incorporated into Northern Algonquin beadwork for over 300 years) and the coloured tassels on the ends of the snowshoe.

A number of informants switched their opinions from positive to negative when they read or heard that the Cree Craft was a commercial product. At first they loved the objects which reminded them of other beautiful Indian arts, particularly from the north-west coast, but when they realised they were made for sale, they suddenly began to find all the aesthetic faults mentioned earlier. A few informants refused to make any significant aesthetic judgments. From the beginning, they attacked the idea that proud native peoples should have to make anything for sale, that they must be oppressed and exploited because of acculturation by the white man.

> In fact they are being forced to do this. It's a pretty inhuman and atrocious thing, and it seems that in the display if you are really concerned about the Eskimo (sic) you wouldn't just put out the things like this, but you'd point out the reasons why these things are happening. I find displays to show how neat things are to be obscene really because it's kind of a voyeuristic, irresponsible looking at something. (Young oriental-American male)

Other remarks were not quite as strong, but similarly expressed the negative value that these peoples should not have to commercialise their arts. 'I thought it was disgusting that they had to paint them in order to make them saleable' (young woman). 'They are now trying to survive off souvenir dollars' (young woman). A few who commented on the political aspects were less negative. As one woman said: 'I hope the Cree, like the Eskimos, can through their commercial art productions gain financial and political control over their affairs and retain their sense of cultural identity.' One perhaps more perceptive informant brought to the surface the feelings that may have been behind the reactions of many others:

I find myself (as a potential purchaser of Cree Craft) playing with the livelihood of a group of people who desperately need economic support, in a world they have been drawn into whether they like it or not. Therefore, I have developed extreme guilt feelings about what my culture has done to these people and others like them. (young man)

Responses to the Eskimo exhibit

The Eskimo exhibit, in spite of the great variety of objects displayed and materials represented, drew more than 98% positive comments. The few negative included three accusations that the art form was commercial, and one comment each alluding to the fact that a piece was crude or primitive, or that an item was too touristy, or that the Eskimos were no longer hunters.

In the last two or three decades the Eskimos who produce arts and crafts for their livelihood have honed their skills to a fine degree of success, aided by the general positive image of the Eskimos in the Western world and by the educational efforts of the Canadian government.[4] Of the pieces displayed the rounded big walrus (Fig. 5), the polar bear and the small walrus (Fig. 6), the leaping fish (Fig. 7) and the woman in childbirth (Fig. 8) were the most popular items, followed by the model kayak (Fig. 9) and the pair of owls (Fig. 1, left centre). Only the large pair of feeding birds (Fig. 10) received more than one negative comment that it was too roughly finished. The one multi-piece scene of two men feeding their dogs outside an igloo (Fig. 11) was mildly criticised as cute and touristy, and obviously a souvenir.

In contrast to the abstract and utilitarian Cree Craft, it is much more difficult to separate the responses relating to aesthetic form from those pertaining to the content of the Eskimo sculptural models. There were many comments as to how beautiful or nice were either individual pieces or the whole display. The most frequent comments referred to the simplicity, the fluidity, smoothness, grace, intricacy, clarity, and rhythmic balance of the pieces. Other adjectives probably expressing a similar set of feelings were such words as rounded,

4 Eskimo soapstone sculptures are a new art tradition related to the souvenir models (usually wood or ivory) that they used to make for traders and ships' crews (Graburn, 1967; Houston, 1961; Martijn, 1964; Swinton, 1965, 1972). Since promotion by the Government of Canada, the Canadian Handicrafts Guild and the Hudson's Bay Company, the figurines have become larger, more realistic in some areas and impressionistic in others, made from a variety of attractive stones in many settlements, with a value approaching millions of dollars a year. It is the most successful commercial ethnic art tradition in Canada or Alaska and the adjacent Indian groups have often been jealous of its success, especially where they trade into the same stores or cooperatives, as in Great Whale River, P.Q.

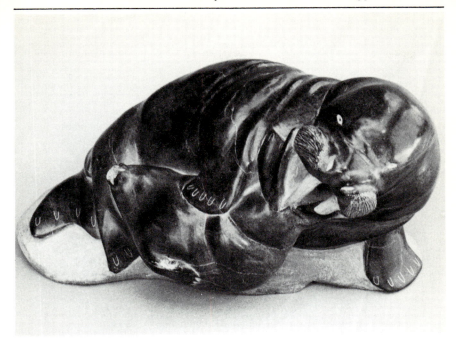

Figure 5. Walrus eating seal, soapstone, by Abraham Niaqu, Povungnituk, P.Q. (1967).

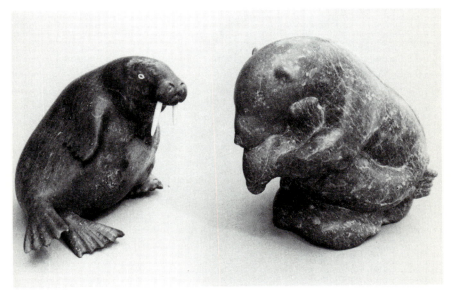

Figure 6. Bear eating seal, serpentine, by Henry Ivaluakjuk, Frobisher Bay, N.W.T. (1968), and (left) Walrus, serpentine and ivory, Aiola, Cape Dorset, N.W.T. (1968).

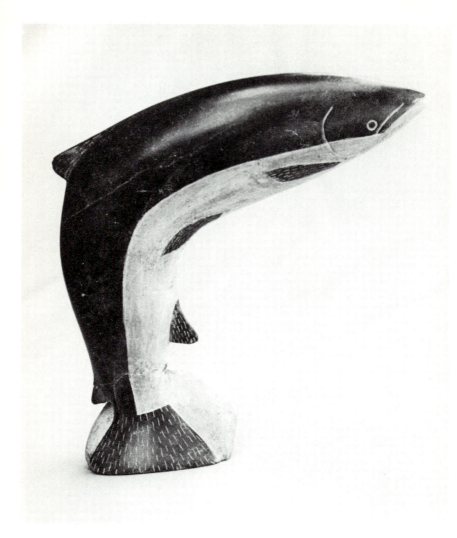

Figure 7. Leaping fish, soapstone, by Peter Pov, Povungnituk, P.Q. (1964).

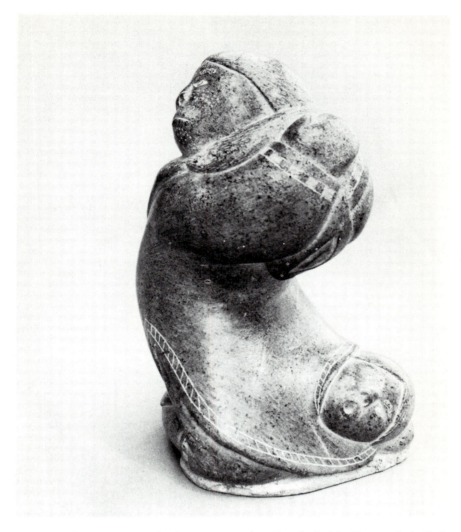

Figure 8. Woman giving birth, soapstone, by Aisapik Smith, Povungnituk, P.Q.
(1974).

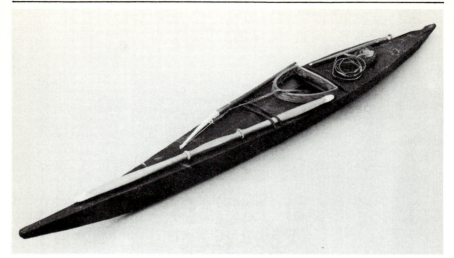

Figure 9. Model Kajak, wood, seal skin and ivory, by Anautak, Wakeham Bay, P.Q., with weapons remodelled by Kiataina, Sugluk, P.Q. (1959).

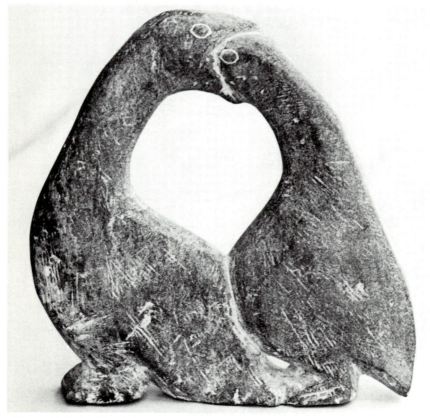

Figure 10. Pair of birds feeding, gneiss, by Mangitak, Cape Dorset, N.W.T. (1967).

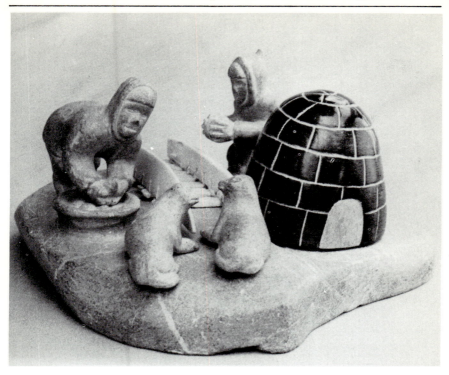

Figure 11. Feeding dogs outside igloo, scene, soapstone and bone, by Jimmy Takirk, Sugluk, P.Q. (1968).

sensual, soft, and solid. A few people also referred positively to obvious qualities such as realism, stylisation or monumental scale.

It's very smooth and flowing, but at the same time it is very simple, but it has a grandeur about it. But I can't describe it beyond that, it's just a feeling I get from it. It goes into it like I can really feel the artist, maybe it's just my imagination, I don't know. It's a very simple thing, but it's a very powerful thing. (Young man, referring mainly to the two large feeding birds, Fig. 10)

Surprisingly few people made much of the qualities of workmanship or the material itself, even though these would have been uppermost in the minds of the Eskimo creators (Graburn, 1974).

The message that the Eskimos were able to communicate clearly was that they were portraying aspects of their life style and environment of which they were (expected to be) proud. The most emphatic responses were about two intertwined themes: the admirations of the Eskimos' traditional way of life, and their closeness to nature and the animal world. People pointed out the high

proportion of representations of living things – people and animals – in the art, and the vitality and naturalness of the portrayals of pairs of beings engaged in natural functions such as the walrus eating the seal, the ptarmigans mating, the birds feeding, the woman in childbirth, and the men feeding their dogs.

> I think it shows that they are more in tune with nature, it's more their livelihood, you know. You don't see any real signs of the sort of civilisation we live in. I mean the whole emphasis is on natural people and animals and living in the cold climate ... uh, maybe ... in harmony with their environment. (young couple)

A few informants felt that the art had an animistic or religious quality; others referred to the violent and predatory nature of Arctic life, the fact that humans and animals must kill to live. Not only the exotic way of life but the very different cultural expressions appealed to romantic notions about 'primitive' peoples.

> Oh wow ... it's sort of grotesque, symbolic representation of something, but yet it's very human, sort of childish touch that makes it very poignant. (Middle-aged woman, referring to mythological figurine, Fig. 12)

Strangely enough, there were almost no comments at all on the context and functions of this art for the Eskimo, or the fact that they had to sell their handicrafts to make a living or had ceased their hunting way of life due to commercialism and exploitation. It was somehow assumed that the Eskimos were happy and fulfilled doing these works whereas the Indians might not have been. There was even less concern with 'authenticity', though the text stated quite clearly that this was, since 1949, a new commercial art form and the pieces were identified by maker and year of manufacture.

The audience had certain preconceptions which differed somewhat for the Indians and the Eskimos. They expected genuine Indian things to be old, crude, with dark woods and rough workmanship, and the paints, if any, to be earthy in colour and carefree in application, based on their experiences more with north-west coast and Plains Indian arts than with the more exact pottery and paintings of the south-west and the southern Plains. Never having seen pre-commercial Eskimo arts or handicrafts, they had no other expectations of the recent Eskimo works, which seemed to bear out the romantic image of Eskimos in which we are steeped from childhood. Many were aware of the recent political struggles of the Indians and some quickly reacted in a 'political' fashion. Whereas the Eskimos are still 'far away', and little is heard about their political struggles and problems; it was as though Eskimos still lived in a romantic vacuum and were telling appropriate stories about their way of life. The audience judged the

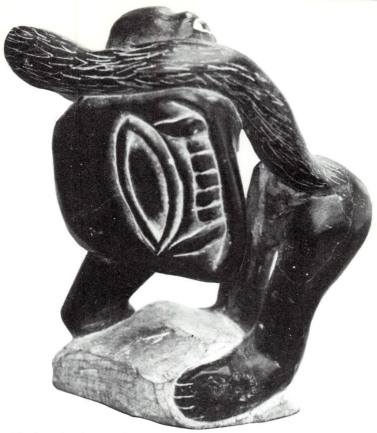

Figure 12. Imaginative penis-man, soapstone, by Eli Sallualuk Qirnuajuak, Povungnituk, P.Q. (1967).

Eskimo art on the basis of how well it told the expected story, not why they had to tell it!

A second feature was the audience's concern was with their own categories of art (illustrative, evocative) as opposed to handicrafts (utilitarian, non-informative). The Cree Craft posed the question of how it should be judged: as functionally adequate or formally decorative. The Eskimos works did not present this dilemma. The informants' value system places a more positive value on originality than on objects which evoke connotations as either mundane utilitarianism or mass production. 'Western concepts of art do not include utilitarian objects. Utilitarian artifacts are subsumed under crafts ... Thus Cree Craft could conceivably end up in a Ghirardelli Square gift shop' (young woman). Most were able to read expected meaning into the Eskimo art, whereas, though attracted to Cree Craft, 'their arbitrary symbols meant nothing to me' (young woman) and, 'the artifacts have no story or meaning to me, so they seem to be

rather unimportant' (young woman). Or: 'There seems to be a standard, simplistic design which may or may not be characteristic of tourist art' (young woman). This observation, and the fact that the Eskimos have managed in their 3-dimensional arts to cover common human and natural themes, reinforces the contentions of Ben-Amos in her paper likening the communicative codes of tourist arts to those of pidgin languages:

> Tourist art ... operates as a minimal system which must make meanings as accessible as possible across visual boundary lines. In order to do this, certain formal and semantic changes must take place: ... reduction in semantic level of traditional forms, expansion of neo-traditional and secular motifs, and utilisation of adjunct communicative systems. (Ben-Amos, 1973, 9)

The Indians had failed to make the requisite changes.

The divergent responses reflect the positive value given to stone as though stone objects were easier to accept as 'pure art' whereas wooden objects are more likely to be utilitarian and hence less valued and have to be justified as art. For instance, in order to import the Cree Craft I had to pay 11.5% U.S. customs duty whereas the Eskimo pieces got in duty free because they were stone, and hence art.

A large proportion of the responses to both exhibits reflect the romantic theme in Western culture specifically expressed in this era in admiration of Third and Fourth World peoples and the 'ecology movement'. The Eskimos combined their exoticness with their closeness-to-nature in these arts. The Indian pieces, however, were less exotic in that they were utilitarian and resembled some other handicrafts, and the designs were detailed and abstract and hence, to the audience, were a further degree removed from 'nature'. Some informants read meanings into Cree designs after looking a while, for instance, seeing butterflies on the fronts of the play bear-paw snowshoes (Fig. 2, right centre), 'faces' or 'bear paws' on the snow shovel (Fig. 3, centre), or 'buffalo horns' and 'whales' flukes' on the dishes and ladles (Fig. 4). The very explicitness of the Eskimo pieces, however, was not only a comfort due to clarity itself, but the audience found in them the very things they were looking for.

As is dramatically obvious in the Appendix below, the audience drew great satisfactions from the clear messages about 'man and nature' in the Eskimo art, and were equally turned off by the unreadable content of the Cree Craft which looked too 'Western'. The Eskimo pieces conveyed enough exoticism without being unreadable, whereas the symbols of the Indian crafts were *so* exotic (in the sense of belonging to a different and unfamiliar culture) that they were passed over and

only the most familiar of the traits – the formal qualities – got the viewers attention.[5]

> If the Cree artifacts were not in a certified university display case, I might dismiss them as well-sanded Boy Scout summer camp projects, daubed with dime store paint dashes, tic-tack-toe marks and curvy squiggles. (Young man)

Most outstanding, perhaps, was the contrasting concerns with 'authenticity'. Most of the Cree Craft pieces have been described or illustrated in Rogers' work on the material culture of the Mistassini.[6] Though Andrée Roegier may have influenced the Indians of Great Whale River in selecting design elements for painting, most of the work and decision making was carried out by Robbie Dick and other Indians. The placement of the painted designs central to the used parts of the utensils is not aboriginal though the painting of implements in general is described by Rogers (1967, 47-8) and some of the colour combinations – contrasting bright colours such as black and red – have been observed in the field by myself and by Lucy Turner who has spent over a year with these Indians (she appears in Fig. 2).

Henri Kamer has recently stated '... authentique est par définition une sculpture executée par un artiste appartenant à un village traditional et destinée à l'usage de sa tribu dans un but rituel ou fonctionnel mais non lucratif' (1974, 19). Perhaps we should propose a new concept of authenticity, one more relevant to the world of tourist arts and ethnic images. The Cree Crafts were 'authentic', that is made for local consumption and actual use until recent years, but the commercial versions were obviously replicas. Thus they became inauthentic by being made for sale, a fact which no one has tried to hide. Conversely the Eskimo sculptures are not replicas of anything traditional, but are authentically original versions of what they appear to be, i.e. models of certain exotic and interesting aspects of Eskimo life. What is not authentic about Eskimo sculptural tradition is the tale

5 The great differences in overall reactions to Cree Craft and to the Eskimo art might be imputed to their not having been simultaneously displayed or possibly to the respective audiences having been different. However, both displays took place for similar lengths of time, in term time, in the same year, and the interviews were undertaken at comparable random times of day covering an overtly similar range of people. Furthermore, the internal evidence of the interviews themselves suggests their very similar sets of informants in terms of life style and taste, and expressed aesthetic and political values. A brief examination of the terminology of responses selected by the audience members themselves, in Appendix 1, should satisfy the reader that while there are differences they are more likely to be attributable to the nature of the objects displayed than to there being two different ranges of audience.

6 Rogers, 1967, cf. for grease ladles, 33-4, Fig. 3, Pl. IIIA; snow shovel, 49, Fig. 17, Pl. IXA; puckered moccasins, 53-8, Fig. 23, Pls. IXB and XA; beavertail snowshoe, 91-101, Fig. 53, Pl. IA; scoop, 34; wooden dishes, 35; rattles with painted moosehide faces, 122-3. Only the imitation-Eskimo wooden snow-goggles are not authenticated.

often told by promoters that it is an authentic, traditional, religiously-based art form!

Conclusions

The objects displayed were considered suitable for judgment as art objects because they were so labelled in a university display case. Objects made of stone, portrayals of man and nature, were considered to have met the criteria for judging art objects more successfully than those made of wood which reproduced utilitarian objects. More crudeness was expected of Indian-made objects than of Eskimo. Thus many found it difficult to make aesthetic decisions about the Cree Craft, replacing or bolstering them with political judgments or aspersions on the commercial nature of the difficult-to-define arts.

There is a need for further research into the nature, generation and leadership in matters of taste in Western culture. Art is a relatively élite or at least value-laden aspect of our culture, and people think that they ought to have taste and be interested in the arts. We must be aware of how aesthetic judgments are affected or even based on contextual phenomena. We have seen how some people felt 'turned off' or 'kind of gypped' when they found that certain objects were made to be sold. There is massive evidence that the aesthetic judgments were made in terms of the expectations the audience had about the kind of people the creators were and the life style being communicated. Prejudgments were also made on the basis of the kinds of material used, the contents of the texts and photos accompanying the exhibit and even the fact that the pieces were on display and not being used by strange peoples in far off lands. I would suggest that we look with great discernment at the aesthetic judgments we make about all art forms, in terms of the cultural categories and temporal characteristics of the audiences, especially critics, and the accidental or managed images we have of the artists themselves.

Appendix

Aesthetic judgements recorded for Cree Craft and Eskimo Sculptures

Positive qualities*	Cree	Eskimo	Negative qualities*	Cree	Eskimo
Generally good	29	25	Generally dislike	16	
Designs good	19	8	Too plain	12	
Stylised		4	Designs against forms	13	
Simple	17	9	Too simple	7	
Symmetry/Balance	17	6	Too symetrical	8	
Colours good	18		Colours poor	12	
			Acrylics poor	12	
Massive/monumental		4			
Shapes good	16	4	Shapes poor	4	
Materials:					
Wood good (in general)	8				
Wood colour	3		Wood too light	14	
Wood texture	1				
Wood grain	6				
Rock (in general)		2			
Workmanship good	16	11	Workmanship poor, haphazard	17	
Smooth, finished	16	7	Too finished	17	
			Too unfinished	7	
From one piece		1	Not from one piece	3**	1
Utilitarian	3		Too utilitarian	6	
			Not utilitarian	24	
Authentic looking	15	4	Not Indian	25	
			Too commercial	23	4
			Too western	3	1
			Look mass-produced	30	
			Too new, clean	16	
			Look plastic, cheap	11	
Meaning interesting:			No meaning	7	
Lifelike, realistic		15			
Animals		10			
Nature		9			
Alive		8			
Other		10			
TOTALS	184	137		287	6

*The aesthetic qualities were ones spontaneously mentioned by the respondents themselves.

**These were errors on the viewers' part; the offending pieces were not actually separate and glued as claimed.

REFERENCES

Alterman, S. (1971), *Cree Craft across the culture line* (manuscript), University of California, Berkeley.

Ben-Amos, Paula (1973), 'Pidgin languages and tourist arts,' (manuscript), paper prepared for the Advanced Seminar on Contemporary Developments in Folk Art, at the School of American Research, Santa Fe, New Mexico, April 16-21 (N.H.H. Graburn, Coordinator), Temple University, Philadelphia.

Carpenter, E. (1973), *Eskimo Realities*, New York.

Child, I.L. and Siroto, Leon (1965), 'Bakwele and American aesthetic evaluations compared,' *Ethnology*, 4, 349-60.

Graburn, N.H.H. (1967), 'The Eskimos and "Airport Art",' *Trans-Action*, 4, 28-33.

Graburn, N.H.H. (1969), 'Art and acculturative processes', *International Social Science Journal* (UNESCO), 21, 457-68.

Graburn, N.H.H. (1974), 'A preliminary analysis of symbolism in Eskimo art and culture', *Proceedings of the XL International Congress of Americanists*, 2, 165-70.

Graburn, N.H.H. (ed.) (1976), *Ethnic and Tourist Arts: Cultural Expressions from the Fourth World*, Berkeley and Los Angeles.

Houston, J.A. (1951), 'Eskimo sculptors', *Beaver*, June 1951, 34-39.

Kamer, H. (1974), 'De l'authenticité des sculptures africaines', *Arts d'Afrique Noire*, 12, 17-40.

Martijn, C.A. (1964), 'Canadian Eskimo Carving in historical perspective', *Anthropos*, 59, 546-96.

Rogers, E.S. (1967), 'The material culture of the Mistassini', *National Museum of Canada Bulletin*, 218.

Swinton, G. (1965), *Eskimo Sculpture*, Toronto.

Swinton, G. (1972), *Sculpture of the Eskimo*, Toronto and Boston.

Wolfe, Alvin (1969), 'Social structural bases of art', *Current Anthropology*, 10, 3-44.

George Swinton

Touch and the real: contemporary Inuit aesthetics — theory, usage and relevance*

Introduction

The purpose of this paper is to clarify concepts of aesthetics in general, and contemporary Inuit — i.e., Canadian Eskimo — concepts in particular. I shall discuss five points:

1. My use of the term 'aesthetics' in the process of art making.
2. My uses of several terms and concepts in art such as form, style, primitive art and acculturation art.
3. My conviction that 'familiarity with a culture also entails the understanding of its art' is a fallacy.
4. My experience that expert knowledge of aesthetics is not a national or ethnic prerogative. The so often asked question as to the opinion of natives — whether they be English, Greek or Eskimo — on 'their' aesthetics is an anthropological exercise in futility and self-deception.
5. While I believe that it is impossible to speak of one single concept of specifically Inuit aesthetics having general validity, these nevertheless appear to exist underlying principles of contemporary Inuit art production. The major one of these is based on the desire to be as 'real' as possible and to achieve this 'hope for the real' through sensuous or tactile means. Hence the title of my paper — 'Touch and the real'.

Theoretical considerations and terminology

My own point of view is conditioned by the fact that I am a practising

* *Note on the illustrations*. The selection of carvings which accompanies this paper is not so much illustrative of particular points in my discussion, but rather to allow the reader some brief visual commentary on the range and variety of material which formed the inspiration for my main hypothesis.

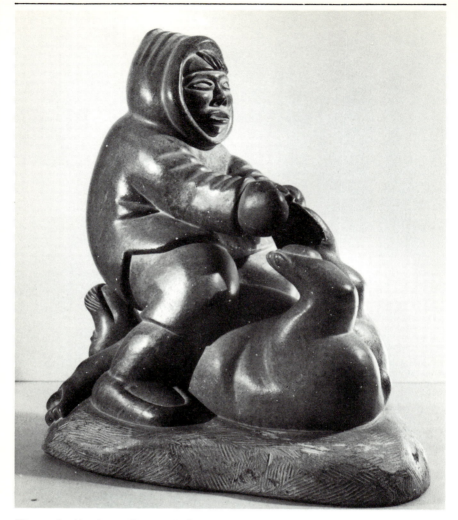

Figure 1. Abraham, Povungnituk (1965), man and bear, soapstone, ht. 40 cm. Typical oversize souvenir art. (*Photo: courtesy Montreal Museum of Fine Arts*)

artist and that, when thinking about Eskimo art and artists, I think in the following order:

1 – art
2 – artists
3 – humanity
4 – ideas
5 – Eskimos or Inuit

Many of my ideas, assumptions, research methodology and conclusions are based on this fact. My being an artist does not mean that

Figure 2. Unidentified artist, Port Harrison (1949), torso and face for toy doll, stone and paint, ht. 9 cm. This is a type of carving encountered by Houston on his first visits to the east coast of Hudson Bay. (*Winnipeg Art Gallery*; *photo: Prescott, Winnipeg*)

I have the same point of view as all other artists: I view my subject matter with my own personal and professional experience, knowledge and bias. I might add further that while I do not speak Inuktitut I have been able to communicate with the artists as a peer and have always felt a close professional kinship with them rather than being an observer.

Second, because of my experiences and my involvement in Inuit art as art, and not as a subject for research within the fields of ethnology or social and cultural anthropology, I have developed a methodology which starts with the premise that the structures and symbolic systems of art are ambiguous and ambivalent. The trouble with art is that more often than not it rejects labels and demands highly differentiated and specific attitudes of investigation and classifying.

If 'art' as such is such a difficult concept to which to attach handles, two specific applications – *primitive art* and *acculturation art* – are no easier to 'manipulate'. Here the triple-polarities of meaning that the term 'manipulate' connotes, and therefore communicates, are well worth noting: to handle manually; to deal with ideas, that is, to handle intellectually; and to manage or operate deviously. All three meanings imply the effective use of skills, but the connotations are so different that 'manipulate' is a risky trigger-word to use, underlining my point about the danger of using convenient labels. It also underlines the semantic difficulties inherent in the terms *primitive art* and *acculturation art*. The first term has been used and discussed profusely, passionately and in a scholarly way but – alas, even in other

Figure 3. Tattenerq, Baker Lake, (1967), two Inuit women, stone, ht. 20 cm. Typical mass-production pieces by an otherwise excellent artist – straight 'souvenir' work. (*Photo: George Swinton*)

papers in the present collection – quite inconclusively. It is simply not adequate as a term to describe the art forms of prehistoric and preliterate peoples and societies. Moreover, the 'diffusionist' style and design theories and the even more disturbing magical and 'functional' hypotheses often attached to primitive art, even by contemporary anthropologists, are to me far too simplistic and therefore fundamentally unacceptable.

The inherently puritanical notions of the 'functional hypothesis' on primitive art have prejudiced many social scientists and art historians against the non-functional content of many new and/or acculturated art forms which have evolved in the developing peoples of North and South America, Australia and Asia – among them the North American Indians and the Eskimos. And, in a very strange and totally unscientific way, we have also developed a highly paternalistic ethnological purism and, through it, an unjustifiable anti-humanistic bias against these new art forms, against their artistic and aesthetic validity (as new, non-tribal, non-ceremonial, non-functional arts) and against the integrity of their producers.

The most glaring example of such practice is the frequent but often apocryphal correlation of economic motivations behind many contemporary 'native' arts and the implied or expressed dislike of the 'artists' producing them. Undoubtedly, certain types of questions asked of 'native' informants – rather than of real or committed artists – will produce certain types of expected answers. I therefore wish to refer the reader to the statements of a few Inuit artists all of whom indicate a positive and understanding attitude to – and often a great deal of pride in – their work as artists.

> There are some people who are art and crafts people and are known in the community as art workers. They're known to be good as artists and they are becoming respected in the same way as good hunters are respected. I prefer to work in the craft shop because I feel happy with myself. (Anaruak, Rankin Inlet: Swinton, 1972b, 23)

> I would also like to say something about how I carve and make prints. It is hard work to make things which people will want and also which are realistic. It makes me happy to carve those things of which I am able, but I have never been taught ... (Kananginak, Cape Dorset, 1973)

> To make prints is not easy. You must think first and this is hard to do. But I am happy making prints. After my husband died I felt alone and unwanted; making prints is what has made me happiest since he died. I am going to keep on doing them until they tell me to stop. If no one tells me to stop, I shall make them as long as I am well. If I can, I'll make them even after I am dead. (Pitseolak, Cape Dorset, 1971)

Figure 4. Unidentified artist, Povungnituk (1949-50), cigarette box and match holder, stone and ivory inlay, ht. 8.8 cm. Souvenir subject and object treated highly creatively. (*Photo: George Swinton*)

As long as I am able, I like to be a sculptor, this is what I like best. I would also like my son to live where I live. Maybe he too could become a sculptor and find happiness as I found. That's what I wish for him. (Tiktak, Rankin Inlet: Swinton, 1972b, 24)

I became a printer and ever since I've been working in the Craft Shop. I am more free working in the Craft Shop and I am happy ... I haven't found any job more enjoyable than working in the Craft Shop where I am still working now. (Simon Tookoome, Baker Lake, 1973)

I do not wish to imply that these statements represent the only or the 'right' attitude. Nevertheless, it is one that does occur frequently, and that represents the point of view of artists rather than of the many Inuit who perfunctorily produce the kind of hackneyed work that is sold under the generic term of 'genuine Eskimo art'.

As to my working definition of aesthetics itself, aesthetics is not just a term for the branch of philosophy which deals with the beautiful, the harmonious or the pleasing, but in addition to particular ideas on the conception of art, it emphasises sensuous cognition; it includes the description and explanation of artistic phenomena and processes involving the senses and sensations (as opposed to the processes of reasoning); the aesthetic experience derived from immediate, that is, sensuous rather than rational experience, and so on and so forth. Obviously, I wish to emphasise the experience and the sense

components of aesthetics which far surpass all others in importance and accent and which give aesthetics its humanistic content. This content, since it is simultaneously universal yet highly individualistic, is capable of transcending most cultural or ethnic boundaries. And it is in the humanistic context of immediacy and sense experience that aesthetics becomes a universally valid means of describing attitudes to and in artistic production.

In that context the cherished reliance on purely ethnographic descriptions of aesthetic concepts and attitudes can actually become a handicap in the endeavour to gain an understanding of art. I would therefore like to paraphrase Anthony Forge and say that we *cannot* know with any certainty the meaning of a work of art produced in another culture, even if we have had considerable experience of that culture (Forge, 1973). Yet the reverse often holds true. We can gain a better insight into another culture through an understanding of its art and its artifacts; that is, through the silent language of form, styles and symbols existing simultaneously on the level of universal, collective-unconscious (or, if you will, 'structural'), cultural, regional, local or even individual aesthetic principles and image configurations.

From this standpoint I wish to discuss two other terms and concepts in aesthetics, and I would refer particularly to the widely

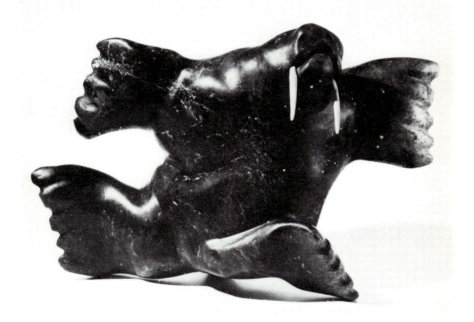

Figure 5. Axangayuk, Cape Dorset (1963), grotesque walrus, stone, ht. 24.2cm. Typical contemporary sculpture by a very knowledgable artist *pour epâter le bourgeois blanc*, creating a fantasy sculpture in highly 'baroque' style. (*Winnipeg Art Gallery, Twomey Collection*)

distributed essay, 'Style', by Meyer Schapiro, which provides some excellent labels and widely accepted interpretations (Schapiro, 1953, 278-303). I, however, am still not comfortable with the term 'style', especially where one speaks of form *and* style, as I do. It then becomes necessary to make a distinction between the two, since these two terms are confusing, both in themselves and in relationship to each other.

To me 'form' always connotes inner structure, function and expression, whereas 'style' suggests outer structure, formal order and, to a certain extent, decoration. Whereas 'form' seems to me to be a direct response to — and a dramatisation of — content, 'style' tends to emphasise an accepted — formalised — presentation of content and is therefore more concerned with rhetoric. Form *trans*-forms subject matter into visually significant images and/or aesthetic objects, and in that sense is functional and expressive. Style *applies* aesthetic means and traditions to a subject matter in order to achieve definite aesthetic effects and is not necessarily functional; therefore it is more likely to be concerned with surface treatment and decoration. Form works from the inside out, style from the outside in. Form breaks out, style contains. Form is usually oriented towards the visceral and emotional, style towards the rational and formal. Both form and style are essential to the life of art and the balance between them determines an art object's intensity and the vitality of expression of its content. Form emphasises content whereas style can survive without that emphasis, which often accounts for the stylistic bravura but also for the emotional and/or functional emptiness of much of mannerist or eclectic art.

For many writers on aesthetics, the term 'style' seems to imply the same as my use of the term 'form'. However, my special and contrasting uses of these two terms arise from my experience as a practising artist, in which activity 'form-giving' seems to be the right term, not only for the creative act of the individual artist, but also for the collective modes of investing ritual or functional objects with 'form-meaning' that derives from content-traditions rather than from mere stylistic practices. And it is precisely in this regard that the art of the Inuit — *when* it is art — displays its inherent vitality and develops its strength; that is, through expressive form. Form which expresses content and life. Form which *becomes* content. Form which is *alive*. Form that *has* style. But form that goes *beyond* style. Form that transforms life and mystery into art ...

The facts of acculturation art

Different as nineteenth and twentieth century Alaskan, Canadian and Greenlandic art expressions are, they have two characteristics in common: they are clearly and identifiably Eskimoan and they have

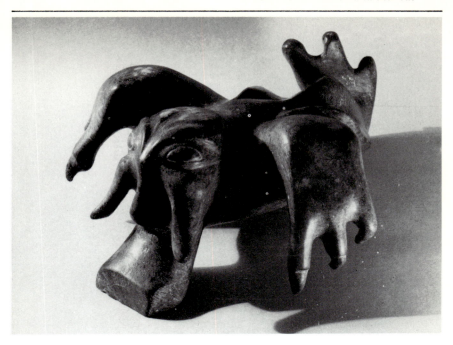

Figure 6. Aggiak, Cape Dorset (1963), legendary walrus spirit, serpentine, ht. 16.5 cm. Typical contemporary fantasy carving deriving from traditional animism. (*Montreal Museum of Fine Arts*)

gradually come into existence and full growth *after* contact with white men and western technologies, yet have retained unmistakably cultural, regional and local characteristics. They are undoubtedly genuine, new, and changing expressions of acculturating Eskimo societies.

In Canada, despite the very intensive contact with whites today, Inuit art has retained many ethnic references. In fact, the contemporary art of the Inuit has become one of their strongest ethnic affirmations of the past twenty-five years, in spite of its conspicuous economic motivation and the ever-growing threats and seductiveness of commercialism.

As to the argument that Euro-Canadian values, technologies, and aesthetic criteria underlie Inuit art and craft production – which therefore no longer bears resemblance to traditional Eskimo life and lacks the fundamental functional, magical, or ritual roots of the art of the past – this argument is spurious because of its naive and specious adherence to the 'functional hypothesis of primitive art', because of its sentimental purism and because of its lack of understanding of contemporary acculturated Inuit life, values and art. It also lacks historical perspective, as trade-art has been part of Eskimo life since the very first white contacts and particularly since the beginning of the nineteenth century (cf. Martijn, 1964, and Swinton, 1972b).

The 'sananguaq' art concept

As to the argument that there does not – or rather that there did not – exist an Eskimo word for art, and that they therefore had no concept of art, this is mere ignorant, semantic quibbling because art, both as process and product, did exist for at least 2,700 years, although a specific term for it did not (a fact which is true of most *Naturvölker* who practised but did not verbalise art).

Today a meaningful compound is used which expressés the concept of art based on Inuit criteria of judgment. These criteria are grounded less in aesthetic notions than in a kind of functional and conceptual effectiveness which relates to both message and medium or – if you prefer – to content, material, and techniques.

The Inuktitut word used for both carving and art is *sananguaq* (or *sananguagaq*) which has significant etymological derivations: *sana-* refers to 'making', and *-nguaq* to the idea of model, imitation or likeness. It is well worth noting that in Alaska *-nguaq* refers to 'play pretending' and in Greenland it signifies 'little' in the sense of a diminutive suffix. In Inuktitut there are several related words which use the suffix *-nguaq* to express a diminutive-likeness-imitation-model-play connotation such as:

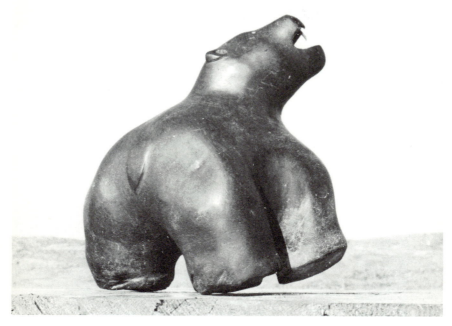

Figure 7. Pauta, Cape Dorset (1964), polar bear, stone, ht. 32.3 cm. Fundamentally a highly individualistic sculpture by a highly original artist. (*Coll. M.F. Feheley, Toronto; photo: George Swinton*)

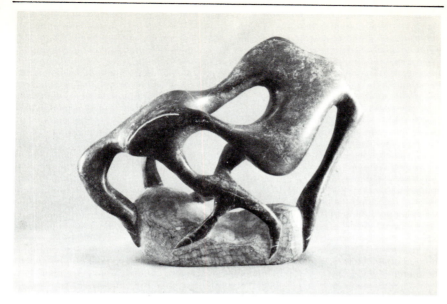

Figure 8. Eli Sallualuk, Povungnituk (1968), fantasy figure, stone, ht. 14.5 cm. A carving by the founder of the 'fantastic style of Povungnituk'. (*Photo: courtesy Ministère des Affaires Culturelles, Quebec*)

inunguaq – doll … a little man-likeness
pinguaq – toy … a little-pretending-toying
atjinguaq – picture … a little likeness like a replica

The *sananguaq* concept also entails, albeit tacitly, a notion of reality in the sense that 'likeness' is achieved as a 'replica of reality' – both actual and imagined – not beautiful but well made. Inuktitut expressions such as *pitsiark, maitsiak* and *anana* are more exclamations or expressions of visual pleasure, while *takuminaktuk* (or *takuminartoq*) means good to see and hence beautiful. These expressions are, however, used less as adjectives to *describe* art objects than to *express* feelings of enjoyment.

Touch and real

What seems to attract the attention and interest of Inuit artists most is a threefold attitude to art objects which arises out of the *sananguaq* concept:

i. the making *process* itself
ii. the concern for *materials*
iii. the concern for *reality* – real or imagined

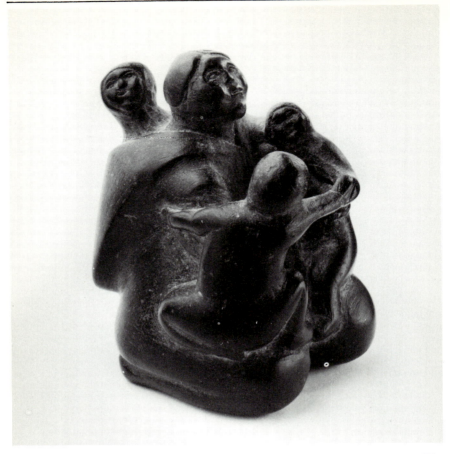

Figure 9. Kanayuk, Baker Lake (1970), mother and children, stone, ht. 9.5 cm. The idea of family and 'being together' is translated into expressive form, i.e. into volumes that fuse in a song of joyful union. Note the diminuitive size of this very free style Baker Lake carving. (*Winnipeg Art Gallery; photo: Prescott, Winnipeg*)

There are other concerns as well, but the three just mentioned – making, materials and reality – are the most essential criteria of judgment, although outside influences are starting to play important roles as well. I am thinking here not only of market feed-backs, but also of the horribly low and vulgar artifacts of our own popular culture brought to the North by the mass-media and the white residents.

Although specific applications of the making-materials-reality criterion differ from region to region and among individual artists, its primary formulation may be put into a succession of statements which clarify each other: an art object's quality depends on how well it is made rather than on how pleasant it looks; quality depends on how well or successfully the artist has worked his material; how successful he was in using the best and perhaps the most resistant material

showing the artist's mastery of, and his sensitivity to, the material used; how successful he was in using the material to achieve a convincing likeness of that which he wanted to create or 'reproduce'; how successful he was in achieving reality, which is the creation of a convincing image of that which is either seen, felt, imagined, or heard of. Ultimately, quality resides in the successful achievement of giving tangible reality (i.e. form) to subject matter.

Graburn has pointed out on various occasions (Graburn, unpublished reports, 1967-69) that in Arctic Quebec this concept – which he calls 'realism' – arises from the phrase *sulijuk*, which actually means true or honest, in contrast to *takusurngnaituk* (or *takuayoknaitoq*) meaning 'imaginative replicas' of things that have never been seen. In a more recent paper (1974a) he elaborates on these notions and extends them to Eskimos in general. But I feel that what he writes is most applicable in Arctic Quebec, particularly in Povungnituk and

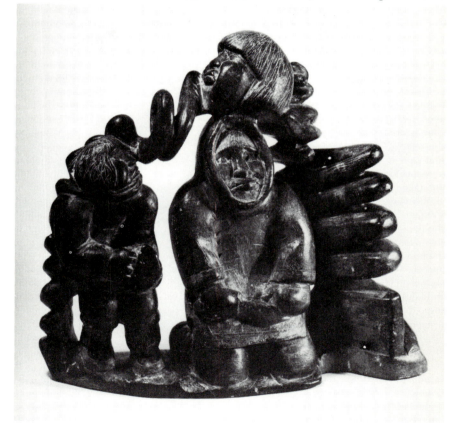

Figure 10. Davideealuk, Povungnituk (1963), Northern Lights, stone, ht. 26 cm. A contemporary carving with a theme taken from Eskimo mythology and demonstrating a delight in complex form. (*Eskimo Museum, Churchill, Man.; photo: George Swinton*)

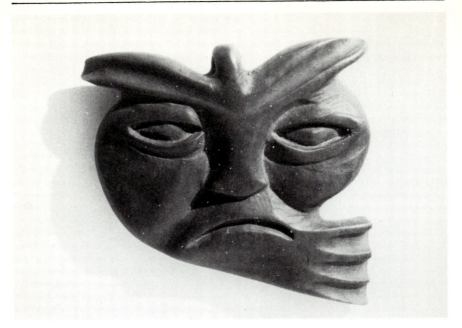

Figure 11. Henri Napartuk, Great Whale River, (1962), pendant in the form of a
 man-bird-seal, stone, diam. 5 cm. Based on an Inuit folk-tale about a man who
 was not satisfied with being a hunter and wanted to be first a bird and then a seal,
 only to find out that it is better to be a dissatisfied man ... (*Inulertak Museum, Great
 Whale River*)

Inoucdjouac (Port Harrison), but not in the entire Arctic. He also
refers to and lists distinctive 'characteristics' in form and/or subject
matter which are applicable to individual artists only. His findings
can be readily expanded so as to become more valid in a general
overview of contemporary Inuit aesthetics.

Furthermore, Graburn's documentation of Ungava (Arctic
Quebec) and, to a lesser extent, Cape Dorset artists is extremely
valuable and his descriptions of attitudes and materials, when
expanded, become not only important documents relating to the
geographical areas of his field work but also to providing effective
handles for the study of aesthetics in acculturating societies in general.
At the same time, I must again repeat that many concepts found in
Ungava or Cape Dorset are not applicable everywhere in the Arctic
and that in places where I have done field work other, and even
opposite, notions exist.

For instance; while in Arctic Quebec – and much more so in
Povungnituk than, say, in Inoucdjouac – 'carvings that are criticised
as *nipitajuk* (all stuck together) are said to be characteristic of women
and weak men' (Graburn, 1974a), in Baker Lake such carvings are
often admired for the very opposite reason, namely the artist's ability

to achieve a multi-faceted massive form of great strength in which otherwise several separate units are combined into one. Such work is often done in large scale and volume by only the younger and stronger men. Simultaneously, Baker Lake artists also admire detailed work with either graceful or bulky appendages, or out-croppings, 'all stuck together' into one carving. Obviously, it is not possible to talk about pan-Eskimo or even Inuit style concepts in general, nor even about unequivocal regional or local aesthetic notions.

It is perhaps this conspicuous new individualism – form as opposed to style which we, with our western cultural concepts, have encouraged – that has become characteristic of contemporary Inuit art and Inuit people, who have always been highly original and individualistic as human beings and are now so in their art as well. It is as if their new art is pointing to this characteristic – or should we not say quality – rather than to their mythical collectiveness.

Strangely enough, this individualism does not contradict Graburn's concept of *sulijuk* as, for the Inuit, the real and the true are part of very healthy pragmatic-existential concurrences and ambiguities which pervade most aspects of Eskimo life, myth and thought. The true and the real cannot be 'truly and really' known beforehand; the act of becoming is true and real; the true-and-the-real is that which is experienced. Things and events change and cannot be known beforehand. They become real only after they have actually been experienced.

To me, perhaps the most important aspect of Inuit reality – and Graburn's *sulijuk* concept – is the translation of what is felt to be true and real into tactile form. That form is not merely well-sculpted form but largely sensuous – tactual – sensation. It is a kind of Rabelaisian

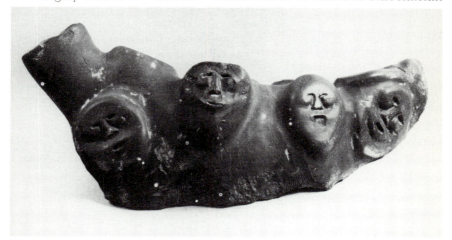

Figure 12. Tiktak, Rankin Inlet (1968), face cluster, stone, ht. 25.4 cm. The Dorset 'face cluster' may have been a ritualistic object carved in a symbolic semi-abstract form but this carving is simply an 'art object' based on a theme from Eskimo tradition. (*Photo: courtesy National Museum of Man, Ottawa*)

exaggeration, an indulging in the organs and the sense of touch. The big becomes bigger, the smaller smaller, the thin thinner, and the long longer. But that is merely visual. Textures become more smooth or rough depending on one's needs, the body action or experience becomes translated into form through increased tensions, bulging volumes, intensified proliferations of shapes that indicate the magnified experience of reality instead of its perception; touch becomes glory, joy, life, pain and death. Through touch all things invisible become overt, without it life is less and objects turn to lifeless shapes of empty matter. True art is in giving life to the stone, the bone, the ivory, the sheets of paper, the string, the cloth, the clay; to change them through one's touch into reality – small replicas of life or death – made by one's hands and senses. That is art. All art. Art everywhere.

To extend the phrase 'the truth of a thing is in the think of it, not in the see of it', the truth of art – of *sulijuk* – is in the touch of it, not in the see of it. I do not wish to insist on my idea being a valid paradigm, nor just a fanciful aphorism, nor that it applies to only good art and probably not to the mediocre. Within my concepts of art, all art always contains the successful giving of form and the making tangible of ideas and visions. The sensation of touch – the touch-form – thus becomes art's most significant aspect. In contemporary Inuit art, touch-form is its most significant and general aesthetic criterion.

REFERENCES

There are two types of references in this bibliography: the sources from which I have quoted and other essential references which will, I hope, extend the usefulness of my paper and its bibliography, but which in most instances are relatively unfamiliar.

Amarook, M. (1971), Introduction, *Baker Lake Prints 1971*, Ottawa.
Arngna'naaq, R. (1973), Introduction, *Baker Lake Prints 1973*, Baker Lake.
Arngna'naaq, R. (1974), 'Baker Lake printmakers', *north/nord* xxii, 2, 13-14.
artscanada (1971/72), *The Eskimo World*, 162-3.
The Beaver (1967), *Eskimo Art Issue*, Autumn.
Butler, S. and J. (1972), 'Wall hangings from Baker Lake', *The Beaver* 303-2, 26-31.
Canada, Dept. of Northern Affairs (1954), *Canadian Eskimo Art*, Ottawa.
Canadian Eskimo Arts Council (1971), *Sculpture/Inuit: Masterworks of the Canadian Arctic*, Toronto.
Canadian Eskimo Arts Council (1974), *Crafts from Arctic Canada*, Ottawa.
Carpenter, E.S. (1959) (with Robert Flaherty and Frederic Varley), *Eskimo*, Toronto.
Carpenter, E.S. (1973), *Eskimo Realities*, New York.
Crowe, K.J. (1974), *A History of the Original Peoples of Northern Canada*, Montreal and London.
Crowley, D.J. (1958), 'Aesthetic judgment and cultural relativism', *Journal of Aesthetics and Art Criticism*, 17, 187-93.
Crowley, D.J. (1970), 'The contemporary-traditional art market in Africa', *African Arts*, 4, 1, 43-9.

Dall, W. (1913), 'An Eskimo artist', *The Nation*, xcvii, 121.

Eber, D. (1972), 'Looking for the artists of Dorset', *The Canadian Forum*, lii, 618-19, 12-17.

Forge, A. (ed.) (1973), *Primitive Art and Society*, London and New York.

Fry, J.D. (1971), 'Contemporary Arts in non-Western societies', *artscanada*, 162-3, 96-101.

Fry, J.D. (1972), *Drawings from Baker Lake*, Winnipeg Art Gallery, Winnipeg.

Gerbrands, A.A. (1961), 'The concepts of style in non-Western art', in D.P. Biebuyck (ed.), *Tradition and Creativity in Tribal Art*, Los Angeles, 58-70.

Graburn, N.H.H. (1969), 'Art and acculturative processes', *International Social Science Journal* xxi, 3, 457-68.

Graburn, N.H.H. (1974a), 'A preliminary analysis of symbolism in Eskimo art and culture', *Proceedings of the Fortieth International Congress of Americanists, Rome, 1972/2*, 165-70.

Graburn, N.H.H. (1974b), 'Some problems in the understanding of contemporary Inuit art', *Western Canadian Journal of Anthropology*, 4, 3.

Heinrich, A. (1950), 'Some present-day acculturative innovations in a non-literate society', *American Anthropologist* lii, 2, 235-42.

Herskovits, M.J. (1959), 'Art and value', in *Aspects of Primitive Art*, New York.

Himmelheber, H. (1958), *Eskimokünstler* (2nd edn.), Stuttgart.

Hoffman, W.J. (1897), 'The graphic art of the Eskimos', *U.S. National Museum Annual Report 1895*, 739-968.

Houston, J.A. (1951a) 'Eskimo sculptors', *The Beaver*, June, 34-9.

Houston, J.A. (1951b), *Sanayasak* (trans. S. Ford and D. Woodrow), Ottawa.

Houston, J.A. (1971), 'To find life in the stone', in *Sculpture/Inuit: Masterworks of the Canadian Arctic*, Toronto.

Isaacs, A. (1972), 'Violations of standards of Excellence and preference in utilitarian art', *Western Folklore*, xxxii, 1, 19-32.

Jones, M.O. (1973), 'On dealing in Eskimo art', *The Canadian Forum*, lii, 618-19, 16-19.

Jopling, C.F. (ed.) (1965), *Art and Aesthetics in Primitive Societies*, New York.

Kanaginak (Kanaginak Pootoogook) (1973), Introduction, *1973 Cape Dorset Prints*, Cape Dorset.

Martijn, C.A. (1964), 'Canadian Eskimo carving in historical perspective', *Anthropos*, lix, 546-96.

Martijn, C.A. (1967), 'A retrospective glance at Canadian Eskimo carving', *The Beaver*, Autumn 4-19.

Martin, P. (1962), 'Prosperous Eskimo print makers', *The Canadian Banker*, lxix, 3, 31-41.

Meldgaard, J. (1960), *Eskimo Sculpture*, London and New York.

Noah, W. (1972), Introduction, *Baker Lake Prints 1972*, Baker Lake.

NOREC (1965), 'The development of Indian and Eskimo art and crafts in the Far North', *Report of the NOREC Conference*, 3 May, 1965, Toronto.

north/nord (1974), xxii, 2 *Eskimo Art Issue*.

Nungak, Z. and Arima, E. (1969), 'Eskimo stories – unikkaatuat', *National Museum of Canada Bulletin*, 235, Anthropology Series, 90.

Oswalt, W. (1961), 'Eskimo ingenuity', *north-nord*, viii, 6, 28-33.

Otten, C.M. (ed.) (1971), *Anthropology and Art*, Garden City, N.Y.

Pitseolak (1971), *Pitseolak: Pictures Out of My Life*, edited from tape-recorded interviews by Dorothy Eber, Toronto.

Purdy, A. (1967), 'The sculptors', in *North of Summer*, Toronto.

Ray, D.J. (1961), *Artists of the Tundra and the Sea*, Seattle.

Ray, D.J. (1967), 'Alaskan Eskimo arts and crafts', *The Beaver*, Autumn, 80-91.

Ray, D.J. (1969), 'Graphic arts of the Alaskan Eskimo', *Native American Arts*, 2, U.S. Department of the Interior, Indian Arts and Crafts Board, Washington.

Robertson, R.G. (1960), 'The carving industry of Arctic Canada', *The Commerce Journal*, Spring 40-54.

Schapiro, M. (1953), 'Style', in A.L. Kroeber (ed.), *Anthropology Today*, Chicago, 287-312.

Swinton, G. (1958), 'Eskimo carving today,' *The Beaver*, Spring, 40-47.

Swinton, G. (1965), *Eskimo Sculpture*, Toronto.

Swinton, G. (1970), *Tiktak: Sculptor from Rankin Inlet, N.W.T.*, Winnipeg.

Swinton, G. (1971a), 'Contemporary Canadian Eskimo sculpture', *Sculpture/Inuit: Masterworks of the Canadian Arctic*, Toronto.

Swinton, G. (1971b), 'Eskimo art reconsidered', *artscanada*, 162-3, 85-94.

Swinton, G. (1972a), *Eskimo Fantastic Art*, Winnipeg.

Swinton, G. (1972b), *Sculpture of the Eskimo*, Toronto and Boston.

Swinton, G. (1974), 'Sanavik co-operative', *Baker Lake Sculpture*.

Tookoome, S. (1973), Introduction, *Baker Lake Prints 1973*, Baker Lake.

Trafford, D. (1968), 'Takushurnaituk: Povungnituk art', *north/nord*, xvi, March-April, 52-55.

Tullik, M. (1974), Introduction, *Baker Lake Prints 1974*, Baker Lake.

Van de Velde, Fr.F., o.m.i. (1970a), *Canadian Eskimo Artists: A Biographical Dictionary*, Pelly Bay, Yellowknife.

Van de Velde, Fr.F., o.m.i. (1970b), *Canadian Eskimo Artifacts*, Ottawa.

Vastokas, J.M. (1971), 'Continuities in Eskimo graphic style', *artscanada*, 162, 3, 69-83.

Veisse, J. (1974a), Introduction, *Baker Lake Prints 1974*, Baker Lake.

Veisse, J. (1974b), 'Paradoxe de l'art esquimau contemporain,' *north/nord*, xxii, 2, 36-7.

Williamson, R.G. (1965), 'The Spirit of Keewatin', *The Beaver*, Summer, 4-13.

Michael Greenhalgh

European interest in the non-European: the sixteenth century and pre-Columbian art and architecture

It is probable that the first men, being less removed from their divine origin, were more perfect, possessing a brighter intelligence, and that with Nature as a guide, a pure intellect for master, and the lovely world as a model, they originated these noble arts, and by gradually improving them brought them at length, from small beginnings, to perfection ...

If some think that I have given excessive praise to certain ancients and moderns, and that it is ridiculous to compare the ancients with the men of this age, my answer is that I have only praised the ancients after making allowance for time, place and circumstances.

These two quotations are both from Giorgio Vasari's *Lives of the ... Architects, Painters and Sculptors* ..., first published in 1550 but revised and enlarged in 1568. They are good starting points for any consideration of European interest in a wider world because they emphasise the theoretical limitations of the Renaissance approach to art. The first passage (from the general *Preface*) might at first glance seem to state the idea of the Noble Savage who, because of his contact with the Godhead through his experience of Nature, can found a tradition of the imitation of Nature which Vasari believed to be the basis of his own idea of art. In fact, Vasari places the 'first men' at the beginning of time in an attempt to show that art is built up on tradition and recapitulation, and that – as he goes on to say – poets like Homer represent for later generations a whole succession of nameless forbears. His knowledge of these, however, is hazy, for ' ... these matters are too vague on account of their antiquity ...'

But it is the second quotation which demonstrates Vasari's lack of interest in the Noble Savage as an alternative to civilised Man. Indeed, to a culture which traced its achievement from Greece and Rome, as recorded in ancient authors and as visible in ancient

remains, the art which was outside that tradition was worthy only of barbarians. Vasari describes a progression from primitivism to perfection under the Greeks and Romans, to decline with the Fall of the Roman Empire, and rebirth in thirteenth-century Italy. The passage quoted makes explicit the notion of progress, and Vasari hardly needs to state clearly that the primitive man of the first extract could meet with little orthodox praise if pitted against the centuries of accumulated artistic breeding of a Raphael or a Michelangelo.

Against this background of a narrow view of the development of art – and Vasari speaks for the whole Renaissance – we can formulate suitable questions for an examination of attitudes to pre-Columbian art. Vasari was an intelligent and perceptive critic but, for him, art was a European phenomenon. He usually keeps to Italian art because he is himself Italian and thinks it best; and he never begins to consider wide-ranging cross-cultural influences – the discovery of America, the importation from India or China of fabrics, drawings, metal-work or ceramics (which we know were popular during the period) – presumably because he considered such contacts of little importance to his theme. The questions we must ask are consequently wide-ranging – so much so that comparatively little work has been done on the problem of America's impact on Europe, except in the field of economics (see Elliott, 1970, 1-27 for a statement of the problem). They might include the following: was European culture as inward-looking in matters of art and religion as at first appears? What did America have to offer the conquerors in terms of collectable works of art? What did European artists (few of whom had been to America) know about American art, and what did they make of its motifs?

For the purpose of this survey, it would be pointless to distinguish between the various and differing cultures of the New World, for Renaissance Europe had none of the aids to identification and classification which we now consider so essential, and little of that historical perspective which is the foundation for any unprejudiced study of the past.

Vasari's insular attitude was relatively new, for the Middle Ages had a very catholic interest in things foreign – an interest which continued well into the fifteenth century in Italy, and longer elsewhere. The strange and the fantastic were interests increased by contacts with Constantinople, with points further east, with the Holy Land and its defenders during the period of the Crusades, and with the Moslems in Spain. Islamic ornament, the dome, various kinds of arch, arabesques, Buddhist imagery – all seem to have been introduced and accepted into European artistic vocabulary, although at what periods is sometimes unclear (Olschki, 1944). Baltrusaitis (1955, 285) states: 'dans son puissant renouvellement des sources, la Renaissance rejoint souvent des fonds déjà exploités. Ses éxotismes et ses monstruosités ont des racines profondes sortant directement du moyen age ...'. And certain scholars have cast even further afield for

an alternative and non-Vasarian explanation for the 're-birth' of art with Giotto and the Pisani (Pouzyna, 1935; Soulier, 1924). Their speculations underline the startling lack of research on cross-cultural influences. For example, Piero della Francesca's knowledge of Flemish art has been approached, but what about his or Donatello's connections with Etruscan art? Or with early Greek sculpture?

And yet we know that artists were fascinated by exotica, even if the use they made of it was restricted. A well documented example surrounds the visit of the Emperor John VIII Palaeologus to Ferrara in 1438, accompanied by a gorgeous retinue, to discuss pressing church matters with the Pope. The artist Pisanello saw him there and sketched his profile for a medal which he subsequently designed. A glance at a selection of Pisanello's medals will show how interested he was in exotic headgear, and he was obviously struck by the Emperor's tall melon-shaped hat with brim turned up front and back, which made the lower part look rather like the hulk of a ship. The fortune of this hat in art has been traced by Roberto Weiss (1966), who shows it turning up again and again as the hat of Theseus, or Constantine, or Mohammed, or on one of the Three Magi (Fig. 1). The use of a rather

Figure 1. The Emperor Mohammed II (H. Schedal, *Liber Cronicarum*, Nuremberg, 1493).

different turban to indicate another wise man of Antiquity is found in the marble pavement of Siena Cathedral, where the subject is Hermes Trismegistus (Chastel, 1961a, 250-1). In the cases cited, the reason for the use of unfamiliar headgear is clear: it points out to the spectator a person who is not European. That it does absolutely nothing further indicates just how far the Renaissance was from modern ideas of accuracy. Such attitudes (often flying in the face of easily ascertainable facts, readily available in illustrated books from the later sixteenth century) were to continue well into the eighteenth century – a token of how artists, unless of a scholarly turn of mind, follow the iconography of their forbears (cf. Iversen, 1961; Greenhalgh, 1974). It is considerations such as these which condition the way in which Europe looks at American art and architecture, and which explain a seeming inability to assimilate such strange forms.

Such a process of partial assimilation without, one might say, digestion, or regard for accuracy, might be termed *stylisation*, a placing in predetermined categories. This is best exemplified in the ever-increasing volume of travel literature, some of it written as accounts of actual voyages, but much of it in a stylised literary form with little regard for facts. The process has been widely studied (Atkinson, 1920; Chinard 1911, 1934; Jones, 1964; Baudet, 1965). And no matter from what corner of the world travellers reported, what they chose to see was as predetermined as the way they chose to see it. Almost without exception, their concern was to describe not the art or architecture of any nation, but rather its social and religious habits, often including minutiae of dress and manners. Anthropology, the study of alien cultures, therefore has a much longer history than the study of alien forms of art (Hodgen, 1964). Indeed, when dealing with American or Chinese or Indian cultures, art and architecture are subsumed under some anthropological category and not considered worthy of separate treatment. Palaces and their architecture are slotted into general descriptions of cities, and temples may be mentioned briefly in accounts of ritual. That attitudes are similar in regard to both Eastern and Western cultures shows that it is the very fact of *difference*, and not the number of years of familiarity, which regulates the way in which Europeans approach them (Lightbown, 1969).

Early references to America conform to these guide-lines. Cortés' *Cartas de Relación* are the focus of several unsolved problems, of which the greatest is the fate of his missives once they reached Spain (Wagner, 1929). References to art and architecture are few; references to handicrafts, customs and rituals are scattered throughout, but nowhere is there a concerted effort to describe the people; his main concern, of course, is with a narration of what he and his soldiers did. He is traditionally supposed to have made a map of Mexico City, which was printed in the Latin edition of the *Second Letter*, published in Nuremberg in 1524; although nearly all this is formalistic in the manner of the map-making of the times, the central square temple

does show, with the legend *templum ubi sacrificant*, two linked towers, with steps leading up opposite sides of either tower.

What were the reactions to the treasure sent back to Spain in a whole series of shipments? One German account of 1520 refers to 'a wonderful new land' and estimates the financial value of the metal objects. The keynote to all the descriptions is *wonder*: the treasures included not only eye-catching tokens of the country's riches, but also 'curiosities', a category to which the century was very prone – 'four harpoons of white flint', 'a large pair of sandals of leather ... The soles are white and sewn with gold thread', 'four animal heads', 'two white cotton cloths' (Nowotny, 1960, 13ff). One famous if brief account of the treasure is that of Dürer, who saw it in Brussels in late August or early September 1520, where it had been taken to show the Emperor. He wrote in his *Diary* of 'wondrous things of many uses' and said that 'these things are all so costly that they have been estimated at a hundred thousand florins ... I have seen therein wonders of art and have marvelled at the subtle *ingenia* of people of far-off lands ...' Deitlef Heikamp, in his study of Medici interest in Mexican antiquities (Heikamp, 1966, 1972, 7-8), has commented that Dürer's remarks are 'of historical importance to us, because they indicate the value attributed to exotic works of art by a contemporary artist'. This is somewhat to overstate Dürer's enthusiasm and its direction: as far as we know, he did not draw any of the objects – surely the immediate reaction of an interested artist. And we must see his high praise in the context of his sightseeing tour of the Netherlands and his easily demonstrated interest in curiosities. In Brussels, as Panofsky remarks (Panofsky, 1955, 208), 'he was no more impressed by pictures or statues than by the big bed ... which could accommodate fifty persons.'

Furthermore, we must balance reactions to America against reactions to Ancient Rome's own exoticisms – to the discovery of the Golden House of Nero and the innumerable much smaller structures with the same kind of decoration (Dacos, 1969a), and compare how artists coped with either kind. Briefly, the grotesques of the Golden House replaced a mediaeval tradition of European decoration, and were all the more acceptable because of their antique, classical nature. They fitted in with artist's conceptions of a classical tradition which linked them to the ancient world they sought to imitate. American objects had no such place in the Renaissance view of art or decoration; Nicole Dacos has surveyed interest in such forms (Dacos, 1969b) and estimates that, for Dürer, Montezuma's treasure was too strange to understand: 'si l'on pense que les collections remplissaient plusieurs pièces du château, la description de Dürer est d'ailleurs extrêmement sommaire et, dans sa brièveté, elle traduit une sorte d'incapacité à les analyser.' She finds that the 'feather hats' which some commentators have found on engravings by Cornelis de Bos are in fact elaborations of Etruscan *antefixae*; and she explains the one

isolated case of Aztec motifs (on the capitals of columns in the Palace of the Prince-Bishop at Liège, c.1526; Chastel, 1961b) as an example of back-water artists continuing a tradition of mediaeval fantastic imagery. Indeed, the only exotica which seemed to appeal to artists were the birds and mammals of the New World. A colibiri bird appears on the eleventh pilaster of Raphael's Vatican loggia (painted by G. da Udine), and a *colinus californicus* on the fourth pilaster.

But if artists found little to interest them among the artifacts of America, such was not the case with the 'anthropological' literature of the sixteenth and seventeenth centuries; and, here again, these centuries continue earlier traditions more than they blaze new trails (Pochat, 1970; see particularly the excellent bibliography). The discovery of a new continent with a radically different set of social structures and religions raised problems moral, social and religious, and provided, as it were, a touchstone by which the institutions of Europe might be assessed. The procedure is most familiar in the literary accounts of Montesquieu's *Lettres Persanes* or Swift's *Gulliver's Travels*, and has been studied for Italy (Romeo, 1954) and France (Chinard, 1934; Atkinson, 1935).

Most worrying of all questions was that of American origins. To the mentality which accepted the Bible as literal truth, the inhabitants of the New World had somehow to be fitted in with the story of Adam and Eve. The links which scholars perceived with the Old World persuaded them to locate the migrations in biblical and not in historical times. Actual theories of origins and cultural connections have been many and various and some rather wild ones have had a life of about three hundred years (cf. survey in Huddleston, 1967; Imbelloni, 1955). Egypt and Babylonia, because of their biblical connections, and because of the acknowledged antiquity of their civilisations, were the favourite countries of origin, with India and China close behind because of their proximity (Smith, G.E., 1933, 208ff; Arnold and Frost, 1909, viii: 'America's first architects were Buddhist immigrants from Java and Indo-China'). Cortés, of course, was not interested in much except military matters and the bringing of the Christian religion, which was an integral part of the project. The religious worked hard at destruction, for pagan gods had to be destroyed before Christian ones could be set up. Zumarraga claims to have destroyed over 500 temples and 20,000 idols between 1525 and 1531 (Nuttall, 1911). It should be remembered that the temples were useless to a Christian since, unlike a Roman basilica, for example, they could not be converted for civilised use. Furthermore, they were usually in strategic positions, and it was therefore in the military interest that the temples if not their substructures be demolished. Their connection with obnoxious and bloody rituals would have hastened an inevitable process.

Yet the pyramidal structures were quickly to contribute toward the problem of American origins. Didaco Valades (1574, 167-72) cannot

have been the first to draw attention to their similarity to Egyptian pyramids – a similarity seemingly confirmed by a study of religious practices. But it was not until the middle of the following century that the Jesuit polymath, Athanasius Kircher, was able to tie American origins in with a global theory of architecture. His theories, sometimes preposterous, had a life of over a century. Thus, in 1795, Dupuis credulously uses Kircher's inaccurate if imaginative material, in spite of the fact that Cornelis de Paux had exploded his credentials a generation before: 'Ce père Kircher, qu'on accuse de tant de choses, avait sans doute des visions étranges, et beaucoup d'audace pour les faire valoir' (Dupuis, 1795; i, 43; de Pauw, 1773, ii, 15).

There is, however, no doubt that Kircher's technique of bombarding the learned world with folio volumes, references, quotations in several languages, and many illustrations, produced a world picture that is internally convincing. He holds a respectable if unstudied place in the theory of architecture, thanks to his *Turris Babel* (1679), *China Illustrata* (1667) and *Oedipus Aegyptiacus* (1652-5), sections of which aim to show how the pyramids of Egypt are related not only to the pyramidal towers of Babylonia, but also to constructions in India, China and America. For Kircher, the pyramid is the first monumental architectural form invented by man. He attempts to prove his thesis by learned reference to the Bible and the ancient

Figure 2. The City of Babylon, showing the Tower of Babel, The Hanging Gardens, the Palace and the Walls (Kircher, 1679).

Figure 3. The Great Pyramid and Sphinx (Kircher, 1679).

authors, and by reconstructing what he believes to have been the first structure of all – the Tower of Babel.

Because the architecture of the Tower of Babel is not described in the Bible, the account of Herodotus (*History*, I, 178-86) assumes great importance, in spite of the fact that we would today assume that Herodotus was not describing the *first* Tower of Babel! He writes of a type of pyramid, formed of eight decreasing towers, all square, with a

winding ascent leading to the summit, on which a large chapel stands. Kircher accepts these details, but makes *his* reconstruction round instead of square (Fig. 2), and explains the introduction of pyramids into Egypt as a desire on the part of the Egyptians to emulate the works of Queen Semiramis of Babylonia (who presumably got her ideas from the destroyed Tower of Babel), 'to fill the whole of Egypt with pyramids and obelisks, moreover with images, temples, labyrinths and other noble buildings to the human faith' (Kircher, 1679, 64-5). Kircher then examines similarities of use. For him, the Tower of Babel was an altar on a particularly elevated podium, and he believed the Egyptian Pyramids to have served the same purpose (Fig. 3). Again it was Herodotus' observations which helped him. The Pyramid of Cheops had a flat top (because it had lost its capping stone) and a series of 'steps' up all four sides (because it had also lost much of its casing of smooth stone); these Herodotus suggests must have been little altars. Kircher had, of course, rejected the idea that the pyramids might be tombs; so much effort to so little purpose was inexplicable to a Christian and the majority of his contemporaries held the same view.

In the *Oedipus Aegyptiacus*, Kircher demonstrates the Mexican pyramidal form as the link between Old and New Worlds. He illustrates one, which shows a king on a throne and one man worshipping the sun, another the moon (Fig. 4). The text confirms that the pyramid was simply a huge altar:

> Altars like this were built by the Egyptians ... For since Egypt is a flat country, and lacks mountains, in the place of mountains they devised those high pyramids and obelisks to which they gave the name of 'columns or altars of the gods'; these structures are reached by steps and are full of a great variety of idols, both inside and outside ... From which it is evident that the name of 'High Places' which the Hebrews gave to their altars had no other origin but Egypt.

But any attempt at a global explanation of the origins of architecture could not ignore the ancient civilisations of India and China. Any attempt to investigate these lands revealed creation myths just as convincing as those given in the Bible. Once more, therefore, Kircher had recourse to Herodotus and also Diodorus Siculus for their accounts of the expansion of the power of Egypt under their god Osiris, and then under Rameses II, known to the Greeks as Sesostris. He built on this foundation in his *China Illustrata*, and showed how the Chinese pyramids (i.e. pagodas – Fig. 5) were similar to what he believed to be their prototypes. Both were religious structures, built in storeys, containing idols, and of great height. He assures us that Chinese towers were regarded with awe by the populace, and his illustration shows an idol perched on the summit: 'There are so many

Figure 4. A Mexican Pyramid (Kircher, 1652-5).

connections between the religions of China, Egypt and Greece that they seem to be identical ... We know that the Egyptians so venerated the pyramids that they seemed to do them honours reserved only for the gods.' The inexactitude and false assumptions of a statement like this do not need underlining – and their fantasy is enlarged when we consider the adequate descriptions of the East available in Kircher's day, particularly among priests (like himself) who sought to understand so that they might then convert. Nevertheless, the only way of linking the East with the lands of the Bible seemed to be through Egyptian expansion – until 1728, when Shuckford tried to forge an even firmer link by claiming that the Ark had come to rest in northern India and not on Mount Ararat (Baltrusaitis, 1967, 272; Greene, 1959; Gillespie, 1951, particularly the bibliographical essay).

It is clear that Kircher starts with a theory, and then selects convenient information to back it up. And since the study of *style* as a means of classifying information is a later development, his judgments must seem naïve. But it is perhaps true that such amassing of miscellaneous information is the inevitable first step toward the

Figure 5. A Chinese Pagoda (Kircher, 1667).

classification of antiquities undertaken by the eighteenth century which was an essential process in the development of archaeology, or the history of art or architecture. Thus the great thesauri of Greek and Roman antiquities by Graevius and Gronovius (Amsterdam, 1694-1702), their continuation by Sallengre (1716) and Poleni (1737), are the foundations for the work of Montfaucon's *L'Antiquité expliquée et représentée en figures* (Paris, 1719), which arranges the material by usage, and then for Caylus' *Recueil d'Antiquités* ... (Paris, 1752-67), which divides the collections of antiquities according to stylistic criteria and tries to support the divisions with comparative data. Caylus' position as an advocate of the Neoclassical style ensures that he does not collect ethnographic material – or, indeed, anything outside the range of 'classical' civilisation. Greek and Roman work form the bulk of his survey, with less attention given to 'Etruscan' and Egyptian, but a relatively large space to 'Gaulish' antiquities, which his numerous contacts throughout France enabled him to collect cheaply. There are few surviving catalogues of ethnographic material from this period and it is therefore not surprising to find descriptions which are summary and identifications which are hazy. Thus the 1725 inventory of Sir Hans Sloane's collection show 140 ethnographic items in six broad divisions (the number had risen to 351 by 1753); most items are now lost, but it is probable that some of the 86 items described as 'Indian' are from elsewhere, in view of the hazardous identification of one surviving artifact, a pendant of Toltec origin as 'an Egyptian head of the sun' (Braunholtz, 1970; Hamy, 1890).

The inability to deal with style outside the Graeco-Roman orbit underlines the wide cultural differences between Europe and the rest of the world. Consequently the use made by Europeans of American motifs in the sixteenth and seventeenth centuries always appears to have been trifling in nature. The feathered head-dress is the element most often used as 'shorthand', in tapestries representing the Four Continents (Thomson, 1973, 394: 'An Indian princess with bow and quiver of arrows and an alligator at her feet') and in theatrical representations or fancy-dress series (see, for example, Burnachini (n.d.,) Pls. XIII-XIV – feather head-dresses and cloaks; Saxl, 1937, Figs. 21, 43-4, from a Milanese tailor's stockbook of the second half of the sixteenth century; Nagler, 1964, Pl. 72, the ship of Amerigo Vespucci from *Il Giudizio di Paride* of 1608, showing America with palm trees but no natives). There appears to be an absence of American themes on Spanish medals and tapestries; the latter confine themselves to the standard heroic tales of Antiquity – the Foundation of Rome, Anthony and Cleopatra, Octavius Caesar, the Triumphs of Love, Death, etc. – while the former (in contrast to the frequent view of French territory on French medals: Paris, Hôtel de la Monnaie, 1970, *passim*) usually confine themselves to personal iconography (Alvarez-Ossorio, 1950).

Attitudes to what was still widely considered as primitive art

change with the wider intellectual curiosity of the eighteenth century (Beraud-Villars, 1972; Smith B., 1960; Stafford, 1973). But the Enlightenment came too late for pre-Columbian art, which had suffered from the anathema of the Council of Trent against the perpetuation of heretical Indian writings and, long before, from the 1510 *requerimento* which Cortés had always read to the Indians before attacking them: 'We shall take you and your wives and your children, and shall make slaves of them, and as such we shall take away your gods, and shall do all the harm and damage that we can to vassals that do not obey.' Mary Beckinsale (1970) sees the conquest of New Spain as a continuation of the freeing of Spain from the Moors, and some of Cortés' letters as based on a literary ideal of chivalry; indeed, in Bernal Díaz' *True History*, the leader is compared to Pompey, Caesar and Hannibal. This natural propensity to see newly discovered lands within a predetermined frame of reference – rather than to seek *another* frame of reference – is a phenomenon of basic importance for the study of attitudes to anything non-European, and helps to account for the almost total lack of impact of American art on Renaissance Europe. Kircher's attitudes fit into the same pattern, but the comparative approach he adopts, while capricious in the extreme, prepares the way for the origins of a scientific manner of study in the works of the Comte de Caylus and Quatremère de Quincy. The history of this process has yet to be fully studied.

Such traditionalism, with its tendency to see the work of alien cultures not as art but as artifact, as something which may explain religion or society, but not as an aesthetic approach to experience which might have something to offer the sophisticated European, was not really to change until the beginning of the twentieth century, when the rejection of much of the academic tradition of European art entailed the exploration of the art-forms of 'primitive' cultures.

REFERENCES

Alvarez-Ossorio, J. (1950), *Catalogo de las Medallas de los Siglos XV y XVI*, Madrid.

Arnold, C., and Frost, F.J.T. (1909), *The American Egypt: A Record of Travel in Yucatan*, London.

Atkinson, G. (n.d.), *Les Relations des voyages du XVIIIe siècle et l'evolution des idées*, Paris.

Atkinson, G. (1920), *The Extraordinary Voyage in French Literature before 1700*, New York.

Atkinson, G. (1935), *Les Nouveaux Horizons de la Renaissance française*, Paris.

Baltrusaitis, J. (1955), *Le Moyen Age fantastique: Antiquités et exotismes dans l'art gothique*, Paris.

Baltrusaitis, J. (1967), *La Quête d'Isis*, Paris.

Baudet, H. (1945), *Paradise on Earth: Some Thoughts on European images of the Non-European Man*, New Haven and London.

Beckinsale, Mary (1970), *Theological Reflections on post-Conquest Mexico in Sixteenth-Century Spanish Writings*, unpublished M.Phil. Thesis, University of London.

Beraud-Villars, M.J. (1972), 'La découverte de la Polynésie', *Archéologia*, xlvi, 8-18.

Braunholtz, H.J. (1970), *Sir Hans Sloane and Ethnography*, London.

Burnachini, L.O. (n.d.), 'Maschere', in the series *Denkmäler des Theaters ... aller Zeiten*, Munich.

Chastel, A. (1961a), *Art et humanisme à Florence au temps de Laurent le Magnifique*, Paris.
Chastel, A. (1961b), 'Masques méxicains à la Renaissance', *Art de France*, i, 299.
Chinard, G. (1911), *L'Exotisme dans la littérature française au XVIe siècle*, Paris.
Chinard, G., (1934), *L'Amérique et le rêve éxotique dans la littérature française au XVIIe et XVIIIe siècles*, Paris.
Dacos, N. (1969a), *La Découverte de la Domus Aurea et la formation des grotesques à la Renaissance*, London and Leiden.
Dacos, N. (1969b), 'Présents américains à la Renaissance: L'assimilation de l'éxotisme', *Gazette des Beaux-Arts*, lxxiii, 57-64.
Dupuis, M. (1795), *Origine de tous les cultes*, 3 vols, Paris.
Elliott, J.H. (1970), *The Old World and the New*, Cambridge.
Gillespie, C.C. (1951), *Genesis and Geology*, Cambridge, Mass.
Greene, J.C. (1959), *The Death of Adam*, Ames, Iowa.
Greenhalgh, M. (1974), 'The monument in the *Hypnerotomachia* and the pyramids of Egypt', *Nouvelles de l'Estampe*, xiv, March-April, 13-16.
Hamy, E.T. (1890), *Les Origines du Musée d'Ethnographie: Historie et documents*, Paris.
Heikamp, D. (1966), 'Les Médicis et le Nouveau Monde', *L'Oeil*, December 1966, 16-25.
Heikamp, D. (1972), *Mexico and the Medici*, Florence.
Hodgen, M.T. (1964), *Early Anthropology in the 16th and 17th Centuries*, Philadelphia.
Huddleston, L.E. (1967), *Origins of the American Indians: European Concepts, 1492-1729*, Austin, Texas, and London.
Imbelloni, J. (1955), *La segunda esfinge indiana: Antiguos y nuevos aspectos del problema de los origines americanos*, Buenos Aires.
Iversen, E. (1961), *The Myth of Egypt and its Hieroglyphs in European Tradition*, Copenhagen.
Jones, H.M. (1964), *O Strange New World*, New York.
Kircher, A. (1652-5), *Oedipus Aegyptiacus*, Rome.
Kircher, A. (1667), *China ... Illustrata*, Amsterdam.
Kircher, A. (1679), *Turris Babel*, Amsterdam.
Lightbown, R.W. (1969), 'Oriental art and the Orient in late Renaissance and Baroque Italy', *Journal of the Warburg and Courtauld Institutes*, xxxii, 228-79.
Nagler, A.M. (1964), *Theatre Festivals of the Medici*, New Haven and London.
Nowotny, K.A. (1960), *Mexikanische Kostbarkeiten aus Kunstkammern der Renaissance*, Museum für Volkerkunde, Vienna.
Nuttall, Z. (1911), 'L'Evêque Zumarraga et les idoles principales du grand temple', *Journal de la Société des Américanistes de Paris*, Mexico, 153-71.
Olschki, L. (1944), 'Asiatic exoticism in Italian painting of the early Renaissance', *Art Bulletin*, xxvi, 95-108.
Panofsky, E. (1955), *The Life and Art of Albrecht Dürer*, (4th edn), Princeton.
Pauw, C. de (1773), *Recherches philosophiques sur les Egyptiens et les Chinois*, Amsterdam and Leiden.
Paris, Hotel de la Monnaie (1970), *La Médaille au temps de Louis XIV*, Paris.
Pochat, G. (1970), *Der Exotismus während des Mittelalters und der Renaissance*, Uppsala.
Pouzyna, I.V. (1935), *La Chine, l'Italie et les débuts de la Renaissance, XIIIe-XVe Siecles*, Paris.
Romeo, R. (1954), *Le scoperte Americane nella coscienza Italiana del cinquecento*, Milan and Naples.
Saxl, F. (1937), 'Costumes and festivals of Milanese society under Spanish Rule', *Proceedings of the British Academy*, xxiii, 401-56.
Schlosser, J. von (1908), *Die Kunst- und Wunderkammern der Spätrenaissance*, Leipzig.
Smith, B. (1960), *European Vision and the South Pacific, 1768-1850: A Study in the History of Art and Ideas*, Oxford.
Smith, G.E. (1933), *The Diffusion of Culture*, London.
Soulier, G. (1924), *Les Influences orientales dans la peinture toscane*, Paris.

Stafford, B.M. (1973), 'Mummies, herms and colossi: Easter Island and the origin of sculpture', *Art Quarterly*, xxxvi, 31-55.

Thomson, W.G. (1973), *A History of Tapestry*, rev. ed., Wakefield.

Valades, D. (1574), *Rhetorica Christiana ...* , Rome.

Wagner, H.R. (1929), 'Three accounts of the expedition of Fernando Cortés, printed in Germany between 1520 and 1522', *Hispano-American Historical Review*, ix, 176-212.

Weiss, R. (1966), *Pisanello's Medallion of Emperor John VIII Palaeologus*, London.

J.B. Donne
African art and Paris studios 1905-20

Il y a plusieurs années que les idoles nègres sont recherchées. Les artistes d'avant-garde en subirent l'influence; certains en devinrent fanatiques ... (Paul Guillaume, *Sculptures nègres*, 1917)

It has become a truism of the history of modern art – but a truism too often taken for granted and seldom subjected to scrutiny – that before the First World War Picasso and the Cubists came under the influence of African art. By the careful selection of photographs, startling visual comparisons can be made between Cubist paintings and African sculptures, regardless of the fact that sometimes the European artist could never possibly have seen carvings of the type depicted. Even Alfred H. Barr fell into this error in his magisterial work on Picasso in which he illustrates a Babangi mask from Etumbi in the Congo Republic, adding: 'This mask from the Itumba region of the French Congo may be compared with the upper right-hand face of *Les Demoiselles d'Avignon*' (Barr, 1946, 257). It may well be compared, but to little purpose, since there is not the slightest likelihood that Picasso ever saw such a mask, which is in fact unique (Siroto, 1954, 149-50), when he was painting *Les Demoiselles d'Avignon* in 1907 (Fig. 1). Indeed, this particular piece only came out of Africa in 1930 (Fagg, 1970, 139)!

Likewise, the cubistic mode of Dogon sculpture is called upon to point up the resemblances between some European painting and African art. In his book on Cubism, Edward F. Fry illustrates not only the Babangi mask but also a fine Dogon sitting figure (1966, Pls. 3-4), though in fairness to him it must be said that he mentions neither piece in the text. Nevertheless, the suggestion must remain in the reader's mind that there is a connection between Dogon art and Cubism. The first examples of the art of the Dogon (then referred to as the Habbé) were brought to Paris in 1906 by Lt. Louis Desplagnes as a result of his official expedition to the French Sudan in 1903-6 and consisted principally of three granary doors, two ritual food bowls, two carved door locks and a stool. They were apparently displayed in the Musée d'Ethnographie du Trocadéro (Desplagnes, 1907, 2), but

Figure 1. Pablo Picasso: *Les Demoiselles d'Avignon*, oil, Paris 1906-7. (*Coll. Museum of Modern Art, New York, Lillie P. Bliss Bequest,* © *S.P.A.D.E.M. Paris, 1977*)

there is no proof that they were ever viewed by any artists living in Paris at the time and they certainly provided no artistic inspiration. Dogon figure sculpture appears to have turned up in Paris first in the 1920s, but as late as 1935 Kjersmeier (1935-8, 1, 19) was aware of the existence of only seven such pieces outside Africa. Almost all of the large quantity of Dogon sculpture known to us today came out of Africa only after the Second World War.

It is patently absurd to discuss the influence of African art on the Cubists on the basis of pieces and even styles that the artists of the time did not and could not know. It is the purpose of the present paper to make a preliminary investigation of the styles of African art that could be seen in Paris in 1905-20, and where possible to identify the actual pieces that came to the notice of the artists of the day.

One of the results of the 'scramble for Africa' of the European

powers at the end of the last century was an enormous increase in the quantity of 'ethnographic specimens' that entered European museums and also began to appear on the collectors' market. Naturally enough, each European country received the preponderance of objects from those areas of Africa which were its agreed sphere of influence and which it was in the process of colonising. Thus the major portion of the booty brought back from Benin by the British Punitive Expedition of 1897 remained in this country (notably in the collections of the British Museum and, until recently, in the Pitt-Rivers Museum at Farnham, Dorset), although a considerable quantity was bought from English dealers by German museums. Objects from other parts of Southern Nigeria, when they did not remain in the hands of British private collectors, tended to gravitate to the British Museum and the Public Museums, Liverpool, since this was the main port for shipping sailing to British West Africa. Sculpture from the German Kamerun entered collections in Germany in large quantities. The Musée du Congo (now the Musée Royal de l'Afrique Centrale, Tervuren) was establishing its vast collections of Congo art, but since the Independent State of the Congo employed many non-Belgians, who themselves collected 'curios', objects from the Congo were even at this period more widely distributed throughout Europe than those from probably any other area of West or Central Africa.

Likewise, by far and away the chief source of African objects in French collections were French West Africa and French Equatorial Africa, especially the Ivory Coast and Gabon. But, as in the colonies of the other European powers, the policy of 'occupation and pacification' took years and even decades to carry through (Afigbo, 1974) and, particularly in the Ivory Coast, it was not until the 1920s that some tribes were subdued. Consequently, the carvings brought back from the French colonies at this time were largely limited to the styles of the coastal areas. This is clearly revealed in Table I and the accompanying map (Fig. 2), the former being based on an analysis of the pieces existing in Guillaume Apollinaire's collection at the time of his death in 1918, which is still preserved (Fig. 3), and also of the pieces from other Paris collections illustrated in three volumes on primitive art published before 1920. One of these, *Iskusstvo Negrov*, by the Lettish sculptor and art historian Valdemar Matvej (who wrote in Russian under the name Vladimir Ivanovich Markov and who died in 1914) was not published until 1919. Nevertheless, the illustrations in this book were all obtained during his last tour of museums in Western Europe in 1913 (see the biographical notes by his friend V.D. Bubnova in Markov, 1919, 3-7). They show what could be seen in the Musée du Trocadéro (together with one example from the Brummer Collection in Paris) at this date.

Paul Guillaume, who became a dealer in African art almost by chance (Laude, 1968, 117, n.95) and who was to mount the first

Table 1. Provenance of African sculpture in Paris collections prior to 1920

Date	Source	No. of African pieces	Guinea	Sudan	Ivory Coast	Dahomey	Gabon	Lower Congo	Other	Unidentified
1913	Markov (1919)	11	–	2	3	–	3	–	21	1
1917	Guillaume (1917)	21	1	4	6	–	8	1	–	1
1918	Apollinaire (private collection)	22	–	–	4	4	4	4	2	4
1919	Clouzot and Level (1919)	29	1	1	10	2	6	3	4	2
	Totals	83	2	7	23	6	21	8	8	8

Tribal origins
Guinea: Baga.
Sudan: Bambara.
Ivory Coast: Grebo, Dan, Ngere-Wobé, Agni, Baule, Senufo.
Dahomey: Fon, Yoruba.
Gabon: Fang, Kuta, Teke.
Lower Congo: Kongo, Kuyu.
These attributions do not necessarily correspond with the captions in the original publications.

Figure 2. West Africa (1914): Location of tribes whose sculpture was reaching Paris

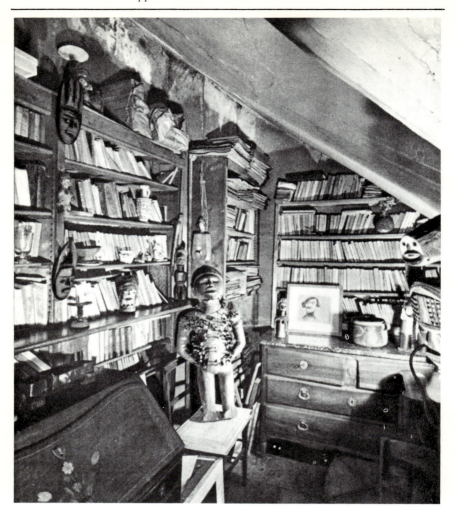

Figure 3. Guillaume Apollinaire's studio, Paris. (*Photo: Atelier René Jacques, Paris*)

exhibition of African art in Paris in 1919, published his *Sculptures nègres* in 1917, with an introduction by Apollinaire which had appeared earlier that year in the *Mercure de France* (Apollinaire, 1955, 234-7, 312; 1960, 483-4). Although this book was published in a limited edition of sixty-three copies and therefore must have had a restricted circulation, its importance lies in the fact that it reproduces pieces from the collections of, among others, Matisse, Picasso, Vlaminck and Vollard – pieces therefore that would have been familiar to many of the artists of the day.

Henri Clouzot and André Level's *L'Art nègre et l'art océanien* appeared in 1919 to accompany Paul Guillaume's exhibition at the Galérie Devambez. With the notable exception of Plate XXIII, which

depicts the famous head of a Princess from Benin in the British Museum, the provenance of the objects illustrated coincides very closely with those in the other two books and with the pieces in the Apollinaire collection.

A glance at Table 1 shows that the political situation of the colonial powers and the extent of French authority in its own colonies are clearly reflected in the Paris collections of the time. There are no objects from the British or German colonies, that is Nigeria and Kamerun: the Yoruba pieces were almost certainly all from Dahomey, as was Apollinaire's famous *Oiṣeau du Bénin*, a fine example of Fon brasswork of the second half of the nineteenth century. Despite what Laude says (1968, 120), this argues that pieces from other colonies, with the exception of the Belgian Congo for reasons already given, were not reaching the French market.

Furthermore, in line with the extent of French authority at the time, the majority of tribes represented inhabited areas on the coast or the near hinterland rather than the deep interior – for example the Baga, Dan, Ngere-Wobé, Agni, Baule, Fon, Dahomey Yoruba and Kongo. The exception is Gabon, whose interior began to be 'opened up' by Savorgnan de Brazza on behalf of the French government as early as the 1870s.

The objects which are numerically best represented are the masks of the Dan and Ngere-Wobé of the south-west Ivory Coast and the figurines of the Agni and Baule of the south-east, and the Fang white-faced masks and the Kuta copper-covered *m'bulu* funerary figures of the Gabon. Notably absent – in the light of our present appreciation of African art – are works of the Dogon; the Bambara and Senufo (represented by two or three figures between them, and no masks); the Bobo, Mossi and Kurumba; the Mende of Sierra Leone; Baule and Guro masks; the Asante; the entire art of Nigeria; and the sculpture of the Cameroons Grasslands. A variety of objects from the Congo area are to be found, such as Kuba cups, but no famous or even fine figure carvings, and no masks.

With a knowledge of what styles of African art could, and what could not, be seen in Paris during the period 1905-20, it is sometimes possible to relate a particular style, and even a particular piece, to a painting or sculpture produced at this time. The obvious case is that of Picasso, not only because of the known influence of African art on his work but also because of the existence of the many volumes of Zervos' catalogue.

From this point of view, one of the most important paintings of 1907 is the *Femme nue* (Zervos, 1932-, 2i, No. 35), sometimes even known as *La Danseuse africaine* (Fig. 4). As has long been pointed out (Barr, 1936, 30; Goldwater, 1967, 150), this derives from a Kuta funerary figure, known as *m'bulu*, examples of which had been reaching Europe at the end of the nineteenth century, and had actually been illustrated in *La Tour du Monde* – a magazine often consulted by artists for its

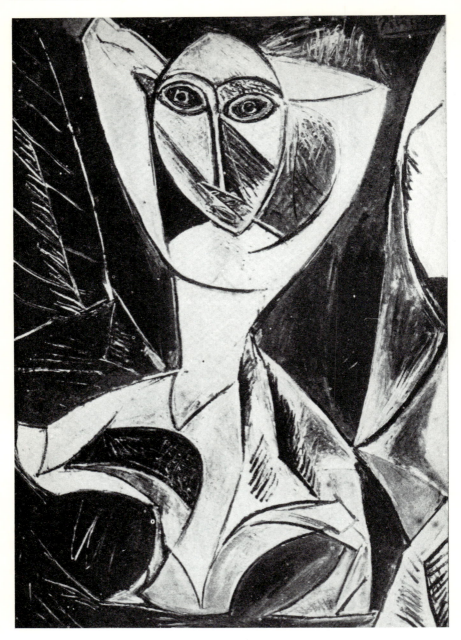

Figure 4. Pablo Picasso: *Femme Nue*, oil, (?) Avignon, 1907. (*Coll. Walter P. Chrysler Jr.; photo: courtesy Museum of Modern Art, New York,* © *S.P.A.D.E.M. Paris, 1977*)

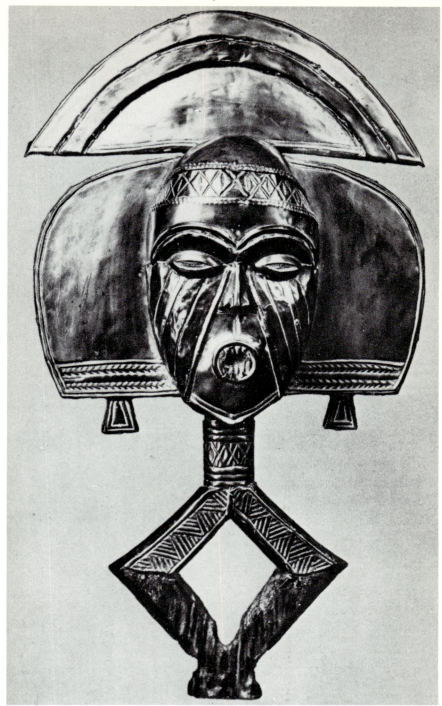

Figure 5. Kuta, Mindassa, Gabon: *M'bulu*, copper and brass reliquary on wood. (*Coll. Charles Ratton, Paris*)

illustrations – as far back as 1887 (De Brazza, 1887, 50). The *m'bulu* consists of a wooden armature in the form of an open diamond, surmounted by a short neck, a flat oval face with wings like a triptych, and a crescentic head-dress, the whole encased in sheets, or a combination of sheets and strips, of copper. Picasso has introduced an un-African dynamism into his dancer and the wings and head-dress of the *m'bulu* have given him the idea of raising her arms and placing her hands behind her head – a pose which, as we shall see in a moment, has significance in other of his works.

But what appears to have passed unrecognised is that the *nez en quart de brie* characteristic of this period, in which a series of lines run obliquely down one side of the nose – as also in the two right-hand heads in *Les Demoiselles d'Avignon* (Zervos, 1932-, 2i, No. 18) – may well derive from a particular type of *m'bulu* attributed to the Mindassa area (Chaffin, 1973, Nos. 24, 27, 28), in which applied strips of copper run down obliquely from the nose or eyes (Fig. 5). Examples of this

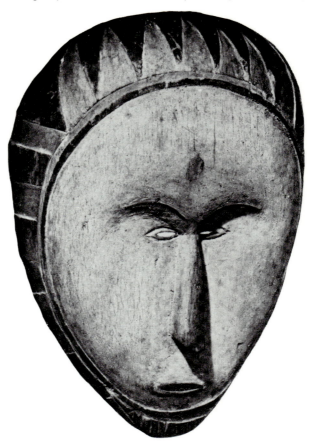

Figure 6. Fang, Gabon: white painted mask. (*Coll. Alice Derain; photo: courtesy Société des Amis du Musée de l'Homme, Paris*)

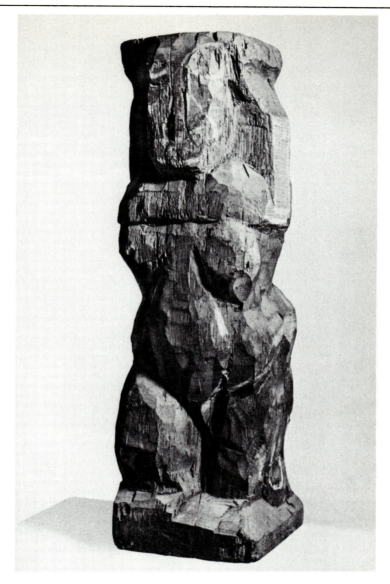

Figure 7. Pablo Pïcasso: *Painted wooden figure*, Paris, 1907. (*Photo: Brassai, Paris*, © *S.P.A.D.E.M. Paris, 1977)*

type are known to have existed in the collections of André Lhote (Bolz, 1966, Pl. XLIIa) and André Level (Clouzot and Level, 1919, Pl. XXV), and even if neither of these pieces was the actual one that Picasso saw at the time of painting the *Femme nue* of 1907, there is no reason why the *m'bulu* he was familiar with should not have been of the Mindassa type.

It is interesting to note that these striations on the face appear in a drawing of 1907 (Zervos, 1932-, 6, No. 962) which itself seems to be based on a Fang white-faced mask (Fig. 6), and specifically that which Vlaminck sold to Derain, who in turn showed it to Picasso (Laude, 1968, 104-5; Goldwater, 1966, 87). However important historically this mask may have proved, it is aesthetically uninteresting. Several better ones were around (Picasso was to own one of them), and it certainly played no part in the composition of *Les Demoiselles d'Avignon*.

In 1907 Picasso also produced half-a-dozen wood carvings which are clearly a response to African and Oceanic sculpture, and which 'although clearly under some primitivising inspiration, give no evidence of specific stylistic sources' (Goldwater, 1967, 145). There is however one exception to this – an unfinished carving in painted wood (Spies, 1971, No. 19). Of this Spies writes: 'This figure seems most nearly to recall the Tahitian *tiki* figures which Gauguin reproduced in his paintings and sculptures' (Fig. 7, and Spies, 1971, 23). It is extremely unlikely indeed that Picasso could have seen a Tahitian *tiki* (there was a fly-whisk with a *tiki* on its handle in the Musée du Trocadéro by 1908), though he already owned a Marquesan figure (Leiris, 1953, 339). But significantly, Tahitian and Marquesan and, indeed, nearly all Polynesian figure carvings have the hands resting on the belly whereas the Picasso piece presents the unusual pose of hands raised to the head as if supporting something. It has already been noted that Picasso had displayed hands raised to the head in the *Femme nue* of 1907; the same pose in the central figure of *Les Demoiselles*, and in several drawings (Zervos, 1932-, 2ii, Nos. 189, 190, 250, 251, 260), one of which appears to be a preliminary sketch for the woodcarving (*ibid.*, 275). Before 1920 a number of woodcarvings of a standing woman supporting a stool, tray, drum or box appeared in private and museum collections; there was at least one in the Musée du Trocadéro. These were in some cases attributed to a non-existent Ivory Coast tribe, the 'Alangoua', but are now known to have come from the Ebrié, behind the lagoon near Abidjan. The earliest illustration so far found, however, which refers such a piece to a Paris collection, dates to 1925 (Clouzot and Level, n.d., Pl. XIa). But as works from the Ivory Coast predominated over those from other areas, several such pieces were to be seen. The pose of Picasso's figure is so unusual even in Africa as *closed* sculpture that it seems most likely that he had come across an Ebrié piece.

The most authoritative account of the direct influence of African art on Picasso concerns his use of projecting cylinders to represent eye-sockets and has been given in various languages over the years by D.-H. Kahnweiler. This concept was inspired by certain masks from the south-west Ivory Coast which are now famous for their projecting eyes, either in the form of hollow cylinders or hemispherical excrescences slit horizontally. In one version (Kahnweiler, 1948), the

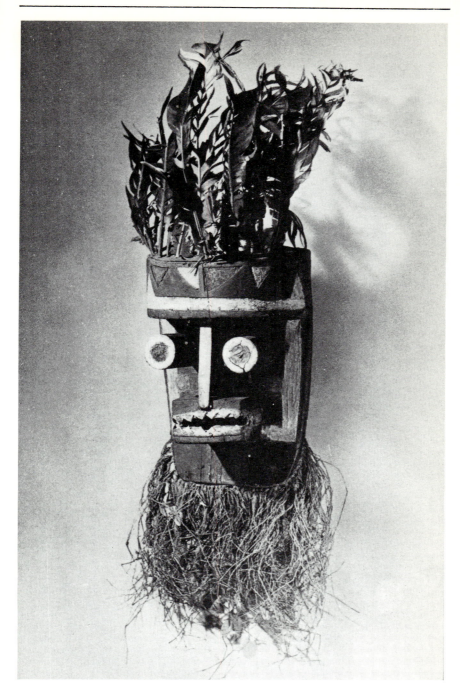

Figure 8. Grebo mask exhibited at the Exposition Universelle in Paris in 1900. (*Coll. Musée de l'Homme, Paris; photo: José Oster*)

text is accompanied by an illustration of a rare Grebo mask from Sassandra which was donated to the Musée du Trocadéro in 1900 (Guy Le Moal, pers. comm. 26 Nov. 1971), and the same photograph is reproduced by Michel Leiris in his account (Leiris and Delange, 1968, 13 and Pl. 12). But Kahnweiler says that 'Picasso possédait un masque wobé et ... c'est l'étude de ce masque qui est à l'origine du bouleversement qui s'opéra alors' (Kahnweiler, 1948). Leiris, for good measure, adds that the mask that Picasso owned came from the region of Sassandra, which would in fact make it Grebo and not Wobé.

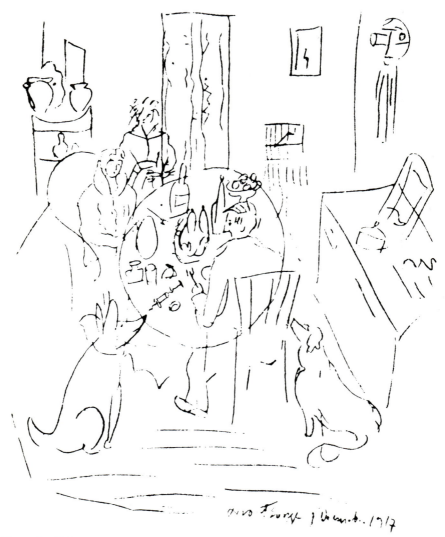

Figure 9a. Pablo Picasso: *Dining room at Montrouge*. Lead drawing, 9 December, 1917.
(*Photo: courtesy Editions Cahiers d'art, Paris,* © *S.P.A.D.E.M. Paris, 1977*)

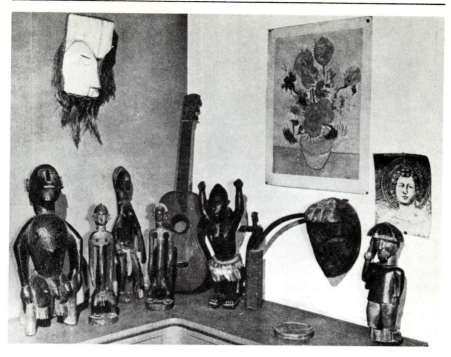

Figure 9b. Braque's African collection c. 1914, including (above left) a white-faced mask from the Gabon and three Bambara figures. (*Photo: Routhier*)

There is clearly some confusion here. Grebo masks are comparatively rare, though they were coming out of the Ivory Coast in the first decade of the century; many Ngere-Wobé masks also have cylindrical eyes and are far commoner (Fig. 8). But Kahnweiler's first account, written in 1914-15 (1958, 9), contains a description which appears to apply to the Grebo mask:

> Während nun die Nase sich einfach als ein schmales Brett aufsetzt, bilden zwei etwa acht Zentimeter vorspringende Zylinder die beiden Augen, ein etwas niederes Hexaeder den Mund. Die vorderen Flächen der Zylinder und des Hexaeders sind bemalt, das Haar durch Rafia wiedergeben. (Kahnweiler, 1957, 87)

However, in the Grebo mask the hair consists of feathers. It is the beard that is made of raffia. It is impossible to know what was on display, let alone what attracted Picasso's attention when he first visited the Musée du Trocadéro in 1907 (the cylindrical eyes do not appear in his work until 1912), but at least he did possess a Ngere-Wobé mask. It appears hanging on the wall of his dining-room at Montrouge in a pencil drawing done in 1917 (Fig. 9a; Zervos, 1932-, 3, No. 106), and its right eye sticks out like a telescope.

Picasso is naturally only one of the painters of this period whose interest in African art may be documented, and needs to be documented far more thoroughly than in the present paper. For example, the works of Braque and Modigliani could be studied closely and rewardingly in this respect. But it must be realised that the clever juxtaposition of African pieces alongside the work of European artists is not evidence that the former influenced the latter. And yet this is suggested not only in many art books but even sometimes in museum displays, such as the one put on by the Museum of African Art in Washington D.C. in 1972. The actual object that can be proved to have been seen, or better still possessed, by the artist at the time of his producing a particular work, is what the art historian needs (Fig. 9b). The evidence of what is unlikely to have been seen for reasons of the colonial situation at the time is important – and even more clearly so when one compares what was happening in Dresden and Berlin before the First World War. That war supplied the background to the Dadaists and the Surrealists, who were to become involved in Oceanic and Eskimo art. African art then began to be something for collectors rather than artists.

REFERENCES

Afigbo, A.E. (1974), 'The establishment of colonial rule', in J.F.A. Ajaji and M. Crowder (eds.), *History of West Africa*, 2, London, 424-83.

Apollinaire, G. (1955), *Anecdotiques*, Paris.

Apollinaire, G. (1960), *Chroniques d'art 1902-18*, T.C. Breunig (ed.), Paris.

Barr, A.H. (1936), *Cubism and Abstract Art*, Museum of Modern Art, New York.

Barr, A.H. (1946), *Picasso: Fifty Years of his Art*, New York.

Bolz, I. (1966), 'Zur Kunst in Gabon', *Ethnologica* n.F.3, 85-221.

Chaffin, A. (1973), 'Art kota', *Arts d'Afrique noire* 5, 12-43.

Clouzot, H. and Level, A. (1919), *L'art nègre et l'art océanien*, Paris.

Clouzot, H. and Level, A. n.d. [1925], *Sculptures africaines et océaniennes*, Paris.

De Brazza, S. (1887), 'Voyage dans l'ouest africain', *Le Tour du Monde*, 54, Paris.

Desplagnes, L. (1907), *Le Plateau central nigérien*, Paris.

Fagg, W. (1970), *African Sculpture*, Washington D.C.

Fry, E.F. (1966), *Cubism*, London.

Goldwater, R. (1967), *Primitivism in Modern Art*, New York.

Guillaume, P. (1917), *Sculptures nègres*, Paris.

Kahnweiler, D. -H. (1948), 'L'art nègre et le cubisme', *Présence africaine*, 3, 367-77.

Kahnweiler, D.-H. (1958), *Der Weg zum Kubismus*, Stuttgart.

Kjersmeier, C. (1935-8), *Centres de style de la sculpture nègre africaine*, Paris and Copenhagen.

Laude, J. (1968), *La Peinture française (1905-1914) et 'l'Art nègre'*, Paris.

Leiris, M. (1953), 'Les nègres d'Afrique et les arts sculpturaux', *L'Originalité des cultures*, Paris, 336-73.

Leiris, M. and Delange, J. (1968), *African Art*, London.

Markov, V. (1919), *Iskusstvo Negrov*, Petersburg.

Siroto, L. (1954), 'A mask style from the French Congo', *Man*, liv, 149-50.

Spies, W. (1972), *Picasso Sculpture*, London.

Zervos, C. (1932-), *Pablo Picasso*: 2i, 'Oeuvres de 1906 a 1912' (1942); 2ii, 'Oeuvres de 1912 à 1917' (1961); 3, 'Oeuvres de 1917 à 1919' (1949); 6, 'Supplément aux vols. 1-5' (1962); 26, 'Supplément aux années 1907-09' (1973), Paris.

Josef Herman

The modern artist in modern society

Modern society is scientific and is technologically orientated. It favours utilitarian ideologies. It favours the scientist and the engineer. Some scholars even claim that the greatest works of art of the twentieth century are to be found not in museums but in the street, in engineering, in the construction of bridges, in the design of aeroplanes, roads and so forth. This way of viewing art is purely formal and functional but it confirms that art in the sense of image-making is on the fringes of our society and not at its heart (cf. Otten, 1971, xv). Society could well do without it. The numbers of people directly involved in the existence of art, the artists, the connoisseurs, dealers and collectors are indeed very small. I doubt whether they amount to more than five figures in the whole of the western world including the Americas.

Art today exists not because society needs it or depends on it but because by some freak of nature artists still exist; and they have their own way of deciding their function. The artist today stands alone, not unlike the philosopher, who has stood alone for a long time. If today we ask an artist 'For whom do you work?' his answer will invariably be 'For no-one in particular'. He may add rhetorically 'For whom does the philosopher do his thinking?' No longer working for an aristocratic patron or a bourgeois Maecenas, the artist, again not unlike the philosopher, believes that in one way or another his labours add to the rest of Man's intellectual efforts to come to know himself, change himself, civilise himself. On this basis there still exists an interaction between art and society. In a purely cultural sense the images created by artists still work, to use the utilitarian expression, for some purpose.

No longer a maker of symbols of magic or myth, no longer a maker of icons. The artist's images have taken over where religions have left off; his image today is a personalising force parallel to the de-personalising of science. The equilibrium of the total man makes him as much dependent on art as on science. Science is for Man's armoury to protect him against a hostile Nature, while art is for his spiritual

health. Science applies itself to the facts of life, art to the experience of life.

For a time the scientific impact on all spheres of life was such that even artists thought that the time had now come to adjust art to the conditions of science. They thought that now was the time to forsake art's autonomy for a link-up with the applied arts which were nearer, at least functionally, to the functionality of science. The artist in front of an easel, working on an image nobody asked for, was thought of as a figure of yesteryear, an anachronism in modern times. The *new* artist, as Vladimir Tatlin, the founder of Constructivism, suggested, 'sits in a clean overall, white or blue, bent over a drawing-board, and works on designs for immediate use, designs for a stove or a suit functional to its use' (Buchman, 1922, 4). 'The art of the future', wrote Franz Marc, 'will be a formal embodiment of our scientific convictions'. The progress of the artist, wrote T.S. Eliot, 'is a continual sacrifice, a continued extinction of the personality ... It is in this depersonalisation that art may be said to approach the condition of science' (Scully, 1966, 9).[1]

Significant though this mood may have been, it was by no means the prevailing mood of all or even of most of the artists of the day. Only a small number of artists professed this view – which was shared neither by Picasso, Braque, Matisse, Rouault nor by the German or Flemish Expressionists. The artist, the maker of images, remained and indeed is still with us. Apparently, nothing can deter him.

True, the images the present-day artist is producing are different from those of former times and cultures. It is in the content of the new images that we must seek the function of the artist in modern society. But first let us examine in what way modern images differ from those of the past. In both painting and sculpture, modern images differ from those which preceded them as follows: they belong to no single tradition, they are totally free from rules, and they embody individual expression to a degree hitherto unknown. The artist of today, following no single tradition, has a free choice of pictorial sources, to be drawn on according to nostalgia or to the needs of his talent. In works of modern artists we may meet traces of traditions as far apart as those of ancient Mexico or tribal Africa, ancient China or classical Greece.

Similarly, every effort at establishing rules has failed. The rules of colour of the Fauves, the Cubists' rules of form and space, the Futurists' rules of movement, the Suprematists' rules of design – each system has attracted a small number of followers for a limited time but has proved generally unacceptable to most artists. Such apparent chaos was in fact the embodiment of the spirit of social democracy, for freedom of the individual implied a free choice of the means of artistic expression as well.

1 See also Hess (1956) for an invaluable collection of modern artists' statements on their art.

Figure 1. Wassily Kandinsky's realistic style (© *A.D.A.G.P. Paris, 1977*).

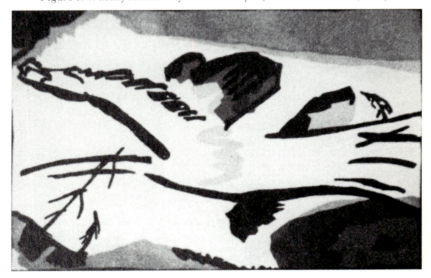

Figure 2. Toward abstraction (© *A.D.A.G.P. Paris, 1977*).

Figure 3. Absolute abstraction (© *A.D.A.G.P. Paris, 1977*).

However, two general attitudes emerged from that 'chaos': one favoured expression through absolute abstraction, the other preferred figurative means. Both attitudes are dominant in the art of our own day and will probably last into the foreseeable future. Let us consider these two attitudes in detail. Abstract art is art without reference to subject or object – art without a definite image. Its surface is its content; colour, shape, design combine in an unexpected unity. Abstract art can be intellectual, as with Mondrian, or emotional, as with Kandinsky; it can even be harmonious or vaguely spiritual. But it cannot go beyond decoration, beyond the general evocation of some sort of experience. The way in which the idea of abstraction was developed into a workable theory can best be seen in the writings of Kandinsky and Mondrian. 'I steadily absorbed impressions' wrote Kandinsky, 'until I trained myself to overlook objects' (Kandinsky, 1964, 35; Figs. 1-3).

The human eye and brain naturally see colour connected with matter and shape connected with objects: abstraction can become second nature only through an effort of the intellectual will, as in the now famous studies by Mondrian of a single-tree. These studies show just how much intellectual strain was required to dissolve the tree into a purely abstract and decorative design (Figs. 4-6). Kandinsky has left no such pictorial record, but has written that he had to strain his mind to the utmost 'until the realm of art drew further and further apart from the realm of nature'. Such artists, having assured themselves that such a process was possible, no longer needed any reference to nature; since their day, all abstract art has followed their lead in a variety of

Figure 4. Piet Mondrian's realistic study of a tree, 1912. (*Museum of Art, Carnegie Institute, Pittsburgh*).

Figure 5. Towards abstraction in which the sources of the design are still recognisable.

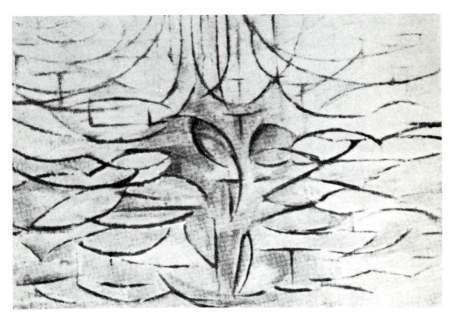

Figure 6. Absolute abstraction.

designs, textures and moods. Basically, abstract art has remained
stationary; although the New York School revitalised it with abstract
expressionism, best seen in the contributions of Rothko and de
Kooning, this variation also bogged down in the limited methods
employed.

Restrictiveness of method is paralleled by the way abstract art deals
with human experience. While it can express sadness or joy, it cannot
delve deeply into the reasons for emotion. Suitable perhaps for the
expression of private psychological attitudes, abstract art cannot
express social emotions, for these would require some kind of
figuration if only as clues. Such restriction of human experience
confines abstraction to the role of a minor, though an authentic art.

In spite of the modern bias in favour of abstraction, figurative art
may prove to be longer lasting, richer in talent, more varied and hence
less prone to monotony. Whether inclined toward fantasy (Chagall),
religion (Rouault), mysticism of nature (Nolde), social protest
(Kollwitz), monumental and epic ideas (the modern Mexican school),
dramatic hallucinations (Beckman) or colouristic ecstasy (Soutine),
figurative art retains some points of contact with abstraction, they
share the same freedom from tradition and the same freedom from
general aesthetic rules. Furthermore, modern figurative art puts mood
above the materiality of its subjects and objects although it cannot
dispense with either. Again, it owes more to the primitive imagination
than to the realistic or classical veins and, like abstract art, is
immediately recognisable as being of our own times. But perhaps the
main contribution of modern figurative art to the development of art is
its success in establishing as serious art a new popular image which
provides the backbone for its various styles (Figs. 7-10).

This new popular image can – like so many aspects of modern art –
be traced back to ideas active in the later nineteenth century. The
Graeco-Roman and Renaissance tradition remained the one great
influence in art until the first half of the nineteenth century, when
artists conceived the necessity of abolishing its innate idealism, its
naturalism, its insistence upon the rule of beauty 'which by tradition
was identical with the aesthetics of the upper classes' (as Lionello
Venturi has remarked). The first break from that tradition came with
the shift in class sympathy and the consequent establishment of a new
iconography. What had hitherto been an occasional tendency seen in
rare artists like Caravaggio, Brueghel or Louis Le Nain, now became
a prevailing mood. Courbet, Millet and Daumier were the moderns
for whom the street and the field became the sole museum of symbolic
references; peasant and worker became for them a source of unique
poetry. This shift in class sympathy was fruitful in new iconographical
ideas which prevented any retreat into idealised historiography or
antiquarianism. Styles of art followed one another, but Impressionists
like Pissarro and Monet and Post-Impressionists like Cézanne and
Van Gogh accepted the new iconography as a matter of course, and

Figure 7. Georges Roualt: *Rustics.* (© *S.P.A.D.E.M. Paris, 1977)*

the moods of the new images remained unchanged, and clearly popular both in taste and appeal. The figurative artists of our century have extended and enriched this popular image-making by their sense of freedom and their search for variety.

Both abstract art and figurative art – the two mainstreams of twentieth-century art – have their eyes fixed Janus-like in different directions. They take different routes to expand the spirit of modern man, but both reveal realities which cannot be reached through logic or language. Herein lies their function and their use in modern society.

Figure 8. Emil Nolde: *Marsh Landscape*, 1916. (Kunstmuseum, Basle)

As we have seen, artists of this century have assimilated many stylistic devices from earlier and also from non-European cultures. African tribal art has been particularly favoured. Nolde spoke for many a painter and sculptor when he said that 'We are now seeking guidance from the vigorous primitives' (Nolde, 1970, 35). Apollinaire, closely connected with painters, wrote that 'Certain masterpieces of Negro sculpture can compete perfectly well with beautiful works of European sculpture of the greatest periods' (Apollinaire, 1972, 471).

What is there in African art which appeals so strongly to Europeans (Fagg, 1970)? Certainly, African art can best be understood in the context of its own culture, but its styles can also be profitably appreciated in terms of aesthetics. Admittedly, such an approach values form and quality above function, but I see little harm in this as long as its restrictiveness is appreciated. For it was precisely the forms of African art, their originality and their astonishing variety which captivated and inspired Europeans of the first decade of this century. Thereafter, going to an ethnographic museum or collecting African works became as natural as going to Rome to 'study' antique art had been for the generation of Winckelmann. Indeed, we should not forget that the guidance Europeans sought from African art was of a practical rather than of a theoretical nature.

It is often difficult to know which of the African tribes exercised most influence in the West, a subject discussed in more detail by John Donne elsewhere in this volume. Jean Laude makes a striking

Figure 9. Marc Chagall: *The Fiddler*. (© *A.D.A.G.P. Paris, 1977*)

comparison between a sculpture of 1910 by Matisse and a head by a
carver of the Cameroons (Laude, 1972). Similarly striking is the
comparison between Picasso's study for the *Demoiselles d'Avignon* and a
Babangi mask – although as Donne points out, similarity may be
wholly coincidental. And in a Schmidt-Rottluff picture, some of the
heads are stylistic echoes of Fang masks. Such comparisons, though
they need further research, are not too difficult to find. But I believe
that more important than the influences of single works or single
tribes is the lasting impact of African art on the *mind* of European
artists, for it is in this wider respect that the African example became
meaningful. From Africa, European artists learned a new way of using

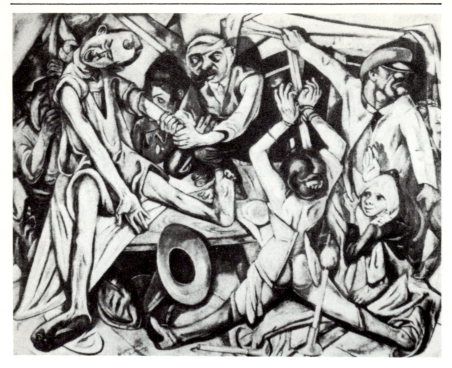

Figure 10. Max Beckman: *Night*. (© *S.P.A.D.E.M. Paris, 1977*)

formal and expressive ideas, of rethinking the very principles of simplification, or animating the surfaces of sculpture or painting, of using volume free from the precision of classical proportions – and of evoking space without the single viewpoint of classical perspective. But above all they learned the need to imbue a work of art with vitality without bothering about the effect of finish; whether the surface was to stay rugged or smooth, their main object was to render life and animation. All this, and much more, is the debt of Europe to the African imagination.

REFERENCES

Apollinaire, G. (1972), *Apollinaire on Art: Essays and reviews 1902-1918*, London.
Buchman, D. (1922), *Two Russian Artists: Interviews with Malevich and Tatlin*, Berlin.
Chips, H.B. (1970), *Theories of Modern Art*, Los Angeles and London.
Fagg, W. (1970), *Miniature Wood Carvings of Africa: the Josef Herman Collection*, Bath.
Hess, W. (1956), *Dokumente zum Verständnis der modernen Malerei*, Reinbeck and Hamburg.
Kandinsky, V. (1964), *Reminiscences* (R.L. Herbert (ed.), London and Glasgow.
Laude, J. (1972), *French painting and 'art nègre'*, Munich.
Nolde, E. (1970), 'Primitive art', in *Voices of German Expressionism*, New York.
Otten, Charlotte (ed.) (1971), *Anthropology and Art: Readings in Cross-Cultural Aesthetics*, New York.
Scully, J. (1966), *Modern poets on Modern Poetry*, London and Glasgow.

II

METHODS OF STUDY AND STYLE ANALYSIS

Michael Roaf

A mathematical analysis of the styles
of the Persepolis reliefs

Introduction

The site of Persepolis in southern Iran was founded by Darius I (521-486 BC). Huddling at the foot of the Mountain of Mercy on the edge of the Marv Dasht Plain still stand the columns and stone doorways of the palaces of the Persian kings. The exquisitely carved reliefs on the doorjambs and on the stone platforms and stairways of the palaces have been admired by many visitors and scholars. Despite the intrinsic interest of the reliefs individual figures are repeated endlessly on the same building at Persepolis and the same scenes are represented time after time on the different buildings. In the words of Lord Curzon 'it is all the same, and the same again, and yet again' (Curzon, 1892, 2, 194). Deplorable as this monotonous repetitiveness may be from an aesthetic point of view, it does enable one to compare each figure in a particular pose with every other figure in that pose and by means of the similarity of the style of the various figures it should be possible to pick out the work of individual sculptors. The study of style, however, is perhaps the most subjective of all disciplines and for this reason I start with a mathematical method for comparing the different sculpted figures. This type of method has been used in a more elaborate form for studying many archaeological and taxonomic problems (Sokal and Sneath, 1963, pp. 68-70; Hodson, 1970; Doran and Hodson, 1975) but, as far as I know, this is the first time it has been applied to an art historical problem. The underlying principle is well known to art historians. It was first expounded by Giovanni Morelli in the later nineteenth century for the study of Italian painting (Venturi, 1964, 234; Wollheim, 1973). He realised that the idiosyncracies of an artist's style would be revealed in the particular way in which he portrayed relatively unimportant details, such as the shape of an ear or the form of a shoe strap. These minor features often betray the authorship of a work of art when the choice of subject and the overall composition were determined by the patron or designer rather than by the artist himself.

The method

To explain the mathematical analysis properly, let us consider an actual application to the twenty-four Persian archers carved along the west side of the southernmost staircase on the east side of the Apadana. Because they are in exactly the same pose, each of the archers lining the staircase can be compared in detail with all of the others; for although all the archers are very similar, they differ in minor details. While at Persepolis I listed a number of features which varied from archer to archer; these were selected for ease of observation and for lack of ambiguity. This meant that measurements were not taken and that features which could not be definitely categorised were not recorded. Thus the shape of the spear-blade which varied between diamond and leaf-shaped was not listed because there were examples which could not be put definitely in either class. The attributes used in the analysis are those shown in Fig. 1 around a drawing of archer 9.

Archer 9 has attribute A (the cross-section of the ribs of the head-dress) as type 3, attribute B as type 1, attribute C as type 1, and so on. Type O means that the feature is destroyed, type 1 is generally the simplest form of the attribute and the type numbers increase with complexity. Archer 9 can be described by the following 21- dimensional vector: 3,1,1,3,2,2,1,2,2,1,1,1,2,1,1,3,2,2,4,3,2,2, and archer 10 by 3,1,1,3,2,2,1,2,2,2,1,2,2,2,3,2,2,2,2,2,2. These two vectors are the same in sixteen places and differ in only five. The number of attributes which are shared by two figures is taken as the similarity index between the two; the similarity index between archers 9 and 10 is therefore 16. The higher the similarity index the more similar are the sculpted figures, the lower the less similar. When archers 8 and 9 are compared, i.e.,

archer 8: 2,3,1,3,3,2,2,1,2,2,1,2,2,2,3,3,4,3,2,1,2,
archer 9: 3,1,1,3,2,2,1,2,2,1,1,2,1,1,3,2,2,4,3,2,2,

only seven of the twenty-one attributes are the same, so the similarity index is quite low, only 7.

Representations of the results

After all these calculations have been performed by a computer we get the similarity matrix shown in Fig. 3. These results can be displayed in a variety of ways. One of the simplest but one of the most difficult to interpret is to shade the matrix according to the values of the similarity indices (Fig. 4). There are high values centred on the main diagonal which appear to form three groups, archers 1 to 8, 9 to 19 and 20 to 24.

The division of the archers into three groups is seen even more vividly in Fig. 5, the similarity diagram. This representation combines

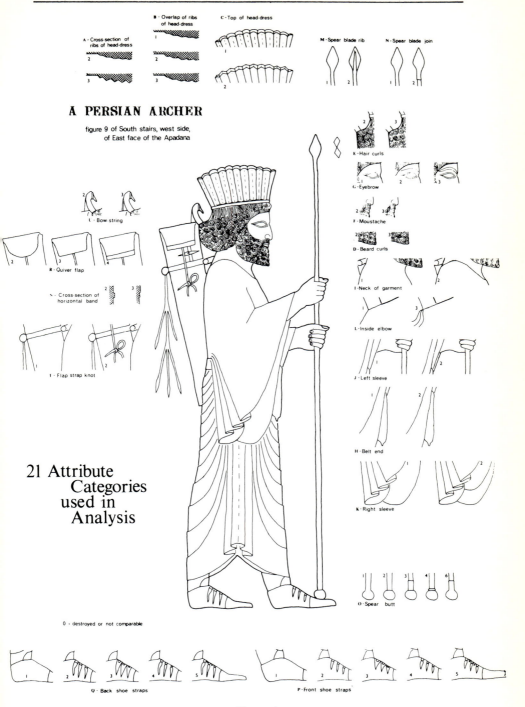

A PERSIAN ARCHER

figure 9 of South stairs, west side,
of East face of the Apadana

21 Attribute
 Categories
 used in
 Analysis

Figure 1.

```
              A B C D E F G H I J K L M N O P Q R S T U

Archer   1    0,0,0,2,3,2,0,1,2,1,1,3,0,0,2,3,4,2,2,2,0,
         2    2,2,1,2,2,2,1,1,2,1,1,3,1,1,2,0,4,2,2,1,2,
         3    2,2,1,2,2,2,1,1,2,1,2,3,2,2,2,3,0,3,2,1,3,
         4    2,2,1,2,3,1,1,1,2,1,2,3,2,2,2,3,4,2,2,1,3,
         5    2,3,1,3,2,2,1,1,2,1,2,0,2,2,4,3,4,3,2,1,3,
         6    2,3,1,2,2,2,1,1,2,1,2,3,2,2,4,3,4,3,2,1,3,
         7    2,3,1,3,3,2,1,1,2,2,2,3,2,2,3,3,4,3,2,1,3,
         8    2,3,1,3,3,2,2,1,2,2,1,2,2,2,3,3,4,3,2,1,3,
         9    3,1,1,3,2,2,1,2,2,1,1,2,1,1,3,2,2,4,3,2,2,
        10    3,1,1,3,2,2,1,2,2,2,1,2,2,2,3,2,2,2,2,2,2,
        11    3,1,1,3,2,2,1,2,2,1,2,2,2,2,0,2,2,4,3,2,2,
        12    3,1,2,2,2,2,1,2,2,1,2,2,1,1,1,5,2,2,3,1,3,
        13    3,1,1,3,2,2,1,2,2,2,2,2,1,1,0,0,3,2,2,2,3,
        14    3,1,1,3,2,2,1,2,2,2,2,2,2,2,5,3,2,2,2,3,
        15    3,1,1,3,2,2,1,2,2,1,2,2,2,3,2,2,4,3,2,2,
        16    3,1,1,3,2,2,1,2,1,1,2,2,1,1,3,2,4,4,3,2,2,
        17    3,1,2,3,2,3,1,2,2,2,2,2,1,2,2,3,4,2,2,2,2,
        18    3,1,1,3,2,2,1,2,2,1,2,2,2,2,6,1,1,2,2,2,2,
        19    2,1,1,3,2,2,1,2,2,1,2,2,2,2,3,1,4,2,2,2,2,
        20    2,1,2,2,2,2,3,1,2,1,2,2,2,2,1,3,4,2,2,1,3,
        21    2,1,2,2,2,2,3,1,2,1,2,2,2,2,0,3,4,2,2,2,3,
        22    2,1,2,2,2,2,3,1,1,1,2,2,2,1,0,3,4,2,2,2,3,
        23    2,1,2,2,2,2,3,1,2,1,2,2,2,1,1,3,4,2,2,2,3,
        24    2,1,1,2,2,2,3,1,2,1,2,2,2,1,2,3,4,2,2,2,3,

              A B C D E F G H I J K L M N O P Q R S T U

                          Ap E S st W side
```

Figure 2. Attribute list.

the advantages of single link and multiple link ordering and still retains the important original places of the archers. Vertical lines from two figures meet on the horizontal line representing the appropriate value of the similarity index for that pair of figures. At the similarity levels of 16 and 15 (16 and 15 out of the 21 attributes the same for any two figures which are linked), the three groups stand out distinctly: archers 20 to 24 form a very tight group and indeed could hardly be more similar to each other; the other two groups are also well-defined groups though more diffuse than the first group. Archers 1, 2 and 12 do not appear on the diagram but their highest similarity indices are

	1	2	3	4	5	6	7	8	9	10	11	12	13	14	15	16	17	18	19	20	21	22	23	24
1+	14	11	9	11	7	9	8	8	5	6	4	5	5	6	4	4	7	6	7	9	10	9	10	11
2+	11	20	14	14	11	13	10	9	10	9	7	10	9	8	7	9	9	9	11	11	10	10	11	13
3+	9	14	20	17	16	18	15	12	6	8	9	9	8	11	9	6	8	10	11	14	13	11	12	14
4+	11	14	17	21	14	16	15	12	4	7	7	8	7	10	7	5	9	9	11	14	13	11	12	14
5+	7	11	16	14	20	19	17	15	7	9	10	8	9	11	10	8	9	11	13	14	13	11	12	13
6+	9	13	18	16	19	21	17	14	6	8	9	9	8	10	9	7	8	10	12	15	14	12	13	14
7+	8	10	15	15	17	17	21	18	6	10	8	6	9	11	9	7	9	9	12	12	11	9	10	11
8+	8	9	12	12	15	14	18	21	7	11	7	5	8	10	8	6	8	8	11	12	11	9	10	11
9+	5	10	6	4	7	6	6	7	21	16	17	13	13	11	18	18	11	13	13	6	7	7	8	9
10+	6	9	8	7	9	8	10	11	16	21	16	10	14	16	17	13	14	16	16	9	10	8	9	10
11+	4	7	9	7	10	9	8	7	17	16	20	12	12	14	20	16	12	16	15	9	10	8	9	10
12+	5	10	9	8	8	9	6	5	13	10	12	21	13	12	12	12	11	11	10	13	11	11	13	11
13+	5	9	8	7	9	8	9	8	13	14	12	13	19	17	12	13	14	14	13	9	10	10	11	12
14+	6	8	11	10	11	10	11	10	11	16	14	12	17	21	14	11	15	16	15	11	12	10	11	13
15+	4	7	9	7	10	9	9	8	18	17	20	12	12	14	21	17	12	16	16	9	10	8	9	10
16+	4	9	6	5	8	7	7	6	18	13	16	12	13	11	17	21	12	13	14	7	8	10	9	10
17+	7	9	8	9	9	8	9	8	11	14	12	11	14	15	12	12	21	14	14	11	12	10	11	11
18+	6	9	10	9	11	10	9	8	13	16	16	11	14	16	16	13	14	21	18	11	12	10	11	12
19+	7	11	11	11	13	12	12	11	13	16	15	10	13	15	16	14	14	18	21	13	14	12	13	14
20+	9	11	14	14	14	15	12	12	6	9	9	13	9	11	9	7	11	11	13	21	19	17	19	17
21+	10	10	13	13	13	14	11	11	7	10	10	11	10	12	10	8	12	12	14	19	20	18	19	18
22+	9	10	11	11	11	12	9	9	7	8	8	11	10	10	8	10	10	10	12	17	18	20	19	18
23+	10	11	12	12	12	13	10	10	8	9	9	13	11	11	9	9	11	11	13	19	19	19	21	19
24+	11	13	14	14	13	14	11	11	9	10	10	11	12	13	10	10	11	12	14	17	18	18	19	21

Ap E S st W side

Figure 3. Similarity matrix.

with archers within the groups in which they fall.

The same groups are picked out by the computer even if we ignore the original order of the archers along the staircase and arrange the archers so that they are placed next to and linked to those figures they are most similar to; this is the single link dendrogram (Fig. 6). Archer 1 is so far out of position because the top of his head is destroyed and so the maximum possible similarity index for this figure is only 14 (see Fig. 2).

One of the disadvantages of single link cluster analysis is that it only uses a very small amount of the information contained in the similarity matrix. Other diagrams attempt to display the information in the similarity matrix in different ways. In double link cluster analysis (Fig. 7) an archer has to be similar to two other archers before forming a group, so junctions are not made as soon as in single

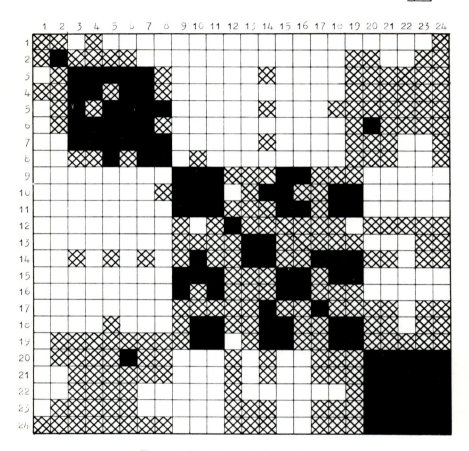

Figure 4. Shaded similarity matrix.

link clustering. Sometimes this is an improvement and sometimes not so; in this case there seems to be a marginal improvement as archer 12 now belongs with its neighbours in the 9 to 19 group and archer 2 has moved so that it does not belong to that group though it is not clear to which of the other two groups it should belong.

There are a great variety of other possible ways of representing the results as a dendrogram and I include three further examples. In the complete link dendrogram (Fig. 8), junctions are formed only when all the similarities between all the members of the groups are greater than the junction point: that is, two groups join at the level of the lowest similarity index between the two groups. Here, of course, the groups coalesce at the last possible moment and the same three

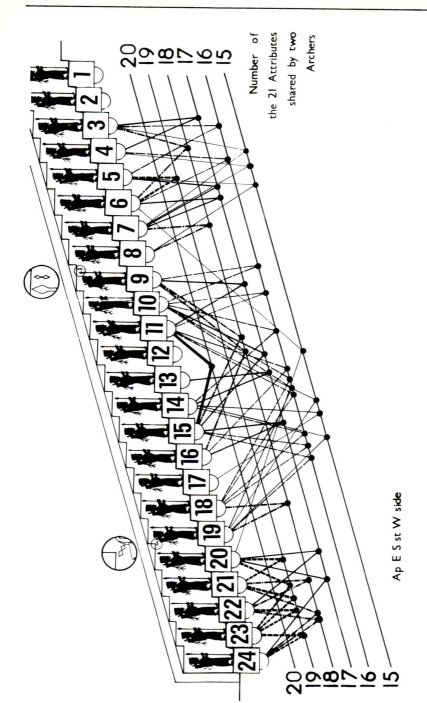

Number of
the 21 Attributes
shared by two
Archers

Ap E S st W side

Figure 5. Diagram of the similarities between the archers.

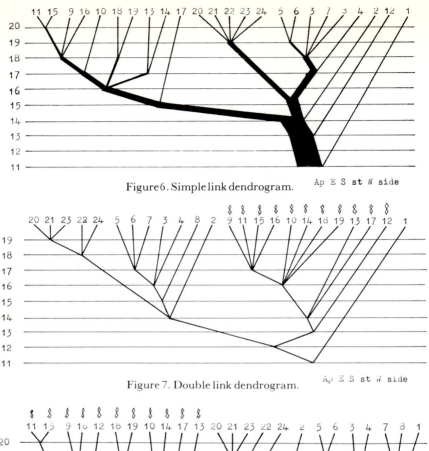

Figure 6. Simple link dendrogram. Ap E S st W side

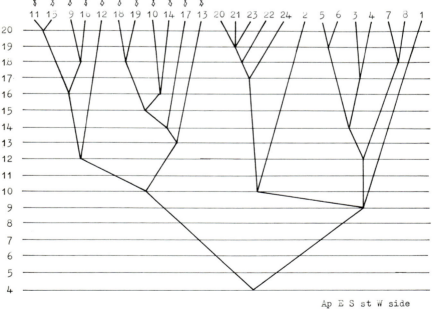

Figure 7. Double link dendrogram. Ap E S st W side

Figure 8. Complete link dendrogram. (Multiple links allowed only when all links are complete; otherwise on highest average value.)

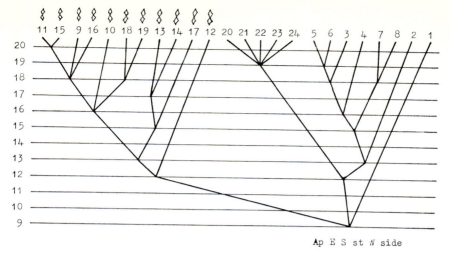

Figure 9. Proportioned link dendrogram (groups join when half of the links between them have been formed).

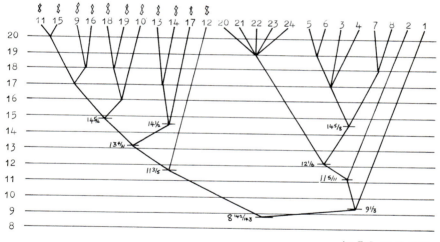

Figure 10. Average group link dendrogram (groups join at the average value of the links between them).

groups are picked out with archer 12 in the 9 to 19 group; but archer 2 has been transferred to the 20 to 24 group because archer 2 is less similar to archer 8 than it is to archers 20 to 24.

The proportional link dendrogram (Fig. 9) is an attempt to combine the advantages and to minimise the disadvantages of the other methods. Here groups join at the level where half (or some other proportion if so desired) of the similarity indices are greater than that level. This dendrogram in this particular example gives the best grouping of all with only archer 1 not definitely associated with one of the three groups 2 to 8, 9 to 19 and 20 to 24.

Average link cluster analysis (Fig. 10) is a method which often seems to reflect the structure of the data clearly and has been very popular with practising taxonomists. Here groups join at the average value of all similarity indices between them. In this way this method is similar to the proportional link cluster analysis but takes the mean instead of the median as the crucial level. Again as might be expected the same three groups are picked out 1 (or 3) to 8, 9 to 19 and 20 to 24.

Other approaches

Within each of these three groups attributes vary less than they do between different groups. If this tendency was due to the idiosyncracies of the individual artists in the manner suggested by Morelli, we may conclude that different sculptors have been at work on each of the three groups. Confirmation for such a hypothesis seems to be found in the presence of sculptors' marks on the reliefs; in front of the spear blade of archer 9 is a double diamond mark and above the quiver of archer 19 the same mark is repeated (Fig. 1 and 5). So the middle group is limited by these double diamond marks.

A close examination of the figures, however, shows that the minor variations are not due to individual artisans working in each group but rather due to different workshops – small groups of artisans working under master craftsmen. According to the mathematical analysis archers 20 to 24 were very similar and indeed all these archers have an incised eyebrow, while none of the archers in the other groups have such an eyebrow. The large regular round curls of the hair and beard, the shape of the quiver, the form of the nose and the expression of the face are all characteristic of this group. In fact these archers are so similar that it seems likely that the faces were carved by a single sculptor.

The case of the middle group is more complicated; the quivers of archers 9, 11, 15 and 16 have a distinctive square double flap (attribute R4 in Fig. 1) but the other archers of the group have a simple rounded flap. Most of these archers have beards and hair with rather elongated, scratchy, hanging curls but a few, archers 12, 13, 17 and 18, have curls carved in different styles, some more regular and some cruder than the typical curls of the group. Similarly in the first group archer 2 has very awkward, ineptly carved curls and perhaps was the work of an inexperienced assistant. These differences in the style of carving of the quivers and of the curls of the hair and beard must be due to different craftsmen carving the different faces. This too is corroborated by a study of the various unfinished figures elsewhere at Persepolis. 'At times one sees the face already finished, modelled with a narrow chisel, while the rest of the body has remained in a preliminary phase. Other times, though, one sees the figure finished and refined except for the head' (Tilia, 1968, 82 and Figs. 75-7). The

sculptors at Persepolis were artisans not artists; the more skilful sculptor would have left the rough work and the final smoothing to his assistants. This practice of master craftsmen working with assistants was normal in the ancient and mediaeval world.

Conclusions

Thus three distinct approaches have been used to analyse the styles of these reliefs – first a mathematical analysis which distinguished three different groups of figures on the south stairs of the Apadana – second, this was confirmed by the presence of sculptors' marks – and thirdly, a close visual study has determined that these groups of figures were the work of different teams of sculptors.

The twenty-four archers we have been considering are only a small fraction of the sculpted reliefs at Persepolis. On the east side of the Apadana there are over 200 other archers and in all, over 800 carved figures, and originally the same number on the less well preserved north side of the Apadana. This mathematical analysis has been carried out on a number of them producing similar results to those discussed above. In fact it turns out that about a fifth of all these sculpted figures were carved by the 'double diamond' team.

As we have seen, the interpretation of the mathematical results depends on the traditional visual analysis of the reliefs. One may well ask why one should bother with these mathematical methods, when visual stylistic analysis has to be carried out to interpret the results, and indeed can produce even more penetrating and more convincing results than the computer. There are of course reasons why one should use mathematical methods, just as one would use scientific methods of chemical analysis in studying painting or sculpture. First, they do bring a check to otherwise completely subjective studies – when a good art historian carries out a stylistic analysis, he does it very well, but a bad art historian does it extremely badly. In such cases it is useful to have a method which may provide independent confirmation of the theories suggested. Furthermore a mathematical analysis may suggest new lines of research to be pursued, as well as giving a different sort of answer to old questions. In the example discussed here the computer has demonstrated the existence of three groups – a conclusion which had not been reached before and which is not entirely obvious from a normal stylistic analysis – and this leads to a discussion of the meaning of this grouping and of the sculptors' marks. Finally it is nice to have an example of cluster analysis which works, is useful, is not too complex and – I hope – is readily comprehensible.

Acknowledgments

I would like to thank the Iranian Archaeological Service for assistance at Persepolis and the Oxford University Computing Service for computing facilities. This research was undertaken while the author was a Randall MacIver Student at The Queen's College, Oxford and a Wainwright Fellow in Near Eastern Archaeology at the University of Oxford.

REFERENCES

Curzon, G.N. (1892), *Persia and the Persian Question*, London.
Doran, J.E. and Hodson, F.R. (1975), *Mathematics and Computers in Archaeology*, Edinburgh.
Hodson, F.R. (1970), 'Cluster analysis and archaeology: some new developments and applications', *World Archaeology*, 1, 299-320.
Roaf, M.D. (in preparation), 'Sculptures and sculptors at Persepolis', doctoral thesis to be presented at the University of Oxford.
Schmidt, E.F. (1953-1970), *Persepolis*, 1-3, *Oriental Institute Publications*, Chicago.
Sokal, R.R. and Sneath, P.H.A. (1963), *Principles of Numerical Taxonomy*, London and San Francisco.
Tilia, A.B. (1968), 'A study of the methods of working and restoring stone and on the parts left unfinished in Achaemenian architecture and scultpure', *East and West*, n.s. 18, 67-95.
Venturi, L. (1964), *History of Art Criticism*, New York.
Wilbur, D.N. (1969), *Persepolis: The Archaeology of Parsa, seat of the Persian Kings*, London.
Wollheim, R. (1973), 'Giovanni Morelli and the origins of scientific connoisseurship', *On Art and the Mind*, London, 177-201.

Addendum

Since this paper was written, a fragment of stone with the head of Ap E S st W side archer 1 has been identified and replaced in its original position at Persepolis. The attribute list (Fig. 2) can now be corrected so that archer 1 has the attributes:

2,2,1,2,3,2,1,1,2,1,1,3,0,0,2,3,4,2,2,2,0

That is, with attributes A,B,C and G added. Thus the first line of the similarity matrix (Fig. 3) should read:

18,15,13,15,10,12,11,10, 7, 8, 6, 6, 7, 8, 6, 6, 8, 8,10,10,10, 9,10,12;

and Fig. 4 should be changed to agree with these similarity indices.

The other diagrams should be altered as follows:

Fig. 5: Archer 1 is connected to archers 2 and 4 at the 15 level.

Fig. 6: Archers 1 and 2 join 3 to 8 and 20 to 24 at the 15 level.

Fig. 7: Archer 1 joins 2 to 8 and 20 to 24 at the 14 level.

Fig. 8: Archer 1 joins 3 to 8 at the 10 level. (There is an error in the drawing of Figure 8 and on the original data archer 1 should have joined 2 to 8 and 20 to 24 at the 7 level not the 9 level.)

Fig. 9: Archers 1 and 2 join at the 15 level and then join archers 3 to 8 and 20 to 24 at the 12 level.

Fig. 10: Archers 1 and 2 join at the 15 level and join 3 to 8 and 20 to 24 at the 11 3/11 level.

The additional accuracy derived from these alterations confirms the division into three groups, archers 1 to 8, 9 to 19 and 20 to 24.

David Frankel

Pottery decoration as an indicator of social relationships: a prehistoric Cypriot example

There are some basic assumptions which are made in regard to the connection between pottery styles on the one hand and social conditions and relationships on the other. Ethnographical data, as well as archaeological studies with an ethnographical background (e.g. Friedrich, 1970; Deetz, 1965, 1968; Longacre, 1970; Whallon, 1968) do indicate the legitimacy of these assumptions, although they by no means provide a reliable guide to the interpretation of similarities and differences in the context or content of decorative style in prehistoric situations (Johnson, 1972, 369-70; Englebrecht, 1974). Although much may be observed without them, it is becoming increasingly clear that more formal, numerical, definitions of stylistic variability are both feasible and desirable. Many problems remain, however, in the manipulation as well as in the interpretation of numerical data.

Two techniques will be used here, in the context of a particular set of problems and body of data from the prehistoric Middle Bronze Age of Cyprus (for further details of both material and methods, cf. Frankel, 1974a, b). One of the methods is the attempt to measure the relative homogeneity of the artistic output of groups of people. This approach assumes a relationship between the nature of the political or social structures of groups and the ability of their members to accept, use, or develop new stylistic traits. The greater the homogeneity, the more isolated or closed the society; the more varied the styles in use, the more open the people are to change (Whallon, 1968; Englebrecht, 1974; Leone, 1968). There is a less formal, but somewhat related possibility to see in the structure of design some reflection of the basic attitudes of a society which may also show themselves in social, economic, or religious behaviour (e.g. Adams, 1973; Munn, 1973).

The other technique to be discussed here involves the calculation of the similarity between different groups. The assumption here is that people who have closer social relationships will have a greater sharing of artistic, stylistic, traits and that this similarity can be measured so

as to give an indication of the degree of contact between the groups (Rowlett and Pollnac, 1971; Renfrew, 1972, 142-7, LeBlanc and Watson, 1973).

Cyprus in the middle bronze age

This period is generally held to be no more than 200 years in length, early in the second millennium B.C. Although most evidence comes from tombs and there is a good deal of information from archaeological surveys, there is very little from settlement excavations either of a stratigraphic or of a more general nature. The period is defined by the pottery types found associated in the tombs, which were usually re-used for successive burials over many years. Of the various forms of pottery the most characteristic is the series of White Painted Wares and it is this tradition that we will be concerned with here.

In brief, we are dealing with an agriculturally based society. There is good evidence for the use of copper (mined from sources in the foothills of the Troodos Mountains) and there was, especially toward the end of the period, and principally from the east of Cyprus, a growing contact with the mainland Levantine coast.

Several fortified sites are known and this, together with the weapons found in tombs, provides some evidence of unsettled conditions, although most settlements were not fortified and warfare could not

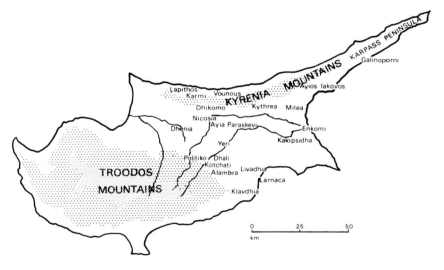

Figure 1. Map of Cyprus showing sites used in the analysis. The island is dominated by two mountain ranges: the northern, Kyrenia, range divides the central plain from the North Coast. Important copper sources are located in the foothills of the Troodos Mountains.

have been too common. Some stylistic variation in pottery decoration has been noted (see Figs. 2, 3, 4) and general comments on the nature of connections between different parts of the island have been made (Åström, 1969, 1972a, b; Catling, 1963, 1966; Stewart, 1948, 1962).

The White Painted Pottery decoration will be used here to attempt a more formal measure of the nature of various social groups and the degree of their interaction.

Differentiation of motifs

The White Painted Pottery is decorated in darker colour on a lighter background with a variety of geometric motifs (see Fig. 2 for some examples). A large number of motifs (81) have been defined and these form the basis for analysis. This preliminary step is not without problems.

Although the motifs on White Painted Pottery can be separated fairly easily, the question of the aims of the study are important in deciding the *level* at which two designs should be considered the same. Here it was taken as sufficient if the general appearance was the same – in shape, orientation and type of filling, e.g. a *horizontal* row of *hatched lozenges* is distinguished from a vertical row, or one filled with cross-hatching. No separation was made, however, between hatching which sloped down to the left or to the right. Minor variations were therefore not considered – an assumed general appearance was aimed at in the differentiation of motifs, while the detail of *execution* was ignored. What was intended, therefore, was to define the common scheme within the repertory of the potters, rather than their individual habits.

Units of analysis

The basic units analysed were tomb, cemetery, or regional groups of pots. Their nature was conditioned by the availability of material and an attempt was made to use only groups of reasonable size. In some cases, however, it was considered necessary to include smaller groups of exceptional importance, due to their location or accepted date.

For the analyses two measures of the distribution of motifs among the groups were used: the simple presence/absence of motifs and the proportional occurrence of motifs. The latter was calculated as the percentage of pots in the group on which a motif appeared at least once. Placement or multiple use of a motif was ignored, as this is greatly affected both by the size and shape of the vessels and creates other problems in comparing different styles.

These two sets of data not only allow different analytical techniques and give different results from similar methods (see Frankel, 1974a, b), but also show slightly different things. The presence/absence data

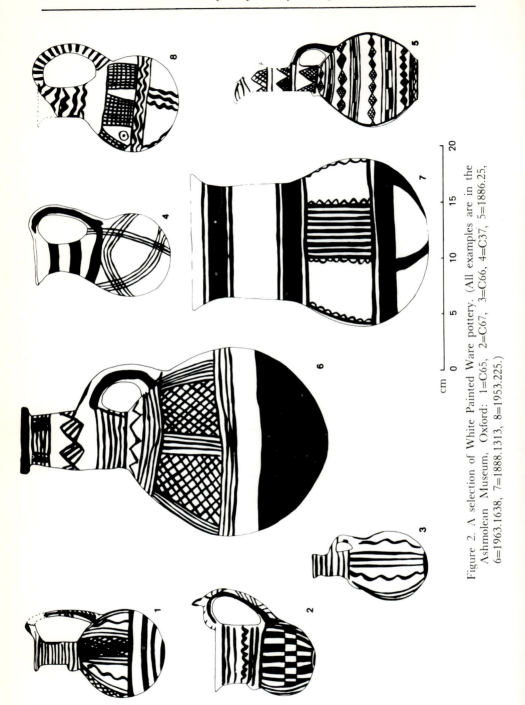

Figure 2. A selection of White Painted Ware pottery. (All examples are in the Ashmolean Museum, Oxford: 1=C65, 2=C67, 3=C66, 4=C37, 5=1886.25, 6=1963.1638, 7=1888.1313, 8=1953.225.)

indicates the range of designs of each group – which we may regard as the overall visual universe available to the painter. The proportional occurrence gives a measure of the relative popularity of the motifs – that is, an indication of the varying acceptibility of the different motifs known to the painter. Although these two sets of information largely overlap, this difference in meaning is an important one.

The pottery, styles and nature

Fig. 2 illustrates a few White Painted Ware pots which demonstrate the essential features of some major styles of decoration from the wide range of variability in decoration. Fig. 3 shows the percentage of pots in eight geographical regions of Cyprus which are decorated with a selection of motifs or sets of motifs. Fig. 4 demonstrates a more complex and sophisticated method (Principal Components Analysis) which also provides a simplification of the data – here again showing up the main variations underlying the proportional occurrence of motifs in the various tomb and cemetery groups. The two axes represent the first two components, with the highest scoring motifs (which can be taken to indicate their meaning) alongside (cf. Frankel, 1974a, Fig. 9; 1974b, Fig. 24). These two figures effectively summarise

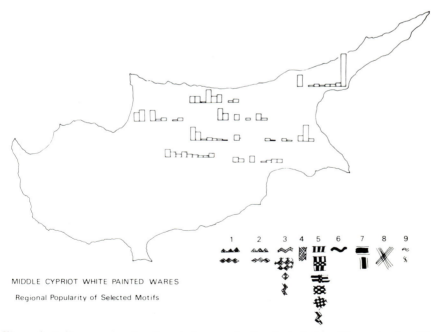

MIDDLE CYPRIOT WHITE PAINTED WARES

Regional Popularity of Selected Motifs

Figure 3. A diagram showing the relative popularity of selected motifs or sets of motifs in major regions of Cyprus. A general picture of the distribution of decorative styles, and the similarities and differences between areas is apparant.

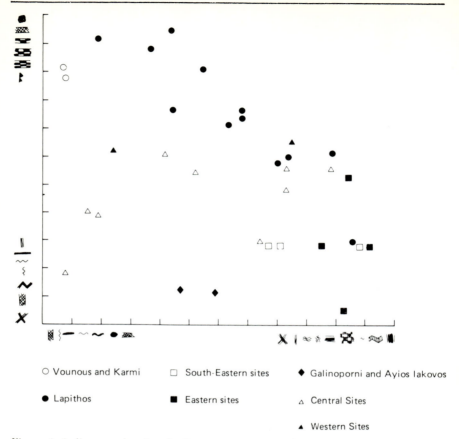

Figure 4. A diagram showing the first two components from a Principal Components Analysis. The results, which broadly correspond to those of the simpler analysis shown in Fig. 3, gives a pattern derived from the relative popularity of motifs in each group of material. The two axes represent the two components, defined by the sets of motifs drawn alongside; the position of sites indicates their relationship to them. A third component, not shown here, separates out sites in the centre of the island, characterised by another set of motifs.

some major stylistic trends, which need not be expanded here, beyond pointing out the great popularity of simpler structures involving fewer motifs in the east of the island and the more complex forms of the central regions (see Åström, 1972a; Frankel, 1974a, b).

The pottery is all hand-made, and was most probably formed and painted by the same person. There is some debate on the context of manufacture which has been suggested to be either a commercial production (Stewart, 1962, 291-2) or, more plausibly, a household tradition, made by women. The general similarity of clay-types in most parts of the island eliminates the possibility of independently establishing the suggested local manufacture of pottery (Frankel, Hedges, Hatcher, 1976).

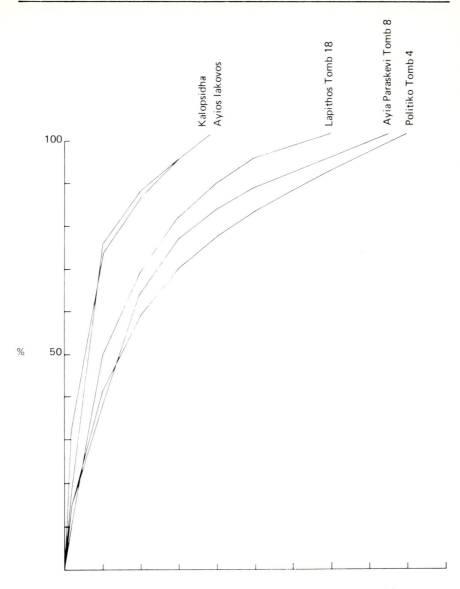

Motifs in order of decreasing frequency (5 motif intervals)

Figure 5. The relative homogeneity of several groups. The more vertical the lines on the graph the more homogeneous the decoration on the pottery; in other words, the fewer the number of motifs used and the simpler the style of decoration. A more precise calculation of a coefficient of homogeneity is possible, and preferable, where more than a few units of analysis are involved. This diagram shows clearly the greater homogeneity and simplicity of sites in the eastern parts of Cyprus, while Politiko, fairly near the copper sources, has a far more complex style of decoration. Other sites fall between the two extremes.

Relative homogeneity

Fig. 5 shows cumulative percentage graphs illustrating the relative homogeneity of a few sites (cf. Whallon, 1968, 224). Although the total number of different motifs used in each group is a general indication of its homogeneity (see their positions along the 100% level), the slope or shape of each line is a more useful guide to the degree of homogeneity. We can see here that the sites of Kalopsidha and Ayios Iakovos (in the east and in the Karpass Peninsula respectively) are far more homogeneous than those in the centre of the island, in particular the site of Politiko.

Other groups, such as those representing Lapithos tombs, are between the two extremes. Such a diagram is not very useful for comparing many groups of data and a calculated coefficient of homogeneity is preferable (Whallon, 1968, 232 n.2). In Table 1 the coefficients for a few groups of pots are listed together with other relevant information – the numerical values confirm the visual pattern of Fig. 5.

TABLE 1

Site	No. of Pots.	No. of Motifs.	Coefficient of Homogeneity (approx.)
Kalopsidha	37	19	0.90
Ayios Iakovos	53	19	0.89
Karmi	9	17	0.81
Lapithos 18	66	35	0.79
Lapithos 313	10	23	0.78
Dhenia 6	34	28	0.77
Dhenia	51	35	0.74
Vounous	23	24	0.74
Lapithos 50	82	37	0.73
Ayia Paraskevi	48	39	0.69
Ayia Paraskevi 8	119	43	0.66
Politiko 4	41	45	0.62
Politiko	58	47	0.56

The predominance of simpler styles in the east, and more complex ones involving more motifs in the centre, is clearly behind this pattern of relative homogeneity. Is it possible to interpret something of the nature of society from this? It may be suggested that the central sites were more open to, or had more opportunity for, influences from other areas of the island, a theory which we will return to in discussing the analysis of similarity. On the other hand, it is pottery of the Eastern styles which is found on the mainland Levantine coast, presumably traded from Cyprus. The simpler styles could, therefore, be seen as a development catering for a foreign market, or, perhaps, a response to

a more organised, commercial production, giving less incentive and less time for intricate decoration. An added factor is the use of multiple brushes, which may be either a cause of, or, more probably, a response to the development of these more linear Eastern styles. In this case, therefore, there appear to be too many alternatives to allow for a confident interpretation based simply on the measures of homogeneity.

Similarity measures

Similarity was calculated both on the presence/absence and on the proportional occurrence of motifs in the groups. These coefficients can be manipulated in a variety of ways to give slightly different results and the acceptance of any one pattern as absolutely correct is not possible. (For a basic introduction to these techniques see Roaf, this volume, and Frankel, 1975.) In Figs. 6 and 7 Close-Proximity Analyses (Renfrew and Sterud, 1969) show only the two highest similarities of each group. Fig. 8 is a cluster analysis (Hodson, 1970) using the proportional occurrence of motifs.

A clear pattern may be seen in Fig. 6, which is based on a

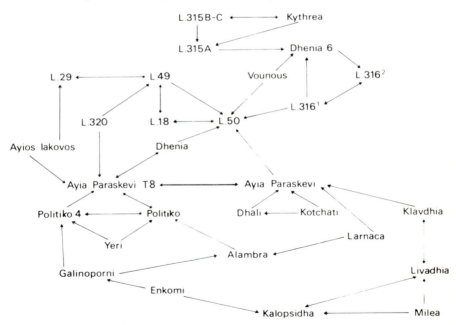

Figure 6. Close-Proximity Analysis, using a similarity coefficient based on the presence/absence of motifs. The two highest similarities of each unit are plotted as diverging arrows. A pattern of the sharing of an available universe of motifs is seen, indicating generally stronger contacts with nearer neighbours.

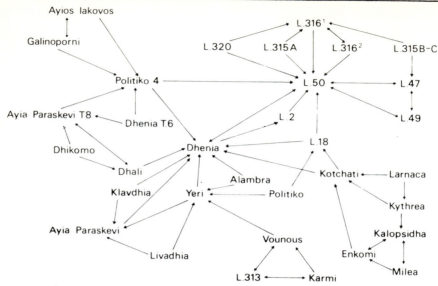

Figure 7. Close-Proximity Analysis using a similarity coefficient based on the proportional occurrence of motifs. The two highest similarities of each group are plotted as diverging arrows. The resulting pattern is similar to that of Fig. 6, but reflects not just the available repertory of motifs, but also their relative popularity or acceptability in each place, giving an indication of the degree of contact between different communities, which can be correlated with the exploitation of the copper sources in the foothills of the Troodos Mountains.

presence/absence measure of similarity. The highest similarities of each group are with geographical neighbours. The particular measure of similarity used creates problems with small groups or those with few motifs and so is not really suitable for other manipulations, but in this simple analysis it indicates that there is a general sharing of motifs between neighbouring sites.

Fig. 7, where the proportional occurrence of motifs is used, again has a basic geographical pattern, but there are some important differences and here the relative popularity of motifs, as opposed to their availability comes into effect. While the presence/absence study shows the neighbourhood repertory, the proportional occurrence study shows a sharing of an aesthetic value judgment about the acceptibility of the motifs. The pattern is also seen in the cluster analysis, included here to demonstrate the use of this alternative, more complex and somewhat troublesome technique.

The further interpretation of these patterns of similarity is of great interest. While some linkages (e.g. Vounous, Karmi, Lapithos 313) indicate a chronological difference in the north coast material, it is otherwise obvious that near neighbours share a common decorative language (this is clearly seen in Fig. 9). There are also other, longer distance contacts between groups. Of particular interest here is the linking of Lapithos, Dhenia and Kotchati. Kotchati is near the copper

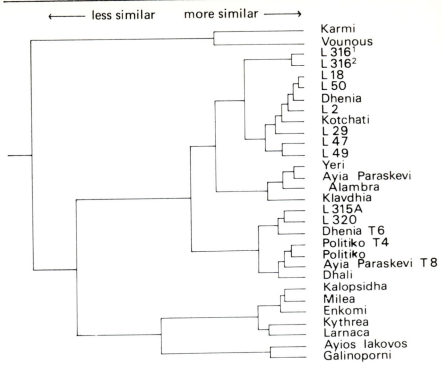

Figure 8. Hierarchical Cluster Analysis based on the proportional occurrence of motifs. The linkages of sites and groups of sites is an indication of their relative similarity in terms of their shared attitude toward different motifs, which can be interpreted as a measure of the degree of interaction between the different communities.

sources, and Dhenia is on the route toward one of the only two reasonably good passes through the Kyrenia mountains which lie between Lapithos and the centre of the island. It is probable that this similarity in decorative appreciation is related to a contact based on the exploitation of copper.

In the homogeneity analysis one suggestion made was that the greater complexity of style in the centre of the island was related to greater interaction with other parts of the island. It may be possible to incorporate this idea with the interpretations of the similarity analysis and to see the settlements closer to the copper sources as being more open to contact and ideas than those further away.

Some mechanics for the exchange of cultural material may be suggested. Of the various possibilities a likely model is that of the exchange of women between villages, normally with neighbours, but also across the island, to set up kinship links to facilitate the copper trade. Women would bring to their marital homes ideas of pottery decoration common in their childhood villages, which would then

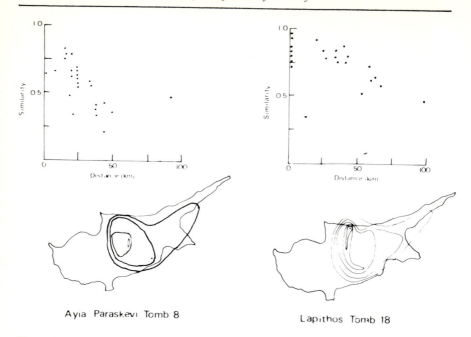

Ayia Paraskevi Tomb 8 Lapithos Tomb 18

Figure 9. The simple relationship between similarity and distance, plotted for two
 groups of material (a) Ayia Paraskevi Tomb 8 (b) Lapithos Tomb 18. This is an
 individual treatment of information involved in the far more complex analyses
 shown in Figs. 6, 7 and 8. The major factor of distance in determining the degree
 of contact between communities operates in conjunction with other relationships
 based on the exploitation of copper.

either be accepted or rejected by their new neighbours. This need not
be for purely aesthetic reasons, however, as the acceptability of the
innovator as a person would strongly influence the acceptability of her
innovations – in other words a socially more popular person could
more easily introduce new concepts in design than one who for some
reason was disliked by her new (or old) relatives and neighbours.
More frequent contacts with others could render a group more
amenable to change and the greater the number of foreign brides, the
greater the possibility of the acceptance of an outside style, while the
more isolated the groups, the greater their rigidity and resistance to
imported ideas.

 Despite the fact that all the pottery considered in these analyses
comes from tombs, there is too little skeletal material at present
available to test this hypothesis of the movement of women by
demonstrating the relative homogeneity of male and female
populations at different sites (Spence, 1974). Nevertheless, with a
continuation of large-scale analytical studies of comparative material
and with a greater study of the individual potters' range of production
and development, this and other models of social relationships can be
built and tested.

REFERENCES

Adams, M.J. (1973), 'Structural aspects of a village art', *American Anthropologist*, 75, 1, 265-79.

Åström, P. (1969), 'The economy of Cyprus and its development in the second millennium', *Archaeologia Viva*, ii, 3, 73-80.

Åström, P. (1972a), *The Middle Cypriot Bronze Age: The Swedish Cyprus Expedition* iv, 1b, Lund.

Åström, P. (1972b), *The Late Bronze Age: relative and absolute chronology, foreign relations, historical conclusions: The Swedish Cyprus Expedition* iv, id, Lund.

Catling, H.W. (1963), 'Patterns of settlement in Bronze Age Cyprus', *Opuscula Atheniensia*, iv, 129-69.

Catling, H.W. (1966), 'Cyprus in the Neolithic and Bronze Age Periods', *The Cambridge Ancient History*, (rev. ed.), Fascicule 43.

Deetz, J. (1965), 'The dynamics of stylistic change in Arikara ceramics', *Illinois Studies in Anthropology*, 4.

Deetz, J. (1968), 'The inference of residence and descent rules from archaeological data', *in* (eds.) L.R. and S.R. Binford, *New Perspectives in Archeology*, Chicago, 41-8.

Englebrecht, W. (1974), 'The Iroquois: archaeological patterning on the tribal level', *World Archaeology*, 6, 1, 52-65.

Frankel, D. (1974a), *Middle Cypriot White Painted Pottery: an analytical study of the decoration. Studies in Mediterranean Archaeology*, xlii, Göteborg.

Frankel, D. (1974b), 'Inter-site relationships in the Middle Bronze Age of Cyprus', *World Archaeology*, 6, 2, 190-208.

Frankel, D. (1975), 'The pot-marks of Vounous – simple clustering techniques, their problems and potential', *Opuscula Atheniensia* xi, 37-51.

Frankel, D., Hedges, R. and Hatcher, H. (1976), 'Chemical analysis of Middle Cypriot White Painted Ware sherds in the Ashmolean Museum, Oxford', *Report of the Department of Antiquities, Cyprus, 1976*, 35-42.

Friedrich, M.H. (1970), 'Design structure and social interaction: archaeological implications of an ethnographic analysis', *American Antiquity*, 35; 3, 332-43.

Hodson, F.R. (1970), 'Cluster analysis and archaeology: some new developments and applications', *World Archaeology*, 1; 3, 299-320.

Johnson, L. (1972), 'Problems in "avant-garde" archaeology', *American Anthropologist*, 74, 366-77.

LeBlanc, S.A. and Watson, P.J. (1973), 'A comparative statistical analysis of painted pottery from seven Halafian sites', *Paleorient*, 1, 117-33.

Leone, M.P. (1968), 'Neolithic economic autonomy and social distance', *Science*, 162, 1150-51.

Longacre, W.A. (1970), *Archeology as Anthropology. Anthropological Papers of the University of Arizona*, 17.

Munn, N.D. (1973), 'The spatial presentation of cosmic order in Walbiri iconography', *in* (ed.) A. Forge, *Primitive Art and Society*, London, 193-220.

Renfrew, C. (1972), *The Emergence of Civilization: The Cyclades and the Aegean in the Third Millennium B.C.*, London.

Renfrew, C. and Sterud, G. (1969), 'Close-Proximity Analysis: a rapid method for the ordering of archaeological materials', *American Antiquity*, 34, 3, 265-77.

Rowlett, R.M. and Pollnac, R.B. (1971), 'Multivariate analysis of Marnian La Tène cultural groups', in F.R. Hodson, D.C. Kendall, P. Tautu (eds.), *Mathematics in the Archaeological and Historical Sciences*, Edinburgh, 46-58.

Spence, M.W. (1974), 'The study of residential practices among prehistoric hunters and gatherers', *World Archaeology*, 5, 3, 346-56.

Stewart, J.R. (1948), 'Cyprus', in A.D. Trendall (ed.), *Handbook to the Nicholson Museum* (2nd ed.), Sydney, 115-99.

Stewart, J.R. (1962), *The Early Bronze Age in Cyprus: The Swedish Cyprus Expedition*, iv, 1a, Lund, 205-41.

Whallon, R. (1968), 'Investigations of late prehistoric social organisation in New York State', in L.R. and S.R. Binford (eds.), *New Perspectives in Archeology*, Chicago, 223-44.

Sheila M. Korn

The formal analysis of visual systems as exemplified by a study of Abelam (Papua New Guinea) paintings

This analysis of Abelam painting is the result of a research project, initiated by Anthony Forge at the London School of Economics and Political Science, in which an attempt was to be made to discover the 'formal rules' of Abelam style, without having recourse to meaning.

The Abelam material consists of about 500 triangular and rectangular panels, averaging c.75-100 cm. in size, from the Abelam and bordering territories in the Middle Sepik area of New Guinea, studied by myself in the form of coloured photographs. These decorate the façade and interior chambers of the *tambaran* house, the large pointed men's house which stands in the central piazza of Abelam hamlets and which is the focus of the *tambaran* cult and its associated initiation-cycle (Forge, 1966; 1967; 1970). Painting is done by teams of men initiated beyond the stage of the cycle being performed at any time. The designs are thought to be sacred in that, if drawn correctly, they will come to be inhabited by the various spirits that they represent, and will be an effective force in ritual because of this. Thus designs are seldom changed. Some of the designs recall human shape – bodies, heads, limbs, while others resemble geometrical patterns – triangles, diamonds, circles. But throughout both categories the same relatively small vocabulary of shapes is used. In this paper, I propose a method of analysing primitive art with a view to providing the formal groundwork on which problems of meaning can later be investigated.

Many works of primitive art (present-day tribal art) make an impact on the non-native observer which leaves him with the impression that something precise and deliberate is intended although he lacks the background information to understand what it is. In general, primitive art is valued for its dramatic decorative properties, but there exist virtually no interpretations of individual works of art which we can rely upon as we would upon interpretations of the art of

Holbein or the French Impressionists provided by art historians. We simply do not know what is being transmitted by these masks, figures and ceremonial boards; we do not know how we should 'read' their shapes; whether a circle is a solid thing, a hole or a cross-section; whether it is seen from the side or from above; whether it represents three dimensions or two. We have no idea of the artistic conventions of even a single 'genre' of primitive art. We assume that most primitive art is 'flat', i.e. that is shows no understanding of geometrical perspective, but are unaware of the many other devices which it may be using, and using together in the same painting with no fear of contradiction.

Earlier anthropologists seem to have made more effort than we do nowadays to extract meanings from informants. Mountford (1956; 1958) inquired about the meanings of hundreds of separate elements in the bark-paintings of Arnhem Land and set these out laboriously in his volumes on Aboriginal art and society. Still, much thought and further questioning of informants would be required to make sense of most of these paintings. Recently, anthropologists have been able to find out the general subject of painted panels, e.g., 'It represents the ancestors', but have not investigated what individual things are referred to by their component parts. Even where careful attempts have been made, explanations often seem fragmentary and sometimes contradictory. Granted, the would-be investigator is confronted with certain difficulties surrounding such works of art. Ritual art is a matter of secrecy, and the anthropologist is justifiably excluded from knowing its meaning. The female anthropologist is in the worst position, since most of the art requiring explanation is associated with male cults. Moreover, where meanings are divulged, there is no guarantee that they are accurate; they may be intentionally or unintentionally wrong. Faced with all these difficulties, if we really do think that some of these works of art contain complex forms of expression, we must devise other ways of complementing our deficiency of information.

One striking and helpful feature of some types of primitive art is their economical and systematic use of the visual symbols. This is what gives the initial impression of deeper meaning behind the patterned surface. In the Abelam case, this is particularly noticeable. Fig. 1 shows a number of paintings from the same village, where several of the shapes occur in several different situations. In 1a and 1e, the oval is the body of a human-looking creature, while in 1d and 1h it is part of what looks to us like a decorative pattern. Pairs of circles are used as eyes, we might hazard, in 1a, but are they eyes also in 1e and 1f? The transition from one of these occurences to the next shows only a small modification in the configuration and suggests a similarly small modification in meaning. One shape is used to refer to a number of things deemed similar, although we are not able to tell exactly what. This inference comes from contact with the visual field itself and

is not drawn from insight gained from study of the Abelam or from meanings provided by informants. The extreme versatility of shapes gives us certain vague notions of the visual metaphors that are being conveyed.

This economical use of forms, perhaps used in the service of metaphorical or telescoped expressions of meaning, has been observed and analysed recently by other students of primitive art in anthropology. James Faris (1972) has shown that the South Western Nuba, by combining items from a relatively small repertoire of shapes produce a variety of different body-designs. Nancy Munn (1962; 1963; 1964; 1966; 1973) shows the wide area of reference covered by a few simple geometric shapes in the paintings and sand-drawings of the Aborigines of the Central Desert of Australia. And Caroline Humphrey (1971), discussing *ongons*, ritual collages of the Russian Steppes, has shown how the same elements are employed again and again, each time with a different meaning, depending on the context. However, the recognition of this economical use of the formal vocabulary was not used by these three authors as a tool to aid the study of meaning but, in all three analyses, as proof that visual art, like language, is also structured. It is my contention that such an emphasis interferes with the basic problem of interpretation in a field of study which is so little explored as primitive art. Having been shown that a system is at work, we would then expect to be shown how it articulates meaning and why it is effective in doing so. James Faris openly dismisses the question of meaning at the outset, saying that Nuba body-designs have only one function and that is the embellishment of healthy bodies. This is a statement of function, but we also legitimately may ask questions about the content of a 'genre' of art which has this general function. The Nuba have forgotten the precise meaning of the various signs, but the likelihood is that they have forgotten something quite substantial. Faris examines the operation of the formal system without reading any significance into it – a very useful and complicated exercise which might possibly have led to more interesting conclusions in terms of the choice of symbols to express different concepts and the placing of these only on specified locations on the body.

The other two authors are more concerned with meaning, but only insofar as, in combination with the formal aspect, it can be shown to operate in the same ways that verbal language operates. Both have found, in the particular body of art that they studied, phenomena capable of being described in linguistic terms. Now, it goes without saying that such phenomena could equally well be described in musical or mathematical terms, but this line of enquiry is not a priority when we are trying to discover what the art is really expressing in its own terms. It may well be that when visual art of this type has been satisfactorily interpreted, there will be some analogies to be made with the field of language, but to set out to describe a

visual system in terms suitable for the description of words and sentences is to turn analogies into functional similarities, which they can never be. It is not only an evasion of the real issues to bring language into the study of visual art; it actually distorts the intention of the art to suit the ready-made concepts being applied to it.

An instance of this from each of the linguistics-oriented studies will demonstrate my point. Caroline Humphrey (1971) discusses the Saussurian concept of *motivated* and *non-motivated* signs in language. A *motivated* sign is attached to its meaning by a relation of similarity, e.g., the word 'bang' actually simulates its meaning by how it sounds. Most words in English, however, fall into the other category of *non-motivated* and do not look or sound like their meanings. Now, when the

Figure 1. Types of composition. After painted panels (approx. 75cm x 100cm) from the North Wosera region, showing repeated use of a relatively small vocabulary of shapes throughout both 'subject' and 'pattern' compositions.

attempt is made to transfer this distinction to visual signs, certain difficulties arise. *Motivated* visual signs would be those which look like the thing which they indicate and *non-motivated* signs would not look like this thing. In the *ongons*, which are composed, like Abelam art, of recognisable and non-recognisable things, those symbols which look like a man and indicate a man would be termed *motivated*, whereas those which looked like feathers and indicated virility would not be *motivated*. But feathers are sometimes worn, in this society, by young,

virile men and that is why they are chosen to suggest virility. Clearly, there is a strongly *motivated* connection between the feather and that which it signifies, if we take motivation to mean more than just resemblance. In visual art there is scope for many types of *motivation* between sign and meaning, and the simple either/or mechanism suitable for language simply is not rich enough to cope with the many orders of meaning able to be conveyed in terms of shape and colour. To avoid tantalising but fundamentally invalid philosophical and aesthetic problems, it is wise to leave the analytical tools of linguistics within the study of language, where they belong. Nancy Munn (1973) introduces, in relation to Walbiri sand-drawings, another pair of opposing terms from linguistics, somewhat related to the one just discussed. It is the distinction between *continuous* and *discontinuous* categories of referents for a sign. The first indicates that in a set of possible meanings for, say, a tree-shape, there would be only a number of different species of tree. The second indicates that, if the referent is a circle, in the set of meanings there could be things as different as a campfire, the tuber of a yam and a conical hill. These divergent classes of things are all signified by the circle and so present a *discontinuous* category. But the Walbiri have a metaphor, stated by Nancy Munn herself, to the effect that straight marks in drawing are, in general, how one refers to the *paths* of the ancestors in their creative journeys through matter and circular marks, how one refers to their *resting-places* on their journeys. If a circle has the basic meaning of 'resting-place', whether this is a campfire, a conical hill or the tuber of a yam, these meanings can be said to be *continuous*, linked under the species 'resting-place'. This is, after all, a key concept for the Aborigines and since we are studying their art, we might, in a genuinely ethno-scientific way, respect *their* categories when we describe their art. Once again, problems of classification are raised which are not easily handled by our own linguistic categories, into which they do not fit. In Aboriginal art also symbols have complex sets of relationships with their meanings which are only beginning to be explored. It is unreasonable to assume that these will fit neatly into our already established linguistic categories. Although these systematic studies of primitive art lean rather heavily on linguistics for their exegesis, they represent a significant step forward, since they have recognised the presence of systems in visual art and have gone to great lengths to study them in detail. However, more might have been achieved by a closer examination of the formal elements, their distribution and interrelationships, which constitute the visual 'mechanics' of the art and which must be the starting-point for any 'search for the system'.

It is a useful exercise, even given that we know the meanings of some of the elements in a corpus of primitive art, to conduct a formal analysis entirely without reference to meaning. This allows for the maximum yield of formal significance, i.e. the use made by a culture

of the properties of shape to suggest meaning. We have to allow for the possibility that the circle, for example, carries with it a basic meaning (say, 'resting-place of the ancestors') and is not being used to describe *any* circular object, but only those which are compatible with this basic sense. We have to allow for a change in form to signal a change in meaning every time, should this turn out to be the case. If we do not record the data in such a way as to allow this to show up, it will never show up. Thus, what is required is a fairly rigorous recording of classes of forms as the observer sees them.

The Form Chart in Fig. 2 is the total vocabulary of elements I worked with. These were selected on the criterion of their status as recurrent elements, and shapes similar, but not identical, were recorded separately if it was thought that the small difference between them was intentional and not a matter of personal ways of drawing the same object. Of course, there is no way to be absolutely certain in cases like this, and one is always working according to intuition. The

Figure 2. Form chart. The main formal elements of Abelam painting. The letter[n] indicates that the form, or the part of it nearest to the[n] is repeated.

shapes are loosely classified on the Chart for the convenience of easy location; the classification is not charged with the observer's cultural bias because the shapes are ordered by their inherent properties and are given numbers and not names. If each form has a number of its own, it will be referred to by this number in whatever stage of the analysis it turns up. Ninety-nine was the largest number for

1. Point to point, outward

2. Point to point, inward

3. Side to side, convex

4. Side to side, concave

Figure 3. Examples of external relationships.

convenient use in a computer and so a larger number of forms was condensed into ninety-nine. A computer was used since it is by far the most convenient means of storing and sorting the information in a sample of data of this size. Moreover, the demands of computer-coding require a stricter type of thinking about the visual data and obliterate the ambiguities which occur in one's normal thinking about visual phenomena. The paintings are so varied in format that what we are looking for is not rules about how to compose an individual painting, but, at the level of shapes and relationships, what is permissible and what is not. The coded data for any painting are not important as a whole, but as a series of complexes giving information leading to a bank of such information. Nevertheless, the coding-sequence adopted was, in most cases, large enough to be comprehensive for each painting.

Now, as well as the solid units in any painting, one must consider also the less tangible relationships between them and these may turn out to be as full of significance (or as empty of it, as the case may be) as the solid shapes themselves. It is possible to discover a finite number of these in Abelam painting, for extreme economy is used in this respect as well as in relation to the shapes themselves. Fig. 3 shows examples of some simple relationships linking many pairs of different forms. Relationships can be described as 'types of contact between contours', and there are two kinds of these: external and internal.

The coding-sequence for all paintings is shown in Fig. 4. Starting with a form larger than the rest, or in a dominant position, this form is coded, followed by a string of externally related forms, always preceded by the type of their relationship to the starting-form. Then, for the same starting-form, the forms related internally to it (i.e., inside it) are coded in the same way and this is followed by information, in the same format, about a second starting-form, should this be necessary. The format of central and satellite forms reflects the natural organisation of the bulk of formal complexes in Abelam art

Figure 4. Computer-coding format – card 1.

	Form	Black	Black dotted	Red	Yellow	White	Other	Total No of Instances
10		18%	18	—	9	36	19	11
1		3	—	28	44	10	15	33
3		21	—	5	37	11	26	20
4		34	10	3	8	2	43	102
2		56	—	18	7	13	6	83
6		73	—	8	3	5	11	182
21		42	15	9	14	3	17	65
28		13	—	9	16	—	62	46
31		7	—	59	8	2	24	170
34		12	7	54	15	—	12	111
11		44	12	14	17	3	10	377
19		13	—	10	5	3	66	40
13		64	10	8	11	2	5	240
16		9	—	9	26	9	47	127
71		22	10	5	26	7	30	131
72		12	10	5	23	5	45	63
52		40	3	51	—	6	—	82
84		53	12	5	10	2	18	62
41		33	18	7	26	9	7	44
47		45	9	9	18	—	19	11
61		27	8	9	5	16	35	77
62		32	23	5	17	15	8	278
67		20	17	8	23	10	22	86

Figure 5. Principal form – colour distribution.

and the method of coding was generated out of respect for this. The nucleus and its subsidiary forms was not the only type of organisation, but the other types of formal arrangement were not incompatible with this sequence of coding. Colour, a factor not yet mentioned, is also important and is coded on a second card for each painting. If the form 45 is recorded in columns 29 and 30 on the first card, its colour, whose code-number is found in a colour-code list, will be entered on the second card in columns 29 and 30. The dimension of colour can be added in or left out at will in specific inquiries. When every painting has been coded in this way, we have a fairly comprehensive account of the positional variants of every form and can ask for the colours, relationships and forms associated with any particular shape. The computer-data can be read in more manageable form in tables of the kind illustrated in Fig. 5. This table is an account of colour in relation to each of the main forms and shows several facts at a glance. White occurs very seldom as the colour of forms (it is used for outlines). Of the main three colours, black, yellow and red, there seems to be a fair distribution, but only three shapes, 31, 34 and 52, have their highest occurence in red. The black/dotted colouring is notably absent from several forms which are frequently coloured black. Findings like these can be called the 'rules' of the style and it is the task of the analyst to discover as many of them as he can. One rule suggests further hypotheses to be tested and once a larger body of formal rules has been built up, meaning may then be introduced to see if problems and ambiguities in meaning can be illuminated by the formal rules. It is a long and painstaking effort to work only in the realm of form and the rules which emerge often sound arid and inconsequential, but it is by this process that the necessary groundwork is done for a proper integrated study of form and meaning.

A formal analysis of this type can be applied to any body of art which has standard units and fixed ways of combining them; however, the sequence of coding used for Abelam art will not be suitable for other visual idioms, which will require their own types of coding to be generated for them. The computer is an optional feature of the analysis, for the process of coding must be done whether the information is stored electronically or on filing-cards. It is hoped that rigorous investigation of the formal aspect of primitive art will be the path along which further discoveries are made about meaning, which will enable us to see works of primitive art in the way that they are intended to be seen.

The findings of a purely formal study such as this can only be formal findings and as such, they are not intrinsically interesting. Nevertheless, it is important to demonstrate the kind of formal rules that can be yielded. The computer-data are cumbersome to handle, consisting of a large number of coded statements which must be organised according to some principle. But the only direction possible in extracting logical rules from formal data is from one form to the

next, one colour to the next and so on. If we start with the oval which is a very dominating form, we would list some of the rules which it obeys as follows:

> Ovals can contain a form if they are black, but not if they have a rim of white dots.
> Ovals can be attached upwards to smaller ovals and circles, but not if they have a rim of white dots.
> Ovals can be connected to forms which look like feathers and plants, but not if they have a rim of white dots.
> Ovals can occur in rows but not if they have a rim of white dots.

Summarising this, we can say that having a rim of white dots seems to alter the usual associations of the black oval, suggesting that when it has these dots it does not stand for the same thing it stands for when it is black. We would then look at the other shapes which occur with a rim of white dots and see if their associated features differed for this reason. We can see from Fig. 5 that rows of stars and rows of ovals are the same in that neither can have the white dots. Several other forms are excluded from having this colouring, mainly circles and variants of the small oval. In this way we collect instances of the use of the black/dotted colouring and try to see if forms coloured in this way make up a special category. But categories of this type can only come to life when the few meanings that we have available from informants are injected into them, and this would take place in the second phase of the investigation, when with the use of the formal data specific ambiguities of meaning are examined.

REFERENCES

Faris, J.C. (1972), *Nuba Personal Art*, London.
Forge, J.A.W. (1966), 'The Curl Lecture: Art and environment in the Sepik', *Proceedings of the Royal Anthropological Institute*, 1965, 23-31.
Forge, J.A.W. (1967), 'The Abelam artist', in M. Freedman (ed.), *Social Organisation: Essays presented to Raymond Firth*, London, 65-84.
Forge, J.A.W. (1970), 'Learning to see in New Guinea', in P. Mayer (ed.), *Socialisation: the Approach from Social Anthropology*, Association of Social Anthropologists, Monograph, 8, London, 269-91.
Humphrey, C. (1971), 'Some ideas of Saussure applied to Buryat magical drawings', *Social Anthropology and Language*, Association of Social Anthropologists, Monograph, 10, London, 271-87.
Mountford, C.P. (1956), *Art, Myth and Symbolism: Records of the American-Australian expedition to Arnhem Land*, 1, Melbourne.
Mountford, C.P. (1958), *The Tiwi, their Art, Myth and Ceremony*, Melbourne and London.
Munn, N.D. (1962), 'Walbiri graphic signs: an analysis', *American Anthropologist*, 64, pp. 972-84.

Munn, N.D. (1963), 'The Walbiri sand story', *Australian Territories*, 3, 37-44.

Munn, N.D. (1964), 'Totemic designs and group continuity in Walbiri cosmology', *in* (ed.) Marie Reay, *Aborigines Now*, Sydney, 83-100.

Munn, N.D. (1966), 'Visual categories, an approach to the study of representational systems', *American Anthropologist*, 68, pp. 936-50.

Munn, N.D. (1973), *Walbiri Iconography*, Ithaca and London.

Martin A. Nettleship

Weaving in its social context among the Atayal of Taiwan[1]

The Atayal are the aboriginal Malayo-Polynesian residents of the central mountains of Taiwan. The rationale and history of my work as an applied anthropologist with the weaving of this group (from 1964 to 1968) have been presented at length elsewhere, along with the only ethnography of the Atayal in English (Nettleship, 1969a,b; 1971, Manuscript a,b). For immediate consideration I shall focus upon the cultural and social context of weaving and aspects of its organisation which have to do with the question of creativity in art.

Technique

The Atayal backstrap loom is unique (Nettleship, 1970) (Figs. 1-6). This and other technical aspects of their weaving and fabric need not be discussed here because there are no unusual technical features of the art which especially affect its socio-cultural involvements.

Cultural involvement

Both weaving and fabric are integrated into Atayal culture through involvement in belief and ritual systems and the economy. Weaving was the female ritual and spiritual complement to the male activities of headhunting and skull preservation before the Japanese terminated

1 Atayal is pronounced 'Tayal. The research upon which this paper is based was sponsored by the London-Cornell Project for East and South East Asian Studies, financed jointly by the Carnegie Corporation and the Nuffield Foundation. Special thanks to the members of my class on 'Art and Craft in Culture and Society' at the Instituto Allende, San Miguel de Allende, Gto., Mexico, for helping to organise and clarify many ideas about creativity and art. An Atayal loom and representative sampling of fabric collected by the author may be found in the British Museum (Museum of Mankind).

Atayal headhunting. In those days, being a leading weaver was the one sure way for a woman to be able to pass over the rainbow bridge, along with the headhunters, to a better life after death (McGovern, 1922; Ishi, 1916). Weaving has no special place in modern day Christianity as practised, at least nominally, by all Atayal.

Today, being a leading weaver has two interrelated aspects yielding prestige, if no longer other-wordly admission. First, the technical and aesthetic qualities of a good weaver's work are generally recognised and complimented. Second, a good weaver is particularly admired by members of her weaving work group and an outstanding weaver is likely to become a group leader. This social position involves the additional prestige of knowledgeable recognition by the group members with whom she works and whom she assists, plus making more broadly known her successful technical, aesthetic and social involvement as a weaver.

The ability to weave was once the major index of maturity for girls. Their puberty rite included a weaving dance in which the girl demonstrated her skill at the loom while her female kindred danced around her. The steady resonant boom made by the hollow-log main loom beam as fill threads are correctly beaten home provided the rhythm for the dance. After the performance the girl received her facial tattoos and could be married. (For a boy, taking a head was necessary to achieve these marks of maturity.)

No longer do all girls learn to weave but quantities of fabric are still included in the exchange of goods marking a marriage. The cloth is woven by the bride and/or her female kindred. Some of it is redistributed to the groom's female kindred and some is kept for use in the new household.

Dancing was once an important part of all Atayal ceremonies. Contemporary dancing has less ceremonial and ritual significance but is still popular for both sexes and all ages. It serves to celebrate Christmas and national holidays when there are vigorous dance contests within and between villages and regions. Costumes with finely detailed overwoven designs are preserved by many households and used only for dancing. (The techniques for overweaving such fine fabrics have apparently been lost and this kind of costume is no longer made.)

Most other present day uses of Atayal hand woven fabric are practical, such as for carrying-cloths and storage wrappings. Except occasionally as a wrap or shawl, it is seldom worn for ordinary clothing. Many older Atayal keep in storage a piece or two of the heavy, well decorated, Big Diamond Style fabric (Fig. 6) in which they wish to be wrapped at burial.

In the past there was not much inter-village trade but a little intravillage non-ritual exchange of weaving supplies, tools and varieties of cloth took place. There is now a considerable within and between village trade of ramie fibre, ramie and woollen yarns, dye

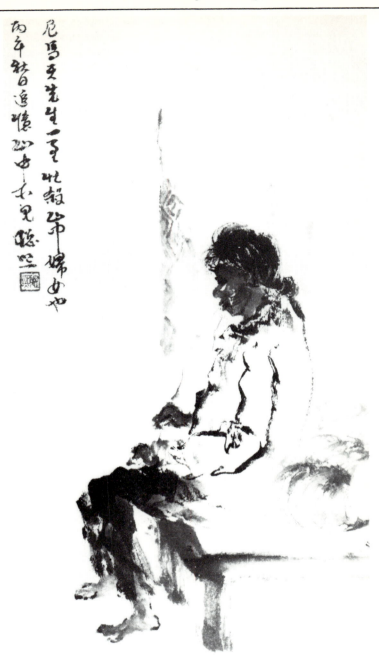

尼馬更先生一
丙年贊追懷
大見臨
此叔亞布婦女也

Figure 1. Atayal weaving: twisting ramie fibre.

Figures 1-6 are from paintings by Cheng Tsong-shih

stuffs and finished cloth. There are cash sales and barter exchanges for agricultural and othe products. Before my applied anthropological project there was some external cash marketing of cloth. (The Atayal economy depends on cash cropping with most sales in lowland Chinese markets.) At present (1974) the more active weavers have a greater outside market than before the project although sales are not as great now as during the height of the project's work.

Aesthetics

Atayal aesthetic experiences are relatively limited in scope and variety. In the past, Atayal made no pottery and did little wood carving, nor were their houses obviously decorated or of particular architectural interest. A little simple, rugged basketry and some netting continue to be made by the men. Some Atayal style houses are built but most are now in a quasi-Japanese style for which the Atayal cut beams and exterior boards but purchase doors, windows and sometimes roofing materials from Taiwanese shops.

Exercise of visual, aural and kinetic aesthetic preferences must now be done mainly from among items to be found in the wider Chinese culture of Taiwan, including survivals and imports of Japanese culture and relatively recent introductions of Western culture. Items available for selection include dances, music on radio broadcasts and records, films, magazines and various kinds of pictures.

Japanese and newly created 'pan-aboriginal' dances supplement traditional forms. 'Pan-aboriginal' dances are made by Chinese school teachers for their Atayal and other aboriginal pupils to perform in dance contests around the island. They relate only vaguely to traditional dances. Japanese magazines and songs are more popular than Chinese, due, at least in part, to the greater facility with the Japanese language among middle aged and older Atayal. There is also a certain sentimental and aesthetic attachment to Japanese culture dating from the time Japan held Taiwan (1895-1945). Records of authentic aboriginal music from various groups on Taiwan have been made and these are prized by the Atayal, especially for dance accompaniment. War films, Westerns, anything with fighting, are the favourite entertainment on trips to town. Films showing modern weapons in use are preferred to epics of ancient Chinese history in which the violence is conducted with antique arms.

In the plastic and graphic visual arts – except weaving – most items found in Atayal houses are purchased in Taiwanese shops. The more simple, less obviously Chinese, forms, patterns and decorations tend to be selected for household furnishings, dishes, etc., except in calendars and painted mirrors. Calendars with scenes of travel on Taiwan or in Japan are preferred. Painted mirrors portraying airplanes and ships are most often chosen: those with exclusively or

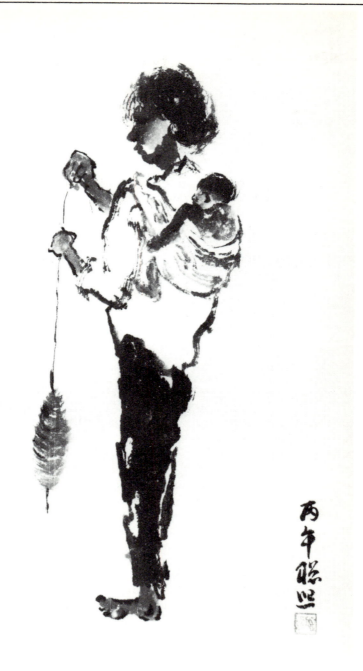

Figure 2. Spinning yarn.

mainly Chinese language characters tend to be avoided. Christian pictures and calendars provided by the churches are very popular. Portrayals of Christ are the most commonly found religious pictures although the Virgin and various saints are found as well. Photographs of family, friends and movie stars are commonly used decorations.

Weaving is a graphic art; the only art manufactured and kept in any quantity in many Atayal households. Both traditional and modern styles and motifs are made. All traditional motifs are geometrical and derive from the rectilinear, angular, diagonal qualities of warp and fill thread relationships. The major traditional styles are Stripe, Dancer's Skirt, Small Diamond, Big Diamond and Costume, with various motifs within each style. Variations of colour, balance and rhythm are constantly being practised within the traditional designs. Modern designs include: Cross Stripe and Tartan Motifs borrowed from commercial, machine-made fabrics; developments of Dancer's Skirt and Stripe Styles with machine made woollen yarns (as opposed to the traditional, hand prepared ramie yarns used for most other fabrics); Necktie Style; and Figured Piece Style.

Figured Piece Style is the most different development in contemporary Atayal weaving. Traditional, geometrical elements are only occasionally used. Instead, most of the motifs are organic in derivation, curvilinear in form, and endeavour to represent or signify shapes from the natural and cultural environments. Traditional pieces of cloth are usually in a single motif. Figured Pieces display several different pictures on a single length and the pictures may be selected from a variety of new motifs such as: Human Figure, Animal, Plant, Human Artifact, etc.

All style and motif names (used above and in my previous papers) are analytical ones supplied by the author. Atayal name individual patterns descriptively but do not use collective, categorical names. No traditional patterns have allusive significance. Figured Piece motifs are obviously allusive and representational but, again, are not categorised or named other than descriptively by the Atayal.

Atayal weaving presents a unique concentration of potential aesthetic experience which gives fabric a special importance in their culture. Minimal contemporary use of hand-woven cloth limits ordinary opportunities to experience it aesthetically or otherwise. Most cloth is kept in the family storehouse. It is seen only during the special circumstances of creation (all types) or performance (dance costumes). Most experiencing of fabric designs takes place during weaving. Atayal of all ages and both sexes are likely to be present in the dwelling when weaving is going on. All Atayal are knowledgeable about the processes and motifs employed.

By comparison, most other objects are constantly visible and experienced aesthetically in routine activities which do not focus on either the objects or the experience. The strongest observable

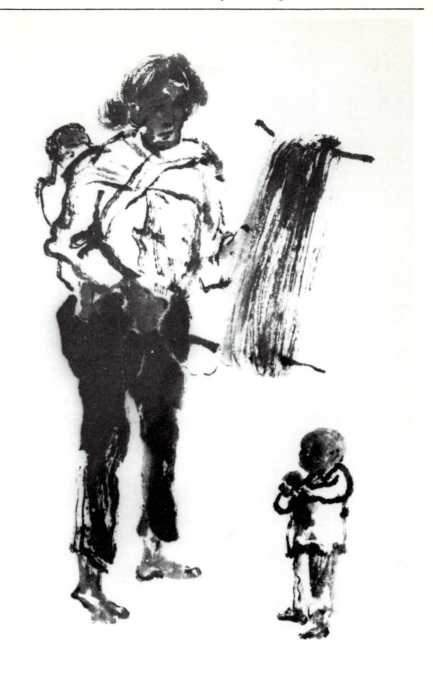

Figure 3. Making a hank of yarn for bleaching and dyeing.

expressions of relationship between Atayal and the objects of their aesthetic experience occur when selecting or making the objects. Day-to-day exposures to objects seldom stimulate noticeable reactions although the objects continue to be enjoyed as normal, desirable but not outstanding parts of the surroundings.

For weavers and non-weavers alike the major exposure to fabric patterns takes place in the presence of the weaver at the time of manufacture. This special circumstance is strengthened because weaving usually entails the presence of a group of informed, active co-participants – the weaving work group – commenting on each other's work. There is relatively little group activity in other situations of object selection or craft manufacture. The conditions of interaction with fabric, combined with the unusual richness of potential aesthetic experience to be found in its designs (as compared with all other artifactual sources of aesthetic stimulus available to the Atayal) combine to make fabric a repository of Atayal visual aesthetics. Primary access to the repository during production of a design is important because such access involves even non-weaving viewers in the relationship between maker and her product at a time when the relationship is strongest and most likely to be expressed. This encourages a vivid transmission of patterns and interaction with them, as expressed by those to whom they are most important.

Because of its aesthetic uniqueness, weaving has survived into a time when it is no longer an economically practical pursuit. It is, and apparently always has been, the primary visual aesthetic activity of the Atayal and has the added importance of being a major source of prestige for many women. That this prestige still adheres to the making of good cloth, even after many social and ritual aspects of the art are much reduced, is a further indication of the aesthetic importance of weaving and cloth for the Atayal.

Social structure

The wide cultural significance of fabric and weaving has been briefly outlined in the preceding pages. Weaving as an activity also has salient social significance because most steps in the process are done by individuals in the context of a work group. Work groups are the most important Atayal social structures because almost every materially productive activity in the culture is performed in such groups.

Atayal work groups are action-sets (Nettleship, 1971). That is, they are purposive creations of a central ego and have a temporary quality: they do not continue indefinitely but are brought together for some specific purpose by ego. There is an awareness of 'setness' – general acknowledgement of working cooperatively toward a common goal – among work group participants. Work groups may be structured

Figure 4. Softening yarn with mortar and pestle.

simply in having all workers linked individually, one-to-one, to the convening ego, or the structure may be complex in having some participants recruited by other participants rather than directly by the convening ego. The linkages within Atayal action-sets are transactional, involving exchanges of labour, cash, debt, skill, knowledge and prestige. Such transactions are seldom completed during a single meeting of a work group. Completion usually requires participation in future meetings of the same or similar groups.

Weaving work groups are not identical to household or church oriented work groups. They may last for years rather than hours or days. The convening ego is always an individual weaver rather than a household or church representative. Furthermore, the transactions between group members tend to be more delayed and more diffuse than in other groups, partly because there is almost no material gain in leading or participating in a weaving work group, and partly because most of the work is not *for* the leader in the same way that the work of a swidden group is done for the convening household. Nonetheless, structural expectations of recruitment, participation, relationships between participants, and methods of leadership are virtually identical among all kinds of Atayal work groups.

It is through weaving work groups that the social roles of Atayal weavers can most easily be described. Almost no weaver works entirely alone although it would not be physically impossible to do most weaving processes independently. Members of a weaver's household know about her work and if she trys to sell some of her fabric this adds to her economic importance: she is probably already the economic mainstay of her household. More importantly (to the weaver, her household and her settlement) her work is aided and continuously evaluated by the members of her weaving work group. Her importance as a weaver in her settlement is determined by the evaluations of the members of her group. There is no formal stratification of membership within weaving groups but the work of the new, less experienced or less talented member is recognised as such most easily and accurately by those who know it best: the other weavers who work with her.

A group leader has more prestige than regular members, even skilled ones. A particularly good leader has even higher standing and is able to attract more and better followers (within the limits imposed by a practicable maximum group size of ten to twelve and the range of feasible recruitment among kindred, neighbours and friends). Leading weavers do not necessarily, because of success in that role, stand out in church or other settlement activities. Leading weavers were all well thought of and all were active Christians but only one woman, whose husband's job in the lowlands saved her from much swidden work, was a leading church member.

The possibility of relatively long tenure as a leading weaver makes the role unusual in contemporary Atayal society. Neither church

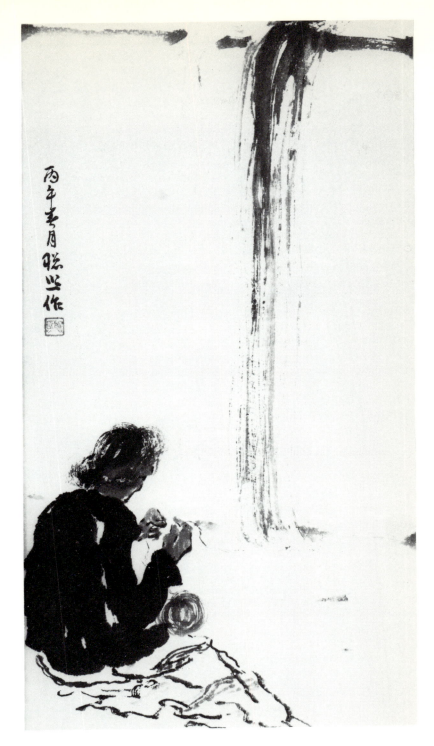

Figure 5. Balling newly dyed yarn.

activity nor having a relatively wealthy household are inherently long-term positions. To maintain prestige in the former requires repeated involvement with a variety of activities in the church, most of which are performed by short-lived church work groups. Such involvement is not always attractive or possible. Household economic prestige is quite insecure and depends on uncontrollable market, weather and climatic factors as well as a good deal of hard manual labour and/or an ideal combination of family size and land holdings. By comparison, once a sufficient level of skill is reached a woman may lead a well known weaving work group for ten years or more simply by continuing to weave well and help her group. The only comparably secure role in Atayal society is that of village elder which is gained through age, respectability and wide friendship and only terminates at death or through being eased out in the rare case of incapacitating senility.

In the presence of a good sustaining external market for Atayal cloth, leading weavers, because of their greater productivity and better fabrics, could come to have greater wealth than average or non-weavers. During my project the few most outstanding weavers and their groups sold more cloth for better prices than average. Increased wealth can buy an easier life and perhaps more or better, if not unique, social roles. A woman whose household is economically secure enough to allow her more free time than usual is likely to spend that time in worship and organising church events. She thereby gains recognition through increased participation in activities which are generally open to everyone.

Social organisation and creativity

In my earlier work on the Atayal, considerable attention was devoted to the concept of social organisation (which, in contrast to those generally held sets of expectations usually defined as social structure, consists of acts of choice and selection between alternatives, made by individuals in a social context). The concept proved useful in an examination of Atayal weaving which helped clarify the values affecting many aspects of the art. It also helped in analysing Atayal reactions – positive and negative – to the efforts of the applied project to bring about various changes.

One positive Atayal reaction was 'inventiveness' or the 'aesthetic renaissance in the quantity of new patterns created under the stimulus of the project'. It was clear at the time of the original research that the concept of social organisation is important for the anthropological study of change. 'Inventiveness' was included as one of several interesting kinds of change requiring study. Yet the importance of individual choice and selection as an aspect of creativity in art did not explicitly occur to me then.

Figure 6. Weaving Big Diamond fabric on an Atayal backstrap loom.

'Who can conceive of art without creativity?' (Altman in Biebuyck, 1969, 189, emphasis added.) With that conception goes an intuitive certainty that we can identify creativity when we perceive it. But what is creativity and how can we, especially we anthropologists who often have unique and intimate access to the periods and processes of manufacture of art objects, identify it? At what stage in the production of an art object does creativity enter in? (See Biebuyck, 1969, for several valiant attempts to deal with the problems of tradition and creativity in tribal art, none of which is wholly successful.)

My suggestion is that creativity is *change*, change which is consciously chosen or used, thus the concepts of social organisation are those which will best enable us to detect, describe and analyse its occurence. Making or performing a work of art is a process occupying time and requiring the person or persons involved to make a vast number of choices at various points in the process. The choices begin with whether to do the work or not, range through problems of media, materials, tools, location and co-workers to questions of content, themes, motifs and elements and may not end with the completion of the work since its use and location may also be matters of choice for the artist.

At each decision point the possibility of change enters in. We may differentiate between creative changes, innovations which are actively selected, and those incidental ones which occur accidentally or may be forced on the artist by circumstance. We should note, however, that accidental changes are often co-opted by the artist and used as creative elements even when not originally conceived as part of the work in hand.

It is a point for discussion whether or not the maker of the work of art must invent a new aspect of that work himself for that aspect, or the whole work, to evidence 'creativity'. It is my position that *both* the use of accidentally occuring new elements *and* choosing or making new combinations of elements from other sources are creative. Thus, I feel that 'creativity' occurs in the process of *selection* as much or more than in the process of *invention*. If this were not so, a serious revision of our vocabulary would be necessary because most of what is now referred to as art could not be so called: it is the rarest of objects which displays totally new invention in even a few of its aspects.

It may be argued that many of the decision points in making art works do not call for aesthetic choices and that changes introduced at those points do not effect the artistically creative aspects of the works. Rather than making *a priori* differentiations, however, I would prefer to keep our analyses open and to gather evidence throughout the period when works are produced. This would enable us to decide if the effects of *any* decisions during the process can be set aside as irrelevant to the final creative quality of whatever work or works are being studied.

The freedom of the artist to be creative, to make new choices, especially for those making so called 'tribal art', has been widely questioned. There are, no doubt, many decision points in making art in any culture (including our most 'innovative' contemporary art subcultures) where choice is highly limited. But anyone who has watched an artist or who has been one knows that there are a great number of decisions to be made and that many of these are only marginally controlled by aesthetic and other value systems. (This is not much different from other aspects of social and cultural existence where structures set down general guidelines but individuals must make ongoing organisational decisions to arrange the details of their lives.) In the absence of general cultural values it is the artist's individual preferences which govern his decisions and through which individually selected changes, or creativity, enter into art.

Atayal creativity

Examples of decision points in Atayal weaving may be briefly noted here to provide a starting point for further discussion of the above definition of creativity.

Once a Atayal weaver is mature in having the strength and knowledge to be able to process yarn fully and weave several kinds of cloth she then faces an elaborate series of decisions whenever she sets about making a new piece of fabric. Problems of when, where and with whom to work are not entirely personal. It is a cultural given that a weaver works on some aspect of fabric making whenever she can, using any time not needed otherwise. It is most probable that she will be an active participant in a weaving action-set thus coordinating her decisions of time, place and companionship with other members of her set, depending on their personal needs as well as seasonal demands of crops, weather, etc. These decisions may have an effect upon creativity. For instance, other weavers may be more or less innovative and thus vary the stimuli available and even the numbers of new ideas being circulated in the set at any given time.

Little innovation is apparently exercised in making certain styles such as Plain, Stripe and Small Diamond. An initial decision to make one of these eliminates, for most weavers, later decisions concerning use of various design elements. Even with these styles, however, there are decisions points concerning eventual use of the cloth, weight of yarn, colours, numbers of stripes, the use of stripes within the basic diamond pattern and so on. For some weavers at some times, simply making the usual motif in a readily available colour is satisfactory but others will make innovative combinations of weights, colours and patterns within the styles.

The weaver who decides on Dancer's Skirt, Big Diamond or Figured Piece styles must make more decisions than the one working

in a simpler style. Indeed, most weavers who choose to make a piece in one of these styles do so because of interest in the complexity of design elements available which encourages a creative approach to each new piece. Copying is not impossible and less skilled weavers may choose a complex style and then copy a piece in it made by another weaver.

Even after a length of cloth comes off the loom decisions need to be made: whether or not to clean and smooth the surface, how to finish the warp threads at the ends and whether to use the piece whole or cut and stitch it. All make a considerable difference in the final effect of the designs chosen earlier in the process.

Within any given Atayal style the choices most important to final appearance of a piece are: weight of yarn, number of colours, what colours to use, what patterns to use, how to arrange patterns, and what motifs to use. Decisions made before weaving begins, such as what colours to dye yarn and what dyes to use, also affect the finished work. They may be considered either by taking the fabric making process as a linearly organised whole or by treating the results of early decisions as providing alternatives for selection at later choice points. The latter is probably closer to actual events for the Atayal since weavers are constantly preparing various weights and colours of yarn without always having in mind special pieces in which they will be used.

Prospect

The above definitions of creativity, and the suggestions that this aspect of the art process is most accessible to study with the concepts of social organisation, are intended to be tried against the bodies of material observation available to us from our fieldwork. Innovation in Atayal weaving can certainly be effectively analysed in terms of choices or 'organisational decisions'. Do other bodies of art, ethnographically examined and otherwise, respond as well?

REFERENCES

Biebuyek, Daniel D., (ed.) 1969), *Tradition and Creativity in Tribal Art*, University of California, Berkeley.

Ishi, Sinji (1916), 'The island of Formosa and its primitive inhabitants', *Japan Society Proceedings*, xiv, 38-60.

McGovern, J.B.M. (1922), *Among the Headhunters of Formosa*, London.

Nettleship, M.A. (1969a), 'Modern redevelopment of handweaving among the Atayal of Taiwan', *Journal of the China Society*, vi, 117-21.

Nettleship, M.A. (1969b), 'Preference for development of indigenous aspects of society and culture in situations of induced change and disruption due to contact', *Journal of the China Society*, vi, 123-9. (1969a and b also appeared in: *Proceedings of the VIII International Congress of Anthropological and Ethnological Sciences*, Tokyo.)

Nettleship, M.A. (1970), 'A unique South East Asian loom', *Man*, v, 686-98.

Nettleship, M.A. (1971), *Background to an experiment in applied anthropology among the Atayal of Taiwan*, unpublished Ph.D. Thesis, University of London.

Nettleship, M.A. Manuscript a, 'The Atayal: Mountain People in Contact and Change',

Nettleship, M.A. Manuscript b, 'The Atayal: An Ancient Craft for Modern Markets'.

Adrian A. Gerbrands

Talania and Nake, master carver and apprentice: two woodcarvers from the Kilenge (Western New Britain)

The Kilenge live in the most western part of New Britain in an area roughly demarcated to the east by a line from Borgen Bay in the north to the Itne River in the south and delimited to the west by the coastline. The Kilenge number some 3,500. Of these about a thousand live on the northwest tip of New Britain in a group of five major villages situated close to each other on the beach and known collectively also as Kilenge. The five seaside villages constituting Kilenge are from west to east: Potne, Kurvok, Ongaia, Ulimainge and Waremo. The other Kilenge live in some 35 villages dispersed over the area with an average of 70 to 80 souls per village. In spite of the fact that the patrol post and the government hospital are 30 km. away in Borgen Bay, Kilenge-on-the-Beach in many respects is the real capital of the area. Ten kilometres away at Cape Gloucester is an airstrip dating from the last war. There is an old bush road in part built during the war by the Japanese and today practicable for four-wheel drive vehicles. This road runs from the patrol post via the airstrip to Kilenge and beyond to Sag-sag (for a map of the Kilenge area see Dark, 1974, 8). The Anglicans have an old mission in Sag-sag, and the Catholic mission established itself in the thirties in Kilenge-on-the-Beach.

The Kilenge maintain trade relations with what could be called the Huon Gulf and West New Britain culture area. This area seems to embrace the Bali and Vitu Islands in the east, Kombei, Kaliai, Bariai, Kilenge, the Siassi Islands, the Tami Islands and some coastal cultures of the Huon peninsula (Dark, 1973, 51; Harding, 1967, map on p.262). However, as the Kilenge are primarily agriculturists and fishermen their role in the trading system is more a passive one in contrast to the role played formerly by the people from the Tami Islands and in modern times by those from the Siassi Islands. These are the real seafarers and the aggressive overseas traders. Harding has

analysed in detail the trading system. According to him the products of trade include several foodstuffs, craft goods like earthenware pots, wooden bowls, hand drums, bows and arrows, and valuables like boars' tusks, dogs' teeth, turtle-shell bracelets and shell money (Harding, 1967, 27-60; 131-32). However, there also existed, and up to a degree even exists today, a dispersion of an 'artistic tradition' closely linked with and probably even superimposed on the trading system as described by Harding. The centre from which this 'artistic tradition' emanated seems to have been the Tami Islands. Even today older people in Kilenge still refer respectfully to Tami as the place where their fathers and grandfathers went to acquire a really 'good' drum, or a mask, or a taro ladle. Analysis of museum collections made around the turn of the century and afterwards demonstrates that many of the art forms found today in Kilenge have or have had their counterparts in the Tami region, the only clear exception probably being the neckrests which abound in Tami, but which are completely absent in Kilenge.

We have insufficient information to state with certainty that aside from the actual art *forms* their original meaning and function, in other words, their *content*, was borrowed and assimilated. This seems not unlikely, however, since Harding has explained that an important, if not essential aspect of the trading system in the Huon Gulf-West New Britain culture area was the kinship ties with which the important traders were linked with their trading partners across the whole area (Harding, 1967, 158-64). Trading parties often had to stay for relatively long periods *en route* waiting for the turning of the trade winds to bring them back to their ports of origin. During such a forced detention the traders very likely not only had a chance to establish or to reinforce kinship ties, but also had ample time to familiarise themselves with the art forms and their meaning and function.

One of the aspects of the cultural context of the arts thus diffused seems to have been the concept of the *namos tame*, the master artist. In 1967, when Philip Dark and I were doing fieldwork among the Kilenge, some of the older Big Men still remembered the names of a few of the *namos tame* from the Siassi Islands. Dark has stated that the concept of *namos* refers to something beautiful, something good or aesthetically pleasing, and hence in a way comparable with the Western concept of 'art' (Dark, 1974, 19). However, there is probably more to the Kilenge idea of *namos*. Dark refers to the aspect of 'skill' needed to perform a good work of art in the eyes of the Kilenge: 'the application of skill and knowledge according to aesthetic canons, resulting in the production of works of art' (Dark, 1974, 19). At Kilenge in 1970, for example, I filmed in great detail the performance with *nausang* masks, taking close-ups of the masks while they were dancing and occasionally following them in their movements in close-up. As I was reloading the camera after one such shot, Makele, himself a well-known carver, came to compliment me in saying that I, too, was a *namos*

tame. Earlier, in 1967, I once had to do some repairs on a tape-recorder. While I was busy with screwdriver and pliers, Talania, who had been watching me silently for a long time, finally exclaimed that I, really, was a true *namos tame*.

If one puts together the scraps of information we have about the *namos tame* one gets a picture, somewhat vague, of a universal artist, a primitive Michelangelo; at one and the same time a master carver of wood and of turtle-shell armlets; an excellent executor of the painted designs on canoe prows, on the side-pieces of the big *vukumo* mask and on the triangular headpieces of the *sia* dancers; the designer of the *naulum*, the ceremonial men's house, and the supervisor of its building operations; the best man to arrange both tastefully and securely the hundred or more long, slender sticks each with a small tuft of feathers fixed at its end, which together are to form the crest of the *vukumo* mask; the man to create the intricate decoration of white cockatoo feathers on the top of the triangular headpieces of the *sia* dancers; a gifted dancer, drummer and singer and probably also a renowned magician knowing how to cast spells and how to use herbs for good or for evil.

Among the Kilenge each village has a number of *namos*, or artists, though one perhaps should better call them craftsmen instead of artists. The Kilenge recognise that not all *namos* are equally good in all the artistic activities described above, that some are good canoe builders, but do not know how to paint the proper design on its prows and so forth. Only the rare artist who excels in all or in many of the arts, and whose skills are recognised by everyone, is considered worthy to be called *namos tame*. With the epithet goes a considerable amount of prestige. Still, among the select group of *namos tame* some are held in higher esteem than others. It is hard to say what could have been the original reason for the difference in rank among the *namos tame*. Probably it was a combination of underlying factors, his artistic qualities, his magic power, the social status of the family group to which he belonged and maybe even his personality. Really great *namos tame* are nowadays no longer to be found among the Kilenge, partly because the *raison d'être* of much of the art is fading away in Kilenge society, but partly probably also because one gets the impression that the truly great masters are to be found in the past, that their greatness in fact is to a great measure a function of history.

Talania, or, to give him his full name, Talania Aritio, is one of the top artists of Ongaia, one of the sub-villages of the Kilenge group (Fig. 1). Dark has written about him: 'a "deep" character; slow but considered, reserved but profound; an intellectual, who demanded of himself the exact emotion for the right artistic act' (Dark, 1974, 20). Though one of the top artists of Kilenge, he is perhaps not quite a *namos tame* in the classic Kilenge sense. This could be because he is not one of the really Big Men in the village. He has to take orders from more influential men: from Chief Tule to make him a wooden *nausang*

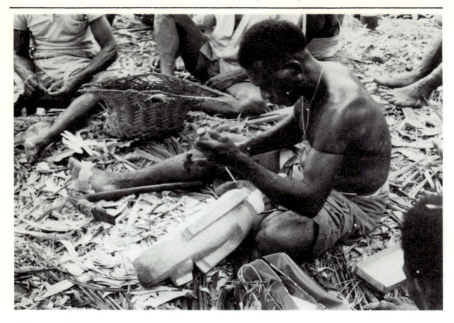

Figure 1. The master artist (*namos tame*) Talania of Ongaia village, Kilenge, West New Britain photographed in 1967 while working on a *nausang* mask. Talania is using a modern European hammer and chisel while in the background are visitors from neighbouring villages who have come to admire his work. (*Photos: Figs. 1, 3-7, by A.A. Gerbrands*)

mask (which Chief Tule then sold at a good price to a white collector); from Chief Navonna of the Waremo sub-village to take charge of a workshop where several men had started carving *nausang* masks hoping to sell them the same way they knew Chief Tule had succeeded in doing (but the scheme collapsed because most of the men had little if any artistic talent); from Paramount Chief Aisapo to assist in the building of a new men's house (*naulum*), to execute personally part of the woodcarvings that were to decorate the new building and to supervise the carving by other *namos*; from one of the chiefs of the sub-village of Ulumainge to shape for him the hull of a new dugout canoe and to paint its prows with the correct designs; to arrange for that same chief the feathers of the white cockatoo in his headdress for the *sia* dance.

Talania, however, has not always accepted these orders without protest. Sometimes his reluctance has been simply because he was not in the mood, or because he had planned to go working in his gardens, but occasionally also for reasons of aesthetic prestige, as in 1967, when he participated in the building of the new men's house in Ongaia under the direction of Paramount Chief Aisapo. Aisapo was not a bad carver himself; he had decided that the carved wall planks were to be decorated with mythological crocodiles, each with its distinguishing features, like a specific arrangement of the basic colours red, black

and white, or objects they held in their mouths (a pig, a man's leg, and so forth). There were to be eight of such planks, one on either side of the entrance which was made in the middle of each of the four side walls of the square building (Fig. 2).

Figure 2. Ongaia: ground plan of the new men's house showing the four entrances and the position of the eight carved wall planks.

The carvings on the planks represented mythological animals which 'belonged' to the sibs (*namon ainge*).[1] Their emotional value was much like that of an heraldic animal on a coat of arms, with little if any totemic significance. Inside the *naulum* the sibs had their simple bamboo sitting- or sleeping-benches behind the planks carved with their respective animals.

Originally, the eight planks were all to be decorated with mythological crocodiles, except for one, which 'belonged' to the family of the late *namos tame* Maracos and which was to carry that family's emblem, a double-headed lizard called Palogiva. The planks were cut from trees with axes and adzes. To facilitate transportation out of the jungle down to the beach of Ongaia, much of the rough shaping of the planks and the designs was done on the spot in the jungle. Here Aisapo and under him Talania were directing several men working on the planks, using charcoal to sketch the outlines of the animals on the planks. Talania had already been showing signs of reluctance to obey the directions given by Aisapo and when he came to work the plank of

1 The social organisation of the Kilenge is basically one of a dual organisation into exogamous patri-sibs. The local term for sib is *namon ainge*, meaning 'big bird' or 'arch-bird'. Each *namon ainge* has a head, called *natavolo*. The position is hereditary in that the first born of a *natavolo* succeeds his father; if the first born is a daughter she is given the title of *nagarara* and her oldest brother will be named *natavolo*. The *natavolo* is the principal of the main men's house or *naulum* of his sib or *namon ainge*. A *namon ainge* may have several men's houses, though today, in most villages, only one men's house is found and it will be shared by the *namon ainge* of the whole village (Dark, 1973, 63 and note 15).

his own family group, instead of sketching yet another crocodile, he drew a *naurama* design, that is, two human mask faces of the *nausang* type, interconnected by a double headed serpent. As soon as Aisapo got word that Talania was about to carve a *naurama* instead of a crocodile, he flatly forbade Talania to use that design on his plank, as his family did not own the 'copyright' on it. Talania maintained that in this case the question of 'copyright' was not relevant, because in his opinion the *naurama* was a free design which could be used by anyone wishing to do so. For half an hour or so the two opponents argued about the matter, or more precisely they spoke in a low voice to people standing nearby, avoiding addressing each other directly. In the end Aisapo won and Talania stopped the work on the *naurama* design. He sat down sulkily and it was not until many days later that he started to carve a new plank, without, however, yielding completely to Aisapo's wishes, for, instead of the crocodile Aisapo had wanted him to carve, he made a beautiful shark. He copied it from a cardboard carton on which it figures as the trademark of a certain make of Scandinavian chisels. This time Talania won, for indeed this now was an original and totally non-copyright design! At the same time it fitted well within the general stylistic system, as there was little trouble in finding a story in which a shark played a role of some kind or another. Some weeks later, when the *naulum* was ready, Talania turned back to the original plank on which he had started the condemned *naurama* design. He finished it in a few days and sold it to the author. It is now in the Rijksmuseum voor Volkenkunde, Leiden.

Another occasion when Talania got quite upset was during the initial stages of the rebuilding of the Giginge Ulumainge *naulum*, one of the two men's houses in the sub-village Ulumainge. This *naulum* had been demolished many years ago and had never been rebuilt. All that remained was a number of large stones on the fringes of an empty area near the shore in the middle of the village. Some of the stones were ritual seats on which *nausang* masks were propped up during their appearance. Other stones, it was told, had been brought there from high up in the mountains by mythical founding heroes of the *naulum*.

In June 1973 the Big Men of the *naulum* decided that the men's house was to be rebuilt. The first steps in its reconstruction were the cutting of two house-posts which were to support the roof-beams. The posts were some 5 metres long and were placed some two metres apart in the middle of the square ground-plan of the *naulum*. Two holes were then dug in the sandy beach, to take the upright poles. It is essential that the poles are the same length once they stand upright. To this end the holes have to be equally deep and the poles have to be cut to the same length before they are put upright in the holes. In theory all this sounds both simple and obvious. In practice, however, it means that often one of the poles turns out to be higher than the other once they have actually been erected. It is for this reason that usually a *namos tame* is requested to supervise these critical building operations.

In this way, Talania was called up. However, when the Master arrived on the building site, other people had already started and, as was to be expected, one of the poles stood about 50 centimetres higher than the other! Talania was furious and, sneering at the amateur architects, refused to raise a finger to help them. But after they had lifted the longest pole out of its hole and had clumsily started measuring its length, the length of the pole still standing and the depth of the hole, and all this amidst a heated debate with much shouting back and forth, Talania could stand it no longer. He pushed away the crowd and started to work silently and with assurance. With a minimum of words he took the necessary measurements using a long stick as a yardstick. Quietly he gave instructions how much to deepen the hole, and finally stood aside self-assured and proud when at last the two poles stood upright again in the sandy beach, this time of precisely equal height.

Unlike Talania Nake was not a *namos tame* but only a *namos* and was very likely always to remain one (Fig. 3). Dark has characterised him as 'nervous, a fidget, a cork that bobbed on the waters of everyday life, quick to feel passing nuances and to turn them to his advantage; in fact Nake was a bit of an operator, but, when engaged with his art, a different man, a man solely concentrating on the work developing under his hand. Nake was the laboured impressionist' (Dark, 1974, 19-20). He lived in the Potne sub-village with his wife Koko and a number of children. Their oldest son was soldier in the army and was stationed at Madang on the New Guinea mainland. Socially speaking the family held a marginal position. On the one side Nake very much

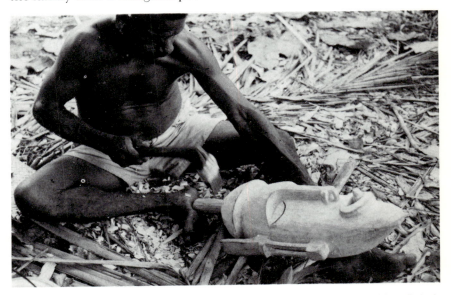

Figure 3. The artist (*namos*) Nake of Potne village, Kilenge, West New Britain photographed in 1967 while working on a *nausang* mask.

wanted to be a Big Man, though on the other side he knew perfectly well that he never would achieve that status, born as he was of a small family in Kumbalup village on the north-east coast of Umboi Island. He knew he had to manoeuvre cautiously so as not to attract too much attention and hence the jealousy of the Kilenge notables, yet he so much wanted to be big and important like them. Seen against this social background, it becomes understandable why Nake tried time and again to find compensation elsewhere, especially by seeking contact with outsiders like anthropologists visiting the village, arranging special performances for them, or adding to traditional performances peculiar new features.

The ambivalence of his attitude also manifested itself in the fact that he seldom failed to show up during a traditional festivity organised in his own Potne village or in neighbouring Ongaia. When, however, he thought it time to organise something himself, as for example to celebrate the occasion of his soldier son coming home on leave to marry a village girl, he preferred to entertain in the White Man's way, that is, he organised a so-called 'sing-sing Rabaul'. This implied that he provided more beer and whisky than he could afford and that he invited young people to dance the twist to the music of guitars or of a tape-recorder.

As a consequence he showed a lively interest in exploiting every possible opportunity of making money. He was an active member of the local co-operative, but he did not hesitate to sell his copra to the mission when the Father offered higher prices. Also he had realised quickly that good money could be made out of the sale of artifacts to whites, be they officials passing through the area, visiting missionaries, plain tourists, or anthropologists. He had his first experience of such sales in 1966 when Philip Dark asked him to carve a drum. Though he readily accepted to do so, he ran into trouble when it came to decorating the centre part of it with the same *naurama* design already mentioned. He could only solve this problem by asking Talania to do the design for him (Dark, 1974, 41 and Figs. 99, 100, 101). The second time he had to seek Talania's assistance was in 1967 when he had offered to sell me a drum too. When asked what kind of decoration I preferred to have on the centre part of his drum, I selected a stylised *nausang* mask face such as appeared on a turtle shell armlet he had in his possession. Nake reluctantly confessed that the design was too difficult for him to execute, but that he would ask Talania to do it for him. Talania indeed did one face, after which Nake copied the others from the one Talania had done. All Talania got from this was a feeling of superiority, for, as Dark remarks 'Talania is giving him a hand partly because he is a friend of Nake's and partly because artists help each other out' (Dark, 1974, 41).

Talania had already given Nake a hand somewhat earlier, in 1967, and the assistance on this occasion was very far from insignificant. Early that year Dark had patiently exercised gentle persuasion on

Talania to carve a wooden mask of the *nausang* type. He had for a long time been very reluctant to do so because for Talania to carve a *nausang* for purely 'profane' reasons was something which could not be done easily. At long last, however, he had given in and promised to carve one. He also agreed to have the whole process documented by still photography and on movie film.[2]

When the day came to go to the forest to cut the tree which was to provide the wood for the mask, not only Talania appeared but Nake as well. Having been told by Talania about the venture he had quickly seized upon the opportunity to join and thus to learn how to make *nausang* masks under Talania's guidance. For this indeed was an excellent opportunity, as Nake had never carved a *nausang* before, and Talania was known to be very good in carving masks. Moreover, Nake smelled money: wasn't it agreed that Talania's mask would be bought from him? So, why not make a second one at the same time, it surely would be bought too! Talania accepted Nake's intrusion with the same, almost paternal benevolence he had shown before when Nake came to him for help because he was at a loss as how to execute the decoration on the drums.

The two carvers started to work in a secluded spot, hidden from the women (Fig. 4). There was little if any formal teaching by Talania.

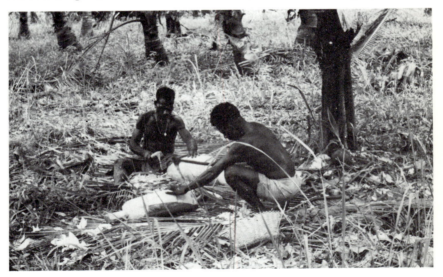

Figure 4. Talania (left) and Nake carving *nausang* masks in March 1967.

2 *Nausang* masks are wooden masks representing superhuman beings. They are very sacred and secret. Even today women and uninitiated boys are not allowed to see the masks. *Nausang* perform at the circumcision of a Big Man's first born son and in former times, they were powerful and dreaded agents of social control. Each mask bears a distinguishing design painted on it in black, red and white. An individual, man and woman alike, inherits the right to use the design from the ancestors, usually preferring the one that was inherited through the most powerful line (Gerbrands, 1972).

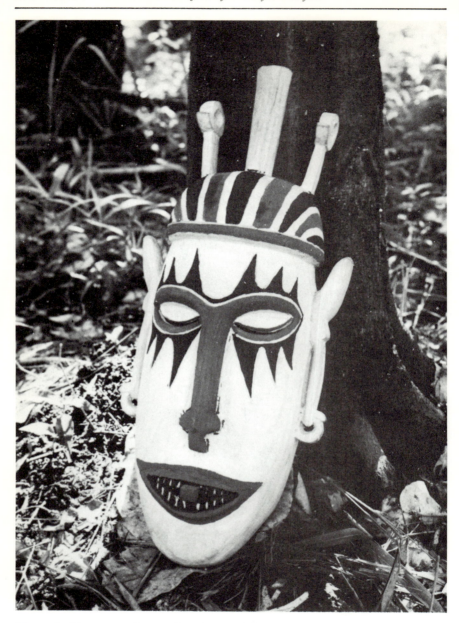

Figure 5. *Nausang* mask carved and painted by Talania. The mask is now in the collection of the Rijksmuseum voor Volkenkunde, Leiden.

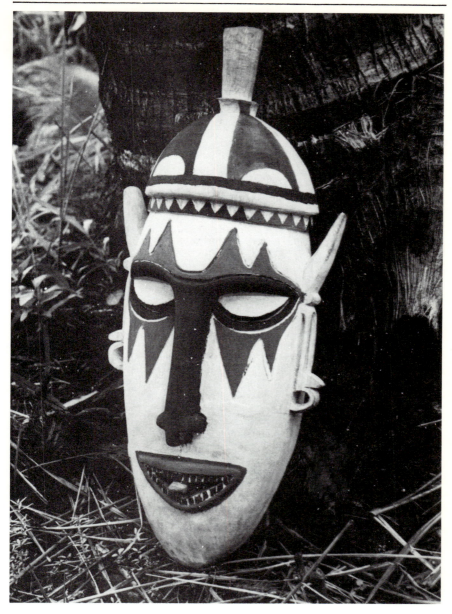

Figure 6. *Nausang* mask carved and painted by Nake. The mask is now in the collection of the Rijksmuseum voor Volkenkunde, Leiden.

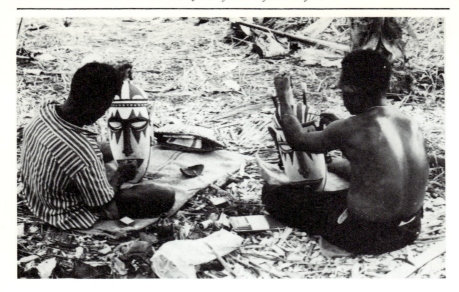

Figure 7. Talania (right) and Nake painting the completed *nausang* masks.

Nake, being a trained carver, knew already how to use his tools: axes, adzes and chisels of various sizes. He worked a bit slower than Talania, watching him out of the corner of his eye and once in a while, but rarely, asking his advice. Usually Talania answered with a few words only, pointing rather vaguely to where Nake should take away some wood. Only at the very beginning did Talania take the trouble to outline with his fingers the shape of the mask on Nake's piece of wood. On one occasion, when Talania was absent for a short while, Nake quickly copied with the help of a length of grass the dimensions of Talania's mask and transferred these to his own mask. After about three weeks of intermittent work the masks were ready, painted with the proper designs and decorated with fresh leaves and a feathered stick (*nasale*) stuck in the upper part of the mask (Fig. 7.) Comparing the two masks one had to admit that the quality of Nake's mask was not much less than Talania's. Which indeed was no mean achievement for a *namos* who had never made one before! Nake had been right in his surmise: I acquired his mask, and at the same price as Talania's. Both masks are now also in the Rijksmuseum voor Volkenkunde (Figs. 5 and 6).

The Big Men of Kilenge had been watching the enterprise with keen interest, especially the financial outcome of it. When it became clear that the author had indeed bought the two masks, Chief Tule immediately used his power to order two other masks which he in turn also sold to me. This time, however, the carvers did not receive any payment except for the food they were given during the days they worked on the masks.

Nake, having learned how to carve *nausang* masks, soon started a business of his own. First he made a mask for one of his friends in the Kurvok sub-village, a man also named Talania. He kept the mask for his own use, being an ardent *nausang* dancer. Then Nake made himself a secluded workshop behind his house and started making masks on order mainly for whites. By 1973 two of these workshops existed in Kilenge-on-the-Beach. One was independently run by Nake for his own profit, the other was managed in a more professional way by members of the family of the famous *namos tame* Maracos who had died in 1965. One of Maracos' sons, Joseph Ailama, more or less successfully tried to sell the masks their workshop produced to curio shops and museums in Papua New Guinea, in Australia and elsewhere. The family had even acquired a Polaroid camera with which they planned to take photographs of the masks and send these to prospective buyers. The main carver was Maracos' other son Makele, a sensitive middle-aged man and a gifted artist, as was his colleague and friend Talania. As he was a severe asthma sufferer, however, his poor health prevented the workshop from producing large numbers of masks, at least of masks having a certain quality. For when Makele suffered one of the long and severe attacks of his illness, others tried to carve, but mostly failed to produce anything but the poorest junk, which was, however, still sold occasionally to an ignorant tourist looking only for a nice piece to decorate the walls of his home.

The other 'traditional' aspect of this enterprise was that most of the money received from the sale of masks was to be handed to Pareki, who was the most important member of the Maracos family (his father had been an older brother of Maracos). Unfortunately no information is available about the number of masks produced and sold by these two workshops. A very rough guess would be a mask a month by each of the workshops at the most, but probably it was much less.

REFERENCES

Dark, P.J.C., (1969), 'The changing world of the Kilenge, a New Guinea people', *Lore*, 19, 74-84.

Dark, P.J.C. (1973), 'Kilenge big man art', in A. Forge (ed.), *Primitive Art and Society*, London, 49-69.

Dark, P.J.C. 1974), *Kilenge Life and Art: A Look at a New Guinea People*, London.

Gerbrands, A.A. (1971a), *Dance of the nataptavo masks*, 20 minutes 16mm colour film.

Gerbrands, A.A. (1971b), *Vukumo mask, construction and performance*, 17 minutes 16 mm colour film.

Gerbrands, A.A. (1971c), *Sia chorus*, 20 minutes 16mm colour film.

Gerbrands, A.A. (1972), *Nausang masks, Part 2: Performance*, 35 minutes 16mm colour film. All four films were produced and distributed by the Foundation for Film and Science, Utrecht, Netherlands.

Harding, T.G. (1973), *Voyagers of the Vitiaz Strait*, Seattle and London.

Thurstan Shaw

The art of Benin through the eyes of the artist, the art historian, the ethnographer and the archaeologist

A 'work of art' is produced by an 'artist' (even if he has assistants there is usually one controlling mind and sensibility) at a particular point (or in a limited period) of time, in a particular 'culture' and for a specific purpose. Works of art are discoursed upon by other artists, by art critics and by art historians; in the case of the works of art of preliterate societies, those discussing the works of art belong to cultures other than those that created the art; the Edo, for example, never saw the works of art of Benin 'nor regarded them in the manner we do' (Dark, 1973, 27); for the understanding of such works, therefore, ethnographers and archaeologists are also involved. Thus while the production of a work of art is a unity, a single entity, our specialisation in different branches of knowledge and expertise means that preliterate works of art are looked at with different eyes by the artist, the art historian, the ethnographer and the archaeologist. I am not here speaking of changes in attitude towards an alien art, such as the difference in attitude towards the indigenous art of Africa and Oceania among artists and art-critics in the eighteenth and twentieth centuries respectively. I am speaking of the different ways in which different contemporary disciplines approach preliterate works of art and arrive at different statements. These differences can be illustrated from views which have been expressed concerning the art of Benin.

It will be recalled that this art, while receiving cursory mention by earlier European visitors, was virtually unknown outside Nigeria before the British Punitive Expedition of 1897, the members of which systematically removed all they could find. This large corpus of material, amounting to some seven thousand objects according to one estimate (Williams, 1974, 176, quoting Fagg) has been the subject of extensive description and study.

Von Luschan (1919) began the process of attempting to order a sequence of Benin styles and the process was further elaborated by

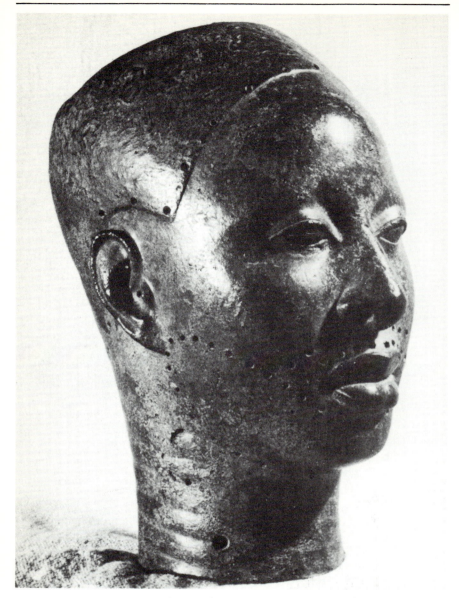

Figure 1. Wunmonije Compound, Ife: bronze head, ht 28.9 cm. (*Ife Museum; photo: Frank Willett*)

Struck (1923). In 1934 Egharevba (confirming Talbot, 1926) published his *Short History of Benin* in which he described the founding of the Oranmiyan dynasty from Ife and the introduction thence of the art of brass-casting by the Oba Oguola. Egharevba placed this *oba* in the later part of the thirteenth century, but as a result of his

ethnographical work Bradbury proposed a shorter chronology (1959, 286) which put his reign some hundred years later. Following the hint of the Ife connection, the sculptor Leon Underwood suggested (1949) that the earliest Benin heads were those most closely resembling the Ife ones (Fig. 1). This became the starting point of a chronology worked out by the ethnographer William Fagg (1958) which he later modified (1963) in acceptance of Bradbury's chronology. Fagg's 'Early Period', containing the most naturalistic types of memorial heads, lasted from the beginning of the fifteenth century until the mid-sixteenth century, with the ensuing 'Middle Period' terminating with the end of the seventeenth century. This 'Middle Period' contained heads with high collars or chokers but is above all the period of the plaques, which often show Portuguese soldiers in sixteenth and seventeenth century attire; Fagg bases his ending of the period of plaques on the basis of the historical references in Dapper (1676), where they are described in position on palace pillars, and in Nyandael (Bosman, 1705) where, according to Fagg, they are not. He

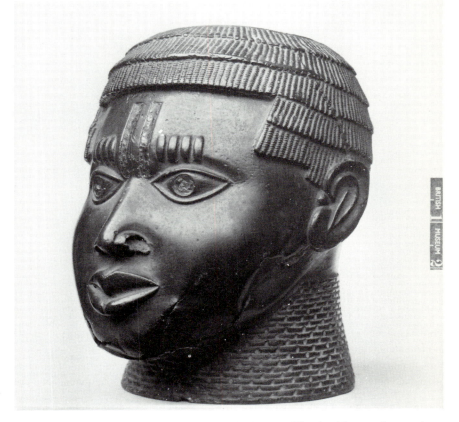

Figure 2. Benin bronze head, Dark Type I, ht 21 cm. (*Nigerian Museum, Lagos; photo: courtesy Trustees of the British Museum*)

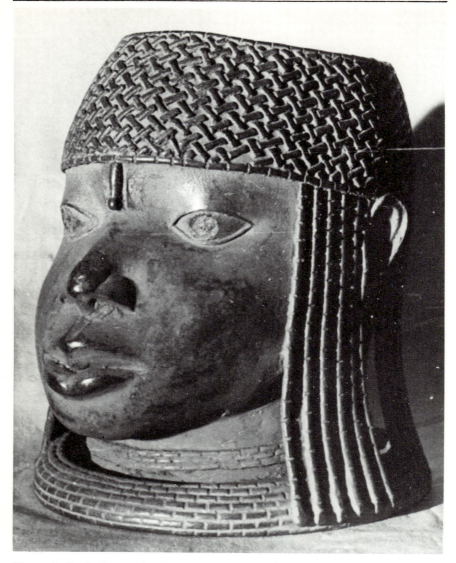

Figure 3. Benin bronze head, Dark Type II, ht 21.5 cm. (*Royal Scottish Museum, Edinburgh; photo: P.J.C. Dark*)

has therefore assumed that by this time the plaques were removed and put in the store-rooms where they were found some 200 years later and that none were made in the eighteenth and nineteenth centuries. Fagg's 'Late Period', covering the eighteenth and nineteenth centuries, contains the most massive and most conventionalised types of heads, including those with winged head-dresses introduced, according to oral tradition, by Oba Osemwede, 1818-48. Dark (1970, 1973), the principal art historian of Benin, follows virtually the same

scheme, but he has elaborated it, dividing the heads into a succession of those with:

(i) High collar under chin: fourteenth-fifteenth century (Fig. 2).
(ii) Rolled collar; 'heads of the olden days': first half of sixteenth century (Fig. 3).
(iii) High collar without flanged base: late sixteenth and seventeenth centuries (Fig. 4).
(iv) High collar with flanged base: eighteenth century (Fig. 5).
(v) Winged cap: nineteenth century (Fig. 6).

There is always the possibility that the characteristics taken by Dark to be of chronological significance merely indicate a difference of meaning or subject. For example, Willett illustrates (1973, Figs. 12, 13) two Benin heads, of early type according to the Fagg/Dark scheme, said not to be memorial heads but to represent war trophies dated, according to oral tradition, to the late fifteenth and the middle eighteenth century respectively. The eighteenth-century head has characteristics which made Kenneth Murray doubt whether it was genuinely early and its metal composition may also be more consistent with the later date, so that 'the so called "early" heads may lack elaborate head-dresses because they represent vanquished enemies and *not*, as Dark and Fagg would argue, because they are necessarily earlier in time or close to Ife style' (Ben-Amos, 1974).

Dark also divides the plaques into three stages beginning with those with a background of a circled cross (Fig. 7), going on to those of low and medium relief on a foliated background (Fig. 8), and ending with those with medium and full relief on a foliated background (Fig. 9).

The validity of the Fagg/Dark scheme has been queried by Pasztory (1970, 1971) and Rubin (1970). The former observes that Fagg's terminology of Early, Middle and Late Periods 'is still unverified' (1971, 553). In a review of Willett's *Ife in the History of West African Sculpture*, Rubin castigates the author for accepting Fagg's thesis that the 'comparative naturalism' of the heads at Benin assigned to the early period indicates a connection with Ife and for attributing differences in style to the inexperience of the Benin craftsmen and their lack of understanding of their Ife models. 'Not only is the stylisation of these early period Benin heads supremely confident and unequivocal,' says Rubin, 'but their thinness and exquisite surface finish contradict allegations of incompetence in any form.' Thus on the internal evidence of the works of art themselves, Rubin denies the connection with Ife which Underwood first suggested, following Egharevba's publication of the oral tradition claiming the connection.

This connection has been disputed on other grounds and the principal modern historian of Benin has pointed out that the oral tradition claiming connexion with Ife is comparatively recent (Ryder, 1965). There is a tradition obtained earlier from the court historian

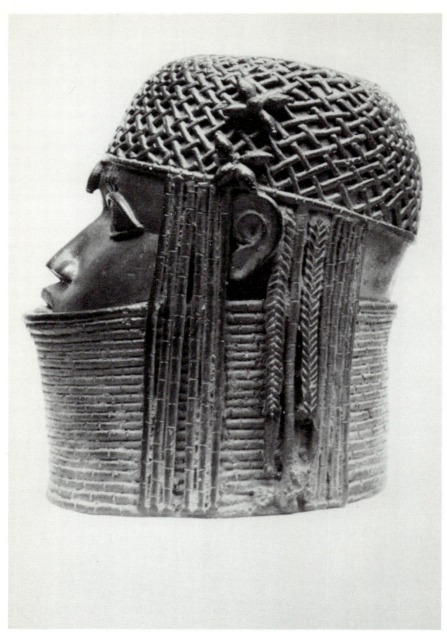

Figure 4, a-b. Benin bronze head, Dark Type III. ht. 24 cm. (*City Museum and Art Gallery, Bristol; photo: P.J.C. Dark*)

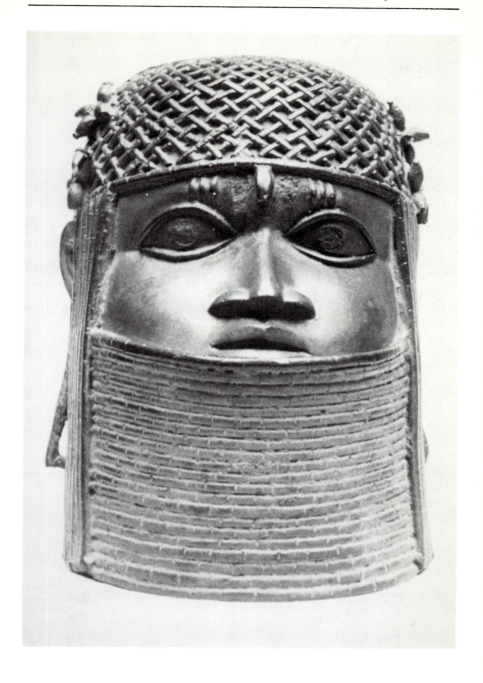

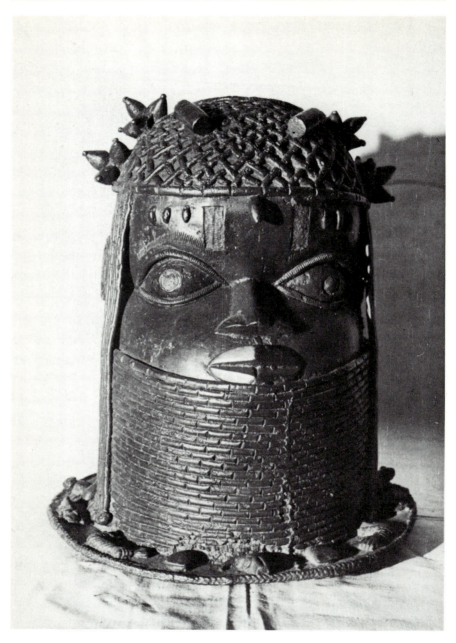

Figure 5. Benin bronze head, Dark Type IV, ht 24.8 cm. (*British Museum, London; photo: P.J.C. Dark*).

Figure 6. Benin bronze head, Dark Type V, ht 48.3 cm. (*Linden Museum für Länder und Völkerkunde, Stuttgart; photo: P.J.C. Dark*)

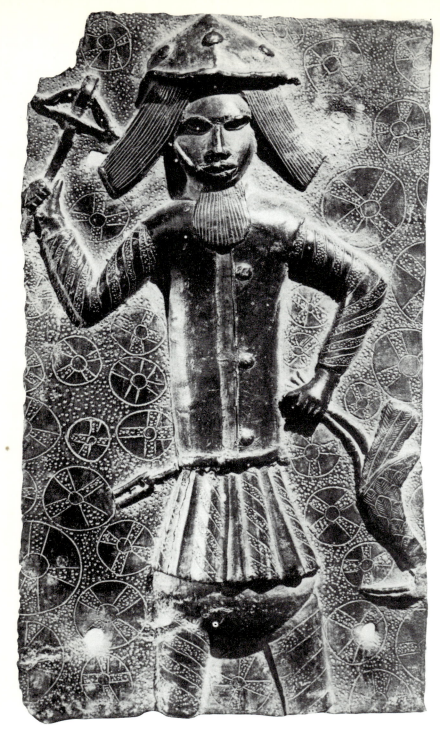

Figure 7. Benin bronze plaque, Dark Stage I, 34 x 18 cm. (*Coll. A. Schwarz, Amsterdam;*)
photo: Dr Wolf Strache, Stuttgart

and the master craftsmen of Benin placing the beginnings of brasswork in the reign of Esigie (early fifteenth century in Egharevba's chronology) and attributing it to a craftsman who came with 'the white men' (Read and Dalton, 1899, 6). One distrustful of oral tradition might remark that this tradition, recorded shortly after the Punitive Expedition, is as politically expedient to its time as the claimed Ife connection had become thirty years later (Talbot, 1926, III, 924). For four centuries of European contact before that there had never been any mention of an Ife connection (Ryder, 1965), unless one identifies Ife with the 'Ogane' to whom Benin owed allegiance and from whom the *oba* obtained insignia of kingship, according to traditions recorded in the sixteenth and eighteenth centuries (Mauny, 1956; Astley, 1745, I, 18). Such an identification requires some rearrangement of the points of the compass, as both accounts refer to the Ogane being to the east of Benin, whereas Ife is to the west. It is therefore misleading to say: 'one of the earliest accounts we have of Benin is that of D'Aveiro, in which he tells how the new king of Benin sent to Ife to be recognised as the proper heir' (Willett, 1968, 29), since Willett's identification of Ife with the Ogane is concealed in this statement, although he later admits (p.32) that Ife lies in the wrong direction. However he goes on to justify the identification on the grounds that Ife has been shown to be old enough to be ancestral to Benin because of radiocarbon dates in the sixth and tenth centuries at the site of Orun Oba Ado at Ife, according to a recent oral tradition the burial site of the heads of the *obas* of Benin. However, these dates and their context do nothing to prove the Ife-Benin connection; they merely indicate human occupation of the spot at the period indicated – which is nothing to surprise us.

Fraser (1972) has pointed to the difficulty of deriving Benin brass-casting from that of Ife due to the fact that the earliest Benin heads still differ considerably from those of Ife. 'Fagg is forced to posit a century-long gap or more between the end of the Ife influence and the earliest survivals from Benin', and the melting down of the earliest pieces. Fraser points out the self-contradiction in the theories and observes that they have been widely accepted 'on the basis of the existence of putative literary evidence and on the strength of Fagg's reputation'. Furthermore, excavations at Owo (Eyo 1972, 1974), between Ife and Benin, revealed the contemporaneous presence there of an art showing both the Ife style and the Benin style, in a time range radiocarbon dated to the fourteenth/fifteenth centuries. Thus it can be seen that the Ife-Benin connection, and the supposition that Benin learnt the art of brass-casting from Ife, is one of those 'working hypotheses which has evolved over time and become more or less ossified into "fact" by virtue of constant repetition' (Rubin, 1970).

Williams (1974) looks at the Benin canon through the eyes of an artist and equally rejects early indebtedness to Ife, while supporting the notion of interaction between the two centres in the seventeenth

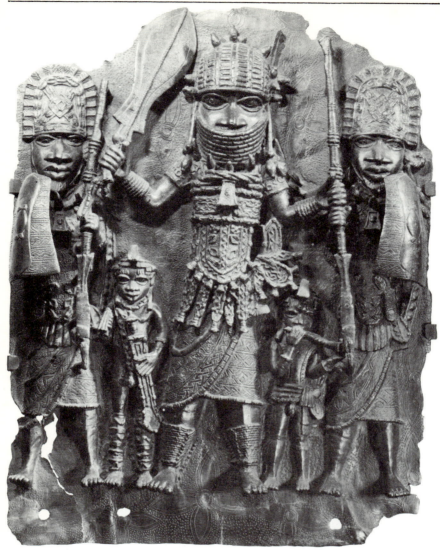

Figure 8. Benin bronze plaque, Dark Stage II: 49.2 x 36.2 cm. (*Coll. A. Schwarz, Amsterdam*; *photo: Dr Wolf Strache, Stuttgart*)

century. He denies that Dark's Type 1 heads represent the beginning of an artistic tradition, and considers Dark's chronology to be based on a combination of unreliable oral tradition and an entirely suppositious sequence of technical and stylistic features; for example he says there is no evidence for making the presence or absence of flanges on the memorial heads carry any chronological significance. While not suggesting that the Bini learnt the art of *cire-perdue* metal-casting from the Portuguese, Williams questions whether they were producing anything more ambitious than bracelets before 1485.

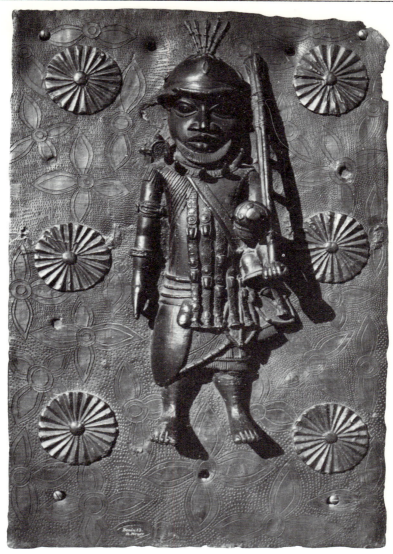

Figure 9. Benin bronze plaque, Dark Stage III. 54.3 x 37.5 cm. (*Coll. Peter Schnell, Zurich; photo: P.F.C. Dark*)

Similarly he rejects Dark's developmental series in the plaques, of early ones which are conceptually 2-dimensional and late ones which have low relief imposed on a flat surface, with intermediate ones in between.

Williams takes Lange's 'Law of Frontality' as his starting point, and argues from what he sees revealed as the history of the Benin artists' struggles with the technical problems of representation. He puts a different interpretation from Fagg on Nyandael's account of his

visit to Benin, understanding this to mean that plaques were still in place and that they continued to be manufactured into the nineteenth century. Williams sees the Bini artist, at the beginning of the seventeenth century, or at the end of the sixteenth century at the earliest, as still struggling with those formal-conceptual problems in the rendering of the human figure which would determine the nature of idiom in this corpus for the next three hundred years. Stage by stage the problems raised of finding plastic equivalents for objective visual and spatial experience resulted in the framing of the Benin canon, whose principles of frontality, bilateral symmetry, and rigorous eschewing of the arbitrary, once laid down, were never to be departed from. The bronze plaques represent the earliest essays of the Bini artist in the conceptualisation of objective experience. The results of experimentation in this medium were transferred wholesale to sculpture in the round at a period not significantly before the mid-sixteenth century. The nature of these essays in the three-dimensional sculpture of the period makes it seem unlikely, for Williams, that the casting of naturalistic bronze heads had been learnt from Ife at a prior date.

Thus Fagg and Dark see Benin art as 'taking off' from Ife, while Rubin and Williams emphatically deny this. Fagg and Dark place the plaques in a 'middle period' of two centuries ending in 1700, while Williams sees the early ones as the beginning of Benin art and the whole series persisting for four hundred years. While Dark divides them into three stages on formal morphological grounds, Williams sees in them an early 'Portuguese period' covering the sixteenth century, followed by a mature 'Hieratic' period with no stylistic development in which the formulae worked out in the earlier period are strictly adhered to.

Can the archaeologist provide any way out of this impasse? The answer is that he cannot until he can find in dated contexts a fair number of works of art comparable to the extant corpus. It is impossible to estimate what the chances for this are, but the prospects do not look bright. Contrary to Williams' assertion, excavation at Benin has not been extensive, and it is tragic that in the great surge of development of the capital city of the Midwest State in the years after the Nigerian civil war there has been no programme of rescue archaeology whereby every site in the old city which was to be built over was not first archaeologically excavated. So far archaeological work at Benin has failed to find any art objects comparable to those constituting the large corpus of collected objects, except for the finds made by Goodwin, who had two seasons of excavating (1954-55 and 1956-57) in the area of the old palace subsequently christened by Connah the 'Clerks' Quarters Site'. These finds consisted of the upper portion of a brass snake head, a plaque fragment and a bronze-handled iron dagger, but the context of their finding did not establish their dates of manufacture nor add anything to our knowledge of such

objects (Goodwin, 1963). In 1961 Willett dug on the site of the new Baptist Church but considered all he found to belong to the nineteenth century. Connah dug two further cuttings on the Clerks' Quarters Site, 12 ft x 12 ft and 29 ft x 12 ft, nineteen large cuttings on the Museum site, and one cutting 40 ft x 6 ft at Usama. These excavations, together with cuttings through the 'inner city wall' and the tracing of nearly a hundred miles of the earth rampart system around the city, have provided (Connah, 1963; 1972; 1974) a lot of valuable archaeological information – but have not thrown light upon the relative validity of the different schemes outlined above giving a temporal ordering to the works of art.

There is one line of research which archaeologists are pursuing and which might one day give a sufficiently coherent pattern to throw light on the Benin works of brass and other copper-alloys – and that is an analysis of the composition of the metal. At one time Fagg asserted (1963, 35) that the early Benin castings were of brass (copper and zinc) and the later ones of bronze (copper and tin), and in this was followed by Willett (1965, 81). However, it was shown (Shaw, 1970) that this belief was not justified by the evidence available, and further analyses of Benin objects give a different picture (Shaw, 1966; 1969, Werner, 1970; 1972, Wolf, 1968). In general, the majority of Benin pieces have proved to be of brass, but the only ones archaeologically dated to the thirteenth century are forty-nine manillas and bracelets excavated from the Clerks' Quarters Site and which are of tin bronze with little zinc and lead content, while the Ogba Road hoard objects, also excavated and dated to the nineteenth century, are of leaded brass. Attempts have been made to make use of the proportions of minor constituents (nickel, arsenic, antimony) to trace relationships between Benin and Ife and with reference to sources of ore outside Nigeria (Werner and Willett, 1975). It is certainly the hope that one day analyses of this kind may be used in this way, but possibly at present the attempt is premature: since we have no independent chronology of the Benin pieces and our knowledge of the composition of ore sources is not yet sufficiently extensive, there is a danger of circular argument. Lead isotope analysis, now being undertaken, may have a better chance of throwing light on sources of origin of the metal. Thermoluminescence, if reliable, may help (Willett and Fleming, 1976).

What, then, is the attitude of archaeologists to the art works of Benin? For the moment, in the face of disagreement among artists, art historians and ethnographers, it is best described as 'agnostic'. Archaeologists are perhaps more aware than others of the dangers inherent in a process of constructing a chronology purely on the basis of stylistic typology (Clarke, 1968, 131-229) and are inclined to consider the various 'periods' proposed for Benin art, not as historically or archaeologically established 'facts', but merely as working hypotheses for which they hope harder evidence will be

forthcoming in the future to provide confirmation, demolition or modification. After all, Dark and Williams cannot both be right, yet the lack of firm archaeological evidence enables both their positions to be maintained.

REFERENCES

Astley, T. (1745), *New General Collection of Voyages and Travels*, 4 vols., London.

Ben-Amos, Paula (1974), Review of Dark's 'An introduction to Benin art and technology', *African Arts* 8, 70-2.

Bosman, W.A. (1705), *A New and Accurate Description of the Coast of Guinea*, London.

Bradbury, R.E. (1959), 'Chronological problems in the study of Benin history', *Journal of the Historical Society of Nigeria*, 1, 4, 263-86.

Clarke, D. (1968), *Analytical Archaeology*, London.

Connah, G. (1963), 'Archaeological research in Benin City, 1961-1964', *Journal of the Historical Society of Nigeria*, 2, 4, 465-85.

Connah, G. (1972), 'The archaeology of Benin', *Journal of African History*, 13, 1, 25-38.

Connah, G. (1974), *The Archaeology of Benin*, Oxford.

Dapper, O. (1676), *Description de l'Afrique*, Paris.

Dark, P.J.C. (1970), 'Benin bronze heads: styles and chronology', Paper read to colloquium on African Art History, Boston University, 14 March.

Dark, P.J.C. (1973), *An Introduction to Benin Art and Technology*, Oxford.

Egharevba, J. (1934), *A Short History of Benin*, Lagos.

Eyo, E. (1972), 'New treasures from Nigeria', *Expedition*, 14, 2, 1-11.

Eyo, E. (1974), *Recent excavations at Ife and Owo and their implications for Ife, Owo and Benin Studies*, unpublished Ph.D. thesis, Ibadan.

Fagg, W. (1958), *The Sculpture of Africa*, London.

Fagg, W. (1963), *Nigerian Images*, London.

Fraser, D. (1972), Correspondence, *Art Bulletin*, 54, 2, 136.

Goodwin, A.J.H. (1963), 'A bronze snake head and other recent finds in the old palace at Benin', *Man*, 63, 142-5.

Luschan, F. Von. (1919), *Die Altertümer von Benin*, Berlin.

Mauny, R. (1956), *Esmeraldo de situ orbis par Duarte Pacheco Pereira*, Bissau.

Pasztory, Esther, (1970), 'Hieratic composition in West African art', *Art Bulletin*, 53, 299-306.

Pasztory, Esther (1971), Reply, *Art Bulletin*, 53, 552-3.

Read, H. and Dalton, O. (1899), *Antiquities from the City of Benin and Other Parts of West Africa in the British Museum*, London.

Rubin, Arnold (1970), Review of Philip Allison's *African stone sculpture* and Frank Willett's *Ife in the history of West African sculpture*, *Art Bulletin*, 72, 348-54.

Ryder, A. (1965), 'A reconsideration of the Ife-Benin relationship, *Journal of African History*, 6, 25-37.

Shaw, Thurstan (1966), 'Spectrographic analysis of Nigerian bronzes: postscript', *Archaeometry*, 9, 148-50.

Shaw, Thurstan (1969), 'Further spectrographic analyses of Nigerian bronzes', *Archaeometry*, 11, 85-98.

Shaw, Thurstan (1970), 'The analysis of West African bronzes: a summary of the evidence', *Ibadan*, 28, 80-9.

Struck, B. (1923), 'Chronologie der Benin-Altertümer', *Zeitschrift für Ethnologie*, 55, 113-66.

Talbot, P.A. (1926), *The peoples of Southern Nigeria*, London.

Underwood, Leon (1949), *Bronzes of West Africa*, London.

Werner, O. (1970), 'Metallurgische Untersuchungen der Benin-Bronzen des Museums für Berlin, *Baessler-Archiv*, n.f. 18, 71-153.

Werner, O. (1972), 'Uber die Zusammensetzung von Goldgewichten aus Ghana und anderen Westafrikanischen Messinglegierungen', *Baessler-Archiv*, 20, 367-443.

Werner, O. and Willett, F. (1975), 'The composition of brasses from Ife and Benin', *Archaeometry*, 17, 2, 141-56.

Willett, Frank, (1965), 'Spectrographic analyses of Nigerian bronzes', *Archaeometry*, 7, 81-83.

Willett, Frank, (1968), 'New light on the Ife-Benin relationship', *African Forum*, 3, 4, 4, 1, 28-34.

Willett, Frank, (1973), 'The Benin Museum Collection', *African Arts*, 6, 4, 8-17.

Willett, Frank and Fleming, S.J. (1976), 'A catalogue of important Nigerian copper-alloy castings dated by thermoluminescence', *Archaeometry*, 18, 2, 135-46.

Williams, Denis (1974), *Icon and Image*, London.

Wolf, Siegfried (1968), 'Neue analysen von Benin-Legierungen in Vergleicherder Betrachtung', *Abhandlungen und Berichte des Staatliche Museums für Völkerkunde*, Dresden, 28, 91-153.

III
SOME ETHNOGRAPHIC
EXAMPLES

G.N. Wilkinson

Carving a social message: the Malanggans of Tabar[1]

The Malanggan carvings of the Tabar Islands lying off the northern coast of New Ireland in New Guinea are composed of clusters of significant elements arranged upon particular forms such as poles, horizontal boards, wooden figures, figures with wooden heads and bush-material bodies, masks and so on. These elements individually bear different levels of significance, from the functional serrated struts (*vevem*) which support free carved elements, to the circular *kowarawar* motifs which bear a symbolic significance (as 'the eye of the fire', Fig. 3), carry magical powers, and serve to indicate to which malanggan 'family' the carving belongs. Such elements often carry ranges of connotation, which groups or individuals can offer as their 'meaning' – to the confusion of empirically-minded questioners. For example, when male visitors from other clans are invited to the 'public' display and pig-feast on the second day of the Malanggan ceremonies (the *Oror*), it is a matter of extreme bad manners to be found looking closely at the displayed malanggans: too open an interest in the hosts' malanggans would certainly lead to recrimination, and possibly retaliatory sorcery. All these elements are capable of rendering further significance to the outsider, as they reflect different aspects of the society which created them; its cosmology, technology, myths and even social organisation. It is the relationship between social organisation and malanggan carvings which I intend to consider here.

Each malanggan carving combines different elements in a fixed, as it were copyrighted, form: the pattern consists of this particular collection of units and rarely has an independent mythical or symbolic meaning. Only its owner can have it made for specific Malanggan ceremonies, when it will be displayed with other appropriate patterns

1 Field research was undertaken in two separate monthly visits to New Ireland and Tabar in 1970 and 1971. Finance was supplied from the University of Papua and New Guinea Research Grant to me as a Lecturer in Literature. For the purposes of clarity, I use a capital M for Malanggan when referring to the ceremonies or general rules, and a lower case m for malanggan when referring to the actual carvings.

to mark one of the important stages of life of a close member of the community (Fig. 2). The displays are in special enclosures and must accompany a pig-feast, a distribution of meat, and exchange of shell-money. Small ceremonies take one day, but important ceremonies, involving dances and masks, can last three days. In this paper my comments are limited to Malanggan as it functioned in the three islands of Tabar, where it is generally assumed to have originated. Malanggan was used in different ways on the mainland of New Ireland where it was adapted to many different types of social organisation (cf. Billings and Peterson, 1967, and Powdermaker, 1933).

The ownership rights of a pattern are acquired when the specific malanggan is on display. The original owner announces who gave him the right to make it, and to whom he is now giving the pattern. The recipient then makes a small payment of shell-money for the right (and indirectly the duty) to have the pattern made in the future. He may be the sole recipient, if the pattern is important to the clan, or one of a number, if it is less important. He normally acquires patterns from his mother's clan, into whose mysteries he can be initiated, and others from his father's clan which can only be passed back to that clan. Normally, the two clans will own different Malanggan families. There are at least twenty-one such Malanggan families in Tabar, each containing a full range of the recognised types which has its own specific function (though today such functions are not always observed, or even known). In one family, *Malanggatsak* for example, I recorded thirty-six different patterns belonging to a limited number of individuals.

The different Malanggan families share the use of most of the various elements such as animals, sea- and freshwater-life, birds, insects, and aspects of human social life such as canoes, spears and so on. They also share the representation of important ritual objects such as cuts of pig and *da* (coconut water bottles). These elements are largely not distinguished stylistically from one family to another, although certain types of these elements, such as birds, can predominate in the patterns of one Malanggan family and be largely excluded from another.

The families however are distinguished in their design of the human, and probably the supernatural figures. They are also clearly distinguished in all rituals involved in the Malanggan ceremony. Many families, furthermore, make use of a special motif which can appear on their patterns. This motif, known as *kowarawar*, is nearly always based upon the circle with a *kembiamat* 'eye' in the centre, and embodies the magical powers of the malanggan and its family. I should make it clear however that my information of many Malanggan families is extremely sketchy and does not extend to details – certainly not to details of motifs. The only information I gained in detail about a *kowarawar* in the field was on the *Valik*

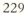

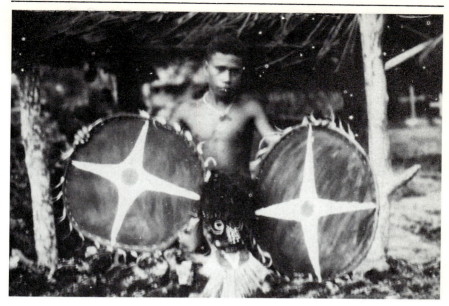

Figure 1. An *mbetarr Verim* mask, made for a Malanggan ceremony for I. Kanarou on Simberi Island, Easter 1970. The reason for the enormous ears (which bear the *Verim kowarawar*) is that the *mbetarr* is deaf to all appeals. Small masks like this one break loose before the big wooden *Verim* masks appear, and they wreak various kinds of havoc. The *mbetarr* chops down trees in the hamlet and cuts a special rope to 'free' the big masks so that they can appear. (*Photo: N. Wilkinson*)

mataling. My conclusions are therefore speculative analysis based on field-notes and observation. However, it seems to be the case that all the *kowarawars* are based upon the circle: conveniently, I do not know if the exceptional *Malanggatsak trokul* would be termed a *kowarawar*. The *Sosambwa* family's *kowarawar* consists of three concentric circles, while *Verim*'s has a four-point star which can create a pattern like four petals (Fig. 1), and the *Mandeis* family has a nine-point star, referred to by one informant as a sun (Fig. 2). The most complex *kowarawar* designs belong to the *Veveil* and *Valik* families. In both, the *kembiamat* is raised from the centre of the circle, and a bar divides the circle into halves. The *Veveil kowarawar*, known as the *simora*, has a looped black snake with white spots (*simora*) on either side of the bar, the loops forming concentric rings. The *Valik kowarawar*, 'the eye of the fire' (Figs. 3-4) has a second cross-piece dividing the circle into quarters which represents a burning stick; the loops and dog-teeth in the quarters represent the fire itself. This *korarawar* probably evolved from the *simora* snake, as the black lines with white spots form continuous loops within each quarter-circle.

There are some striking variations on this circular motif. The *Kulipmou* family has a round hole in the centre of its patterns, which is often used functionally by having birds 'drinking' at it as at a pool, or

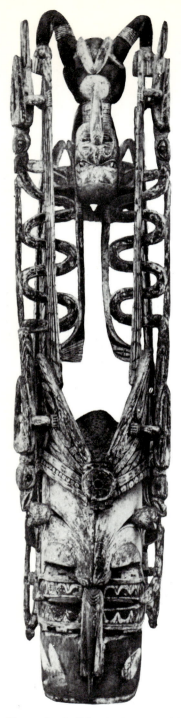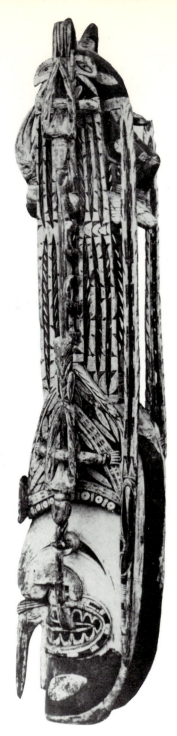

Figure 2. A 'Mandas' mask: this is presumably an enclosure mask used during initiation. The features represent one kind of *ges*. The *kowarawar*, which has lost it central *kambiamat* and is rather damaged, is in the middle of the *ges*'s bifurcated helmet (cf. Meyer and Parkinson, 1895). (*Photo: Ethnographisches Museum, Dresden*)

Figure 3. A drawing of a *mataling*, which is the *kowarawar* of the *Valik* Malanggan family. There are triangular openwork holes between the black polkadotted lines to enhance the flame-effect which in the original have been shallowly incised.

Figure 4. A *matur Valik* carved for A. Gemel of Simberi by E. Salle, and erected in an appropriate Malanggan-house on 15 January, 1971. The malanggan has fish at either end, surmounted by a pig's belly (*timborr*), from which emerge crayfish which bite the ends of the 'eye' of the *mataling*. Above the Valik is a *rorplipli Kulipmou*, made of sacking sewn over a ratten frame (in the past it would have been of bark-cloth). Its *kowarawar* is the hole in the centre. This *Kulipmou* should not have been placed on a *Valik* Malanggan-house, and special explanations and permission had to be publicly given, to allow it a place. The Valik is now in the British Museum. (*Photo: N. Wilkinson*)

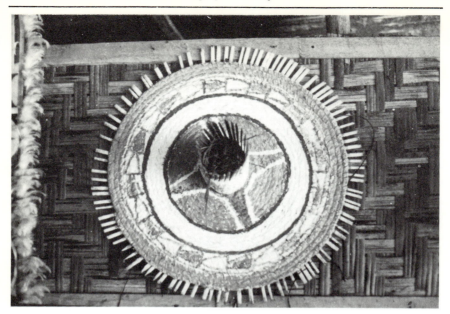

Figure 5. A *Wawara*, collect by P.H. Lewis at Lossu in New Ireland, and hung in the house where he resided. It is about 76 cm. in diameter. (*Field Museum of Natural History, Chicago; photo: N. Wilkinson*)

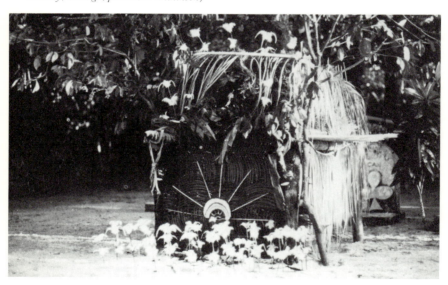

Figure 6. A *tchurur* or pigbed of the *Malanggatsak* Malanggan family, made for I. Mora of Simberi on 13 January, 1971 by S. Kona. In front of the legs of the *tchuru* are two *nggornggorsurinda* figures carved from fern-root. Between them is a *katsembeura Wawara*, representing the moon, placed against appropriate *Wawara* Malanggan family leaves: its presence required special explanation. The pig's snout can be seen emerging from the shredded palm-fronds, where it was displayed prior to distribution and consumption. (*Photo: N. Wilkinson*)

practically by having an initiate thrust his head through it in a coming-out dance (Fig. 13). The *Wawara* family, made of flat mats woven onto basketwork spokes, are normally totally circular (Fig. 5), though they can also be oval or even form a crescent (Fig. 6). The centre is a hole, sometimes with a protruding tube, and occasionally filled with a wooden carving. This Malanggan family is regarded as peculiarly dangerous, because different, requiring specially stringent purificatory rites.

In Tabar it appears, then, that the circle was considered the most significant shape. As the Malanggan system developed, many of the aesthetic possibilities inherent in the circle must have been explored for a specific purpose: to create individual yet similar elements which

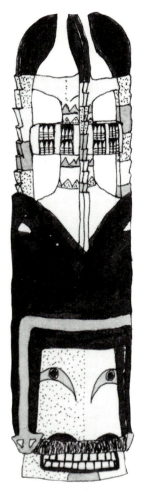

Figure 7. A *Malanggatsak* head, drawn from memory of a *tchurumbos* figure made by the late S. Kona of Simberi for his son, November, 1970. The figure measures 86 x 12 cm. and face is 14.6 cm. high. (*Papua New Guinea Museum, Port Moresby*)

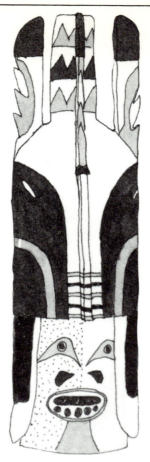

Figure 8. A drawing based upon a *Malanggatsak* head, about two feet high, collected by A. Bühler in 1930 from Pakinamberiu on Tatau Island. (*Museum für Völkerkunde, Basle*)

could serve to differentiate the patterns of different groups.

Something of the same exploratory process probably took place in the development of the figures: basic forms were developed and modified to create individualising characteristics. The figures represent supernatural and human beings. Though many types of supernatural being are represented, two predominate: these are *tangala* which are very small but immensely strong and are great fishermen, and *ges* which live in the bush and possess great powers of sorcery. *Tangala* are found in almost all families and are made for all important Malanggan ceremonies, because they take revenge upon any mischief-maker who interferes with the ceremony. *Ges* come in at least four different types but bear certain recognisable characteristics such as almond-shaped eyes, pierced noses, moustaches and so on. All figures with wooden heads and separate bodies (probably including

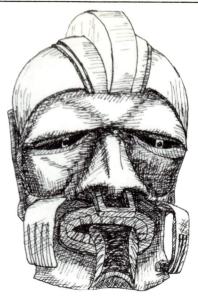

Figure 9. Drawing of a *koambat Maranda* which is over eighty years old, once one of a pair, which is in the possession of Songeis of Tatau village. It is unpainted, but for display the central crest is normally painted red, and the incisions on moustaches and tongue picked out in white: the rest is probably black. c. 91 cm. high

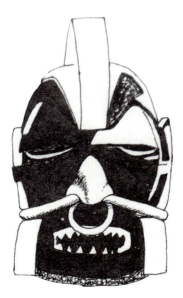

Figure 10. This drawing is based on a rather unclear photograph published in Krämer, 1925 (original now lost), which was probably taken by Walden during the Deutsch Marine Expedition 1907-9. The photograph shows a large *Maranda* figure with a wooden *koambat* head and black mud body, flourishing a spear. c. 76 cm. high

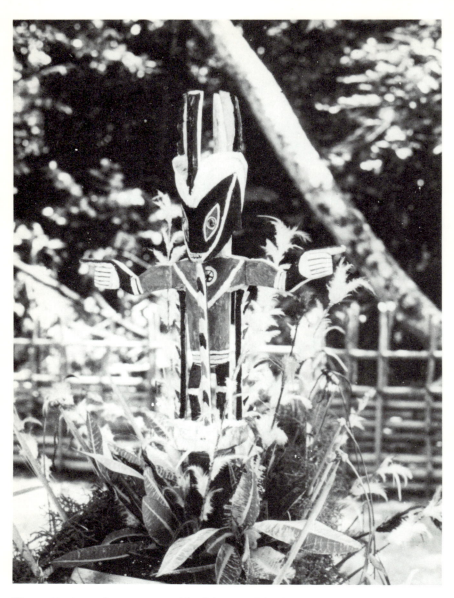

Figure 11. A *ges Songsong*, carved by Mogoto of Simberi for the A. Gemel funerary
Malanggan ceremony in January 1971. The pattern consists of two small *ges* in a
canoe. The triangular pattern on the chest is another characteristic of some *ges*.
The figure measures 78.5 x 47 cm. (*Photo: N. Wilkinson*)

masks) are *ges*. Moreover, certain families such as *Malanggatsak* and *Totombo* are comprised entirely of *ges*. Though much detailed information is lacking, two families which use only *ges* of very different types can be identified. The *Malanggatsak* family has a helmeted type, with a distinctive red snake, *trokul*, running round the helmet (Figs. 7 and 8). This type of *ges*-head is common outside the *Malanggatsak* family, but this family alone carries the *trokul*. The *Maranda* family's *ges* characteristics are revealed by the pierced nasal septum and the moustache. It was not the practice among the Tabar people to pierce the septums of their noses (though most *ges* have pierced noses): their only form of self-mutilation was to 'break' their ears with cuts. They also rarely wear facial hair: if they do, it is normally a beard, with or without moustache, worn by older men. The *ges* head-shape, with its central wooden crest, is the family's distinctive characteristic (Figs. 9 and 10). There are also small *ges* with triangular heads culminating in a mouth (Fig. 11); and a further kind with the face made of two flat panels, either square or almond-shaped, into which the eyes are set. These various types of *ges* are found in a number of Malanggan families, and probably all bear characteristic differentiating elements.

The human heads show more marked differences between families than the *ges*, as they depend upon the painted decorations and the material used for the hair. Human figures usually have a straight line for the brows, the eyes set deeply under them; the head is rounded and covered with hair of various materials (such as seeds, sticks or pith), or is bald, or wears a conical dance-hat. Though the hair material is copyrighted, the copyright can be shared by different Malanggan families. The face painting is distinctive; *Valik*, for example, has a black line with white spots circling the right eye and curving beneath the left (Fig. 12). This decoration is worn on the faces of full initiates during important parts of the ceremonies.

The various Malanggan families, therefore, hold the different categories of elements in common, and the range of these categories is large enough to leave enormous potential for variation even where some are excluded in particular families. Variation, where it marks family differences, lies in the detail (added or subtracted), thereby leaving the basic characteristics of the category intact. The differences can accordingly be regarded as essentially aesthetic rather than functional: they are a modification of design rather than a change in the form or of basic significance. Thus, E. Salle, when he was carving the *matur Valik* (Fig. 4), for his *mingutsh*, had never before seen a crayfish on a malanggan, but it was part of the pattern demanded. He thoroughly enjoyed the challenge of working out how to make an effective malanggan interpretation of a crayfish. He is, unfortunately, fairly exceptional.

In some of the Tabar origin-myths, malanggans were first given to individuals of two founder-families which then established four clans, each with its own Malanggan family. This reveals that clan-

ownership of Malanggan families is basic to the system. Today, there are many more clans than Malanggan families, so a number of clans necessarily regard one family as their own – into which their members can be initiated. An important aspect of Malanggan ceremonies is their assertion of clan individuality (though they are by no means the only form of individuation). Each clan, therefore, ensures that its malanggan patterns and ceremonials are distinct, even when they belong to a 'shared' Malanggan family. This is achieved by including, omitting or modifying small elements in the basic family design.

In the *Malanggatsak* family, two 'owning' clans live about fifteen miles apart, on different islands. Fig. 7 comes from Simberi, and bears much more detail: it has a fibre moustache, and on the column on the head (representing a stripped pandanus-fruit) there is a round belly of pig, *timborr*, and above it a star-shaped coral, *kevratz*. Fig. 8, from Pakinamberiu, not only lacks these details, but the characteristic *trokul* snake has been split down the middle. The latter is comparatively massive because it was made for a big-man's death, while the other was made for a child. There are other *Malanggatsak* variations observed, such as the addition of birds' heads, or variation in the painting of the eye-shape. These variations are all concentrated upon the heads, as these are the focal point of all malanggan patterns.

The differentiating detail on the figures of different clans owning the same family is again essentially aesthetically conceived as variations upon basic forms. They have been developed in order to reflect the social differences between clans. The malanggans are displayed in ceremonies in which all the main elements are held in common while differences in detail are emphasised. The cultural emphasis is upon variations of accepted norms of all phases, of diversity within uniformity. The ceremonies emphasise the qualities of the presenting clan, giving them status and prestige against other groups, while acknowledging their place within the society as a whole. The biggest displays are reserved for funerary Malanggan ceremonies, to which many outsiders are invited (although nowadays outsiders are invited to all Malanggan ceremonies). When a clan is 'on show', in effect, it presents its most spectacular patterns.

Within the clan, distinctions are also observed. Each clan is divided into sub-groups localised within individual hamlets. The leader of each group, the *mingutsh*, owns their most important patterns and organises the Malanggan ceremonies (often with other groups of his clan). Among the patterns he holds, some are on his own behalf and others on behalf of his group or the whole clan. The latter are usually the larger collections of units which allow for a variable number of figures. The *Kulipmou* in Fig. 13 is probably a *mingutsh's* personal malanggan, in that the two figures form a balancing aesthetic unit which cannot easily be added to. Smaller patterns can be owned by anyone in the clan, and usually have non-funerary purposes, such as induction into the father's Malanggan family (Fig. 12). The *mingutsh*

can also be an owner of a mask-pattern of the *Verim* family which are owned by important men in addition to their two normal Malanggan families – a sign of status which functions alongside the normal Malanggan system.

There are some members of a clan who have no patterns of their own (for whom the *mingutsh* holds the large patterns) and others who own a small number of unimportant types. Therefore the ownership of malanggan patterns marks social distinctions within a clan, distinctions which are not readily apparent in the patterns but which are reflected in their size and the importance of their function. Normally, a carver develops his own characteristic style as well as carving the forms as clearly as possible. However, the really large

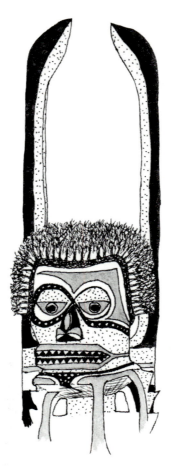

Figure 12. Drawing based on a *molangeniuwinepuris Valik* made by A. Salle for his son, January 1971 (later presented as a gift to the author). The figure has its head turned aside in anger, and is sometimes made to call back errant travellers. The hair is made of small fruits, dipped in red paint and pressed into a ground-bark gum. The head itself measures 16.5 x 10.5 cm., the whole figure is 74 cm. high

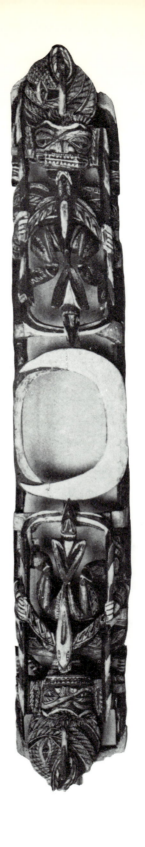

Figure 13. An 'awara' *kulipmou* collected by E. Walden from Mapua, Tatau Island. (*Photo: Museum für Völkerkunde, Berlin*).

malanggan patterns were carved by a team: a big *eguar* was erected in Simberi in 1957 to 'finish' the deaths of people who had died during World War II in the Sipiv clan (the Japanese fleet frequently harboured between Tabar and Lihir Islands). It was carved by the three greatest carvers of Simberi Island. In such a case, individuality of style would have been subordinated to the overall effect.

In the society of the Tabar Islands, therefore, it appears that aesthetic variations have been explored in carvings which have a central place in the culture's primary ceremony. They have been utilised to express the divisions by which the society was organised, along with other levels of meaning. Variety of detail was used to emphasise the identity of the owning group, so each carving can be identified as to clan and owner by the knowledgeable. The patterns also, in a different way, revealed the power-structure of their owning group. It has been commonly recognised that art works are often used, through factors of size and quality, to emphasise the social prestige of their owner or donor. It is less commonly recognised that art work can also reflect lateral, rather than vertical forms of social organisation. Nevertheless, the Malanggan material does demonstrate quite clearly how the Tabar society used aesthetic criteria to mark its lateral social divisions and this might be of some use in examining not merely the art works of other 'acephalous' societies, but also the art works of peer groups within a vertically-organised society.

REFERENCES

Billings, D. and Peterson, N. (1967), 'Malanggan and memai in New Ireland', *Oceania*, 38, 1, 24-32.

Groves, W.C. (1934-5), 'Tabar today', *Oceania*, 5, 2, 224-40; 6, 2, 147-57; 6, 4, 346-62.

Groves, W.C. (1936), 'Secret beliefs and practices in New Ireland', *Oceania*, 7, 2, 220-46.

Krämer, A. (1925), *Die Malangane von Tombara*, Munich.

Lewis, P.H. (1964), *The Social Context of Art in Northern New Ireland, Field Museum of Natural History*, 58, Chicago.

Meyer, A.B. and Parkinson, R. (1895), *Schnitzereien und Masken von Bismarckarchipel und Neuguinea*, Dresden.

Nevermann, H. and Walden, E. (1940), 'Totenfeiern und Malagane von Nord-Neuecklenburg', *Zeitschrift für Ethnologie*, 72, 11-38.

Powdermaker, H. (1933), *Life in Lesu*, London.

Wilkinson, N. (in press), *The Malanggans of Tabar*, London.

Joan M. Vastokas

Cognitive aspects of Northwest Coast art

The conception of culture as a 'cognitive' system, a conception which incorporates the view than an essential aim of cultural anthropology is to discover and to understand 'the organising principles underlying behaviour' (Tyler, 1969, 3), is a particularly promising one for the study of visual art and may provide the long-sought theoretical basis for a systematic and distinctively anthropological approach to its investigation. This paper, therefore, is an exploratory attempt at discovering the 'organising principles' or conceptual rules that shape and govern the art and architecture of the Northwest Coast Indians of North America.

The validity of any cognitive approach to art, however, depends upon its being an 'ethnoscientific' one (Sturtevant, 1964); in other words, the anthropologist must study a culture 'from the inside out rather than from the outside in' (Tyler, 1969, 20) and seek 'to discover and describe the behavioural system in its own terms' (French, 1963, 398). In this context, works of art must be recognised as not simply the by-products of a culture, nor as documents about a culture, but as a vital part of the totality of the culture itself. In brief, works of art do not imitate or represent culture, they are the culture.[1] Hence, the visual forms and imagery of Northwest Coast art will be examined, not comparatively, not cross-culturally, nor even 'objectively' from 'the outside in', but in themselves as components of culture and in the perspective of Northwest Coast mythology, ritual behaviour and world view.

In addition, cognitive anthropologists have already recognised that culture is not a unitary phenomenon, that it 'cannot be described by only one set of organising principles'. Instead, several sets of order

1 This line of thinking follows in part that of Etienne Gilson who writes with regard to painting in particular that 'paintings are physical beings – more precisely solid bodies – endowed with an individuality of their own ... each painting that meets the requirements of a true work of art is a completely self-sufficient system of internal relations regulated by its own laws. In this sense, paintings are mutually irreducible beings, each of which needs to be understood and judged from the point of view of its own structure' (1957, 135-6).

may co-exist in complementary distribution (Tyler, 1969, 4-5). However, it may also be hypothesised that these several sets of order do not merely co-exist but, as general systems theory would hold, function as 'parts in interaction' (*q.v.* von Bertalanffy, 1968, 19). Indeed, for cognitive anthropology to advance as a whole as well as in its specific application to visual art, the utilisation of developments in general systems theory would seem helpful if not, in fact, essential. Heretofore, cognitive anthropology has been caught up in seemingly unproductive exercises in terminological and semantic classification. As von Bertalanffy has pointed out, an overriding concern with static classifications – taxonomies, paradigms, trees (as in Tyler, 1969, 7-10) – must now give way to 'interactionism' (von Bertalanffy, 1969, 88). In keeping with that view, this paper will maintain the concept of visual art as a 'system', a system consisting of a plurality of simultaneously interacting visual principles. By the application of the 'ethnoscientific', rule-seeking method of cognitive anthropology and of the 'guiding idea' of general systems theory (von Bertalanffy, 1968, 24-5), the inaccuracies, contradictions, and paradoxes that have pervaded many previous descriptions and interpretations of Northwest Coast art – indeed, of visual systems in general – may eventually be resolved.

Although language has provided the focus for cognitive studies so far and although several attempts at the direct application of linguistic methodological models to studies of material culture and art have previously been made (cf. Munn, 1966, and Kaufmann, 1969), it is clear that linguistic models or methods as such should be avoided. This is because visual systems are not completely isomorphic with linguistic systems,[2] even though both art and language – as well as music, myth, and kinship – may be ultimately governed by the same rules of conceptual order.[3] It is the view taken here, that to 'get at' the tacit rules that govern visual art, we should not make the mistake of applying analytical methods of linguistics. We must recognise that concrete works of art produced within a given society constitute a cognitive sub-system parallel to, rather than shaped by, the cognitive sub-system of language.

Indeed, cultural anthropology would do well to give the study of visual systems its rightful due, as equally central to the workings of a culture as language, social organisation and economics. As Reichel-Dolmatoff's Desana informant once stated, art, in its broadest sense,

2 This is true even within the sphere of the arts. As Gilson has made clear, painting, music and literature display radical differences in 'their respective modes of physical existence. They *are* not in the same way' (1957, 33).

3 See, for example, the essentially cognitive approach of Erwin Panofsky in which he demonstrates that both philosophy and architecture of Gothic France were governed by the same principles of formal order: Panofsky shows convincingly that 'the new style of thinking' correlated with 'the new style of building' and that it 'affected all the arts' (Panofsky, 1957, 4 and 39).

may be 'the highest level of communication' (1971, 246). The view that visual systems constitute an even 'higher' form of human communication than language goes, of course, against the grain of current linguistic theory, certainly against the Whorfian hypothesis regarding the primacy of language in shaping human thought (Whorf, 1956). Nevertheless, recent developments in the' psychology of perception, particularly the work of the *Gestalt* psychologist Rudolf Arnheim (1969), lend credence to the possibility that 'vision is the primary medium of thought', indeed, that 'perceptual and pictorial shapes are not only translations of thought processes but the very flesh and blood of thinking itself' (Arnheim, 1969, 18 and 134).[4] Hence, this paper aims to begin to analyse art and architecture of the Northwest Coast in terms of cognitive pattern, as a visual system independent from that of language and, in doing so, to utilise analytical procedures relevant and appropriate to visual rather than verbal phenomena.

Initially, our analytical procedure must avoid the imposition of arbitrary, external, or pre-conceived categories more pertinent to Euroamerican art-historical practice than to classification of the Northwest Coast, categories such as sculpture, painting, or architecture; high art or applied art; ceremonial or utilitarian; and the like. Also, without becoming embroiled in unproductive discussion regarding the definition of what constitutes a work of 'art', let it be stated briefly that what we are concerned with here is visual imagery[5] in the broadest sense, no matter what form it takes, whether that imagery be representational or abstract, pictorial or structural, explicit or implied. What is important for our immediate purposes are the generalised patterns, principles, or ideas that underlie and shape all those various visual manifestations and not the materials, techniques, or media employed or the uses to which the work is put. We are concerned with how that visual imagery embodies and communicates cultural-cognitive meaning. Visual images as such are vital because it appears that these constitute a most direct route to cognitive behaviour, if they are not, in fact, manifestations of the cognitive process itself (see Arnheim, 1969).

The principle of dualism

Efforts to determine underlying principles of organisation in Northwest Coast art and culture have not been entirely lacking. Beginning with the structural analysis of the serpent image in Northwest Coast art and religion by G.W. Locher (1932) and

4 This is a view likewise supported by Panofsky who, while citing Arnheim, credits the medieval philosopher Thomas Aquinas with discoveries only now advanced by Gestalt psychology (1957, 37-8).

5 That is, with independent visual configurations partly in the sense of Gestalt psychology (Köhler, 1947, 104-5).

continuing with the interpretation of 'split representation' by Claude
Lévi-Strauss (1963), dualism and dual structures have often been
observed as a major characteristic and underlying formal pattern in
Northwest Coast design.

Although dual systems may eventually be demonstrated to be
universal categories of human cognitive experience (see, for example,
Needham, 1973, xxxi) based, perhaps, upon physiological factors (cf.
Gardner, 1969, 39-47; Gooch, 1972, 76-90; and Shepard, 1972, 3), it
does not necessarily follow that dualism is a dominant principle
within any given cultural system. Examination of the formal features
of Northwest Coast imagery reveals, however, that one of the more
pervasive and most easily recognised 'dualistic' principles latent in
Northwest Coast imagery is that of bilateral symmetry, defined by
biologists to mean 'that the left side is a mirror reflection of the right'
and in which 'there is no resemblance between front and back, or
between top and bottom'. Mathematics, on the other hand, has
defined this visual phenomenon even more precisely: the principle of
bilateral symmetry constitutes just one kind of symmetry, that kind
known as 'reflection symmetry' which implies a central axis. Thus,
'any plane figure', as in two-dimensional forms of art, 'with at least
one axis of symmetry is symmetric in the sense that it can be
superposed point for point, on its mirror image' (Gardner, 1969, 20,
30). It is this form of bilateral or axial symmetry that characterises

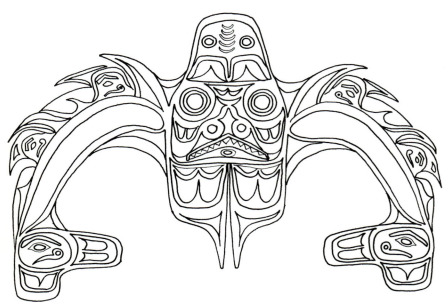

Figure 1. Haida Dog-Fish, an instance of the principle of bilateral symmetry in
 Northwest Coast art. The two-dimensional figure is symmetric in the
 mathematical sense that one side can be superposed, point for point, on its mirror
 image. (*After Mallery, 1893, pl. xxv*)

Figure 2. Diagram showing position of 'Cannibal Pole' in Kwakiutl dance house. Architectural space is also divided bilaterally by a vertical axis, defined by the pole, and by an horizontal axis, made manifest by ceremonial behaviour. (*Drawing by the author*)

one of the underlying principles of Northwest Coast two-dimensional art where the axis of symmetry is always vertical (Figs. 1-2).

The foregoing, simple example illustrates that, in our striving for descriptive precision, the direct application of mathematics to the study of visual systems would have considerable value. In applying the concerns of cognitive anthropology to Northwest Coast art, we realise as well why the use of mathematically based linguistic models has been unsatisfactory: the utilisation of linguistic models represents not only an indirect application of mathematical models, but the models derived from those branches of mathematics more appropriate to linguistic operations, that is, those branches having to do with logical operations of a linear and classificatory sort such as symbolic or mathematical logic and algebra. In the study of visual systems, more suitable mathematical models would be derived from those branches of mathematics developed to study problems dealing with the

properties of space, particularly the relations and properties of points, lines, angles, surfaces and solids, and with place – location, region, direction, space – that is, with geometry and topology.[6]

To continue our exploration of bilateral symmetry, however, an examination of Northwest Coast architecture and of ritual behaviour related to architectural form reveals the importance and prevalence of horizontal axes as well. Here we enter the more difficult but cognitively no less meaningful sphere of implied rather than explicit pattern, one that becomes apparent only through observation and analysis of ritual performance and of human interaction with works of art in a three-dimensional space. While pictorial representations, painted or carved on house-façades or on supporting posts, are commonly recognised and referred to as 'motifs' or 'images', structural elements and directions, boundaries, or points in space are no less instances of imagery and bearers of cognitive meaning.[7] Hence, for example, the uncarved and unpainted ceremonial pole of the Kwakiutl winter-dance cycle serves as an image in three-dimensional space. Known to the Kwakiutl as the 'Cannibal Pole', this 30-40 foot column was erected at a specific location within the 'dance-house', that is, in the rear of the building directly opposite and in line with the central doorway. This pole defined a ritually significant vertical axis, climbed at the climax of the ceremony by the chief performer. But the pole was also positioned on the less explicitly defined horizontal axis. This horizontal axis runs through the doorway and down the longitudinal centre of the house structure. Among the Bella Coola, for example, when an individual died his body was taken out through a hole knocked into the side-walls of the house, not the door, the prohibition preventing the moving of the remains across the central line of the house. During Kwakiutl dances, performers spun around whenever they crossed this median line (see Vastokas, 1966, 157-82). In Northwest Coast architecture, therefore, bilateral axes may be vertical or horizontal. Most importantly, however, they intersect at a particular point, at the centre-rear of the house (Fig. 3). The principle of bilateral or axial symmetry, whether vertical or horizontal, thus serves as an ordering principle both in two-dimensional pictorial art and in Northwest Coast architecture.

Although one might easily classify bilateral symmetry as a form of 'dualism', the importance of the central axis as a necessary referent for the two sides of the mirror image raises an interesting and significant

6 Topology, conceived as 'the study of the properties of geometric figures that remain unchanged even when such figures are distorted' (Marks, 1964, 148) seems particularly relevant in the case of Northwest Coast art which is well-noted for the adaptability of its images to a wide variety of two- and three-dimensional surfaces.

7 This is because 'architecture' consists not only in the material components of a building's structure, but also in the enclosed as well as external space that is defined and rendered visible by that structure (see Vastokas, 1966, 172-5 and Zevi, 1957, 22-3, 30).

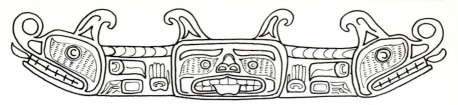

Figure 3. Kwakiutl *Sisiutl* image, one important instance of triple organisation and of visual tension in Northwest Coast art. (*Detail after Hawthorn, 1967, Fig. 14*)

problem in ambiguity. Do we give emphasis, as does Lévi-Strauss, to the two sides or do we recognise the primacy of the median axis as the fundamental organising principle? Subsequent analysis of still other patterns and arrangements in Northwest Coast art and architecture will help us decide.

Tripartite pattern

A more careful examination of the imagery of Northwest Coast art indicates that the underlying principle of actual works of art is more commonly a tripartite one. Ironically, the key to this tripartite pattern of visual organisation is the image of the enigmatic *sisiutl*. As intially described by Boas, the *sisiutl* is a 'fabulous double-headed snake, which has one head at each end, a human head in the middle, one horn on each terminal head and two on the central human head' (1897, 371; see Fig. 7). Any eye innocent of pre-conceived polar categories should recognise at the outset that the structure of the image is not a dual one but a composite of three, mutually interdependent parts: central human head, left-side serpent head and right-side serpent head. Whereas the central head is frontal, the two side heads are in profile and represent mirror images of each other. Yet what we have is not a case of simple bilateral symmetry but a more complex and dynamic visual system. The central component of the image is not to be read as a mere dividing line or point of demarcation between, or subservient to, the two sides. It acts, in fact, as the focus for visual tension between the two heads which are directed outward and which seem to signify movement away from a stable centre. The validity of this observation is supported by the dynamics of the *sisiutl* image in Kwakiutl transformation masks. One example (see Waite, 1966, 283) shows a Thunderbird which opens vertically as well as horizontally, the horizontal one yielding to an image of the *sisiutl*. Significantly, the two serpent heads are painted on the horizontally unfolding portions of the mechanical mask, the central face remaining stable. Thus, the visual distinction between stability and movement and the observation of the central face as a fulcrum or axis, are explicitly manifest in *sisiutl* transformation masks. The human head at the centre of the *sisiutl* image, therefore, attains a

structural importance equal to, if not greater than, the lateral serpent heads.

An examination of other images in Northwest Coast art verifies the importance and prevalence of the tripartite rule observed initially in the *sisiutl* motif. The highly abstracted imagery on 'Chilkat Blankets', for example, provides a further instance of triple organisation. Major importance is given in these textiles to the central panel in which the fragmented image is always portrayed in frontal posture. The two side-panels are secondary in terms of size as well as their use of faces or figures in profile view (Fig. 4). The dynamics of this tripartite rule, however, are most clearly manifest in what has been described as the 'simultaneous image' (Fraser, 1968. 96-7), a recurrent formal configuration in Northwest Coast imagery that is also characterised by visual ambiguity. This formal pattern, like that of bilateral symmetry, may be 'read' in two different ways, either as a duality of two confronting profiles or as a tripartite structure with a central, frontal head (Fig. 5). Thus, dual and triple organisations interact and we are consequently faced with a dynamic perceptual phenomenon; a visual transformation seems to take place before our very eyes in the context of an apparently static image. It may be said, in fact, that the eye is given a choice between two cognitive possibilities, a choice between division and separateness or centredness and stability. The validity and significance of this visual phenomenon, however, will become evident only upon an examination of Northwest Coast culture as a whole.

Quadripartite pattern

Dualism in the form of bilateral symmetry and, more especially, the systemic tripartite rule described above, constitute the most readily observed rules of pictorial, structural and spatial organisation in Northwest Coast art and architecture. The application of more refined techniques of formal analysis – perhaps with the aid of appropriate mathematical models – would no doubt yield a more precise description of these two modes of compositional organisation as well as other, less easily recognised patterns. The tendency, for example, towards rectangularity, towards the 'squaring-off' of apparent surface curves – already noted by Bill Holm in two-dimensional Northwest Coast art[8] – seems part and parcel of a latent predisposition towards quadripartite pattern. Two-dimensional images, whether painted or woven (Figs. 4-5), are composed of

8 'The most characteristic single design unit in the art is the formline ovoid used as eyes, joints, and various space fillers. It has been variously termed a rounded rectangle, an angular oval, a bean-shaped figure, and other more or less descriptive names.' Moreover, 'the ovoid is invariably horizontally symmetrical' (Holm, 1965, 37-8).

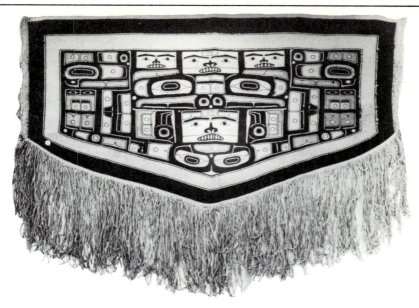

Figure 4. Tsimshian 'Chilkat Blanket'. As in the *sisiutl* image, the central panel in this tripartite structure assumes visual dominance over the subsidiary side-panels by virtue of size and frontality. Frontal images have a more powerful grip on any observer's attention, hence the cross-cultural prevalence of frontality in hieratic and sacred art. (*Photo: courtesy of the National Museums of Canada, Ottawa*)

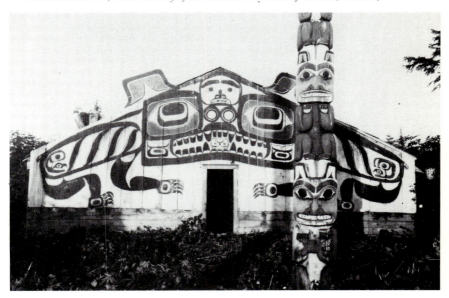

Figure 5. Tlingit façade painting. In this 'simultaneous image', dual and triple organisations interact, since the image may be 'read' either as a duality of two confronting profiles or as a tripartite structure with a single, frontal head. (*Photo: courtesy of the Museum of the American Indian, Heye Foundation, New York*)

elements that form both implicit and explicit squares, rectangles, paral-
lelograms and quadrangles. These elemental geometric components,
however, are rounded off at their corners to create a surface impression
of curvilinearity. Holm has most thoroughly explained this phenome-
non of apparent surface curvilinearity in terms of his so-called 'form-
line'. The 'formline' is essentially curvilinear in conception; it has a
calligraphic and organic quality that implies and suggests freedom of
movement. As described by Holm: 'the curves are gentle and
sweeping, breaking suddenly into sharper semiangular curves and,
immediately upon completing the necessary direction (usually around
90 degrees), straightening to a gentle curve again' (1965, 37). But this
surface impression of free curvilinearity is controlled and held in check
by angular shapes, achieved by the use of symmetrical oval bark
templates (Fig. 6). As Holm points out, 'when templates have been
used, the primary formlines are negative in the sense that they are the

Figure 6. Tracings of bark templates (not to scale). Use of these ovoid modules in
 Northwest Coast paintings imposes a formal stability which counteracts and
 competes with the free curvilinearity of calligraphic 'formlines'.

spaces between the patterns. This gave the artist considerable control over the formlines themselves, but he had always to hold uppermost the concept that they were, in the end, the positive delineating force of the painting, and that they must also conform to somewhat rigid characteristics' (1965, 35). Thus, tension between opposites and visual ambiguity between stability and movement may once again be noted as an important expressive feature in Northwest Coast art.

Tension and ambiguity

To expand upon these concepts of tension and ambiguity, it should also be noted that whereas the axes observed earlier, whether horizontal or vertical, have the possibility of infinite extension into and through space – using the model of 'coordinate geometry' in which two axes, x and y, run perpendicularly to each other – squares, rectangles, parallelograms, and quadrangles signify limitation and enclosure by virtue of their four sides and four corners. Recognition of the conjunction of these two distinct kinds of classes of tacit geometric phenomena – one 'free' and open-ended, the other limiting and self-enclosed – adds yet another dimension to the underlying tension and ambiguity in Northwest Coast imagery.

Cultural validity of dual, tripartite and quadripartite patterns

So far, however, we have been exploring the imagery of Northwest Coast art without the benefit of evidence from the Northwest Coast informants themselves or from any other domains in the Northwest Coast culture. In an exploration of mythology, ritual, and world view for some evidence of explicit, 'ethnoscientific' support for dualism, for example, we are faced again with a problem of ambiguity. It centres, to a large extent, on the relationship between human and animal life, the belief that men can become animals and animals men. This may be read as 'dualism', as two orders of life that are mutually interchangeable, one a mirror image of the other. As Waite makes clear in her analysis of Kwakiutl transformation masks, masked performances re-enact the belief that 'the world was originally populated by animals, many of whom, being magical, eventually transformed themselves into other animals or human beings'. Kwakiutl transformation masks express in explicit fashion 'the most frequent theme that runs throughout the legends ... the concept of a dual animal-human nature for various creatures' (Waite, 1966, 270 and 285).

On the other hand, in the sequences of Kwakiutl ritual drama, it is the phenomenon of transformation in itself that assumes prime

importance. None of the recorded songs accompanying the masks emphasise or hint at their dual nature (cf. Boas, 463-6). In addition, the mask served to climax the dance performance. As described by Audrey Hawthorn, the 'high point in the evening's performance was often marked by the use of a transformation mask. The dancer drew attention to an approaching change by the rhythm of his dance and by the centrally prominent place he chose to stand, as the beat of the song sticks intensified. Slowly the mask opened, revealing within it another being who also belonged in the myth of the dance' (Hawthorn, 1967, 59). Thus it is the element of surprise, the miracle and magic of transformation that is given dramatic emphasis. This emphasis upon the point of transition in Kwakiutl transformation masks thus parallels what has been observed in the case of bilateral symmetry, that is, the two subsidiary sides having as their major referent the central axis. This lack of any articulated emphasis upon dual pattern among Northwest Coast peoples would suggest that dualism as such is of relatively minor cognitive importance.[9]

By contrast, however, the systemic tripartite rule seems to serve as a framework or major ordering principle for almost the whole of Northwest Coast culture: both implicitly and explicitly in ritual, myth, and world view. The validity of our formal analysis of the *sisiutl* image is verified by native belief and by recorded statements about its meaning and the implications it bears for the underlying structure of Northwest Coast cosmology. Native descriptions of the role and meaning of the *sisiutl* indicate at the outset its enigmatic and complex character, its power and changeableness. *Sisiutl*, moreover, is clearly a symbol of cosmic order. As the Lightning of the Thunderbird in its fight against whales, the *sisiutl* functions as a creature of the upperworld. But the *sisiutl* sometimes replaces the whale as the Thunderbird's food and will transform itself into a salmon, thus becoming a creature of the sea or underworld. But because it also has a human face as well as aquatic scales (Barbeau, 1950, i, 337) a snake-like body, horns, and sometimes 'feathers' (Drucker, 1951, 153), the *sisiutl* is clearly a composite creature belonging to three cosmic zones, sky, earth, and sea. Moreover, the *sisiutl* is capable of passage from one zone to another. This tripartite cosmic character, with its accompanying implications of movement from one region to another, visualises native cosmological structure. Native statements about the structure of their cosmos reveal this tripartite world order, one that is explicitly verbalised in the course of the winter dances. Since it has already been established elsewhere, for example, that the structure of the Northwest Coast house embodies cosmic order (Vastokas, 1966, 135-88), it will suffice here to demonstrate that that order is a

9 It should be noted, however, that the dual conception of 'left' and 'right' as 'evil' and 'good' has been articulated in a ceremonial song (See Boas, 1897, 463). Dual classifications of this sort, however, may constitute a universal rather than a culturally specific category (Needham, 1973, x).

tripartite one, paralleling and intersecting with the meaning of the *sisiutl* and validating the systemic tripartite rule as a major cognitive pattern.

We have already noted that the ceremonial pole of the Kwakiutl defines an important vertical axis. To the Northwest Coast peoples, this 'Cannibal Pole' is, in fact, a cosmic axis. As such, it is identified with a range of celestial phenomena. In one myth, a 'rainbow ... is the Cannibal post of the dancing house'. In a Cannibal Dancer's song, the pole is also called the 'Milky Way'. But even more importantly, the pole manifests the conceptual centre of the world, for, while singing yet another song, the Cannibal Dancer stands on the horizontal axis of the house-floor while looking up at the vertical pole and declares himself to be located 'at the centre of the world... at the post of the world' (Boas, 1897, 404, 457-9).

The Kwakiutl Cannibal Pole, moreover, is a ceremonial manifestation of a more widely held and explicit Northwest Coast conception of a cosmic axis (see Haekel, 1958). Indeed, this conception is central to the even more widespread phenomenon of shamanism and to the characteristically shamanistic concept of the cosmos as a triple-layered structure united by a central tree or post (Vastokas, 1973-4). In the course of the winter ceremonial the pattern of the various dancer's movements – up the pole to the roof of the house, into a hole in the floor of the house – signify shamanistic travel through the three cosmic regions of the universe, to the underworld, middleword and upperworld (see Boas, 1897, 482-3, 528, and Drucker, 1940, 209). This triple order is also made explicit in the several songs of each dancer, the enclosed space of the house being referred to as the 'middle world', the roof as the upperworld, the area beneath the house as the underworld and the rectangular house walls as defining the 'edge of the world' (Boas, 1897, 457, 466, 492). The centre and axis of these three cosmic levels was visualised by the Cannibal Pole, the route of access between the three regions (Vastokas, 1966, 164). The structure of the Northwest Coast house is thus a microcosm of a vertically conceived, axially centred and tripartite cosmos.

But this division of the cosmos into a vertical tripartite system did not prevent the coexistence of an horizontally conceived divisioning of cosmic space. We have already seen how ritual behaviour served to manifest a horizontal axis through the central doorway and down the longitudinal axis of the house. These two axes thus played a major ordering role in Northwest Coast ceremonies, the vertical one visualised by the Cannibal Pole and the horizontal one defined by the median line of the dwelling (Fig. 3). As indicated by the geographical association and classification of mythological beings and by the pattern and sequence of dancer's ritual, this horizontal axis also links three cosmic regions – an underworld signified by the sea, a middleworld signified by the village, and an upperworld signified by

the forest behind the village (Vastokas, 1966, 177-8, 182-3). Thus, exterior geographical space is brought into a tri-partite relation with architectural and cosmological space.

Tripartite organisation is thus horizontal as well as vertical and serves to organise ritual behaviour in relation to architectural, cosmic, and geographical space. In addition, and related to these intersecting vertical and horizontal axes, the concept of a 'centre' played an important conceptual role in Northwest Coast patterning of culture. The idea of a 'centre' as a vital point on two equidistant extensions is linked with notions of social rank as well as with degree of ceremonial sacredness. We can see this in village arrangement where high rank was associated with centredness: 'the house of the highest ranking chief was located in the centre of the village row; those of the next ranking chiefs were beside him on either side and those of the commoners still farther out ... In the long Coast Salish shed houses, the centre of the dwelling was usually occupied by the chief of the extended family with the sub-chiefs (his nearest relatives) on either side of him and the commoners beyond' (Vastokas, 1966, 102-3).

The concept of a 'centre' was not only equated with high rank but with the concept of sacredness, the point in the Northwest Coast dance house where the two axes intersect, the ceremonial 'Centre of the World', reached by the Cannibal Dancer, for example, at the climax of his initiatory and ritualistic endeavours (Vastokas, 1966, 177-9). Thus, movement around this centre takes place horizontally and vertically, continually, however, with reference to the all-important central axis or point.

The observation in works of art of a predisposition to quadripartite pattern is also supported by native statements about their universe. We have already noted the fourfold repetition of ritual events and the reference in ceremonial songs to the walls of the house as 'the edges of the world'. Thus, while the cosmos is vertically and horizontally tripartite, it is nevertheless conceptually square in shape, like a house. Among the Tlingit, for example, the 'earth is considered square, the corners pointing north, south, east, and west' (Boas, 1888, 238).

The world view of the Northwest Coast Indians, therefore, may be described, to a certain extent, as an angular, 'carpentered world', one that is conceived in terms of the culture's predominantly wood technology. It is a world given over to systematic ordering in terms of squares, rectangles and linear members: as a house was shaped, so was the universe.

Conclusion

In this preliminary exploration of cognitive principles in Northwest Coast visual art, it does appear that the rules and patterns of organisation yielded through a formal analysis of imagery have a basis

in cultural fact. We must conclude that dualism, tripartite structure and quadripartite pattern are indeed valid principles of cognition. It was noted at the outset that a number of sets of order may co-exist within a single cultural system and it now seems clear that this is indeed the case for the Northwest Coast. In terms of their relative dominance, however, it has also been observed that the tripartite rule serves to classify and to order a wider and more significant variety of cultural phenomena – ritual behaviour, mythological pantheon, cosmology, village arrangement and works of visual art – and may be acknowledged as the major, underlying system of formal order in Northwest Coast culture.

The cognitive principles that have thus emerged have tended to fall into broad and rather abstract structural categories. Such statically conceived structures, however, tend also to have generative powers, each basic pattern giving rise to more complex and elaborate variations. In the end, however, it must be observed that all these structural patterns – dual, tripartite, or quadrilateral – resolve themselves into a single unifying theme. They are all characterised by tension and ambiguity. In the visual phenomenon of bilateral symmetry, for example, the median axis was seen to compete for importance with the two lateral extensions. The same is true of the tripartite *sisiutl* image whose human head functions as a pivotal centre between two unstable and moving parts. In the configuration of the simultaneous image it became evident that these dual and triple organisations interact in a perceptually dynamic way, the observer's eye moving between stability at the centre and lateral movement. So also, two-dimensional Northwest Coast design revealed a visual tension between rigidly conceived and executed quadrilateral shapes and free calligraphic 'formlines'. And in architectural, microcosmic symbolism, we saw that ritual movement was accomplished with continual reference to vertical and horizontal axes. That movement, however, reached its climax at a single point, at the intersection of the two axes, the point of ultimate stability and equilibrium.

Works of art and architecture among the Northwest Coast Indians, therefore, embody in visual terms the tension between opposites, the pull of conflicting visual forces. Northwest Coast cognition seems an amalgam of contending drives for free untrammeled movement and for stability and rest. Visual images, therefore, reveal themselves as mechanisms for the expression of these latent cultural-cognitive tensions, the rivalry between one principle of order and another and a striving for integration and balance, never perfectly achieved. That such is the underlying, fundamental meaning of the cognitive apparatus we call art in Northwest Coast society gains additional support from a consideration of that anomalous culture as a whole. Economically, for example, it is located somewhere between a subsistence and a surplus economy; in terms of social organisation, it ranges between relative egalitarianism and rigid class structure; in

religion it lies somewhere between individualistic shamanism and organised priesthood.

Although stated here in terms of ethnographic categories, these fundamental ambiguities were nevertheless experienced and, in turn, expressed by the people themselves. Ruth Benedict has captured the nature of this ambiguity in her characterisation of Kwakiutl society as 'Dionysiac'. She describes the cultural system as dis-oriented and lacking in socio-cultural integration. The lack of fundamental unity is attributed to developmental factors whose effect on Kwakiutl culture represents 'a compromise between two incompatible social orders, the relatively individualistic one of the Salish and a more rigidly structured system, whose features were more recently adopted from the northern coast' (1934, 210). The observations made in this paper are thus supported by an hypothesis advanced by Benedict forty years ago: '[The Kwakiutl] may very often incorporate into their ... art techniques most contradictory procedures' (1934, 208).

In conclusion, this initial attempt at seeking out the fundamental cognitive principles that shape and govern the visual art of the Northwest Coast Indians makes no pretence at thoroughness. What has been explored here must be seen as a mere, but hopefully fruitful, beginning at a more integrated and systematic formal analysis of Northwest Coast art and architecture than has so far been attempted. Most of the material presented has been essentially Kwakiutl in derivation and that people has exemplified the whole of the Northwest Coast in a number of arguments. A more thorough application of cognitive analysis would have to take into account not only variation from group to group, but variation through time. This paper, therefore, is a mere prologue to what will be a larger task of analysis.

REFERENCES

Arnheim, R. (1969), *Visual Thinking*, Berkeley and Los Angeles.

Barbeau, O.M. (1950), 'Totem poles', *National Museum of Canada, Bulletin 119, Anthropological Series*, 30.

Benedict, R. (1934), *Patterns of Culture*, New York.

Bertalanffy, L. von. (1968), *General System Theory: Foundations, Development, Applications*, New York.

Boas, F. (1888), 'The houses of the Kwakiutl Indians, British Columbia, *Proceedings of the United States National Museum*, xi, 197-213.

Boas, F. (1897), 'The social organisation and secret societies of the Kwakiutl Indians', *United States National Museum Report for 1895*, 311-733.

Covarrubias, M. (1954), *The Eagle, the Jaguar, and the Serpent: Indian Art of the Americas*, New York.

Drucker, P. (1940), 'Kwakiutl dancing societies', *Anthropological Records*, 2, 201-230.

Drucker, P. (1951), The northern and central Nootkan tribes', *Bureau of American Ethnology Bulletin, 144*, Washington.

Fraser, D. (ed.) (1966), *The Many Faces of Primitive Art: A Critical Anthology*, Englewood Cliffs, N.J.

Fraser, D. (ed.) (1968), *Early Chinese Art and the Pacific Basin: A Photographic Exhibition*, New York.

French, D. (1963), 'The relationship of anthropology to studies in perception and cognition', in S. Koch (ed.), *Psychology: A Study of the Science*, New York, 388-428.

Gardner, M. (1969), *The Ambidextrous Universe: Left, Right, and the Fall of Parity*, New York and Toronto.

Gilson, E. (1957), *Painting and Reality*, Cleveland and New York.

Gooch, S. (1972), *Total Man: A Bold Re-Examination of the Development of the Human Brain*, New York.

Haekel, J. (1958), 'Kosmischer Baum und Pfahl in Mythus und Kult der Stämme Nordwestamerikas', *Wiener Völkerkundliche Mitteilungen*, vi, 33-81.

Hawthorn, A. (1967), *Art of the Kwakiutl Indians and Ohter Northwest Coast Tribes*, Seattle and London.

Holm, B. (1965), *Northwest Coast Indian Art: An Analysis of Form*, Seattle and London.

Inverarity, R.B. (1950), *Art of the Northwest Coast Indians*, Berkeley and Los Angeles.

Kaufmann, C.N. (1969), *Changes in Haida Indian Argillite Carvings, 1820 to 1910*, Ph.D. Dissertation, Anthropology, University of California (Ann Arbor, Mich., University Microfilms).

Köhler, W. (1947), *Gestalt Psychology*, New York.

Lévi-Strauss, C. (1963), *Structural Anthropology*, New York.

Locher, G.W. (1932), *The Serpent in Kwakiutl Religion: A Study in Primitive Culture*, Leiden.

Mallery, G. (1893), 'Picture-writing of the American Indians', *Tenth Annual Report of the Bureau of Ethnology ... Smithsonian Institution, 1888-89*, Washington.

Marks, R.W. (1964), *The New Mathematics Dictionary and Handbook*, New York.

McIlwraith, T.F. (1948), *The Bella Coola Indians*, 2 vols., Toronto.

Munn, N.D. (1966), 'Visual categories: an approach to the study of representational systems', *American Anthropologist*, 68, 936-50.

Needham, R. (ed.) (1973), *Right and Left: Essays on Dual Symbolic Classification*, Chicago and London.

Panofsky, E. (1957), *Gothic Architecture and Scholasticism*, New York.

Reichel-Dolmatoff, G. (1971), *Amazonian Cosmos*, Chicago.

Sephard, P. (1972), *Man in the Landscape: A Historic View of the Esthetics of Nature*, New York.

Sturtevant, W.C. (1964), 'Studies in ethnoscience', *American Anthropologist*, 66, 2, 99-131.

Tyler, S.A. (ed.) (1969), *Cognitive Anthropology*, New York.

Vastokas, J.M. (1966), *Architecture of the Northwest Coast Indians of America*, Ph.D. Dissertation, Fine Arts, Columbia University (Ann Arbor, Mich., University Microfilms).

Vastokas, J.M. (1969), 'Architecture and environment, the importance of the forest to the Northwest Coast Indians', *Forest History*, 13, 12-21.

Vastokas, J.M (1973-74), 'The shamanic tree of life', *artscanada*, 30, 5-6, 126-49.

Waite, D. (1966), 'Kwakiutl transformation masks', in D. Fraser (ed.), *The Many Faces of Primitive Art*, Englewood Cliffs, N.J., 266-300.

Whorf, B.L. (1956), *Language, Thought, and Reality*, New York.

Zevi, B. (1957), *Architecture as Space: How to Look at Architecture*, New York.

Adrienne L. Kaeppler[1]

Melody, drone and decoration: underlying structures and surface manifestations in Tongan art and society

The theoretical position taken in this paper is essentially that of ethnoscientific structuralism. Structural relationships among the arts and society are seen in terms of homology, that is, as consistency relationships between various cultural and social manifestations and the underlying structures that they express. The reader may also recognise the influence of techniques and theory used in linguistics, such as transformational grammar, which attempts to present a set of instructions on how to produce the cultural forms in question; and etic/emic distinctions derived from phonology, or, in other words, the Saussurean distinction between acts and system. These techniques, however, are not strictly 'linguistic', but rather, are methods that can be productive in the analysis of various cultural phenomena including linguistics, society, and art. Structuralism here is given the requirement that the structure derived is recognised by members of the society as a set of principles with which they help to organise their lives – not necessarily verbalised as such, but derived from ethnographic data in several domains in which the structure consistently repeats itself.

Art is defined in this paper as 'cultural forms that result from creative processes which manipulate movement, sound, words, or materials' and aesthetics as 'ways of thinking about such forms'. In my view,

if we are to understand (rather than just appreciate) an aesthetic, or even an art style, it is essential to grasp the principles on which it

1 Research in the Tongan Islands was carried out for 18 months from 1964-67 supported by Public Health Service Fellowship No. 5-FI-MH-25, 984-02 from the National Institute of Mental Health and the Wenner-Gren Foundation for Anthropological Research. To both of these foundations I wish to express my appreciation.

is based, as perceived by the people of the culture which holds them. This underlying organisation is more important for understanding human behavior than an analysis of the content of the item itself. Only after the principles of organisation have been deduced can we decide that any specific item either conforms to or fails to meet the standards recognised by the society. We want to know what meaning the formal characteristics have to the people being studied and how these regularities in structuring and presenting are expressive of a given group of people. (Kaeppler, 1971a, 176)

Unfortunately there is no established methodology for doing this and each researcher must find for himself what the relevant questions are for the society he studies and must try to delineate what is considered art in that society, what the aesthetic principles are for that society, and through what means an aesthetic experience may be obtained. In this paper I attempt to demonstrate not only how various artistic domains in Tonga partake of an underlying structure, but also how they are related to social organisation. The implication is that the various artistic and social domains are surface manifestations of underlying structures of the society. Further, I propose that the aesthetic experience arises, at least in part, from the realisation or awareness of underlying structure in specific works of art; that is, fundamental principles made manifest so that they can be comprehended.

An analysis of a variety of artistic and social domains in Tonga reveals similar conceptual structures in music, dance, material culture, and social organisation. There are no words in either English or Tongan which can be found to apply to the structural elements of these several domains. Their conceptual similarity, however, can be illustrated by using an analogy derived from Tongan music – i.e., melody or leading part (*fasi*), drone (*laulalo*) and decoration (*teuteu*). As used in this paper, the leading part consists of essential features, the drone defines or outlines the space in which the essential features operate, and the decoration is an elaboration of specific features which are not necessary for its existence or function (Table 1).

Traditional vocal music in Tonga was said to have had six parts, four men's parts and two women's parts. The most important parts, however, were said to be the *fasi* (melody or leading part) and *laulalo* (drone), while the other parts were 'decoration' of the *fasi*. Today the traditional polyphony has been largely replaced by a six-part polyphony based on Western harmony and using, for the most part, Western pitch intervals. Of the terms used for the six traditional parts, four are largely obsolete while *fasi* and *laulalo* have been retained. *Laulalo* today refers to the base part, but in singing Tongan songs such as *lakalaka* (rather than church hymns), the base functions mainly as a drone (see Kaeppler, in press, for more detail). In both

traditional polyphony and the more recent polyphony evolved form it, all parts are not consistent or even present. The parts usually present are *fasi* and *laulalo* while one or more decorative parts, improvised rather than prescribed, may be sung higher or lower than the *fasi* or may cross it in both directions. Decorative parts are preferred by many Tongans and the *fasi* sometimes disappears entirely, although the Tongans say they can hear it in their heads so that it is always conceptually present. Such part singing today is particularly characteristic of *lakalaka* songs. A total performance of *lakalaka* includes other artistic domains which have a similar conceptual structure.

If we apply the concepts of leading part, drone, and decoration to dance, it is easily perceived that their structural analogies are with movements of the arms, legs and head respectively. The most important and essential movements in Tongan dance are *haka*, i.e. movements performed with the hands and arms, and are the medium for conveying the 'story' of the text by visual means just as the *fasi* is the main conveyor of the text in the auditory dimension. The performer in Tongan dance is never an actor in the Western sense but a storyteller, who by movements of his arms and hands alludes (often in a nonrealistic manner) to selected words of the text. Movements are not narrative, yet the spectator (who understands the text) uses them to help him understand hidden poetic meanings. Leg movements are used mainly to keep time and add to the rhythmic dimension of the performance. Some dances are performed seated and small movements of the knees or feet keep the rhythmic pulse. The leg movements can be considered the conceptual analogue of the drone. Just as the drone realises audibly a pitch level as the substratum to hold the performance together, both in rhythm and as a basis to which the leading part can refer, the leg movements realise visually the movement substratum which holds the performance together rhythmically and represents a basis to which the *haka* (arm movements) can refer. Further, the *fakateki*, head movement, is added as a decorative element and can be considered the structural analogue of decorative vocal parts. The *fakateki* is not choreographed nor is it prescribed. Rather, it is added by the dancer – not as an essential element in the performance – but from an inner feeling of *māfana* or exhilaration. Thus, just as the decorative vocal parts are not essential (although desirable) to the realisation of the sound, the *fakateki* is not essential to the realisation of the movement. Yet both add *teuteu*, or decoration, to the vocal and visual drone and leading part.

Traditional musical instruments that formerly accompanied dance performances functioned as drone and decoration. The only melodic instruments in Tonga were the nose flute and panpipe. Nose flutes were said to have been played for awakening songs and 'lullabies', and possibly functioned as a replacement for the human voice when the voice itself was tabu (for example, to awaken a chief) or irrelevant (for

example, when poetic texts were not audible to other humans). Panpipes were said to have been played as a pleasurable pastime activity. Traditional dances, however, made use of wooden slit drums, bamboo stamping tubes, struck slit bamboos and a struck idiophone of bamboos wrapped in a mat. Both slit drum (*nafa*) and mat idiophone (*tafua*) may be played by two people (either on one instrument or two). One player sets the beat with one stick as a rhythmic drone, while the other player, using two sticks, decorates the drone rhythm with complex beating, which, at least in the case of the slit drum, has different tones depending on the part of the drum struck. Some dances, particularly the *me'elaufola*, were accompanied by bamboo stamping tubes of different lengths, 'but all of them of the hollow or base sort' (Cook, 1784, i, 249). Although such instruments (now obsolete) would be capable of playing a melody, they were probably played in much the same manner as their counterparts in Fiji are played today, i.e. as drone (single or multiphonic). The stamping tube drone was accompanied by a second idiophone, made of longitudinally split bamboos, which was also struck and can be said to have decorated the drone with a sound that was, in Cook's words 'as acute as those produced by the others were grave' (Cook, 1784,i, 250).

It would appear so far that the melody dimension (*fasi* in music and *haka* in dance) is the medium for conveying the most important element of the overall structure, i.e., that part that deals with meaning. The *fasi* melodic line carries the poetic text while the *haka* arm movements allude to selected, but important, words of the text. The lack of melodic instruments in *faiva*, traditional danced poems which tell stories but do not act them out, suggests that the function of musical instruments in these dances was not to convey meaning but to hold a performance together and decorate it.

If we consider the three aspects discussed so far as they occur together, they form a larger combination of leading part, drone, and decoration. The sung poetry – whether it be in one, two, three, or more parts – is basic and can be considered the leading part of the performance, while the musical instruments serving mainly as a rhythmic dimension function as a drone and the dance movements add the decoration.

To move now to the domain of material culture, let us begin with bark cloth which is the most important two-dimensional art form practised in Tonga today. The making of the bark cloth or *ngatu* can be shown to have a three-stage process comparable to drone, leading part, and decoration, but even more important, the design itself incorporates the analogy.

The fabrication of Tongan bark cloth has three main stages. The first stage is the beating of the inner bark of the paper mulberry plant, a process called *tutu*, which forms small pieces called *feta'aki*. The second stage consists of the pasting together of these small pieces and

the printing of the design by rubbing dye onto the white cloth which is laid over a stencil, a process called *koka'anga*, which forms a large printed piece called *ngatu*. These two processes, I submit, are comparable to drone and leading part as expressed above. The beating of the *feta'aki* is often done by a woman alone or with help of her daughters, sisters, or other close female relatives. It is considered hard and boring work, and the sound produced is a drone much like the beating of the *nafa*, to which they compare it. Indeed, to announce the lifting of a tabu imposed on a village by the death of a chief, an anvil for beating *feta'aki*, rather than a slit drum, is beaten with a bark cloth beater, a ritual called *tukipotu*.

The second process, *koka'anga*, is done by a group of women who belong to a *kautaha*, a work group formed specifically for *koka'anga*. Here the *kupesi* or design is added to the white cloth while it is made into the proper size of a *ngatu*, i.e., about 4.25 x 23 metres. This is the most important process in the making of bark cloth and, although it is hard work, it is not boring for the women have an enjoyable time while they are working and eat well afterwards (the food being prepared and served by the men of the family of the woman who will own the *ngatu* being made that day). The whole process is comparable to leading part, and singing is often heard during *koka'anga*. The songs, however, are not 'work' songs (*tau'a'alo*), a category which does exist in Tonga, but *hiva kakala* (sweet songs).

Only these two processes are necessary for making *ngatu* and the bark cloth can be used at this stage.[2] The third stage is one of decoration and is not essential, but in the Tongan view should be done in order to make the *ngatu* complete. This stage, called *tohi ngatu*, is done by a woman alone or by her close female relatives and consists of painting over the design that has been printed from the stencil with dark brown paint and a brush made of a pandanus key. Depending on the skill (or patience) of the person(s) who does the *tohi ngatu*, the finished product may be precise and beautiful or it may be slipshod (*fepāeki*), but it adds the decorative element without which the *ngatu* is not complete.

More important than the manufacturing process to our interests here are the three parts of the design itself, comparable to drone, leading part and decoration. The three elements which make up the design of a *ngatu* are straight lines, a named design, and a decoration of the named design. There are two ways of making the *ngatu* into a large piece during *koka'anga*. In the usual method the lines run crosswise, having been made from a series of pegs which run down the centre and the long edges of the *papa* (the curved board on which the stencils are held in place) and the designs run across between the crosswise lines. In the more ceremonial bark cloth called *fuatanga* the lines run lengthwise and the finished piece is much more difficult to

2. I was given a piece of *ngatu* at this stage as a ritual gift during a funeral ceremony.

Table 1. Analogies in Tongan Art and Society

	Vocal music (hiva)	Dance (faiva)	Musical Instruments	Overall Performance
Melody/ leading part (essential features)	*Fasi* main conveyor of text	*Haka* arm movements convey the 'story' by alluding to selected words of text	(Melodic instruments used when human voice tabu or irrelevant)	Sung poetry (in one to six parts)
Drone (space definers)	*Laulalo* holds performance together in rhythm and as a pitch basis to which leading part can refer	*Lakalaka* (step it out) leg movements keep time, rhythmic dimension	*Nafa* or *tafua* beaten with one stick as rhythmic drone. Bamboo stamping tubes played as a drone	Musical instruments
Decoration (elaboration of specific features)	Up to four decorative parts not prescribed	*Fakateki* head movement not choreographed or prescribed	Second *nafa* or *tafua* using two sticks decorates drone rhythm with complex beating (and differrent tones). Slit bamboo rattles decorated drone from stamping tubes	Dance

Bark Cloth (ngatu)	Bark Cloth design	Material Culture	Societal Structure	Kin Group (kainga)
Print design process *(koka' anga)* forms *ngatu*	Named motif e.g. *fata, manulua, mata hihifi, tokelau-feletoa*	Items of ceremonial use *(koloa)* (mats and barkcloth) [Sacred]	Chiefs, *'eiki* (Chief of chiefs = Tu'i Tonga) (intermed-iate class, *matapule,* ceremonial attendants)	*Tamai* (father and father's brothers) also to some extent *tu' ofefine* (sisters) and *mehekitanga* (father's sisters)
Beat inner bark, pro-cess *tutu* forms *(feta' aki)*	Straight lines *(langanga* or *fuatanga)*	Items of everyday use [Profane]	Commoners, *tu'a*	Ego and some family members e.g. *tokoua* (brothers), *fa'e tangata* (mother's brothers) also *fa'e* (mother and mother's sisters)
Hand decoration process *(tohi ngatu)*	Decoration of named motif *(teuteu)*	Items of decorative use *(teuteu)* *(sisi, kahoa, teunga)* [Celebra-tions, e.g. *Kātoanga*]	Decorative persons to the Tu'i Tonga, *i.e.* sister — Tu'i Tonga Fefine and sororal niece — Tamaha	Decorative persons, *'Ilamutu* (sister's children), *mokopuna 'eiki* (chiefly grand-children), also to some extent *tu' ofefine* (sisters) and *mehekitanga* (father's sisters)

make. It is these drone lines that separate the two kinds of bark cloth, rather than the design motifs themselves, and form the frame for the arrangement of the motifs. A series of *kupesi* stencils attached to the *papa* include a named design which gives its name to the whole *ngatu*, even though it may be only a small part of a whole series of stencils – just as the *fasi* may be only one small part of the six-part polyphony. The rest of the stencils add decoration to this named design. This decoration, or *teuteu* as it is called in Tongan, is considered the more creative part of the design. Although the *teuteu* is not the essential part of the design, it is necessary to make the design complete. The *teuteu* may vary, but the named motif is standardised.

Consider the design in Fig. 1 in which the named motif *manulua* is decorated with diagonal and straight lines – the latter having equal space to the *manulua* motif. In Fig. 2 the named design is *fata* which is decorated with flowers, stars, and triangles. In the principal stencil itself which runs down the middle and each side one half of the area is *fata*, but in the overall design *fata* is only a small part. Sometimes *manulua* and *fata* are used as the decoration of other named motifs. These traditional designs are universally recognised in Tonga and today are often used as the *teuteu* or decoration of more modern tapa designs local to a village, which in recent times have become more and more realistic. For example, a flying fox might be depicted, indicating that the *ngatu* comes from Kolovai village. Also, the name of the principal motif(s) may be spelled out as part of the *kupesi*.

Figure 1. Tonga: Ceremonial bark cloth design with *manulua* motif.

Figure 2. Ceremonial bark cloth design with *fata* motif.

If we place bark cloth into the more comprehensive domain of material culture it can be considered as part of the leading part, for all objects belong to one of three categories – items of everyday use; items

of ceremonial use called *koloa* or valuables, which include mats and bark cloth; and items of decorative use or *teuteu*, which include *sisi* or decorative girdles, *kahoa* or decorative necklaces, *teunga* or decorative costumes, and in former times, feather head-dresses and decorated combs. These categories of material culture were (and are) used, respectively, during portions of their lives which might be called profane, or day-to-day living when ordinary objects are used; sacred, such as funerals or other rites of passage where *koloa* are used; and celebrations or *kātoanga* where *teuteu* come into their own. These categories of material culture are not mutually exclusive, but it is predominance of the type of material culture appropriate to the occasion that is important.

Let us move now to the social domain which can be considered the basis of the leading part, drone, and decoration trilogy. The leading part in Tongan society is certainly the chief's. But because of the complex ranking system, other individuals appear and disappear, weaving their way above and below, depending on the activity or situation. In the societal ranking system, chiefs (*'eiki*) are distinguished from commoners (*tu'a*), who would be analogous to the drone and define the space in which the chiefs play their leading part. The chief of chiefs is set apart and known as the *tu'i* (or king). An intermediate class between chiefs and commoners is the *matāpule* who are ceremonial attendants, who trace their origin either to the sky or to a foreign land such as Samoa. Traditionally the Tu'i Tonga, the sacred highest chief who descended from the sky god Tangaloa, was outranked by at least two people – his sister (the Tu'i Tonga Fefine) and his sororal niece (the Tamaha).[3] The Tu'i Tonga Fefine and the Tamaha can be considered a 'decoration' of the Tu'i Tonga and such 'decorative persons' can be found at all levels of Tongan society.[4] At the level of *kainga*, or all kinsmen to whom one can bilaterally trace a relationship, sisters outrank brothers. The relationships of ego to members of the generation above depend on whether they are related through the father or mother – those related through the father being higher than ego while those related through the mother being lower than ego. Thus, as sisters outrank brothers and father's side outranks mother's side, the father's sister, *mehikitanga*, has the highest status. The relationships of ego to members of the generation below depend primarily on whether they are related through sisters or brothers. A man's sister's children have higher social status than ego and also have a special term, *'ilamutu*. Thus, every man is outranked in social status by his sister and sororal offspring, just as the Tu'i Tonga is outranked by the Tu'i Tonga Fefine and Tamaha (Kaeppler, 1971b). These individuals are decorative persons of the *kāinga* and it is they

3 Or anyone of the kinship category *'ilamutu* ('man speaking' children of *tuofefine* or 'sister').

4 In Samoa a titled unmarried girl of the chief's family, the Taupou, was also considered an ornament of the chief's rank (Mead, 1930. 14).

who will be elevated on ceremonial occasions with deference and visual symbols of *teuteu* material culture, i.e. with *sisi, kahoa,* and *teunga* (see above). These individuals, however, have little power. Political power esecially is the prerogative of the chiefs, while power within the *kāinga* is the prerogative of *tamai* (father and father's brothers).

Chiefs and *tamai,* I submit, are analogous to *fasi* or the leading part. They can be given additional prestige by the elevation of decorative kinsmen, especially during *kātoanga* and other ceremonial occasions. These decorative persons provide a way to demonstrate visually that, through prestigious marriages, the class rank of the decorative individuals may be higher than that of the chief or *tamai* himself, which may bring to him another dimension of prestige besides that inherent in his own birth. This latter dimension is usually manifested two or more generations below ego – for example if a man or his son marries a woman of higher rank, his grandchildren will outrank and 'decorate' him. Such grandchildren are designated *mokopuna 'eiki* (chiefly grandchildren) and are acknowledged on the most important ceremonial occasions. During formal kava ceremonies, for example, a large pig is brought into the kava circle and divided, ostensibly to be eaten by the chiefs and *mātapule* in the kava circle, but actually to be ritually taken away from each of the individual participants by a relative of higher rank. Those who take this ritual food are *mokopuna 'eiki,* sororal offspring, or their descendants, i.e., the decorative kinsmen of the chiefs and *mātapule.*

In certain activities and on selected occasions several of these artistic and social domains coincide, producing a product more complex than simply a sum of the parts. For, while each domain has an aesthetic of its own, a convergence of domains presents all the prerequisites for an aesthetic experience. An occasion on which a number of domains coincide is the performance of a formal *lakalaka* at an official *kātoanga. Lakalaka* is a Polynesian counterpart of Western 'total theatre' and the audience is completely involved in the performance. In a previous article (Kaeppler 1971a) I have analysed some of the aesthetic dimensions of *lakalaka* including craftsmanship in composition, appropriateness, skill and feeling of the performer and

Figure 3. *Lakalaka* performers. (*Photo: courtesy Bernice P. Bishop Museum, Honolulu*).

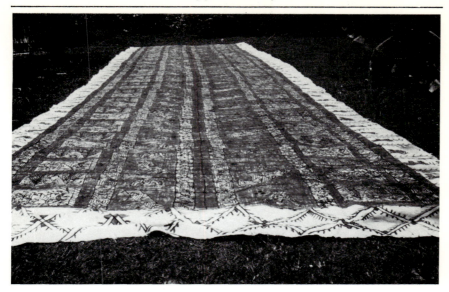

Figure 4. Large bark cloth (*ngatu*). (*Photo: courtesy Bernice P. Bishop Museum, Honolulu*).

the inner state of the spectator. Here, I want to place *lakalaka* into a broader socio-cultural context to illustrate the convergence of several dimensions of leading-part, drone, and decoration.

Let us compare, first of all, the arrangement of *lakalaka* performers (Fig. 3) and the arrangement of the design elements on a large *ngatu* (bark cloth) (Fig. 4). Performers are arranged in long lines – at least two, but more often three or four – much like the arrangement of motifs on a *ngatu*. The negative space between the rows of performers can be equated with the lines on a *ngatu* which were formed, almost incidently, by the pegs at the mid-line and sides of the *papa* (the pegs are used to hold a mesh of strings that form the background for the *kupesi* stencils and serve as another decorative element of the named motifs). Just as a *ngatu* has a named motif and decorative motifs arranged in rows or long lines, so the *lakalaka* has named positions with other dancers unnamed but decorative. The named positions are held by those of chiefly lines (analogous to leading part) while other dancers are undifferentiated, arranged in long lines (analogous to a drone) and a few are decorative, especially the *mālie taha*, or best dancer. Further, just as a standard length or *ngatu* of four to seven *langanga*, called *fala'osi*, is divided at the centre, each half forming a *maokupu*, so the dancers are divided at the centre, half being male and half female. Just as the named design appears in each *maokupu* half, while the decoration of the two *maokupu* may be different, so the named positions are in each half and male and female dancers perform different sets of movements to decorate simultaneously a single poetic verse – i.e. selected words of the text are alluded to by each half of the performers in two different ways.

In addition, the individuals who hold the named positions, *vāhenga* and *fakapotu*, although they are of the chiefly lines as far as the societal structure is concerned, may also be 'decorative individuals' as far as the individual chief of the village presenting the *lakalaka* is concerned. The *vāhenga* middle positions may be held by the chief's daughter for the female side or a high ranking female kinsman, while the male *vāhenga* may be his son, but often is a male of the category *'ilamutu*, e.g. his sister's son. The *fakapotu* end positions are usually held by *mokopuna 'eiki*, who may also represent another chiefly line of the village. Finally, *ta'ofii vāhenga*, i.e. individuals of *mātapule* (ceremonial attendant) lines, stand next to the two *vāhenga* and serve to separate the chiefs from the undifferentiated commoners, just as *mātapule* serve as liason between chiefs and commoners in everyday life. A function of the *mālie taha*, best dancer, who stands third from the middle, is to decorate the movements of the chiefs. *Mālie taha* have impeccable arm movements, can be counted on to keep the time properly with their leg movements, and have *māfana* (inwardly exhilarating) head movements, thus decorating the chief in the same way that decorative motifs of a *ngatu* decorate the named design – and in the same overall layout.

Teuteu material culture also comes into its own during such performances. Individuals who decorate the chief of the dancing village (i.e. daughters, *'ilamutu*, and *mokopuna 'eiki*), but form the leading part/motif of the performance, wear *teunga* (decorative costumes), *sisi* (decorative girdles) and *kahoa* (decorative necklaces) which are often specific to individual chiefly lines. Traditionally, and sometimes today, the other performers (male and female) wear a length of bark cloth decorated with motifs that may indicate the village they are a part of, or related to. They, too, wear *sisi* and *kahoa* but usually less ostentatious ones than the *vāhenga* or *fakapotu*.

Thus, visually the performance has leading parts (essential features), drones (space definers) and decorations (elaborations) in several dimensions, while the poetry, sung polyphonically and decorated with movements, incorporates the analogy on yet other levels. A total understanding of all dimensions comes to only a few – usually other artisans who cultivate such knowledge of socio-cultural allusions. But even without complete understanding of all dimensions, the spectator is immersed in the artistic allusions of his society and can understand at least some of the correspondences immediately. At the end of a twenty to thirty minute performance the dancing ground is alive with song and movements of the performers and empathetic movements (especially of the head, *fakateki*), applause and shouts of '*mālie faiva*' (bravo) of the spectators. No longer can each domain be analysed separately for there are levels and levels of decoration upon decoration, at least some of which are understood by everyone. Through these complex associations an aesthetic experience can be attained by performer and spectator alike.

It would appear that artistic works in Tonga have conceptual similarities in their underlying structure. Design space and design elements can only be combined in certain ways according to certain rules which are culturally understood by artist, performer and spectator. Areas are nearly always rectangular, divided into square compartments by lengthwise and crosswise lines. Squares are usually divided again by diagonal or straight lines forming triangles, squares and rectangles. Only at the last stage are curved lines added (if they are added at all) and such curves are always in relation to a straight line or a line that has crossed the square or rectangle. This is most apparent in bark cloth designs, but can also be seen in incised clubs, basketry, tattooing, prehistoric pottery, and even in a *lakalaka* dance where the dance space is a long rectangle divided in half (men on one half, women on the other half) and each performer having a sense of a square for himself. For the most part, leg movements are side to side and forward and back within this square. Curved lines come only in the *haka* arm movements giving to the surface structure a graceful curving appearance, especially in the women's movements. Polyphony, too, can be considered rectangular – the drone underscores the design space, while the *fasi* moves above it and decorative parts curve among them. The convergence of rectangles, squares and curves in varied artistic media create works of art and carry with them the possibility of aesthetic combinations and potential aesthetic experiences. I propose that aesthetic experiences, at least in Tonga, are realised when fundamental cultural principles are made specific in works of art (that is, when the deep structure is manifested in a cultural form resulting from creative processes which manipulate movement, sound, words or materials) and are comprehended as such by individuals.

From this analysis I draw several tentative conclusions:

1. Some underlying structural features have revealed themselves in an analysis of the ethnographic data, or if you will, in an analysis of the surface manifestations of various domains of Tongan art and society. These underlying features may be some of the unconscious, or at least unstated, principles by which individuals help to order their lives.

2. What the artisan does during creation may be essentially a series of transformational processes by which he converts the underlying principles or conceptualisations of these principles into a work of art which has potential for aesthetic experiences for those who comprehend (consciously or unconsciously) the underlying structure. I would further venture that it may be because the underlying structure is *not* comprehended by outsiders that they do not react to the surface stimuli of works of art in the same way as members of the society for which they were made.

3. I hesitate to propose rules or a grammar that will transform the underlying structure to generate works of art in Tonga, although Tongans continually demonstrated the processes to me (they seldom verbalised them, however, and never stated them as rules). Simply stated, they usually began with what I have called the drones, long lines, or space definers, and used these as a reference for placement of the leading part (motif/*fasi*/*haka*/etc.) and in some ways the leading part can be considered as a decoration of the drone. Only when the drone and leading part were satisfactorily arranged were the more creative decorative parts added. Thus, in effect, the leading part decorates the drone and the 'decoration' decorates the leading part.

4. How and why a specific arrangement is chosen is preeminently context-sensitive. For example, which direction the lines run in a bark cloth depends on its ultimate use, and which *lakalaka* will be chosen for performance depends on the occasion. This context-sensitivity is often apparent throughout the entire choice and arrangement of the movements, sounds, words, or materials.

5. It appears that the traditional function of the arts in Tonga has been to reflect and reinforce in a positive manner the socio-political system based on social status and societal rank. Although this is relatively easy to discern in material culture, other domains can now be seen to partake of the same underlying conceptual structure, in addition to what their surface manifestations tell us, and the more general statement can now be proposed with more credibility.

REFERENCES

Cook, James, (1784), *A voyage to the Pacific Ocean ... in the years 1776, 1777, 1778, 1779 and 1780*, London.
Kaeppler, A.L., (1971a), 'Aesthetics of Tongan Dance', *Ethnomusicology* 15, 175-85.
Kaeppler, A.L., (1971b), 'Rank in Tonga', *Ethnology* 10, 174-93.
Kaeppler, A.L. (in press), *Tongan Musical Genres in Ethnoscientific and Ethnohistoric Perspective*.
Mead, M., (1930), 'Social Organisation of Manu'a', *Bishop Museum Bulletin*, 76.

Peter Gathercole

Obstacles to the study of Maori carving: the collector, the connoisseur, and the faker

In the last few years, there has been a welcome tendency by some social anthropologists to consider afresh the relevance of ethnological collections to their discipline (e.g. Leach, 1974, 5-6). This is an encouraging sign to museum ethnologists who have often felt that they have charge of material which can be made into a rich source of ethnographic information, provided it is critically assessed in the light of present-day anthropological methods. In this paper, I discuss to what extent it is possible to use Maori artifacts from private collections in order to clarify, if not answer, certain questions relating to Maori carving.

Maori artifacts have been acquired by outsiders since Cook's first landfall in New Zealand in 1769. Early collections occasionally survived as groups in European museums, but often they disappeared into private houses, perhaps to reappear without documentation in sale rooms (Kaeppler, in preparation). These early pieces are today receiving much painstaking attention because they do reflect in some way the nature of Maori society at first European contact. Where documentation exists – and it often does, to a surprising extent – it is possible to provide a cultural context for specimens obtained during Cook's visits to New Zealand between 1769 and 1777 (Shawcross, 1970; Gathercole, n.d.; Kaeppler, 1971; Gathercole, 1976).

The same approach can be used, of course, for documented specimens obtained after the settlement of Europeans began in New Zealand in the early nineteenth century. But settlement introduced changes within Maori society on a much greater scale than hitherto and, because the novelty of observing Maoris quickly gave way, in European eyes, to problems associated with living with them, documentation of specific items of material culture rapidly became less reliable. Cook's crews had collected objects as reflections of their particular experiences with strange natives in the South Seas. Increasingly in the nineteenth century, Maori objects were sought for their own sake by collectors, who conceived a passion for the artifacts

of a far-off 'neolithic' man, but whose direct experience of a Polynesian environment was nil. This was particularly true in England. In 1840 the young colonist, Francis Molesworth, could send home to his mother in Cornwall the fine nephrite *tiki* now in the County Museum, Truro, purchased from a Maori at the new settlement at Port Nicholson (Wellington). In 1854 Wollaston Franks received at the British Museum some fine carved door lintels and other objects from his friend Sir George Grey, who had been given them during his first term of office as Governor. But by the 1890s, when Anatole von Hügel was expanding the tiny Maori collection at the University Museum of General and Local Archaeology (as it was then called) at Cambridge, he turned mainly to the salerooms to acquire pieces of carving and other artifacts. Within a hundred years, Maori society changed so much that it rejected as irrelevant many aspects of its own past. During this time, artifacts flowed out of New Zealand to salerooms, museums and the cabinets of private individuals overseas, notably to Britain. This means that today the great majority of surviving Maori artifacts lack adequate contextual documentation and many have no known history at all. At Cambridge, only about 15% of the collection of 500 pieces is documented and half of this 15% comprises pieces from Cook's voyages. Some 300 Maori objects survive in the world's museums from these voyages (Dodge *in* Duff, 1969, 88). This is just half the total Maori collection obtained by the English collector Captain Fuller during the first half of this century, much of which is localised only to its sources of origin in Britain (Force and Force, 1971, 20). In fact, Fuller's collection is better documented than most. Maori museum collections may be a rich potential source of information, but they often lack an indication of provenance or date of acquisition within New Zealand, which would provide a starting point to their detailed investigation. No wonder these collections have been ignored by anthropologists for so long. They appear to comprise a haphazard assemblage of junk, reflecting only their unsystematic methods of acquisition.

To understand a collection, one must understand the collector and be aware of the historical climate within which his objects were obtained. The major period of acquisition of Maori objects by museum curators and private individuals was between the second New Zealand war of the 1860s and 1914. This was a time of enormous intellectual activity in New Zealand. It saw the founding of the four university colleges in the main urban centres, the establishment of the major museums, the creation of the New Zealand Institute (now the Royal Society of New Zealand) and a great deal of field research in the natural sciences. Considerable attention was given by a number of talented amateurs to the ethnology of the Maori, much of it under the aegis of the Polynesian Society, founded in 1892. But no museum employed an ethnologist until Best went to the Colonial Museum,

Wellington, in 1910 (Bagnall, 1966, 200) and academic anthropology did not start until 1919, when Skinner was appointed to Otago University (Freeman, 1959, 20). Collections of artifacts, therefore, were never made very systematically by ethnologists among Maoris relatively unaffected by outside contact. Whether put together within New Zealand or in Europe, collections were reflections of a century or more of cultural contact, and they were shaped more by the enthusiasms of the collectors and the state of the dealers' market than by contemporary Maori society (cf. Wiśniowski, 1972, 111-15 for a fictionalised portrait of a North Island dealer in curios).

Until about 1950 Maori objects did not usually command high prices in salerooms. They were not particularly fashionable and escaped almost entirely the serious attention of Western artists. The Surrealists, for example, saw forms of universal appeal in the arts of Melanesia, but apart from a few of the more exotic forms, Maori carving did not usually attract them. The sculptor Epstein had a collection of 40 *tiki* when he died in 1959, but he was an exception. Von Hügel regularly picked up good quality weapons for a pound or so between 1884 and 1914. The dealer W.D. Webster was advertising excellent specimens in 1900 costing between £7 and £10. Oldman, the well known dealer and collector, vowed in 1946 that he had never paid more than £80 for any object in his large and varied collection (Fig. 1; Hewett, J., pers. comm.). The market in England tended to be

Figure 1. W.O. Oldman with part of his collection at his home in Clapham, London, in 1948. (*Photo: courtesy John Hewett*).

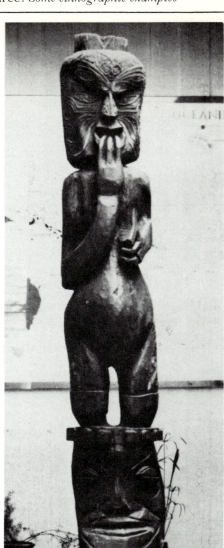

Figure 2a. Fake *tekoteko* carving, maker unknown. (*Photo: State Ethnographic Museum, Warsaw*)

dominated between about 1890 and 1950 by a few collectors, dealers and curators, who often knew each other and evolved a sort of potlatch relationship reminiscent of schoolboys swapping marbles. For much of this century, the most important private collectors were Fuller, Beasley, Oldman, Wellcome, K. Webster and Hooper. They had a

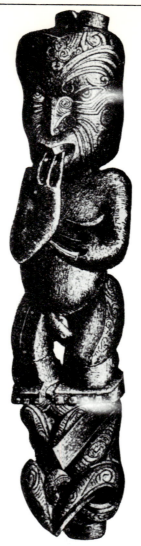

Figure 2b. A similar carving in the Museum für Völkerkunde, Leipzig. (*Photo: University Museum of Archaeology and Ethnology, Cambridge, after Buck, P.H.*, Vikingové jižnich moři, *Prague, 1963, Pl. between pp. 144-5*)

firmer grip on the market than did the museum curators and they built up extensive collections, large portions of which are now in various museums in Britain, the United States or New Zealand. The sizes of these collections varied and are difficult to estimate, but at one time or another Fuller had nearly 600 items, Beasley 530, Oldman about 400, Webster 400 and Hooper 260. By comparison there were only about one thousand items in the *total* Oceanic collection at the Otago Museum, Dunedin, when Skinner went there in 1919

(Freeman, 1959,16).

Within New Zealand, the collecting pattern was very similar to that existing in England, though on a smaller scale. By the time that informed local opinion could force the Government to adopt legislation to keep artifacts at home (in 1901), many of the finest specimens had already gone overseas. 'Overseas', incidentally, included the European continent. The collection obtained by the Austrian, Reischek, between 1877 and 1889 went to the Museum für Völkerkunde, Vienna (Moschner, 1959), and a smaller collection made before 1914 by the Czech painter Lindauer was given to the Náprstek Museum in Prague. Reischek's collection was the last one with any pretentions to authenticity, having been made among Maoris. Reischek was an ambitious and sometimes ruthless man, not above using trickery to acquire pieces (e.g. Reischek, 1930, 214-6). But his objects were provenanced to some extent and therefore they can be used to indicate in a rough way which indigenous artifacts survived among the Maoris he visited. It was the last major collection to come from New Zealand to Europe.

Most of the collections I have mentioned were not representative in any ethnographic sense at all. They were mirrors of European tastes. Whatever eclectic ethnological knowledge the collectors were guided by, they were, geographically and psychologically, a very long way indeed from the Maoris who made their passion possible. Fuller said that the 'guiding principle in forming my collection has been, and is, the study of comparative technology and the evolution of design' (Force and Force, 1971, vi). Oldman professed an eye for 'fine old work' (1946, 1, 11). Beasley, to judge from the quality of those items from his collection now in museums in Britain, had a flair for choosing the rare and the beautiful. His unpublished catalogue shows that he maintained his records of acquisitions, sales and exchanges with equal care. Wellcome (of Burrows, Wellcome Ltd) on the other hand, was simply very acquisitive, with little sense of discrimination. Webster was a New Zealander, dedicated to the task of rescuing fine objects for modest sums from small museums and private owners alike and selling or giving them to New Zealand museums. As an episode in English social history, however, the acquiring of Maori artifacts was totally divorced from Maori society, past or present.

A bizarre indication of this can be seen in the rise and fall of the Maori fake, which flourished particularly around 1890-1930. Fakes have been the subject of recent papers by Legge (1970) and Skinner and Barrow (in Skinner, 1974, 181-92), and there is no need to cover the same ground again here. It is worth stressing however that, because fakers must reflect in their activities the tastes and knowledge (or lack of it) possessed by their potential purchasers, they do provide a guide to the prevailing level of interest among collectors. Most Maori fakes are small, although there are a few large wooden ones in European museums (Fig. 2a and b). According to Skinner, several

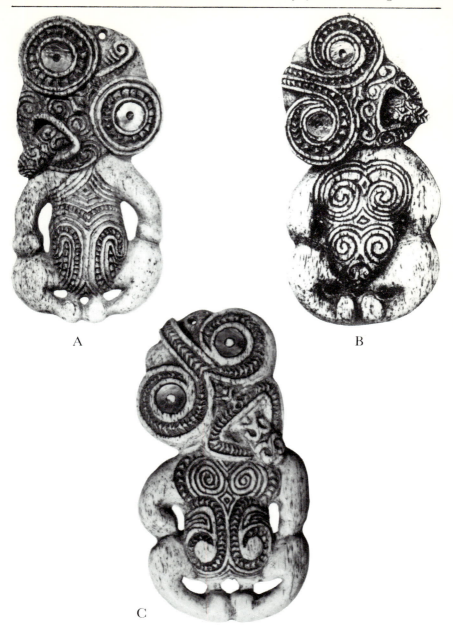

Figure 3. Three fake (whale?) bone *tikis* showing Little's 'trumpet' style. (a) In University Museum of Archaeology and Ethnology, Cambridge (Z.6458), ht. 9 cm. Purchased as genuine from W.D. Webster, London, 1907. (b) Advertised (Lot 287) for sale as genuine at L'Hôtel Drouot, Paris, 23-25 May 1934. No dimensions recorded. (c) Ht. 8.5 cm. Sold (Lot 39) as 'probably the work of Robieson' at Christie's, London, 11 December 1974. (*Photos: a and b, University Museum of Archaeology and Ethnology, Cambridge; c, Messrs. Christie's*)

lapidaries in Germany and New Zealand made *tikis* and other nephrite pendants. In England, faking was usually modest in range, the two best known fakers, as Legge and Barrow have shown, being Little and Robieson. Some of the objects produced, however, were not copies of traditional forms, but new types. In Auckland, according to Skinner, Lloyd specialised in the production of an unusual form of snake pendant. In England, Little marketed a type of flute which was actually an overcarved Tibetan human thigh bone trumpet. I believe that he was also responsible for those bone *tikis* which are decorated partly in his 'trumpet' style and still make transient appearances in salerooms (Fig. 3a, b and c). For his part, Robieson produced, for example, a uniquely decorated flute and a strange carved moa bone inlaid with *paua* shell as Skinner recounted in a survey of 'the faking of Maori art' (Barrow in Skinner, 1974, 183-5). Small though it was, it seems that the market was interested in obtaining specimens which were so unusual that they need not have had any cultural connection with the Maoris at all. These objects were wholly a product of the European imagination.

Of course, although the fakers did successfully dispose of their pieces to museums and to Wellcome, they did not deceive serious collectors like Fuller and Oldman. The latter openly denounced Little's work in *Man* (1910). But the fakers were really only taking to extremes the passions of the private collectors. Fuller, Oldman and the others were interested in objects. They divided their collections up into classes which were defined by the artifacts themselves. Their standards were set by the aesthetic or other qualities that they saw in their specimens. They had an abiding interest in weapons. Of the 71 Maori pieces from the Fuller collection in the Field Museum, Chicago, illustrated by Force and Force (1971), no less than 29 are weapons. Oldman possessed in 1938 80 *taiaha* (two-handed clubs) in a total collection of 400 objects (Oldman, 1946, 19). The rich accoutrements of the chief, skilled in war and suffused with *tapu*, figure largely in all collections. There are fine cloaks, breast and neck ornaments, combs, one- and two-handed clubs, and such status objects as feather boxes, feeding funnels and ceremonial adzes. The collectors hunted just as eagerly for carved items of all sorts: store house fragments, lintels, paddles, canoe terminals, parrot perches and human figures. They were fascinated by objects which were, or appeared to be, esoteric or unusual, especially if, by virtue of their shape, style or feel, they seemed to be *old*. Oldman stressed whenever possible the apparent age of the specimens offered for sale in his monthly catalogues. In such an atmosphere, questions of specific cultural context were deemed unimportant.

One should not be unfair to the collectors. They were no worse than some museum men of the time. Maori culture was thought to be dead and until the early years of this century it was widely assumed that the race was dying. There was a surge of romantic interest in the Maori

past, well expressed in the *art nouveau* drawings by Dittmer (1907), where myths and traditional stories were represented in a charmingly idealised way. Indeed, to handle these collections today is to be haunted by a vision of an 'old time Maori' (the phrase is Best's) who did not exist. He was portrayed as having fine martial qualities, a love of carving, music and dancing and a picturesque mythology which symbolically mapped his environment with an allusive understanding of its utility. This essentially timeless Maori was a compound of the eighteenth century noble savage, nineteenth century economic man and the European stereotype of the valiant tribesman honourably defeated in colonial wars. Visiting the King Country in 1882, Reischek said that it was 'as though I were making a journey into the dim receding past' (1930, 114). There he saw '*herculean* chiefs and warriors [my emphasis] ... sitting together in groups before the huts, all in native dress' (1930, 152). In 1885, J.A. Froude, the Oxford historian, went to Ohinemutu, which was already a tourist centre. He contrasted the old Maori warrior, who was 'brave, honourable, and chivalrous; like Achilles, he hated liars "as the gates of Hell" ', with the Maoris he saw there: 'Their interest now is in animal sloth and animal indulgence, and they have no other' (Froude, 1888, 257). He likened them to the Irish peasants he had seen in the 1840s. Samuel Butler wrote home from his sheep run in the Canterbury back country in the early 1860s: 'What will you all say if I marry a Maori? ... Unfortunately there are no nice ones in this island. They all smoke and carry eels and are not in any way the charming, simple-minded innocent creatures which one might have hoped' (Kiernan 1969, 263). Native charm and innocence, as well as chivalry and honour, became qualities of the idealised past, reflected in the paintings of a group of Auckland painters: Steele, Walter Wright, Lindauer and Goldie (Docking, 1971, 82-90). Some years later, even Cowan, often a perceptive writer, compared Maori symbolism 'with that of the Greeks and Romans'. He thought that the Maori had 'all the mysticism and imagination of the Celt', and that there was 'more than a strain of the Ossianic in his poetry, in his figurative laments and wild tangi-songs' (Cowan, 1959, 30). Maori artifacts were equally idealised. Cowan described the *taiaha* as 'probably the most handsome as well as the most effective weapon of wood ever invented by a warrior race' (Cowan, 1959, 37). He believed that 'the Maori artisan was also an artist. He combined utility with decoration as probably no other primitive race combined them' (Cowan, 1959, 47). The collectors of artifacts were only following a persistent European trend by indulging in this form of romantic, ahistorical abstraction. It made the contemporary plight of the Maori more palatable and his past more appealing. These collections were one of the minor offshoots of the acquisition of an Empire.

That Empire has now gone, but the collections remain and they cannot be ignored. Specimens which have a known history can

provide direct evidence and models of the past. Others, which have characteristics that can be shown by comparison to be morphologically related to provenanced and dated examples, can be linked with them into assemblages or classes. It can be demonstrated that these classes often had pragmatic functions and even wider meanings. Studies of godsticks (Barrow, 1959; 1961), the so-called nose flute (McLean, 1972) and the shell trumpet (Gathercole, 1976) have been conducted in this way. But this approach leaves much in the collections as untouched as ever. It perpetuates the attitude of the older collectors by narrowing attention to particular types, dividing collections 'vertically' into discrete, self-contained units, and assuming that Maoris always did likewise. This 'vertical' approach tends to atomise collections and render them even more useless than they already are. An approach is required which seeks to establish 'horizontal' correspondences and contrasts between artifact types, in order to show the ways in which Maoris perceived the interrelationships between them. Mead's study of Maori clothing (1969) clearly demonstrated that this approach not only placed artifacts in their cultural context, but also illuminated the relationship of clothing to concepts of social organisation and status. Jackson's work on lintels (1972) extended the links of material objects still further, to aspects of psychology and cosmology.

Maori society was rich in the use of metaphor, allusion and the personification of natural phenomena. Its art was one way of expressing esoteric phenomena in symbols of sound, gesture and carving. The presence of gods was represented by music, by spirit possession and occasionally by carved images. Ancestors were commonly shown in figure carving, and groups of carvings symbolised whole sets of socially desirable moral qualities. Thus the meeting house expressed aspects of tribal solidarity and history. The store house demonstrated the status and fructifying power of a chief, summarised in his *tapu*. The carved feather box, which often had similar decoration to the store house, w , in a sense, a small store house which was portable. Carving had a moral purpose. It follows that the details of a carving, or set of carvings, carried messages, but also bore meanings themselves. These details could have been expressed on a variety of objects of widely different forms. If the details can be recognised, they can be used to link objects together at a symbolic level in terms of their meanings.

For example, let us examine the apparently mundane notch. Notches occur on a range of objects in positions which often seem to be non-functional. They are found for instance on several types of prehistoric (Archaic) and later ornaments; on ceremonial adzes; on parrot rings; occasionally at non-functional positions on fish-hooks; and sometimes on the outside margins of eyes of *paua* shell inlay on carvings. They are part of certain carving motifs found on store houses. Notches occur naturally on the teeth of the *tuatini* shark, and

are therefore incorporated into such artifacts as shark-tooth knives and certain forms of necklace. They are also the distinguishing characteristic of the tally-stick used for the correct recitation of genealogies (*whakapapa*).

The meaning of the word *whakapapa*, however, is not confined to the recitation of genealogies or legends in proper order. According to Williams' *Maori Dictionary*, it has a variety of meanings, including to lie flat; to go slyly or stealthily; to lay low, strike down; and to place in layers, lay one upon another (Williams, 1971, 259). This range suggests the tentative hypothesis, via the association of *whakapapa* with a notched stick, that notching itself may have been one way of expressing a number of possible actions or attitudes, some of which were concerned with hunting or combat, others with putting things into order. The cutting of notches into the shank of a bait-hook, therefore, need not have been solely to provide a firm seating for a lashing cord. It could also have been done to imbue the hook with the power to catch fish by stealth. The notches cut into the sides of adzes could have expressed not only the particular genealogy of the owner, but also the precise ordering of social relationships which recognition of this genealogy implied. Ornaments bearing notches could have had similar meanings. The shark-tooth knife, reputedly used for ritual scarification and even for the dismemberment of human bodies, might have been a symbol both of cutting and killing, and also of the re-ordering of ranked relationships which followed the death of a person of high status. The notching incorporated into some of the designs on chiefly store houses could have had similar meanings, although the meaning conventionally applied is that of a water symbol (Barrow, 1969, 121).

Meanings could have been multifarious, and expressed in a range of contexts. Just as one form of art, ceremonial dancing, occurred on such widely differing occasions as 'war, peace making, (the) reception of visitors, divination, mourning the dead, greeting the new moon and the reappearance of stars' (Best, 1924, 284), so another, carving, could have conveyed its messages in a variety of social situations. The human face, the *manaia* design, and curvilinear patterns, were recurrent motifs on objects used in almost every aspect of life. They seem to have been necessary elements defining the completeness and efficacy of many objects. Thus to regard a ceremonial adze as belonging to a different class of object from a chiefly orator's *taiaha* simply because they had different shapes and overt functions is misleading. One of their most important attributes was the same; they helped to define the status of the user. Similarly, although gods were rarely delineated in carving, the fact that they could be summoned to inhabit a godstick emphasised their continual links with ancestors and men (Barrow, 1959, 185-6). The top of the godstick was carved as a human head which on many other objects symbolised ancestors. The human head, or the face, or *moko* (tattoo) carved into the skin, were

therefore continually reflected in carving, even merely as a small stylised fragment on the haft of a weapon. Carving reminded the Maori of his place in a timeless ideological continuum embracing gods, ancestors and men. Just as the application of *moko* was a long process signifying status, so the decoration of objects with similar designs was an elaborate and time-consuming activity which gave the objects an enhanced identity in the total context of Maori society (Mead, 1975, 174-9). It seems to me no accident that there is a richness of detail on very many objects from the nineteenth century, compared to most of those acquired in the 1770s. During and after the wars against the colonists it was of crucial importance to the Maoris that they should have their own visual means of expressing an identity different from that of Europeans. Art became (if it had not been before) an expression of politics.

This was a world away from the domain of the private collectors. Their significance should not be exaggerated, though they call for more detailed biographical study than given here. What is unfortunate is that their attitudes have been inherited and perpetuated by certain recent writers on Maori art. For example, Dodd has claimed that 'the Maori ceremonial adze ... clung closer to its streamlined, utilitarian paternity and achieved a real beauty of polish, finish, and shaping. The main point in the evolution from functional to ceremonial, is universally, *intentional loss of function*: the role of the object changed from a tool to a god or a repository of spirits' (Dodd, 1969, 169). This could have been Fuller speaking. The assumption that there is an inevitable dichotomy between function and meaning is also implicit in Barrow's discussion of Maori symbolism (Barrow, 1969, 18-21). He sees symbolism as something *necessarily* obscure. 'Primitive arts have their roots in mystical religions ideas and unusual social customs which are remote from modern scientific thought' (Barrow, 1969, 20). In my view, the reason why Maori symbolism is still sometimes regarded as remote is because its study has been neglected at the expense of the functional examination of artifact types. At one time this examination may have appeared to be a proper activity for museum ethnologists who studied the material remains of a conquered minority, because these types could be perceived and explained in terms of the categories of European culture. The study of symbolic meaning, however, was thought to be secondary, alien and obscure. Actually it is symbolism which explains function. It is neither alien nor remote, but lies at the core of the corpus of Maori ethnography, waiting to be used.

Acknowledgments

My thanks are due to the following for discussions on collectors and their activities, which gave rise to this exploration of one aspect of race

relations: Dr Terry Barrow, Mrs Elizabeth Cowling, Dr Roger Duff, Mr John Hewett, Mr Kirk Huffman, Dr Adrienne Kaeppler, Dr Sidney Mead, Dr S. Novotný, Mr Stuart Park, Mr Steven Phelps, Dr H.D. Skinner and Miss H. Waterfield.

REFERENCES

Bagnall, A.G. (1966), 'Elsdon Best (1856-1931)' *in* (ed.) A.H. McLintock, *An Encyclopaedia of New Zealand*, 1, pp. 199-200, Wellington.

Barrow, T. (1959), 'Maori godsticks collected by the Revd. Richard Taylor', *Dominion Museum Records in Ethnology*, 1, pp. 183-211.

Barrow, T. (1961), 'Maori godsticks in various collections', *Dominion Museum Records in Ethnology*, 1, pp. 213-241.

Barrow, T. (1969), *Maori Wood Sculpture of New Zealand*, Wellington.

Best, E. (1924), 'The Maori', *Memoirs of the Polynesian Society*, 5: 1.

Cowan, J. (1959), *The Caltex Book of Maori Lore* (revised by J.B. Palmer), Wellington.

Dittmer, W. (1907), *Te Tohunga: The Ancient Legends and Traditions of the Maoris Orally Collected and Pictured*, London.

Docking, G. (1971), *Two Hundred Years of New Zealand Painting*, Wellington.

Dodd, E. (1969), *Polynesian Art*, London.

Duff, R. (ed.) (1969), *No Sort of Iron: Culture of Cook's Polynesians*, Christchurch.

Force, R.W. and Force, M. (1971), *The Fuller Collection of Pacific Artifacts*, London.

Freeman, J.D. (1959), 'Henry Devenish Skinner: a memoir', in J.D. Freeman and W.R. Geddes (eds.), *Anthropology in the South Seas: Essays presented to H.D. Skinner*, pp. 9-27, New Plymouth.

Froude, J.A. (1888), *Oceana or England and her Colonies*, London.

Gathercole, P., n.d. (1970), *From the Islands of the South Seas 1773-4: An Exhibition of a collection made on Capn. Cook's Second Voyage of Discovery by J.R. Forster*, Oxford.

Gathercole, P. [1976], A Maori shell trumpet at Cambridge', in G. de L. Sieveking, I.H. Longworth and K.E. Wilson (eds.), *Problems in Economic and Social Archaeology*, pp. 187-199, London.

Jackson, M. (1972), 'Aspects of symbolism and composition in Maori art', *Bijdragen tot de Taal-, Land- en Volkenkunde*, 128, pp. 33-80.

Kaeppler, A.L. (1971), 'Eighteenth-century Tonga: new interpretations of Tongan society and material culture at the time of Captain Cook', *Man*, n.s. 6, pp. 204-220.

Kaeppler, A.L. (in preparation), *Captain James Cook, Sir Ashton Lever and Miss Sarah Stone*; incorporating *Art and Artifacts of the 18th Century* (R.W. and M. Force), Honolulu.

Kiernan, V.G. (1969), *The Lords of Human Kind*, London.

Leach, E. (1974), 'Rain making: the future of the royal anthropological institute', *R.A.I. News*, 4, pp. 3-10.

Legge, C.C. (1970), 'Les faux océaniens de James Edward Little dans la Collection Fuller', *Journal de la Société des Océanistes*, 26, pp. 107-119.

McLean, M. (1972), 'The New Zealand nose flute: fact or fallacy?', *Working Papers ... Department of Anthropology, University of Auckland*, 18.

Mead, S.M. (1969), *Traditional Maori Clothing: a study of technology and functional change*, Wellington.

Mead, S.M. (1975), 'The origins of Maori art: Polynesian or Chinese?', *Oceania*, 45, pp. 173-211.

Moschner, I. (1959), 'Katalog der Neuseeland-Sammlung (A. Reischek), Wien', *Archiv für Völkerkunde*, 13, pp. 51-131.

Oldman, W.O. (1910), 'Polynesian forgeries', *Man*, 10, p. 188.

Oldman, W.O. (1946), 'Skilled Handwork of the Maori' (2nd. ed.), *Memoirs of the Polynesian Society*, 14, Wellington.

Reischek, A. (1930), *Yesterdays in Maoriland*, London.

Shawcross, F.W. (1970), 'The Cambridge University Collection of Maori artefacts, made on Captain Cook's First Voyage', *Journal of the Polynesian Society*, 79, 305-348.

Skinner, H.D. (1974), *Comparatively Speaking* (eds. P. Gathercole, F. Leach and H. Leach), Dunedin.

Williams, H.W. (1971), *A Dictionary of the Maori Language* (7th ed.), Wellington.

Wiśniowski, S. (1972), *Tikera, or Children of the Queen of Oceania*, Auckland.

G. Reichel-Dolmatoff

Drug-induced optical sensations and their relationship to applied art among some Colombian Indians

The use of narcotic substances, the ingestion of which produces a wide range of altered states of consciousness on the perception-hallucination continuum, is a common feature in many native societies of Colombia. There is archaeological evidence for drug-use in the prehistorical past and the early Spanish sources contain abundant references to the use of narcotics, especially in connection with shamanistic practices. The principal plant sources were – and still are – tobacco (*Nicotiana* ˙ spp.), coca (*Erthroxylon coca*), yopo (*Anadenanthera peregrina*), vihó (*Virola* sp.), several species of *Datura*, and the jungle vines of the genus *Banisteriopsis*, a malpighiaceous plant of the tropical rain forest. In the present paper I shall concern myself with certain photic sensations produced by the chemical components contained in *Banisteriopsis* and with their possible influence upon the origin and significance of certain native art styles.

Banisteriopsis was discovered by the British explorer Richard Spruce, in 1852, when travelling among the Tukano Indians of the Northwest Amazon (Spruce, 1908). The geographic distribution of hallucinogens prepared from *Banisteriopsis* in South America has been traced by Friedberg (1965). In Colombia, these drugs are used by many native groups of the humid tropics where they play an important role in religious rituals, medical practices, or in divination. The vine (and the drug prepared from it) is known under a number of vernacular names: in Colombia, *yajé*, in Peru and Ecuador, *ayahuasca* and in Brazil, *caapi*. The botanical species used by Colombian Indians are mainly *B. caapi*, *B. inebrians*, and *B. rusbyana*. For actual use, these drugs are prepared from the bark of the vine, mainly in the form of a beverage or, occasionally, of a finely powdered snuff.

Phytochemical and pharmacological research on the psychotropic substances derived from the Colombian Malpighiacea began over fifty years ago when Fischer (1923) first isolated a crystalline alkaloid from *Banisteriopsis*. In 1928, Elger showed that this alkaloid was identical to

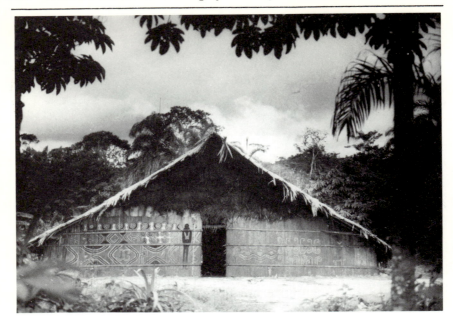

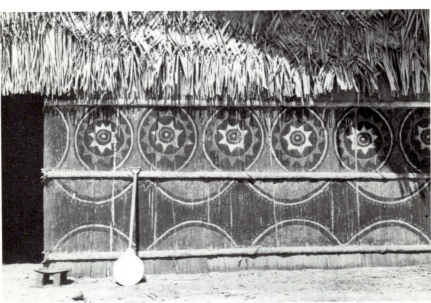

Figures 1 and 2. Pira-paraná, Vaupés territory, Colombia: wall paintings on a Tukano house. (*Photos: 1-7, G. Reichel-Dolmatoff*).

the harmine isolated years earlier from a shrub found in the Near East, *Peganum harmala*, the narcotic properties of which had been known since antiquity. As valid botanic identification became more precise, it was possible to detect the presence of harmine in *B. caapi* (Chen and Chen, 1939) and in *B. inebrians* (O'Connell and Lynn, 1953). Furthermore, Hochstein and Paradies (1957) found other derivatives of the beta-carbolines in stems of *B. caapi* – for example, harmaline and d-tetrahydroharmine (Bristol, 1966, 115-16; Naranjo, 1967, 394; Schultes, 1969, 250). *Banisteriopsis rusbyana* was found to contain large amounts of the hallucinogen N, N-dimethyltriptamine (Agurell, Holmstedt and Lindgren, 1968; Poisson, 1965).

The anthropological, botanical, and pharmacological literature contains descriptions by several authors of the psychotropic effects of the components of *B. caapi* and other species of Malpighiacea (see, among others, Harner, 1968; Naranjo, 1965, 1967; Reichel-Dolmatoff, 1972). From these descriptions we learn that the ingestion of an infusion prepared from *Banisteriopsis* causes vertigo, nausea and vomiting, followed by states of euphoria. After a while, colourful images will appear, which may be of sublime beauty but which may also involve great anxiety. Animals – usually felines and reptiles – appear in these visions, sometimes turning into threatening monsters, or one may behold shouting crowds, men brandishing their weapons and other scenes of violence. Sometimes the individual finds himself flying on the winds, visiting far-off places, or communicating with divine beings, dead relatives, or shamans of neighbouring groups.

In the following I shall refer mainly to the Tukano Indians, a large group of natives of the Colombian Northwest Amazon. The Tukano use a number of different narcotic substances in order to produce altered states of consciousness on certain occasions. *Banisteriopsis* infusions play an important part in many of their collective rituals, during which the participants claim to have visions of spirit-beings and mythological scenes. However, *Banisteriopsis* is also used by them for purposes of divination and in medical practices. In any case, drug-induced trances and hallucinatory experiences are at the core of many – if not most – native beliefs and are of great consequence in myth and ritual and in many practical affairs of everyday life.

According to the Indians, there exist essentially three stages of *Banisteriopsis* intoxication. Shortly after the ingestion of the drug, after an initial tremor and the sensation of rushing winds, harmaline produces a state of drowsiness during which the person concentrates with half-closed eyes upon the luminous flashes and streaks which appear before him. This first stage is characterised by the appearance of small, star-shaped or flower-shaped elements which flicker and float brilliantly against a dark background, in repetitive kaleidoscopic patterns. There is a marked bilateral symmetry to these luminous perceptions which sometimes appear as clusters of fruits or feathery leaves. Grid patterns, zigzag lines and undulating lines alternate with

eye-shaped motifs, many-coloured concentric circles or endless chains of brilliant dots. The Indians interpret this stage as one of pleasant reveries during which the person watches passively these innumerable scintillating patterns which seem to approach or to retreat, or to change and recombine into a multitude of colourful panels. After a while the symmetry and the overall geometrical aspect of these perceptions disappears and the second stage sets in. Now figurative, pictorial images take shape; large blots of colour will be seen moving like thunderclouds and from them will emerge diffuse shapes looking like people or animals, or unknown creatures. The Indians interpret these images as mythological scenes peopled by spirit-beings, visions which to them bear witness to the essential truth of their religious beliefs. In a third stage, all these images disappear. There will be soft music and wandering clouds, a state of blissful serenity.

While the second stage obviously marks the onset of hallucinations, the first stage is a trance-like state during which the person, while not divorced from reality, visualises elements that appear in external objective space as geometrical patterns, clearly outlined and brilliantly coloured, but which cannot be designated as true hallucinations. The Indians themselves recognise quite clearly that this is not an inner subjective dimension; they call these luminous sensations 'sprigs', 'little flowers', or 'clusters' and consider their sight as a pleasant experience, quite different from the emotion-charged images of the second stage.

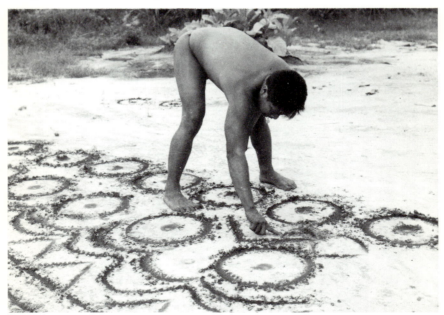

Figure 3. Pira-paraná, Vaupés territory, Colombia: a Tukano Indian drawing phosphene patterns in the sand.

The literature on native hallucinatory content abounds with descriptions of the weird imagery produced by advanced harmaline intoxication. It should be kept in mind here that the sphere of hallucinations is one of subjective interpretations in which the person projects a set of pre-established, stored material upon the wavering screen of shapes and colours. Understandably, the mythical scenes seen by the Tukano during the second stage of the drug experience, can be seen only by members of *their* society. But the repetitive luminous patterns perceived during the first stage of the toxic condition represent neurophysiologically an entirely different aspect of the experience and it is this dimension that is of interest to our inquiry.

While engaged in ethnographic field work among the Tukano Indians, I had asked the men to depict the visual images they perceived while under the influence of *Banisteriopsis*. I offered the men a choice of twelve coloured pencils and some sheets of white paper 28 cm. x 22 cm., mounted on a wooden tablet. They were all adult males who frequently took *Banisteriopsis*; further, all were non-acculturated Indians who did not live in contact with civilisation, none of whom spoke Spanish. The men showed great interest in this task and spent from one to two hours finishing each drawing. For our drawings, they first traced a rectangular frame and then divided the space into convenient quadrants. The colours they selected spontaneously were exclusively red, yellow and blue, on very few occasions adding a shade of hazel brown. There were comments that there was not a good choice of the various tones of the basic colours, since the Tukano discriminate carefully between a number of shades of the same pigment, such as clear yellow, orange yellow, reddish yellow, etc. and evidently would have preferred to execute the drawings in a wider range than allowed by each of the basic colours. When each drawing was completed, I recorded on tape the explanation the artist gave for his work. Sometimes these comments were extremely concise: others were long and detailed explanations (Figs. 5-7).

Once I had obtained a short series of drawings it became clear that some of them represented the stage of repetitive geometrical patterns, while others depicted the stage of figurative imagery seen during hallucination. The Indians themselves readily pointed out this difference. But, more important still, I noticed that the drawings — mainly those of the first category — consistently repeated certain design motifs. The elements were rarely exactly the same, but each motif had in common a certain basic shape: a zigzag line, a triangle, a circle, a U-shaped element, and others. There were variations in size, colour, or elaboration, but the essential outline was the same within each motif and could easily be recognised. They could be drawn in a single, a double, or a triple line; in one, two, or three colours, with little appendages or other secondary additions; but the basic shape was the same.

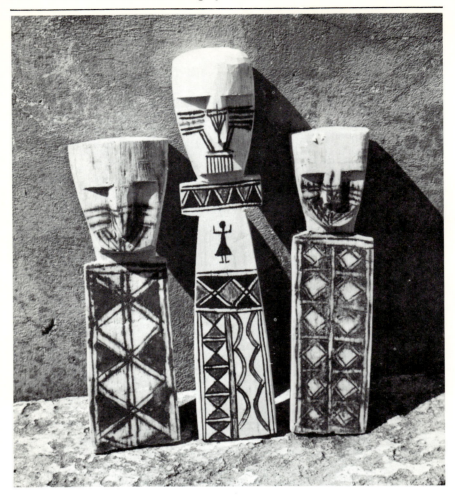

Figure 4. Headwaters of the Sinú River, Colombia: wooden figurines of the Chocó
 Indians.

I now proceeded to isolate these design motifs by drawing each of
them on a numbered card and showing these around, soliciting
comments. It soon became clear that the drawings contained
individual variations of some twenty well-defined design motifs. As a
matter of fact, it seemed that different people, men belonging to
different age-groups, occupying different social positions, and
representing different personality types, all perceived basically the
same geometrical patterns during the first stage of *Banisteriopsis*
intoxication. This observation brought to mind the possibility of an
underlying biological basis, that is, of the question whether similar
brain stimuli would produce similar optical sensations in different
people.

The fleeting perception by the human eye, of specks, stars, or irregular patterns, is a common phenomenon known by the name of *phosphenes*. Phosphenes are subjective images, independent of an external light source, and are the result of the self-illumination of the visual sense (Oster, 1970). As they originate within the eye and the brain, they are common to all men. Occasionally, phosphenes can appear quite spontaneously, especially when the person has been deprived for a certain time of visual stimuli, such as would be the case in prolonged darkness or when exposed to extremely unvaried sights such as a cloudless sky, the sea, or rain in open country. They can also be produced by external stimuli: pressure on the eyeballs, a sudden shock, or by looking into the darkness when waking up at night. In all these cases the eye may perceive photic sensations which vary from tiny dots to intricate moiré patterns, and from fan-shaped rays to glowing circles, all in different shades, generally blue, green, orange, and yellow.

Moreover, phosphenes can be induced by a number of chemical agents. Hallucinogenic drugs such as LSD, psilocybin, mescaline, bufotein and harmaline are known to produce phosphenes of abstract design motifs, and frequently the after-images can be observed for several months after the initial experience.

Laboratory experiments carried out by Max Knoll (Oster, 1970), who induced phosphenes in more than 1,000 people, gave the following results: when applying low voltage square-wave pulses to the temples, pulses in the same frequency as brain waves produced luminous sensations in the visual field of the subjects and about half of them perceived geometric design motifs. The patterns of these designs changed whenever the frequency of the pulses varied and it became possible to group these motifs into fifteen categories.

A cursory comparison between Knoll's categories of fifteen universal phosphenes and the twenty design motifs isolated from the Tukano drawings shows the following correspondences:

Table 1.

TUKANO No.	KNOLL No.
1	13
2	9
6	3
7	9
8-9	12
10	10
11	15
13	7
14	1
15	2
17	3
18	4

Moreover, Knoll's numbers 5, 8, 11 and 14 are found in numerous drawings. These correspondences are too close to be mere coincidences; they seem to demonstrate that the geometrical patterns perceived by the Indians under the influence of *Banisteriopsis* are phosphenes comparable to those isolated by Max Knoll (Fig. 8).

I have mentioned before that I had asked the men for comments on the complete drawings and especially on the individual design elements. In the majority of cases their interpretations coincided and I was led to conclude that these phosphene-based motifs were codified, each having the fixed value of an ideographic sign. At the same time I observed that the interpretation of these signs often made reference to aspects of sexual physiology and, in direct relation to this, to the tribal laws of exogamy.

Taken one by one, the native interpretation of the Tukano design elements appears as follows:

1. Male organ	8. Group of phratries	15. Sun
2. Female organ	9. Line of descent	16. Plant growth
3. Fertilised uterus	10. Incest	17. Thought
4. Uterus as 'passage'	11. Exogamy	18. Stool
5. Drops of semen	12. Ritual box	19. Rattle
6. Mythical canoe	13. Milky Way	20. Cigar holder
7. Exogamic phratry	14. Rainbow	

This is not the place to go into the details of Tukano symbolism. Suffice it to say that the sun, the Milky Way, the rainbow, etc. are all

Figure 5. Pira-paraná, Vaupés territory, Colombia: a Tukano Indian drawing phosphene patterns.

connected with native concepts of procreation and fertility, and with the details of marriage rules.

The interpretation given to the design motifs revolves almost entirely around the problem of incest, a problem which is all-pervading in the native culture, and the message transmitted by the code insists on the observance of the laws of exogamy. The important point, however is that the code is extended beyond the narrow confines of individual trance and is applied to the wider physical environment of everyday life. In fact, the designs and patterns perceived under the influence of *Banisteriopsis* are transplanted to the concrete objects of material culture where they come to constitute an art form. Practically all decorative elements that adorn the objects manufactured by the Tukano are said by them to be derived from the photic sensations perceived under the influence of the drug; that is, are based on phosphenes. A closer look at the applied art of the Tukano is most revealing.

The most outstanding examples are the paintings executed on the front part of the longhouses. The walls, made of large pieces of flattened bark, are covered wholly or in part with bold designs painted with mineral colours – occasionally with the admixture of vegetable dyes – and represent the same geometric motifs I have discussed above. Sometimes they are combined with figurative designs of people and animals. When asked about these paintings the Indians simply reply, 'This is what we see when we drink *Banisteriopsis*'.

Further examples are numerous. The bark-cloth aprons used during ritual occasions are painted with phosphene patterns and among some Tukano groups that manufacture bark-cloth masks these, too, exhibit the same designs. One apron shows the sign for exogamy painted prominently over the genital region while others are adorned with the sun, the rainbow, or other designs. The large stamping tubes which the Tukano use to accompany their dances are covered with similar designs showing zigzag lines, rhombs and rows of dots. The gourd rattles are sometimes covered with phosphene patterns. The large drums that were formerly in use were painted with these designs and occasionally a modern beer trough will be adorned with similar patterns. At present the Tukano have almost abandoned the manufacture of pottery, at least of small vessels that are likely to be decorated. The older people assured me that formerly many pottery vessels were decorated with phosphene patterns and even now one can occasionally find a small vessel adorned with these design motifs. The ritual vessel in which the narcotic beverage is prepared is always adorned with painted designs, generally in red, yellow and white, showing wavy lines, rows of dots, or a series of rainbow-shaped patterns. On some of these ritual vessels the U-shaped design of the uterine 'passage' is painted on the foot of the container.

It is important to point out here that the after-images of phosphenes can repeat themselves for up to six months. Within this time-span it is

very probable in our case that the person will have taken part in one or more *Banisteriopsis* sessions, or that he has consumed another narcotic drug, so that the after-images are likely to persist in a latent, chronic state, appearing in the visual field at any instant when they are triggered off by a change in body chemistry or an external stimulus. As these after-images might appear superposed on the normal vision of the individual and in plain daylight, the particular spectrum of phosphenes, together with their cultural interpretations, can be said

Figures 6 and 7. Pira-paraná, Vaupés territory, Colombia: Tukano drawings of phosphene patterns.

to accompany the person in a permanent manner. That phosphenes and their after-images are occasionally being reinforced, brought into focus or, perhaps, triggered off by normal visual perception, is also quite possible. It has been proved experimentally (Oster, 1970) that, when flickering, shapeless phosphenes are combined with normal visual perception, the phosphenes begin to take a more definite form.

The physical environment during a *Banisteriopsis* session provides

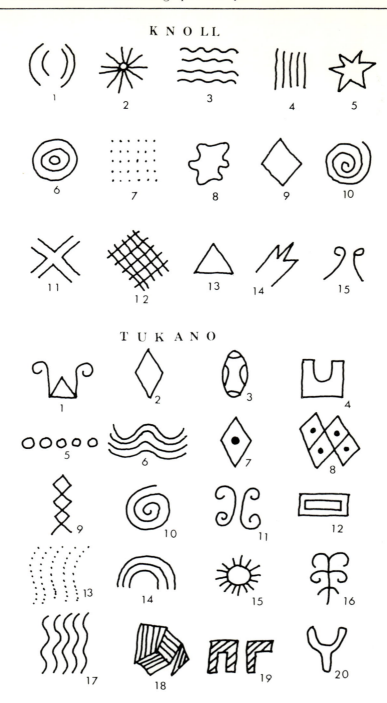

Figure 8. Phosphene patterns.

many models or stimuli which are almost permanently before the eyes of the individual as, for example, the very symmetrically interwoven leaves of the thatched roof and of the walls of the long-house, basketry trays, feather head-dresses and other ornaments. There are probably other stimuli present, many of which seem to be well recognised as such by the Indians. The intense red light of a torch used during *Banisteriopsis* rituals seems to be an important factor in the production of phosphenes and, eventually, of true hallucinations. Obviously, the Indians practise various non-drug techniques in order to produce endogenously certain altered states of consciousness.

In summarising, with the exception of a few more or less realistic designs of animals or houses, the entire art style of the Tukano can be said to be based on drug-induced phosphenes. Most of the elements that compose this art style carry a message: exogamy, and everywhere, especially on ritual occasions, the individual is reminded of the law of exogamy, expressed by these visual metaphors which adorn utensils, or which are ever-present in the spectrum of his phosphenes.

Motifs such as rainbows, stars, circles or bright dots, undulating lines or multicoloured stripes, all figure in a wide range of sensations perceived during the initial or advanced stages of intoxication by *Banisteriopsis* and other drugs as well. Paintings and drawings executed by individuals of our culture under the influence of LSD, mescaline, peyote and other drugs, or when attempting to fix the visions after the primary effect has worn off, frequently have common characteristics. It would be difficult to attribute this commonality solely to the cultural experience shared by these artists. On the one hand it is true that when the Indians interpret their visions, certain projective and feedback processes are at work, as well as earlier cultural experiences; they are therefore influenced by their visual and circumstantial memory and by the models that appear in their physical environment. But on the other hand, there exists an element of rhythm, of pulsation in the imagery of *Banisteriopsis* intoxication, that seems more likely to be organically based than determined *only* by a visual and culturally moulded memory.

More than a thousand kilometres to the north-west of the Tukano territory, in the Pacific lowlands of Colombia, the Chocó Indians have developed an art style which, in many ways, is similar to the one associated with the Tukano. Although both groups are inhabitants of the humid tropical forests, they vary widely in their cultural characteristics. In the case of the Chocó, colourful geometrical designs are painted on all ritual objects, most of which are manufactured of wood. Again, the designs have a distinct phosphene character and it is hardly a coincidence that the Chocó Indians, too, use *Banisteriopsis* infusions for their religious purposes (Reichel-Dolmatoff, 1960). It may be added here that those Colombian Indians who apparently do not use *Banisteriopsis*, cannot be said to have a readily recognisable art style (Fig. 4).

It would not be difficult to find parallels to phosphene-derived design motifs in prehistoric artifacts, such as the decoration of ceramics, or petroglyphs and pictographs. The pottery of a prehistoric burial cave in northern Colombia, associated with snuff tablets and bone containers suggesting the use of narcotic snuff, is decorated with designs clearly comparable to the Knoll-Tukano series (Reichel-Dolmatoff, 1949).

Could archaeology lead us then to a zoning of these symbolic systems? If we suppose that the use of hallucinogens by the American aborigines is a very ancient practice, and that in general it is related to the religious sphere, we may also assume that ceremonial objects were manufactured and decorated by specialists, or at least by persons who were thoroughly immersed in the religious symbolism of their culture. But can we then speak of 'decoration' in an aesthetic sense? And would this not put into doubt the value of many cross-cultural similarities?

The assessment of the possible relationship between drug-induced phosphenes and applied art in native societies is far beyond the competence of the field ethnologist. Only interdisciplinary research, with the participation of specialists in the neurosciences, of biochemists, pharmacologists, botanists and psychologists, can show us the way through this borderline area, and help us avoid its pitfalls, or provide us with new insights.

Addendum

Between the writing of this article and its appearance in print the topic here treated has been discussed in various publications. The author wishes to draw special attention to the following book: Joseph Eichmeier and Oskar Höfer, *Endogene Bildmuster*, Munich-Berlin-Vienna, 1974. This work contains a detailed study of neurophysiological phenomena and discusses the relationship of phosphenes to primitive and modern art.

REFERENCES

Agurell, S., Holmstedt, B. and Lindgren, J.E., (1968), 'Alkaloid content of (*Banisteriopsis rusbyana*', *American Journal of Pharmacy*, 140, 5, 148-51.

Bristol, Melvin L. (1966), 'The psychotropic *Banisteriopsis* among the Sibundoy of Colombia', *Botanical Museum Leaflets, Harvard University*, xxi, 229-248.

Chen, A.L. and Chen, K.K. (1939), 'Harmine, the alkaloid of caapi', *Quarterly Journal of Pharmacy and Pharmacology*, xii, 30-38.

Der Marderosian, A.H., Pinkley, H.V. and Dobbins, M.F. (1968), 'Native use and occurrence of N, N-Dimethyltryptamine in the leaves of *Banisteriopsis rusbyana*', *American Journal of Pharmacy*, 140, 137-47.

Efron, Daniel, (ed.), (1967), 'Ethnopharmacologic search for psychoactive drugs', *U.S. Public Health Service Publication No. 1645.*

Elger, F. (1928), 'Uber das Vorkommen von Harmin in einer südamerikanischen Liane (Yagé)', *Helv. Chim. Acta*, xi, 162-66.

Fischer Cárdenas, (1923), *Estudio sobre el principio activo del Yagé*, (Doctoral thesis, Universidad Nacional, Facultad de Medicina, Casa Editorial de 'La Cruzada', Bogotá.)

Friedberg, Claudine, (1965), 'Des Banisteriopsis utilisés comme drogue en Amérique du Sud', *Journal d'agriculture tropicale et de botanique appliquée*, xii, 403-37, 550-90, 729-80.

Furst, P.T. (ed.) (1972), *Flesh of the Gods: The Ritual Use of Hallucinogens*, New York.

Harner, M.J., (1968), 'The sound of rushing water', *Natural History*, lxxvii, 28-33, 60-61.

Harner, M.J. (ed.) (1973), *Hallucinogens and Shamanism*, Oxford.

Hochstein, F.A. and A.M. Paradies, (1957), 'Alkaloids of *Banisteriopsis caapi* and *Prestonia amazonicum*', *Journal of the Am. Chem. Soc.* 79, 5735-6.

Knoll, M. (1958), 'Anregung geometrischer Figuren und anderer subjektiver Lichtmuster in elektrischen Feldern', *Zeitschrift für Psychologie*, xvii, 110-26.

Knoll, M. and Kugler, J. (1959), 'Subjective light pattern spectroscopy in the encephalographic frequency range', *Nature*, 184, 1823-4.

Knoll, M., Höfer, O., Lawder, S.D. and Lawder, U.M. (1962), 'Die Reproduzierbarkeit von elektrisch angeregten Lichterscheinungen (Phosphenen) bei zwei Versuchspersonen innerhalb 6 Monaten', *Elektromedizin*, vii, 4, 235-42.

Knoll, M., Kugler, J. and Lawder, S.D., (1963), 'Effects of chemical stimulation of electrically-induced phosphenes on their bandwidth, shape, number and intensity', *Confinia neurologica*, xxiii, 201-26.

Naranjo, C. (1965), 'Psychological aspects of *yajé* experience in an experimental setting', Paper presented at the 64th annual meeting of the American Anthropological Association, Denver.

Naranjo, C. (1967), 'Psychotropic properties of the Harmala alkaloids', *in* (ed.) D. Efron, *Ethnopharmacologic Search for Psychoactive Drugs*, 389-91.

O'Connell, F.D. and Lynn, E.V. (1953), 'The alkaloids of *Banisteriopsis inebrians* Morton', *Journal of the American Pharmaceutical Association*, xlii, 7534.

Oster, G. (1970), 'Phosphenes', *Scientific American*, ccxxii, 2, 83-7.

Poisson, J. (1965), 'Note sur le "Natem", boisson toxique péruvienne et ses alcaloides', *Annal. Pharm. Françaises*, 23, 242-4.

Reichel-Dolmatoff, G. (1949), 'La cueva funeraria de La Paz', *Boletín de Arqueología*, ii, 5-6, 403-12.

Reichel-Dolmatoff, G. (1960), 'Notas etnográficas sobre los indios del Chocó', *Revista Colombiana de Antropología*, ix, 75-158.

Reichel-Dolmatoff, G. (1969), 'El contexto cultural de un alucinógeno aborigen: *Banisteriopsis caapi*', *Revista de la Academia Colombiana de Ciencias Exactas, Físicas y Naturales*, xiii, 327-45.

Reichel-Dolmatoff, G. (1971), *Amazonian Cosmos*, Chicago.

Reichel-Dolmatoff, G. (1972), 'The cultural context of an aboriginal hallucinogen: *Banisteriopsis caapi*', in P.T. Furst (ed.), *The Flesh of the Gods*, 84-113.

Reichel-Dolmatoff, G. (1975), *The Shaman and the Jaguar: A Study of Narcotic Drugs among the Indians of Colombia*, Philadelphia.

Rivier, L. and Lindgren, J.E. (1972), 'Ayahuasca', the South American hallucinogenic drink: an ethnobotanical and chemical investigation, *Economic Botany*, 26, 2, 101-29.

Schleiffer, H. (1973), *Sacred Narcotic Plants of the New World Indians: An Anthology of Texts from the 16th Century to date*, New York.

Schultes, R.E. (1957), 'The identity of the malpighiaceous narcotics of South America', *Botanical Museum Leaflets, Harvard University*, xviii, 1-56.

Schultes, R.E. (1969), 'Hallucinogens of plant origin', *Science*, clxiii, 245-54.

Schultes, R.E. (1972), 'De plantis toxicariis e mundo novo tropicale commentationes X. New data on the malpighiaceous narcotics of South America', *Botanical Museum Leaflets, Harvard University*, xxxiii, 137-47.

Schultes, R.E. and Hofmann, A. (1973), *The Botany and Chemistry of Hallucinogens*, Springfield.

Spruce, R. (1908), *Notes of a Botanist on the Amazon and Andes* (ed. A.R. Wallace), London.

Tart, C. (ed.), (1969), *Altered States of Consciousness: A Book of Readings*, New York.

Uscátegui M., Néstor, (1959), 'The present distribution of narcotics and stimulants amongst the Indian tribes of Colombia', *Botanical Museum Leaflets, Harvard University*, xviii, 273-304.

Malcolm D. McLeod
Aspects of Asante images

In this paper I wish to discuss a neglected area in the study of African art and images: that of their subject matter, what they are made to represent. Although considerable thought has been given to function, form and style in African art very little has been said about why image-makers have portrayed some creatures or items and not others.

The problem I wish to discuss is posed by the subject matter of one sort of Asante image. I raise this problem in the hope that someone can offer a satisfactory solution to it or show that the problem, as posed, does not exist. The problem itself can be stated simply: why did the Asante people of Central Ghana create portable images of certain objects, creatures and situations from their life and environment and not create images of other things, creatures and situations?

The tentative answer I put forward is that this selective imaging is in some way linked to the way the Asante impose a more or less coherent, constant and predictable pattern upon the social and material world they dwell within. I further suggest that the creatures which are not portrayed are those which occupy a particularly close and 'moral' relationship with man in Asante thought. As such, I suggest, they serve to represent or embody certain moral categories and shades of moral discrimination. These must be protected from blurring or alteration. What are key creatures at a 'basic' level must, I argue, therefore be prevented from becoming 'token' creatures at another, lesser, level. In particular, they must be kept out of a conceptual sub-system which exists to blur or to overcome the basic categorical distinctions on which the Asante build their world: the system of exchanging different goods or creatures through the medium of gold-dust.

I am fully aware that my approach ignores many questions of meaning and aesthetics; for the moment I am happy to put these aside. It will also be noted that wherever possible I use the term 'image' rather than 'art'. I believe this may help remove a few of the multitude of problems created by labelling as 'art' what we do not understand.

My problem thus turns on how men create universes for themselves and how they try to keep these intact. It is clear that they use many methods to impose order and pattern on their multiple, shifting experiences and of these a common language and common sets of categories are among the most important. But any of the human universes constructed in this way must also admit of a limited degree of internal flexibility. Some universes may be more rigid than others, some 'tighter' or 'looser' than others, but none can be completely monolithic, fixed, inflexible. While key categories or acts may be protected from alteration, things of lesser importance can be allowed to suffer modification as the need presents itself. Lévi-Strauss, Leach, Douglas and others have suggested that mechanisms exist whereby basic categories are clarified and protected: what cannot easily be classed as one thing or another is subject to avoidance behaviour, regarded as polluting or destroyed. I would suggest that what is now needed is some appreciation that not all social and intellectual phenomena are of the same importance: some things are far more important than others, and therefore what befalls them is of far greater importance to the general system than what befalls lesser categories. I suggest, for want of a better solution, that the absence of certain creatures from Asante images is linked to the importance given to those creatures in the Asante moral universe. What is a key category is that universe cannot therefore, I argue, be diminished in importance by being tangled up in a lesser symbolic system: especially when that lesser system is concerned with the pretence that different things are in some way the same. The argument I present may be involved and insubstantial, nevertheless the problem it tries to attack is, I believe, a real one.

I would also point out that I am conscious of trying to reconstruct a world which fell into decay 70 or more years ago and that I am dealing with a defective sample of the items produced and used in that world. However I use the problems arising from that attempted reconstruction to discuss how far the idea of reducing cultures to structural systems by analogy with linguistic analyses may contain assumptions for which no proof has ever been offered and which may dramatically oversimplify the problems of 'de-coding' these systems.

It is first necessary to sketch in the ethnographic background. The Asante people occupy the central area of Ghana (formally called the Gold Coast). In the pre-colonial period (i.e. before the end of the last century) they were one of the most successful imperial powers of West Africa. They exploited the tropical rainforest in which they lived by both hunting and farming, but two special resources of the area, gold and kola-nuts, enabled them to build up outside trade links. From the Europeans on the coast they obtained firearms and by using these they were able to extend the area of their political and economic dominance until they became the major power in the region.

The Asante are not famed for their representational art. What they

produced is, in our eyes at least, of a fairly low quality. They have no elaborate aesthetic theory and most of their carvings and terra-cottas seem to have been made non-professionally by local people for local use. They have little or no concept of 'art' in our sense, although they recognise good craftsmanship, skill or cunning (*adwini*) in working materials and have fairly well developed ideas about the qualities they expect to see in the things produced. Craft specialisation existed and was largely associated with the needs of the royal courts, especially that of the Asantehene at Kumasi, and with production for local trade. Formerly there was a certain amount of political control over what was made and the monarch had, in theory at least, first offer of any new cloth or stool designs when these were invented. But the type of control over art content in which I am interested is one which operated at a far deeper level than this conscious political sort of restriction.

Asante representational images can be divided into three broad types each with different conventions of use, purpose and style. The first sort was 'political'; images used to emphasise and elaborate the various levels of chiefship and clarify their distinctions. This type of image was found in the form of gold-foil covered umbrella tops, staffs carried by chiefs' spokesmen, gold finger and toe rings, armlets and gold decorations for chains, head gear and sandals. This art was also used as a mnemonic for important historical or mythical events and to communicate, in the absence of writing, certain verbal expressions. These proverbs or aphorisms, *ebe*, had as their ostensible subject matter a wide variety of relationships between humans of different ranks and occupations, between men and beasts or between these creatures and inanimate objects.[1] By representing in their carvings and castings the protagonists of these proverbs the Asante were able to convey the proverb visually. The proverbs utilised in this way in court art were most often those concerned with the dangers and responsibilities which are associated with political inequality. Thus the three-dimensional image, through the proverb, posed abstract relationships which could be applied to new or recurrent situations in which chiefs and people were involved. Verbal messages of a related sort are also transmitted by other two- or three-dimensional representations; for example a simple repeated chevron design is understood by many Asante to mean that abuse and over-frank speaking is to be avoided when addressing chiefs: the design is said to derive from the fern *aya* – a common word which, pronounced with different tones, means 'abuse'. In regard to this sort of art it is the *verbal* dimension which is most important to the Asante and which gives a carving or a casting its 'meaning'.

1 E.g. 'The rain wets the leopard's spots but does not wash them off'; 'The dew on the bushes does not drop on the creature which walks behind the elephant'; 'I cannot see God when lying on my back; what chance do you have lying on your belly?'

Figure 1. Asante brass gold-weights in 'abstract' forms. (*Photo: courtesy Trustees of the British Museum*)

The second type of art was used in making links between the world of men and other worlds such as the world of the ancestors, that of the yet unborn, and of the free divinities (*abosom*) and the lesser powers (*asuman*). Most of the items in this category were small, black, anthropomorphic carvings used in shrines, or in the case of so-called 'fertility-dolls' (*akua'mma*) carried about by women. As far as can be ascertained there was little or no verbal dimension to this art and the carvings communicated meaning through their form alone or by the physical and ritual context in which they were used.

The third type of image is that for which the Asante are most famous: gold-weights (*abramo*; Menzel, 1968; Plass, 1967). These are small lost-wax castings in brass formerly used as weights in measuring gold-dust (*sika futura*) in everyday commercial transactions and in paying legal fines and so forth.

There are two basic sorts of weights: 'abstract' geometric ones (squares, cubes, pyramids, discs, decorated with straight and cursive designs; Fig. 1) and ones which reproduce in miniature the physical form of items and creatures in the Asante universe. To the former no sane Asante now tries to attribute meaning. It is the latter which are my concern here, for their subject matter shows a curious patterning.

Representational weights were probably made between the end of the seventeenth century and about 1880-90 (Figs. 2-3). Although those which survive are outnumbered by about 6 to 1 by geometric weights they were produced in considerable numbers and perhaps as many as 100,000 survive. They were made by professional casters and a considerable number of these must have been involved, over the

Figure 2. Asante brass gold-weight in the form of a lion. (*Photo: courtesy Trustees of the British Museum*)

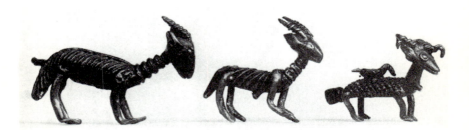

Figure 3. Asante brass gold-weights in the form of antelopes. (*Photo: courtesy Trustees of the British Museum*)

centuries and throughout the area, to have produced the large numbers of weights which were formerly in use (Werner, 1972). Many of these weights are proverbial and others, representing items which are elements in proverbs, can have one or more proverbs linked to them. Like the images used around the court, most of these proverb weights are concerned with relationships of inferiority, superiority or of equality. But, as far as we know, weights were not used to communicate proverbs in the way that court images were. Proverb weights were not usually, if ever, used directly to pass messages. They were primarily weights which were given a form consonant with the

rest of Asante culture. And this brings me to my problem. Any examination of the surviving corpus of weights shows that while these reproduce in miniature a very large number of the creatures, objects and human situations of the Asante world, there are also some things, creatures and situations which are absolutely absent from the corpus. My problem is to explain why this should be (and Asante today are not aware of this fact nor can they, when it is pointed out, offer any explanation for it) and how it can be related to Asante ideas on the proper positioning of things in their cosmology. The list seems prosaic but is important.

The following subjects are not represented as weights: cats, dogs, sheep, pigs, goats, cows (although severed heads of cows appear as the decorations for state sword weights) and horses without riders, rats, mice and spiders (although the spider Ananse is the hero of most Asante folk-tales).[2] Certain birds are not represented and to the outsider the most noticeable of these are vultures, ducks, turkeys and crows (the modelling of birds is usually fine enough for the species to be identified). Nor is the wild dog represented, nor the hare nor the hyrax-like rodent, the grass-cutter, or the arboreal tree-bear. Two objects which are present in large numbers in the area are also absent from the weights: the cowrie and the neolithic ground stone axe (*nyameakuma*) which washes out of the ground in great numbers and is used in shrine rituals. Other subjects missing are the ordinary village house and the distinctive three-stone hearth on which all cooking is done. Human parturition and excretion are never modelled and copulation is shown in only a handful of authentic weights. Virtually everything else the Asante knew is represented in gold-weight form.

I emphasise that these absences are absolute: the things I have listed do not occur even in ones or twos in the thousands of genuine pre-1900 weights I have seen. I do not believe these absences are accidental or unmotivated. The total absence of, for example, cats or dogs from a corpus of weights numbering perhaps 100,000 or more must be more than an accident and therefore result from some principle or principles which held good for all weight casters (?and also their customers) over a period of 200 or more years. Simple technical or historical explanations do not work: these creatures or things were not left out because they were unknown or of no importance to the Asante: houses and hearths must have existed for a long time, and even the turkey or duck, which were transmitted to Asante through European contacts, were well established in the forest by the eighteenth century. The domestic animals listed were kept for food and sacrifice in large numbers. Nor is there any good technical reason for these absences – it is just as easy to model a goat and cow as it is to make an antelope or buffalo, both of which are represented in

2 It is true that I know of three weights showing spiders; I am inclined to think these were made during the revival of weight casting in the 1920s.

considerable numbers. It should be understood that all the items listed were utilised both directly and metaphorically in other areas of Asante culture, in proverbs, in religious rites, in preparing medicines, in folk tales (Anansesem) and some of them were also portrayed in court art. Why then do they not occur as weights?

To a certain extent some of these absences seem to fit into the general pattern of the Asante universe, and the categories into which animals are classified and by which man orientates himself physically and morally with the rest of the world. The key categorical division in Asante life is between things of the house and village (*'fie, kuro'm*) and those of the bush or forest (*wura'm*). Formerly, each Asante village was separated from the next by a tract of dense rain forest. Asante culture took and elaborated this necessary environmental and visual contrast and made it a moral one. The contrast and opposition between bush and village runs through almost all Asante thought and I believe it is the key to understanding much religious and therapeutic ritual, the structure of proverbs and many local myths of origin. The forest was seen as a dangerous but potent area into which man ventured to hunt or seek exceptional knowledge and power at his peril, in contrast the village was the place where all essentially human activities were properly to be performed. To copulate in the bush, for example, polluted the earth deity *Asase Yaa*, while to die in the bush meant the deceased was classed as *otofo*; that is, he was classed with convicted witches and executed criminals and thereby deprived of a proper funeral and the possibility of becoming an ancestor. While the village, centred on the symbolic shade tree, *gyadua*, was ideally peaceful and cool (*dwo*) the bush was 'hot' and full of beasts and beings antagonistic to man. In the bush dwelled *sasabonsam*, a red, man-eating monster and the *mmoatia*, unpredictable goblin-like creatures. The bush was the resort of witches and the place to which gods drove the men they seized to be taught priestcraft by the *mmoatia*. Also in the bush were 'hot' animals with vengeful spirits (*sasa*) which could trouble those who slew them.

This conceptual opposition was given a physical sign with the erection of small stiles or fences (*pampim*) across the path at each end of the village. These marked the line between wild and domestic life. Although not large enough to be more than symbolical barriers they were believed to help keep death and sickness from the village. At them, in times of crisis, the *mussuo yie* rite was performed. In this 'pollution' was cast out by sweeping all the dirt, hair trimmings and broken goods from the village and depositing this dirt (*efi*) as a barrier across the path from the bush on the outer side of the *pampim*.

Between the bush and village, at the fringes (*'tia*) of the dwelling area, was an in-between zone in which were positioned those bush things which impinged on man and those human things of which the village wished to be rid. Here were a number of places for incomplete, damaged, decaying or dirty materials or for those entities which were

not fully absorbed into the human world. Here in the spaces between the backs of the houses and the beginnings of the forest were located the men's and women's latrines, and the village midden (*sumina*). The midden was the dump for all the sweepings and scraps removed twice daily from the village houses. But it was also used as the place for dumping the bodies of those who died in infancy, and for burying miscarriages, the bodies of those who died in child-birth, the bodies of convicted witches and criminals and the sterile: that is, it was the disposal place for those who were in some way physically or socially incomplete. Here, it is said, witch women bathed and trained their daughters in witchcraft. In this general zone, though a little closer to the bush, were the graves of ordinary people. In this in-between area were also placed the temples of free divinities and powers associated with the bush which, from time to time, possessed men and entered, for unpredictable periods, a symbiotic but uneasy relationship with them. Here also were the shrines of lesser, non-possessing powers, the *asuman*. In the same general area were also placed the *bradan* – simple huts to which women retired when menstruating. Thus the 'cool' village was separated from the bush by an area where the 'hot', unformed, decaying and polluting things were placed.

This is all directly relevant to the problem of the missing subjects in weights. Nearly all those animals which are not represented as weights are those classes as *fie'mmoa* – house or domestic animals. The house and hearth which are missing are also, of course, central elements in the domestic sphere. Among the other creatures which are not represented the vulture, wild dog and crow are associated by the Asante with the fringe areas of the village where they scavenge on the things discorded by man. The missing bush animals, the hare, tree-bear and grasscutter, seem to be treated rather like domestic animals which live in bush: they can be easily killed, are 'cool' and are hunted even by young children. We can therefore argue that the pattern matter in weights seems to accord in some way with the bush/village dichotomy which I suggest is a basic element in Asante thought.

But this does not explain why these animals are not portrayed nor the mechanism whereby they are excluded or ignored. It is here that wild speculation starts. Weights were used in effecting exchanged through the medium of gold-dust, i.e. they were used to impose units on amorphous gold. (No other money stuffs were used or permitted in Asante: the cowries, coinage and iron currency used elsewhere in the region were forbidden). In a sense the role of gold is to overcome, eliminate or subsume the differences between the items exchanged – they are in some way made equal through the gold. As Codere (1968) has argued, money is a symbolic system which increases in power according to the number of other abstract systems (e.g. numbers) which are combined with it. Money, at its highest levels of development, as in the Asante case, has the power to dissolve categorical restrictions, everything is made equal through the medium

of the money stuff. It is apparent that many cultures with highly developed 'general purpose' moneys think of these in liquid terms – we outselves talk of liquidity, solvency, floats etc. This accords with the idea of money stuffs as occupying an unclear, non-solid position or at best a special ambiguous, real-while-token position. In these circumstances we might also expect their treatment to reflect the common pattern for handling such substances as outlined by Douglas and Leach. The Freudian idea of the equivalence of excrement and money in Western culture, also, for example, fits this general theme: both are marginal, amorphous materials, which deny the differences of the materials from which they are made or which they are used to manipulate. On the one hand money is needed to operate, lubricate and carry out limited, abstract transformations, on the other there is always a danger it may destroy the moral categories based on the separation of different creatures and substances. It is necessary to relate this view to other aspects of the ordering of items in the Asante cosmos. The Asante are extremely conscious of problems of pollution and dirt. Although this is an impressionistic view I believe it is one which most people who know the Asante material would accept. Asante have many rules for keeping different classes of material or different types of behaviour separate and distinct. Menstrual prohibitions are strong and complex, certain acts to do with the margins of the body, such as nail trimming, must be kept to designated times of the day and away from other acts, food and drink, liquids and solids should not be mixed, hot and cold substances should not be brought into contact and so on. They inhabit a 'tight' universe at the opposite end of the scale from such free and easy universes as that said to be hinhabited by the Bambuti pygmies. Bathing and cleansing also play a large part in Asante rituals and the margins of the body have to be kept clearly defined and intact; blood and faeces carry a heavy symbolic and emotional charge and the category of dirt, *'efii'*, is a large and complex one. Although the elaborations and complexities of these practices and beliefs cannot be discussed here it seems that most of them are ultimately based on a few simple oppositions such as hot/cold, liquid/solid, bush/village. But at the base of all these patterns it is the bush/village dichotomy and man's varying relations with the animals within each area which is of primary importance. 'Pollution' is avoided by keeping each of these creatures in its proper place and treating it in the proper way. As in other cultures a homology can be drawn between the physical and moral positioning of such creatures and the patterning of sexual and marital categories, the physical ordering of space and even, in the Asante case, the structuring of time. I am thus suggesting that pollution ideas in Asante are, as elsewhere, connected with margins and that human self-identification and positioning in the world is strongly associated with the bush/village dichotomy and especially with the varying and subtle shades of behaviour practised towards

intra-village animals. It is these which set or emphasise the pattern used in other areas of life. So it may be claimed that the bush/village separation which lies beneath other, more delicate, categories must be preserved from blurring and confusion as it is basic to the Asante system.

I have already suggested that gold dust, on an abstract level, when used for buying and selling clearly serves to establish a form of equivalence between things which in other circumstances the Asante may feel should be kept separate and clearly different. There is some evidence that Asante are aware of the fluid marginal character of gold-dust. In some rituals, for example, gold (and 'money' in the form of cowries and coins) is tied into children's hair. According to some Asante this is done to 'keep the children from returning to the world of spirits'. Some claim it does this by 'strengthening', the hair-money here seems to be linked to marginality and perhaps it is possible to interpret this as a way of making clearer the edges of the person and so making them more substantial, more solid.[3] There is also some evidence that formerly there was a difference in the way gold dust was involved in the buying and selling of domestic and bush animals and this seems to support the idea that the key domestic animals were treated in ways which kept them distinct and different from other creatures. Thus some, if not all, domestic animals were apparently bought and sold only for a nominally fixed price. The very term for an irreducible price is a 'cat-price', and sheep, goats and dogs are said to have had their own special and theoretically fixed prices. Even today 'a sheep' is a synonym for a traditional quality of gold dust. It is also possible that there were other differences in the ways bush and village animals were sold. Bush animals never seem to have been sold alive: they were slain in the bush or before being brought into the village and were only sold in dismembered form. On the other hand village creatures were only killed and divided in very special ritual circumstances (and in the case of the cat after a token 'trial' for theft) and they were not initially sold dead, i.e. they were traded alive for nominally fixed sums.

If we argue that these creature categories were ones on which the patterning of the Asante world was especially dependent, and that the danger with money is that as an intermediate, marginal substance, it may weaken and destroy these basic categories, then it seems mildly plausible to argue that key categories, or representation of things in those categories, should be kept *out* of the money system as far as possible and not therefore appear as weights for the units in that money system.

3 Another interpretation is that it makes the children 'dirty' and so unwanted in the spirit world.

Conclusion

The transformations between one symbolic level and another in Asante culture are complex. I have touched on problems of what I believe to be primary categories, their manipulation and protection in only the most cursory and superficial way. A full examination of Asante thought would have to include an examination of the items used in magical and therapeutic rites, the creatures used in sacrifices, and the metaphorical chains of proverbs and folk-stories as well as all dietary and other prohibitions. Nevertheless the problem of a selective representation of parts of that universe as images remains.

I have tried to show how this selective representation seems in some way to be related to the village/bush dichotomy. I have also suggested that in a pollution conscious society the buying and selling of domestic animals may be subject to special rules. It is, of course, another thing to argue that living creatures cannot serve both to clarify man's position and to appear as weights for transactions which, at another level, confuse the very distinctions these creatures serve to clarify; and it is also another thing to suggest a mechanism by which this occurs.

It has become fashionable in anthropology to assume that cultures can be analysed as consisting of a number of (probably related) semiotic systems and that these convey meaning to those who use and experience them. The limitations of this approach, borrowed from post-Shannon communication theory and modern linguistics, have been stated frequently enough – it is hard to identify the senders and receivers in such systems and prove that any message has been passed, or to isolate the supposedly basic units which convey meaning by virtue of their structural oppositions when arranged in sequence. It has also been complained that the 'decoded' messages produced are too platitudinous or simple to be worth sending in such elaborate ways through myths or magic or dress. Words like code and paradigm are bandied about and used but the striking thing about nearly all the analyses produced in this way is, however, the almost insolent ease with which the postulated cultural codes have been broken and read. Let me therefore, having tinkered with the surface features of part of such a supposed code, propose another approach. All such analyses ultimately depend on regularities and the statistical predominance of certain items or forms which the analyst chooses to accept as the basic units which make up the message. But even if a directly contrary view of cultures were taken and if we accepted these as codes and ciphers in the true sense, i.e. as devices to *conceal* meaning from those without the key, then such regularities could still be present but not be meaningful. Both codes and ciphers work by transposing a coherently organised communication into another form by systematically substituting new symbols or signs for those in the original message. If this is done two or three times, each set of substitutions being carried

out on those produced by the preceding operation, the end product may still betray a regular patterning but one which it is almost impossible to return to the original. If we argue that the brain 'encodes' in the way Lévi-Strauss suggested, we might equally claim it 'encodes' because it cannot help doing so and therefore the end product need not be meaningful. Even if cultures do have basic categories or units of meaning on which they build other structures and 'messages' it might still be worth considering how far some areas of a culture may be rule-governed systems but precious little more; that is, certain forms of elaboration and manipulation become so complex that the minds which produce them in interaction with other minds are incapable of individually understanding them – they become all form and no meaning. Thus the problem of identifying 'receivers' of such messages can be avoided by the premise that they are not, in fact, received.

In this sense therefore, a patterning in weights (Werner, 1972), a regularity in their form, or in any other areas of culture, would not even need to be meaningful to those involved: its pattern might merely be the by-product of the application of rules important in other areas of that culture.

I therefore put forward two contradictory interpretations of the fact that certain subjects are missing from weights. One is that this is necessary to avoid a confusion, at different levels, of key categories centred on certain beasts. The other is that there is no real explanation: that the pattern isolated cannot be decoded so easily, that it may merely be the by-product of a general ordering tendency in the human mind, and that, as many readers may by now agree, it is not of the slightest importance.

REFERENCES

Codere, Helen (1968), 'Money-exchange systems and a theory of money', *Man*, n.s. iii, 557-77.

Menzel, Brigitte (1968), *Goldgewichte aus Ghana*, Berlin.

Plass. M. (1967), *African Miniatures: Goldweights of the Ashanti*, New York.

Werner, O. (1972), 'Uber die Zusammensetzung von Goldgewichten aus Ghana und anderen westafrikanischen Messinglegierungen', *Baessler-Archiv*, 20, 367-443.

James C. Faris

The productive basis of aesthetic traditions: some African examples

The object expands beyond its appearance because of our knowledge of what lies behind it. (Paul Klee)

Introduction[1]

An established canon of contemporary anthropological approaches to aesthetic traditions is the contingent relationship which is said to exist between art and society; that is, the contextual emphasis which it is argued must accompany any analysis of art traditions. We can all agree to this. The problem, however, rests in the precise nature of the relationship and the specification of the relevant contexts. It will be the argument here that the overwhelming majority of anthropological interpretations either never get beyond a descriptive or banal functional account (cf. Arnheim, 1960) or must assume psychological or neuropsychological causality in the explanation of the aesthetic systems (cf. Turner, 1966, Lévi-Strauss, 1963). It is suggested that a clearer understanding may be had of both the form and content of aesthetic systems with careful attention to the mode of production of the society in question.

It is not enough to simply indicate that a particular sculpture is an ancestor figure and deduce that the society venerates ancestors. It must be understood why some societies who reckon ancestors have ancestor figures and why others who reckon ancestors do not; why the particular ancestor figures in question appear as they do, and what the role of the ancestors is in the society's productive activity. We must be able to generate particular aesthetic traditions from knowledge of their material foundations, not mystify them with functionalist bias.

1 For valuable discussions of the points herein, I would like to thank J. Driscoll, D. White, and particularly T. Northern. I am also grateful to C. Montgomery and F. Delaney for photographs. This acknowledgment in no way commits these persons to the essay's speculative position or its polemic.

A. Explanatory traditions

The vulgar functionalist interpretation so prevalent today is represented by Arnheim (1960, 103):

> Typically primitive art springs neither from detached curiosity nor from the 'creative' response for its own sake. It is not made to produce pleasurable illusions. Primitive art is a practical instrument for the important business of daily living. It gives body to superhuman powers so that they may become partners to concrete intercourse. It replaces real objects, animals, or humans, and thus takes over their jobs of rendering all kinds of services. It records and transmits information. It makes it possible to exert 'magic influences' upon creatures and things that are absent. Now what counts for all these operations is not the material existence of things but the effects that they exert or are exerted upon them ... Thus, for example, in the representation of animals the primitive limits himself to the enumeration of such features as limbs and organs and uses geometrically clear-cut shape and pattern to identify their kind, function, importance and mutual relationships as precisely as possible. He may use pictorial means also to express 'physiognomic' qualities, such as the ferocity or friendliness of the animal. Realistic detail would obscure rather than clarify these relevant characteristics.

Aesthetic traditions are in this view simply utilitarian and instrumental. While it can be assumed that art does something, that it is relevant to the 'important business of daily living', Arnheim gives us an empiricist description, not an analysis. It leaves aside – indeed, removes from introspection – the questions noted above, Why would some other medium, form or content not do as well? In other words, it fails to show why things are as they are, only how, descriptively they function. It is the position adopted here that even this latter task cannot be fully accomplished without knowledge of why such traditions exist. That is, we cannot even fully understand the functions of the tradition without knowledge of its generation.

Some writers posit causality in biology or psychology – in species – specific innate mechanisms (Lévi-Strauss, 1963), in subliminal responses (Turner, 1966), or in universal psychological salience (Chafe, 1970; Hays, *et al.*, 1972). Fischer (1971) provides an example linking specific stylistic elements in art traditions (straight *v.* curved lines, simple *v.* complex elements) to society, as expressions of 'fantasised social situations' on the part of the artists of the various societies concerned. Though his analysis focuses on specific form and content, his causality rests in concepts of modal personality and unconscious psychological representations. And although his material

may be falsified empirically, it is more fundamentally theoretically inadequate. It is simply not enough to link society and art functionally – we must have an explicit *theory* of society and social causation.

B. Social production

It will be argued that cultural symbols such as manifested in an art tradition symbolise social relations and people's ideas about social relations, and that significant social relations (those which must be symbolised for purposes of maintenance, celebration, socialisation and mystification) in societies basically stem from productive activities.

Social production is the species character of human beings. It requires the ability to project activity – hence to value labour – and thus produce activity instead of simply responding to nature. So long as producers control, projected activity is formulated for use, rather than exchange. This necessitates an organic relationship between producers and the transformation of nature involves and informs their consciousness. In objectifying nature, humans learn of its processes, and the cognitive expression of this is frequently seen in artistic or aesthetic traditions. Art will, in classless societies, celebrate human productive activity and thus be the basis of a consequent universal creativity. For in changing the world to our productive requirements humans *do not* adapt in a significant way, to the world – they adapt the world to themselves – cf. Faris, 1975) we learn about it and we are informed of new relationships and sensitivities not noticed before. Therefore, 'basic aesthetic problems ... grow organically out of the real reflection of the problems of social existence' (Lukacs, 1972, 51).

However, in situations where producers do not control, where they are alienated in some way from full control over the products of their activity or full control of their labour power, such circumstances must be justified, sanctioned and legitimated. Inasmuch as such social relations are basically exploitative, symbols of them and people's ideas about them must be mystified in order that they be legitimated in the absence of overt force. Symbolic activity (here aesthetic traditions) plays a critically important role, particularly in the absence of the overt force of state organisations. Symbolic activity generated by those in control of production is commonly a fetter on an objective and revealing view of the dynamics of the social world: it encourages a false consciousness with precisely functional consequences – the maintenance of the existing exploitative social relations of production by mystifying the objective nature of society.[2]

It will be argued that such relationships acquire (require) an extraordinarily heavy symbolic load, critically necessary to their very

2 Just as alienated labour transforms free and self directed activity into a means, so it transforms the species-life of man [social production] into a means of physical existence (Marx, 1963, 128).

maintenance and sanction, for as the objectification of the world does not necessitate such relationships, if they are to be made acceptable, mystification is required. If the rational material basis for the support of a non-producing segment of the population is missing, the symbols of their maintenance must be mystifying (see Faris, 1974). Art traditions, then, come to serve as explicit social control, or as symbols of social control.

The notion of particular aesthetic products serving in social control capacities is not new (cf. Harley, 1950). What is distinct about the current analysis is that it attempts to suggest *why* specific forms and specific contents may look as they do. By a careful examination of just what social relationships of production are symbolised it is possible to anticipate parameters on the appearance those symbols will take. Thus, it is possible to look behind the descriptive statement that Poro masks, for example, are agents of social control (Harley, 1950) by looking at the social relations they express. Then it is possible to know why this form of expression is used, why the content of the masks is as seen, and why the social relations of production in societies with the Poro masking tradition have (or require) such traditions.

C. Some methodological implications

The fundamental theme is that the neglected aspect of analyses of aesthetic traditions of any society is in the ideological function – that cultural symbols are ideological expressions of the social relations of production in that society. By knowing something of the relations of production, it is possible to eliminate certain alternatives to what might come to be aesthetic expressions of the social relations in question. That is, by knowing something about the social relations of production of the society in question, it may be deduced what sorts of cultural products will *not* be generated. Bacon and Warhol, much less Leonardo da Vinci or Goya, are not going to be the product of a society such as the San Bushmen. And it is not simply a matter of technique, media, materials or scale. It is a matter of differences in the social relations being symbolised in the societies of these different artists.

It must be stressed that this is not a methodology of positive prediction and induction. It is a method of eliminating certain alternatives to what can exist, because in having some view · of causality in aesthetic tradition, we have knowledge of what *cannot* take place. Knowledge of the causal relations between social relations of production and their symbols is not deterministic – it cannot dictate in a mechanical way what the symbols will be in form and content. But it is possible to know what they cannot be. Working the other way around is certainly less satisfactory. That is, speculating on the social relations of production which might have generated the cultural

expression from *only* the evidence of the cultural expression. This is sometimes the situation archaeologists find themselves in. And symbols may survive for some time after the social relations of production which generated them have changed. But certainly, understanding of and familiarity with the theory and method outlined here makes this situation unfortunate.

Let us look at examples. It is not likely, to take one example, that a state-organised society will extensively employ masking traditions in socio-political control. The Asante state, as has been seen in the preceding paper, excelled aesthetically in gold weights and small items of sculpture. Masks were confined to but a few royal portrait examples, i.e. symbols of control, not controlling symbols. Certainly the neighbours of the Asante, lacking state organisation, relied heavily on masking traditions in social control. The Asante simply did not need masks – the social relations of production could be maintained by the classic apparatus of state power, and aesthetic manifestations could be directed to the pleasures of the controllers of production. Hence the excellence of gold weight sculpture discussed above (pp. 305 ff.), celebrating as it did the export trade of the empire, and the realm emblems.

Similarly, though it is not possible to *predict* masking traditions in socio-political control for a stateless society such as the Dan or Ngere, neither is it possible to eliminate masks as symbolic manifestations necessary to sanction and mystify certain social relations of production characterising the society. In fact, masking traditions are an important part of the social control mechanisms of both societies.

As structural-functionalists would have it, masks disguise or hide and are thus indicative of boundaries – boundaries which maintain, destroy or establish. But an explanatory science must do more than this, it must ask why a mask came into being and why it looks like it does. In other words, what can be said about *why* it functions as it does? And, as seen in contrasting Dan-Ngere with Asante, why masks appear at all.

Ancestor figures, in classical explanations, represent and symbolise continuity, principles of descent and clanship, and are indicative of unity extended beyond the life of group members. But an explanation must ask why. What can be said, for example, about a society with ancestor figures such as those of the Dogon? Certainly not all societies with lineal descent systems have ancestor figures. Why some and not others, and what of the differences in the appearance of those having ancestor figures? Arguing the same way, why do some societies (or segments of societies) have grotesque and frightening masks while others have very tranquil and pacific masks (contrast Fig. 4 with Figs 5-6)? And why do other societies, particularly in regions known for masking traditions, lack masks? Of course the aesthetic traditions are peculiar to some extent to local situations and history, and of course their functions may be easily specified. But to understand not only the similarities but also the differences in the aesthetic productions of

these societies, it requires moving beyond functionalism. It can no longer be a substitute for explanation.

D. Examples: form and function

1. Ancestors and their representation

Concretising the example shown above, it is possible to contrast the Dogon and Tellum ancestor figures (Figs. 1-2) with those of the Baule (Fig. 3) or the sculpture of the Bakuba (Fig. 7) or Ife (Fig. 8). Can the differences be explained in terms of the differential skills of the carvers and the types of materials available? Of course there are technical and material parameters. But the explanatory key, it is suggested, may be seen in the differential social relations of production and their political sanction of the different societies.

In Dogon society the kinship system is the common basis for mobilising persons for work organisation and social production (including, here, *re*production, inasmuch as marriage is also ordered in these terms). This accounts for the reckoning of kinship and to a certain extent, the lineage structure (those with whom there are demonstrable kin links). But kinship is also the basis of clanship (clan being that descent unit with only a *tradition* of common descent and kin links). And the ancestor figures are regarded as representative of genealogically distant clansmen and clanswomen. They do not represent actual persons with whom one has specifiable links of kinship. It will be the argument here that the clan is specifically ideological and that ancestor figures are necessary to the maintenance of the ideology and to the mystification of actual social relations of production.

Access to productive land and claim to agricultural resources (including cattle, water and harvested crops) rests in kin group membership. But actual distribution and assignment of access rests with *clan* elders. Moreover, there are a series of clan-based and filled positions of an explicitly ideological character: those who propitiate the ancestors and exclusively maintain other rituals, and those responsible for certain decisions concerning group welfare. Dogon ancestor figures are important to furnish ideological support for the status and authority of clan elders. If the ancestors are not propitiated (witness the sacrificial encrustations of many of the older Dogon: Fig. 2), multiple maladies will affect the living. It is the clan elders who interpret the potential wrath of the ancestors, and whose status and authority in decision-making rests on the threat of that wrath. Materially, there is no reason for the clan, nor for the sanction and authority of the clan elders. Certainly Dogon social production does not require it; the mobilising potential of kinship is sufficient for the tasks required. The clan and the ancestors are a supradetermination of kinship for ideological purposes.

Figure 1. Dogon ancestor pair. (*The Barnes Foundation, Merion, Pennsylvania; photo:*
 C. Montgomery)

Figure 2. Tellum ancestor figure – note bisexuality. (*Musée de l'Homme, Paris; photo: F. Delaney*)

The ancestor figures, then, are essential to support a system of status, authority over the command of resources and their allocation, and some labour command, for one segment of the population, the clan elders. It is *not* that they are used to influence the spirit world (*contra* the acceptance of Dogon elder ideology by most anthropologists: cf. Willett, 1971, 41); the spirit world is simply the medium through which the elders justify and sanction the social relations of production.

What about the *particular* appearance of Dogon ancestor figures? As can be seen, Dogon ancestor figures are generalised and highly stylised (Figs. 1-2). They are not representative of specific individuals, for the Dogon have no aristocracy. Thus, the figures need not display individual qualities or particular personalities. The particular form is no more than the aesthetic translation of their mission – plastic representations which sanction behaviour and maintain the authority of the clan elders (leaning on the possibility of malady should they not be supplicated by their closest living kinsmen). Iconographically, the ancestor figures symbolise several cardinal qualities: fertility (witness the common appearance of both sexes, even to both sexes appearing in a single ancestor in the case of the Tellum sculpture; Fig. 2), companionship (particularly of male and female), the dignity of elderhood (witness the scarification, jewelry and hair fashion of maturity, including beards), and the long-suffering or pious attitude of the sculptures themselves (seen in the extreme in the supplicating posture of the Tellum examples).[3] These are not qualities foreign to normal life, and thus the sculptures are not removed from comprehension by normal people, but they require the clan elders to supplicate them, even if not to interpret them. They symbolise the distance of age and wisdom, but are not beyond the experience of ordinary people. In fact they reveal the virtues and requirements of normal life, particularly in its maturest expression, its elders, thereby reproducing the ideology necessary for elder hegemony.

The exploitation involved must not be understood to be oppression, nor anything severe or exclusive. Command over resources is not accumulative, it is, rather, redistributive. But advantages and prestige do accrue in command over persons, rights and benefits. Dogon clanship has its foundation in the material requirements of group production, in the social relations defined by kinship. Thus the clan *appears* a rational extension of such kin relations. Unfortunately it appeared so logical an extension that few anthropologists examined its explicit ideological character.[4] Clan elderhood is not an ascribed status. Behaving oneself and living long enough constitute the

3 That Tellum can be considered an earlier horizon of Dogon is a matter for debate. They may well have been replaced in the area by the Dogon (cf. Laude, 1973.)

4 The exceptions, not including the recent work of Marxist scholars (particularly in France), are Fortes (1945) and Forde (1964).

fundamental prerequisites. But it does confer status and authority which does not have a material rationale in kinship *per se*. Therefore, it requires ideological support: it is legitimated by projection onto the supernatural. That is, the dead clansmen are propitiated by their closest kinsmen, the living clan elders, without which all sorts of supposed maladies would result.

An ideology of ascription (such as characterises the lord/serf relationship in manorial feudalism) could not survive in Dogon society, nor could the finality associated with its ideological justification (humans are born lords or serfs: one cannot become the other). In Dogon society, everyone ostensibly has access eventually to clan elder status and authority. Its sanction can thus very logically rest on the mystery of propitiation of deceased clansmen, for authority in elders is projected onto the 'eldest', the ancestors, who apparently have the power to create great malady if not succoured. That is, succoured by the clan elders. The Dogon ancestor figures project, in form and content, exactly this situation.

Dogon ancestor sculpture may be contrasted with Baule sculptural figures (Fig. 3). The Baule (westward migrating Akan speakers in an environment distinctly different from the Dogon) were a stratified society with an aristocratic class whose position was secured from birth. The Baule figures are thus more appropriately commemorative. Some were 'ancestor' figures, others were simply representations of the spirit (living or dead) of the owner (cf. Vogel, 1973). Though they were sometimes regarded as being representative of particular persons, they are the archetypal 'beautiful people'. That is, they are not aged representations such as the ancestor figures of the Dogon, they are young adults in prime health, the epitome of well-groomed leisure. These figures are the work of specialists – highly polished and finished, even down to their elaborate coiffure. They are extremely serene, and usually display what can only be called an attitude of benevolent contempt. The Baule figure sculptures do not support a weak hegemony of elders as do the severe Dogon sculptures, they symbolise the confident position of the Baule aristocracy. As the Baule do not have the apparatus of a state organisation, these figure sculptures were important in social control, in the sanctioning of resource and labour allocation by the aforementioned supradetermined kinship manner, in clans. But the class structure appears more manifest – of a segment of the population ascribed from birth – and the figures celebrate and commemorate this structure as well.[5]

Baule sculptures contrast, then, with the ancestor figures of the Dogon in qualitative ways. The differences between them are not

5 I do not here consider the more unfinished 'nature spirit' Baule sculptures, only those 'civilised' and more polished 'spirit lovers' (Vogel, 1973, 25). But as noted above, neither do I consider the local Baule ideology for the sculptures as a necessarily adequate explanation.

Figure 3. Baule figure sculpture. British Museum, London. (*photo: C. Montgomery*)

simply technical, material and stylistic. The Dogon figures are important to an incipient stratification system; the Baule figures symbolise and are important to the serene arrogance of a type of 'civilised' class hegemony. Any categorisation, then, that lumps all 'ancestor' figures together is very likely to miss the essence of their possible qualitative differences.

Both the Baule and the Dogon figures may also be contrasted to the elaborate royal plastics of the Bakuba (Fig. 7). These Kuba sculptures were specific royal commemoratives. The figure illustrated is Shamba Balongongo (who reigned c.1600-20). The sculpture demonstrates iconographic indicators of his reign, such as the gaming board, which, it is said, was symbolic of his attempt to turn people away from excessive gambling (cf. Willett, 1971, 106). Here a well-organised state system no longer needed the support of ancestor figures, and it assigned its artisans to commemoratives of its kings. More stabilised state systems in different circumstances could even concentrate on portraiture and develop the unequalled magnificence of Ife royal terracottas (Fig. 8), which include even exaggerated human dimensions intended to increase the perception of perfection in the viewer.

2. The Dan-Ngere and Poro Masking traditions

Although there are repeated indications that some Dan-Ngere masks, irrespective of their form, could fulfill several functions and be used in different ways (cf. Willett, 1971, 185; Gerbrands, 1971, 370), it also seems clear that those masks used by the feared Poro secret society are of a basically similar form (Harley, 1950, and Fig. 4). Poro masks, whether of the Dan-Ngere or some other society in the Poro secret society area, seem to have an essential moderation in expression. They lack the grotesqueness which characterises other Dan-Ngere masks, for example (Figs. 5 and 6), and manifest a polished understatement of composure (perhaps cool, if not icy). Since the Poro society masks actually come from masks whose original purpose was more localised (Willett, 1971, 185), it is significant that not every local society mask becomes a Poro mask, and that only certain forms come to be used by the Poro. Why, for example, are the flamboyant and grotesque masks (Figs. 5-6) not chosen for Poro? The hypothesis here is that the aesthetic expressions of the various societies reveal something of the symbolic 'weight' or message that must be projected.

The Poro society is widely represented in the Ivory Coast, Sierra Leone and Liberia. It is a men's society undoubtedly having its origins in a single tribal society, but now much more widespread (D'Azevedo, 1962), with membership and shared influence across tribal and local society boundaries. The Poro society has a significant influence on political life, in local societies governed primarily by elder councils and, in some areas, weak district headmen (whose authority is

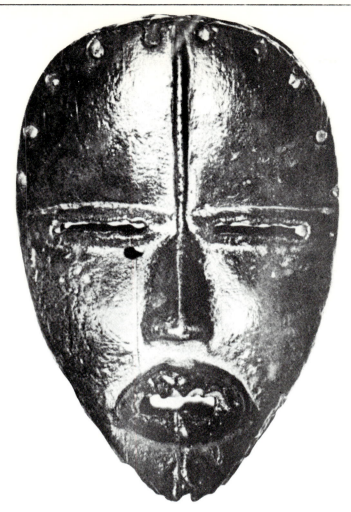

Figure 4. Poro society mask. (*Private Collection; photo: F. Delaney*)

supplemented by their Poro membership). The sanctions of secrecy also combine to inspire great dread and fear of Poro in all, particularly non-member males, women and children. The Poro society functionaries normally give first allegiance to the Poro society, not to their own 'tribe'. The Poro society functions to influence decisions on morality, law, economics, and uses the threat of physical and supernatural punishment for offenders against the general social order. It maintains its hold through fear and threat.

Other local sodalities occur among societies of the area (here, specifically, the Dan and Ngere), but because they are localised, they have none of the power of Poro. They operate in various specific ways – in initiations, medicine and curing, and in a series of other social

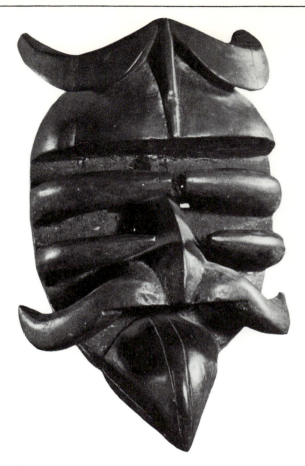

Figure 5. Dan-Ngere local society mask. (*National Museum, Copenhagen; photo: C. Montgomery*)

control and ordering ways. But they require symbolic 'help', inasmuch as they lack the potential physical threat of the Poro, and do not inspire the same dread as the widespread and cross-tribal Poro.

The Poro, by virtue of these cross-tribal ties and well-established socio-political control functions, could achieve aesthetic expression in ways which did not require leaning on the symbol itself to establish the essential message. One alternative, then (and the one that appears to have been adopted) was a masking series of cool, polished understatements. The masks themselves only had to disguise their wearers and diacritically mark them as Poro. They did not have to bear the weight of frightening observers. The knowledge of the Poro society did that.[6]

6 It might also be argued that the actual cool and subtle arrogance of the masks themselves is indicative of the potential in the message. That is, there is manifest a more fundamental dread than in the overtly violent local society masks.

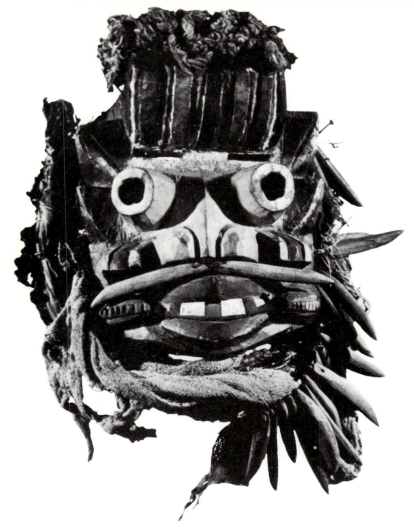

Figure 6. Dan-Ngere local society mask. (*Museum of Primitive Art, New York; photo: C. Montgomery*)

The local society masks (Figs. 5-6) of the Dan-Ngere, on the other hand, had to take on a signification of substantial proportions. In addition to masking the wearer and diacritically marking the local society group, they had also to project fright themselves.[7] Poro masks

7 Lest readers suspect the author's interpretation of fright, Willett (1971, 218) describes an experiment in which African informants were asked to describe several types of masks. These responses were compared to European informant responses to the same masks. An interesting inconsistency of agreement was found in the Africans' judgment about 'fierce' masks. Willett comments. 'Since these are used to exercise social control, it may be that those who were in a position to exercise power through

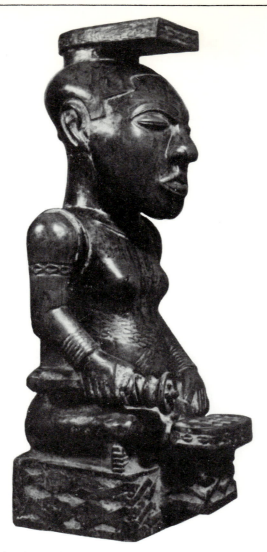

Figure 7. Bakuba king, Shamba Balongongo. (*British Museum, London; photo: C. Montgomery*)

could project assured and arrogant coolness because of people's knowledge of what was behind them. The local society masks had to project fright themselves for the very same reason: they simply did not have behind them the same sanctions to command response as did the Poro. As the social relations they symbolised were less threatening

them looked upon them with favour, whereas those who were dominated by them felt fearful and hence disliked them.' I here take the position of the viewer on whom they were designed to exert control.

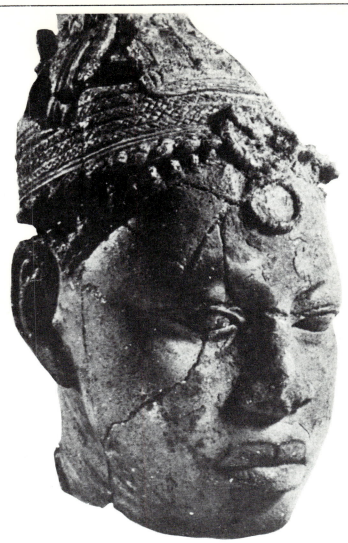

Figure 8. Ife terracotta, probably Oni of Ife. (*Nigerian Museum, Ife, photo: C. Montgomery*)

than those of Poro, so their manifestation bore a greater load and had to assume, in form, what the social relations symbolised lacked in content.

It is not intended to suggest anything universal by this particular comparison; only that, in this circumstance, such an analysis is possible. The existence of similar situations elsewhere does not justify prediction – each situation would of course have to be concretely examined.

3. Southeastern Nuba personal art

The personal art of the Southeast Nuba may serve as a final illustration of a generative approach to the functions of aesthetic traditions. Southeast Nuba society is characterised artistically by the personal art traditions of its young men and women (Faris, 1972). At every available opportunity, oil and ochre are applied to the healthy and strong body. Colours are peculiar to age grade status, but the designs, both representative and non-representative, have no functional signification beyond the celebration of the young healthy body. Thus, the design of a particular leopard species (Fig. 9) gives the artist no power over the animal, no leopard-like behaviour is acquired, and the design is in no way totemic. Apart from age status, there are no symbolic or ritual indications at all in the art tradition discussed here.[8]

However, the status of health and strength and youth are very important. When ill, or without oil and ochre (the latter a conspicuous sign of poverty, and therefore non-productivity), young persons will clothe themselves. If the body in its health and youth cannot be displayed and complemented with design, it is covered. Thus elders, male and female, wear clothing and no longer oil and ochre their bodies. And just as young men or women temporarily ill will clothe themselves, so will persons in 'ritual' removal – those in mourning or in sexual pollution.

Designs, in fact, are often used to complement a feature of the body considered attractive, or disguise a feature considered unattractive. Balance and symmetry *vis-à-vis* the total body are thus critically important, in concert with the natural bilateral symmetry (Fig. 10). Designs cannot despise the body (*contra* Lévi-Strauss, 1963, 215), but must enhance it and never detract from it. In fact, one will never see action scenes or 'stories' told in personal art, although these are common as paintings on hut walls and on granaries.

But why all this celebration of the young healthy body? Here once again, looking to the social relations of production is crucial to understanding the aesthetic tradition. The Southeast Nuba are rainfall agriculturalists in a precarious environmental niche – in a region of uncertain rainfall and with the presence of a multitude of pests and predators. Production in these circumstances requires considerable health and strength, and the society is replete with symbols of this requirement, from post-partum sexual restrictions and the recognition of the danger of twins, to the celebration of the archetypal healthy body in personal art.

8 There *is* ritual body painting, but it is not part of the tradition discussed here and is distinctly different – in form, content, technique and materials used (Faris, 1972, 43).

Figure 9. Southeastern Nuba representative design (leopard *sp.*). (*Photo: J.C. Faris*)

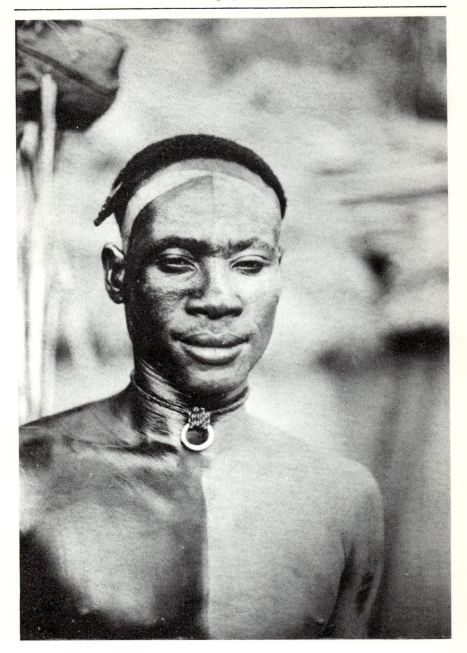

Figure 10. Southeastern Nuba non-representative design, focus on body bilateral symmetry. (*Photo: J.C. Faris*)

The 'functions' of the personal art tradition, such as in the classical manner outlined by Arnheim (see above p. 318), are simply missing among the Southeast Nuba. Only by a careful consideration of *why* the tradition looks as it does, with specific reference to the society's productive base, can the art tradition make sense at all. It celebrates the requirements for social production, for in the absence of class-dictated aesthetics, or aesthetic support for mystification and social control, the Southeast Nuba art tradition may emphasise the fundamental essence of human social activity, namely health and strength (and therefore beauty) necessary to production.[9]

Conclusions and summary

This paper has attempted to illuminate the correlation between art and social organisation. This attempt has pursued a functional approach in many ways similar to existing studies. The essential difference between this approach and others, however, rests in the theory which reveals, informs, and generates the function. It has been argued that all symbolic manifestations (here aesthetic traditions) are ideological: they are statements about what people view as the social relations to be symbolised. Since it is a fundamental premise that the relevant social relations are those of productive activity, those dictating aesthetics are those in control of the products of their labour, or in control of the production of others, or otherwise in a position to command resources or people.[10]

Examining in an excessively cursory fashion some of the art traditions of selected societies in Africa, we have indicated how form and content are both expressions of the ideological relationship of art to the productive requirements of society. And with such an approach, we have illustrated how the specific appearance of an art manifestation may come to be understood in a scientific sense that is, how it may be explained.

The methodological implications are apparent. We do not completely know how a particular aesthetic manifestation will appear by knowing something of the social relations of production, but we do know how it will *not* appear. We know, for example, that Poro masks do not have to project fright, for the social relations which they

9 I do not here consider the ideological significance of age and sex in southeast Nuba personal art, which a more detailed analysis must consider (cf. Faris, forthcoming).

10 Symbols are, of course, more properly communicative of contradictions – contradictions between processes (natural and social) of the world and our immediate knowledge of these. Symbols mediate this contradiction in various ways depending on control over production and therefore of knowledge of the world's processes. As such, symbols may either facilitate understanding or mystify understanding. In any case, they are ideological. For a discussion of this see Faris (1974).

symbolise do so effectively. An alternative (and the one which occurs) is instead to project a cool arrogance – an expression of the fact that what they symbolise is known to be feared. We do not know what Southeast Nuba personal décor will be. We know, however, that it will not violate, disguise or despise the healthy body, or celebrate an unproductive body. We know that Dogon ancestor figures need not personify or commemorate the way Baule figure sculptures do, and we know why the Asante do not need ancestor figures at all. Indeed, in terms of those societies considered, it is possible to sketch a progression in inegalitarian social relations of production from the Southeast Nuba through Dogon, Don-Ngere, Baule, to Asante – from the least stratified and hierarchical Nuba to the state-organised Asante – and see the way in which the messages carried by the aesthetic productions change concomitantly.

This paper is excessively speculative and isolates aesthetic manifestations from much of their total social context. But it is exactly such isolation from context that commonly faces the researchers, particularly the archaeologist. I have focused on specific manifestations and their explanation with reference to the social relations of production. It may be much more difficult or impossible to treat every aesthetic expression in such manner. Perhaps this little essay will, if nothing else, help researchers approach their data in a more informed and less inductive manner.

REFERENCES

Arnheim, R. (1960), *Art and Visual Perception*, Berkeley.

Chafe, W. (1970), *Meaning and the Structure of Language*, Chicago.

D'azevedo, W. (1962), 'Some historical problems in the delineation of a Central West Atlantic Region', *Annals of the New York Academy of Sciences*, 96, ii.

Faris, J.C. (1972), *Nuba Personal Art*, London.

Faris, J.C. (1974), *Structure and cognition: materialist approaches to creativity and consciousness* (manuscript).

Faris, J.C. (1975), 'Social evolution, population and production', in S. Polgar (ed.), *Population, Ecology and Social Evolution*, The Hague.

Faris, J.C. (forthcoming), *The Southeast Nuba: Production and ideology in a classless Sudanese society*.

Fischer, J. (1971), 'Art styles as cultural cognitive maps', in C. Otten (ed.), *Anthropology and Art*, New York.

Forde, D. (1964), *Yakö Studies*, London.

Fortes, M. (1945), *The Dynamics of Clanship Among the Tallensi*, London.

Gerbrands, A.A. (1971), 'Art as an element of culture in Africa', in C. Otten (ed.), *Anthropology in Art*, New York.

Harley, G. (1950), 'Masks as agents of social control in Northeast Liberia', *Papers of the Peabody Museum of Archaeology and Ethnology*, 32, 2.

Hays, D., E. Margolis, R. Naroll and D. Perkins (1972), 'Color term salience', *American Anthropologist*, 74, 5.

Laude, J. (1973), *African Art of the Dogon*, New York.

Lévi-Strauss, C. (1963), *Structural Anthropology*, New York.

Lukacs, G. (1972), 'Preface to Art and Society', *New Hungarian Quarterly*, 13.

Marx, K. (1963), *Karl Marx: Early Writings*, New York.
Turner, V. (1966), 'Color classification in Ndembu ritual', in M. Banton (ed.), *Anthropological Approaches to the Study of Religion*, London.
Vogel, S. (1973), 'People of wood: Baule figure sculpture', *College Art Journal*, 33, 3.
Willett, F. (1971), *African Art*, London.

INDEXES

GENERAL INDEX

INDEX OF AUTHORS